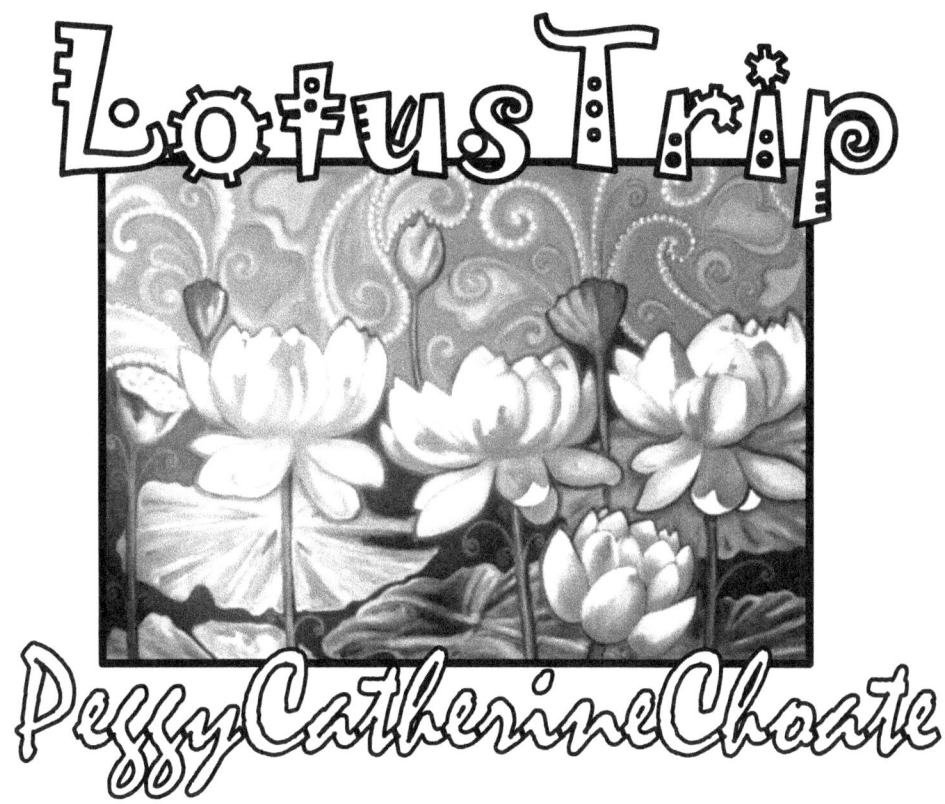

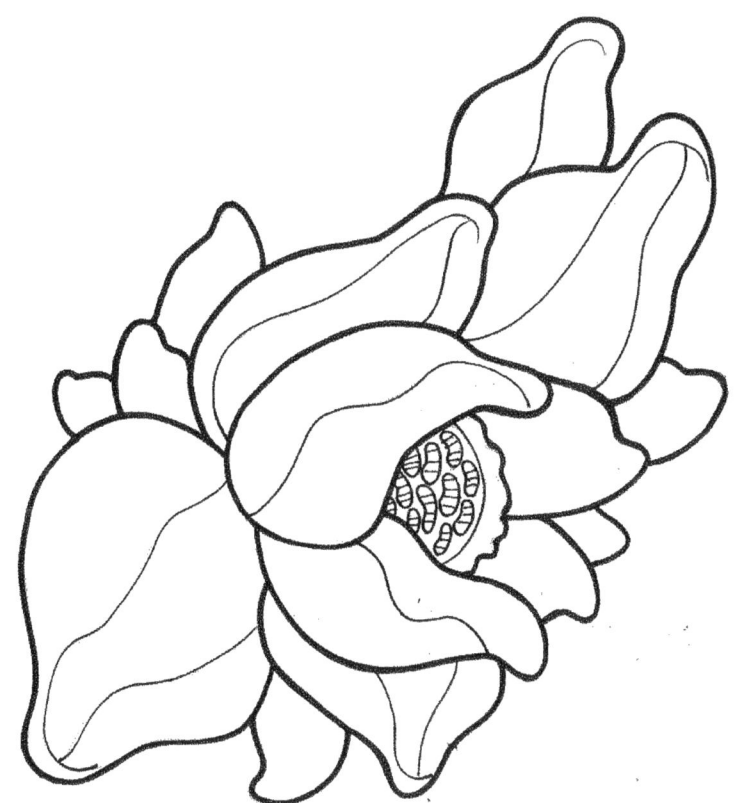

Time does not exist when I am

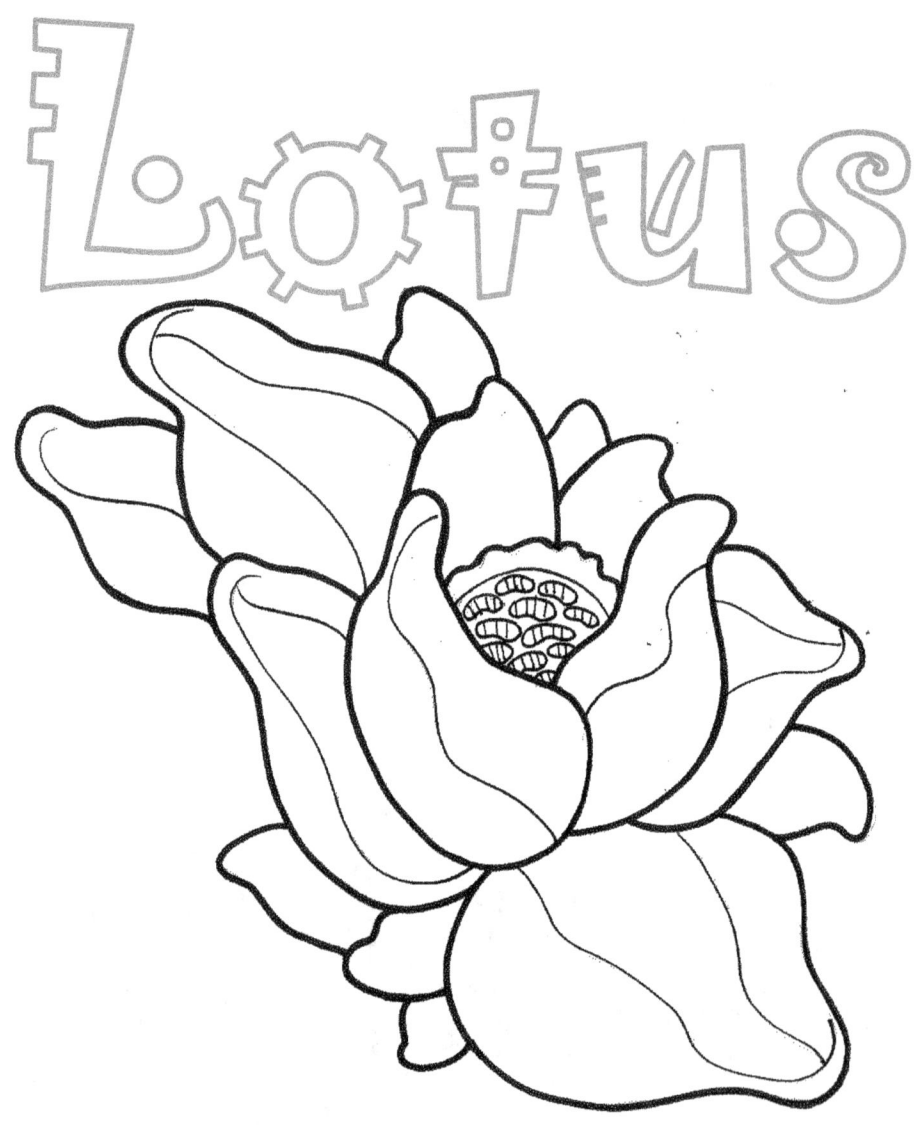

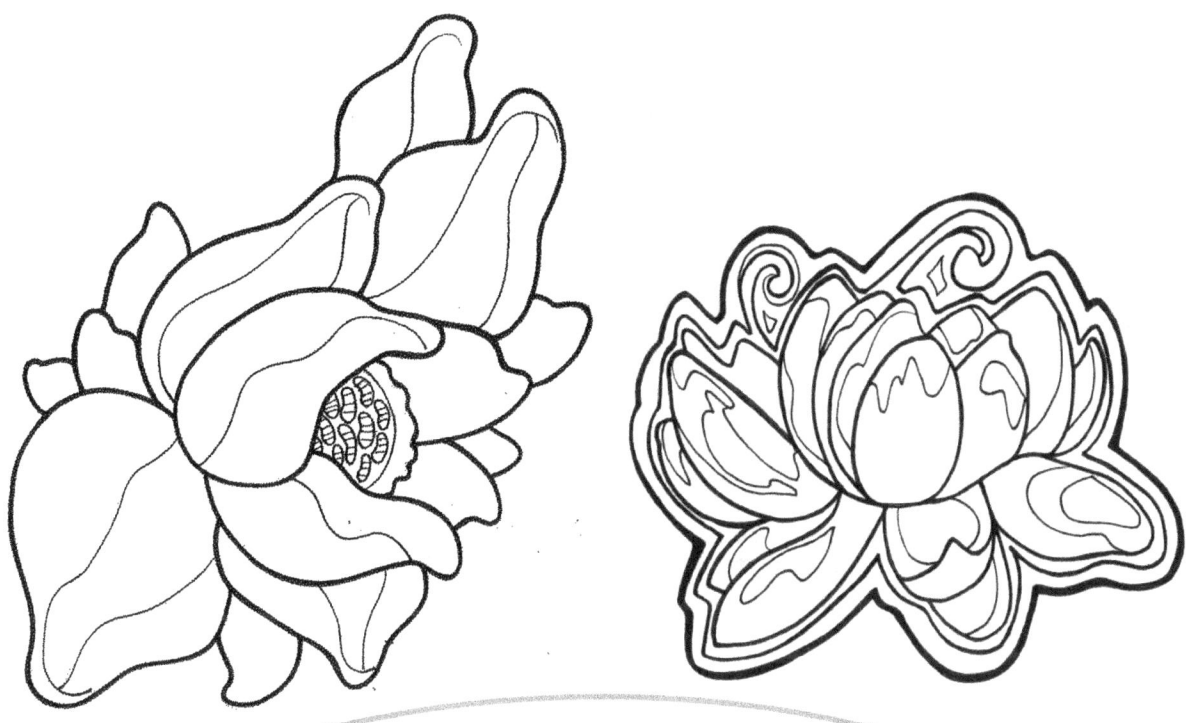

This illustration is inspired by My Painting of the same name and is also the Cover for this book. The painting was so much Fun the way it unfolded and the Inspirations for these Coloring Pages came from the Pink Lotus flower.

Lotus Trip

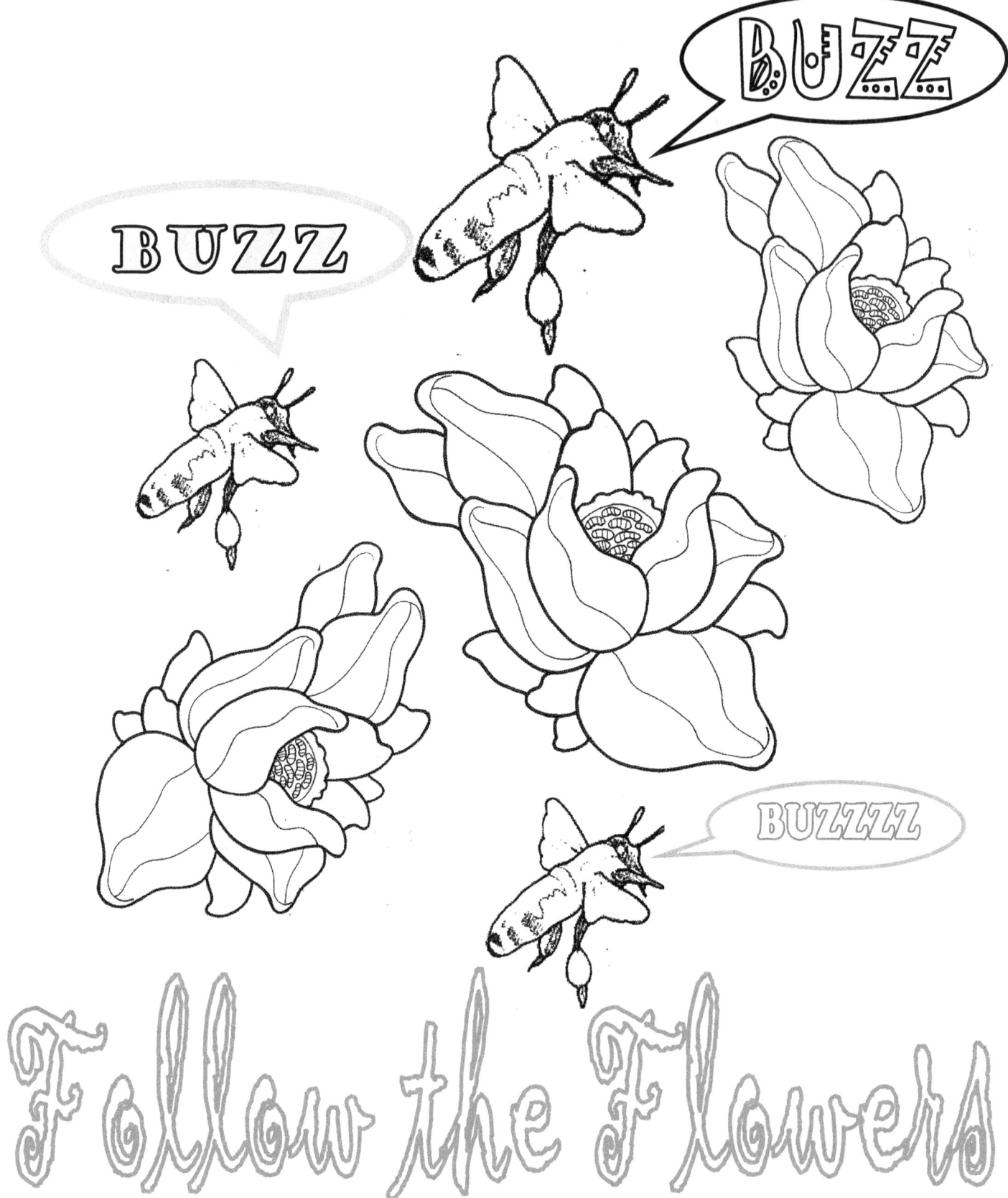

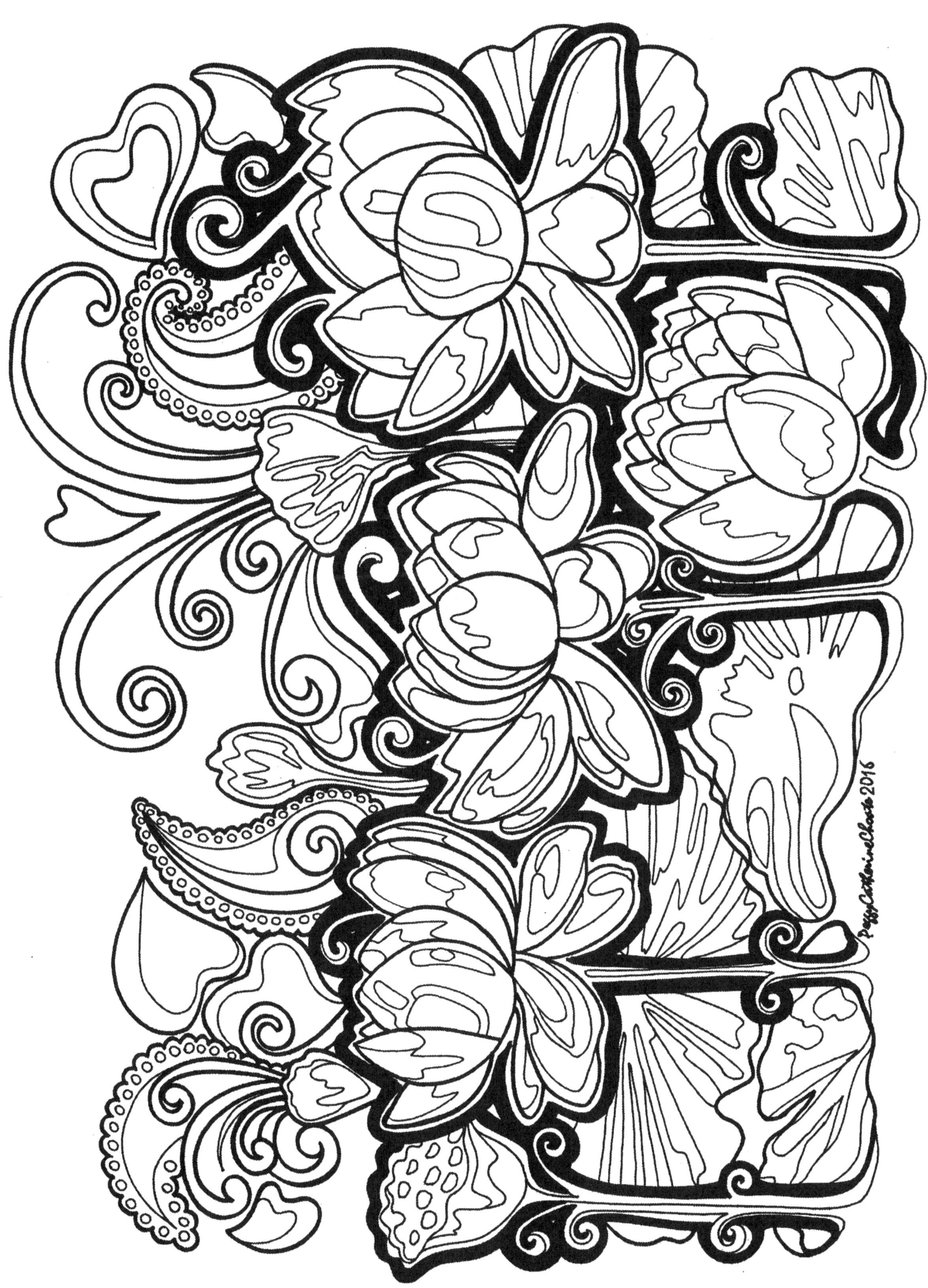

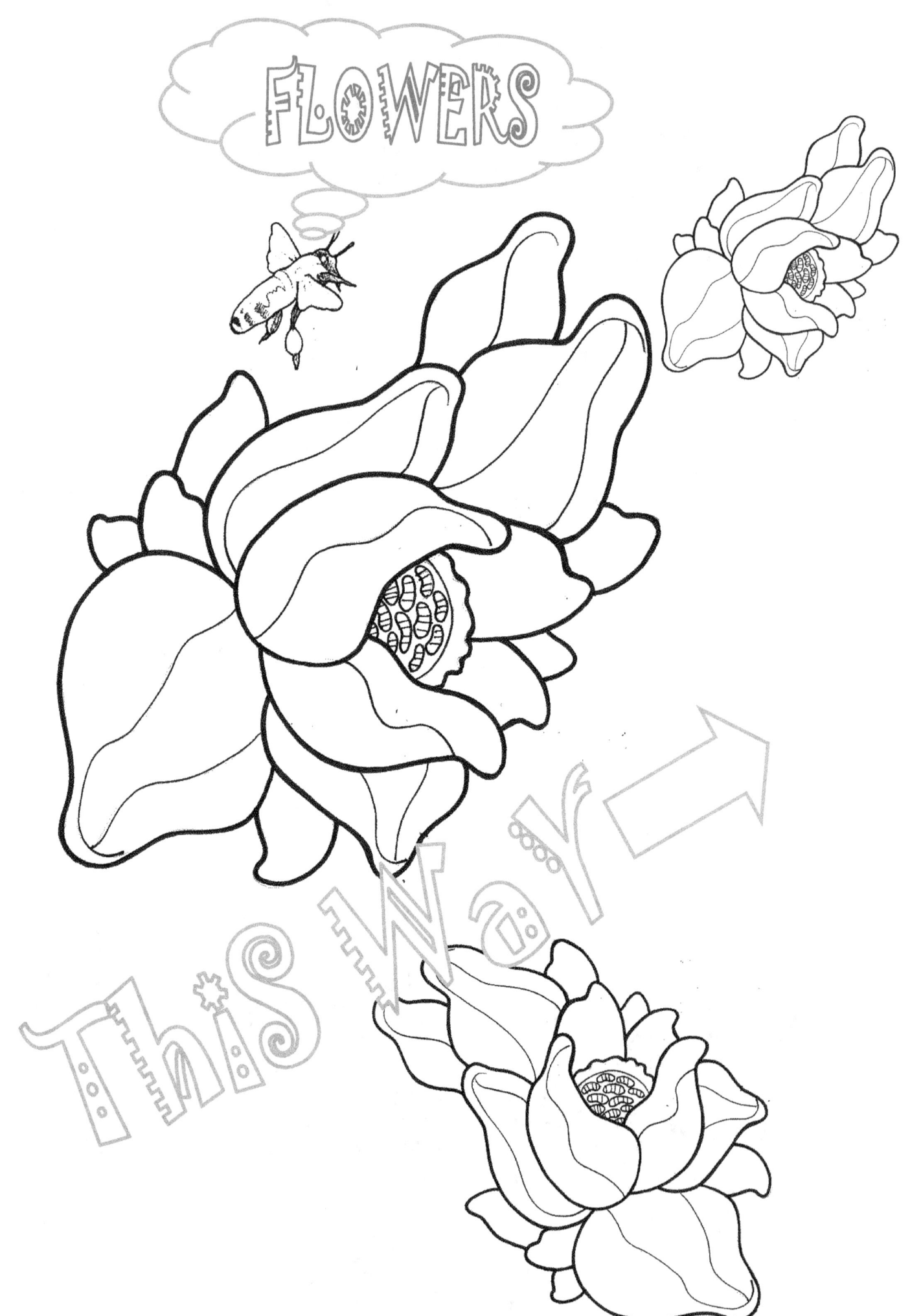

Pink Lotus

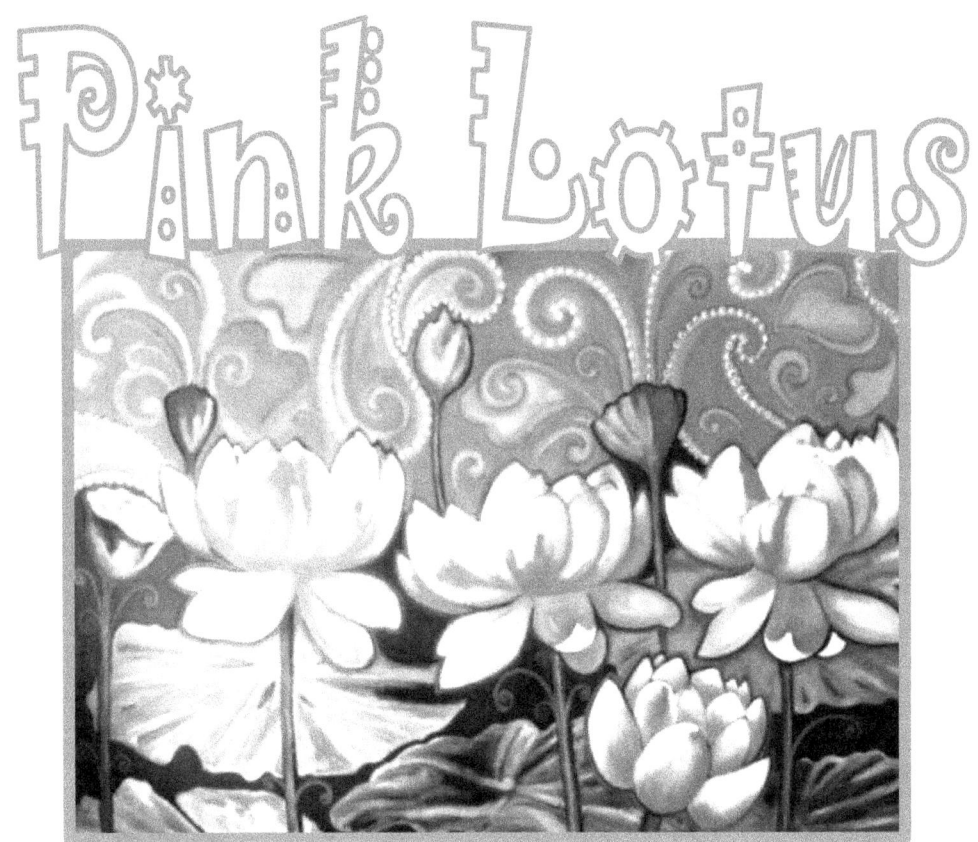

Stop and Smell the Lotus

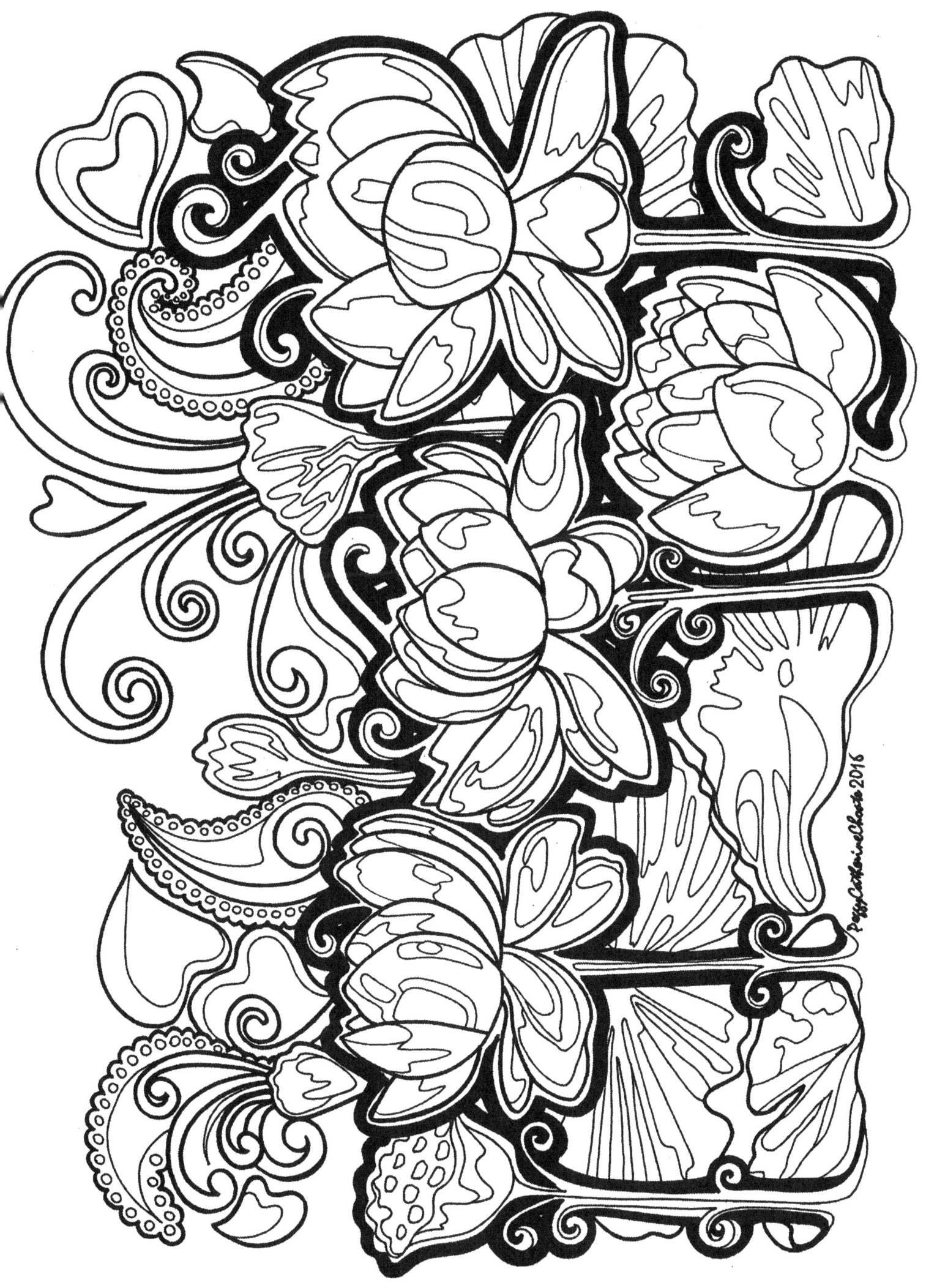

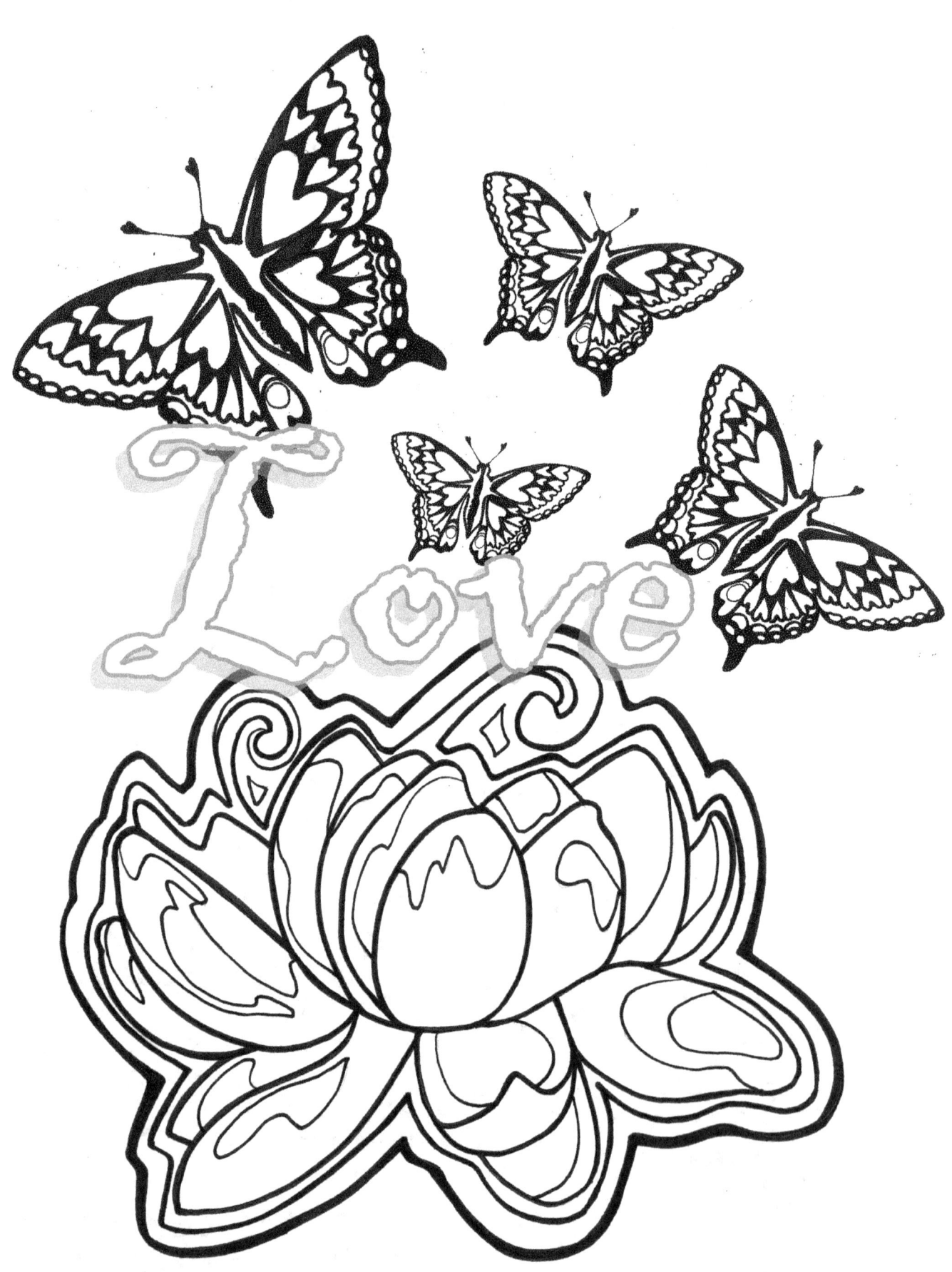

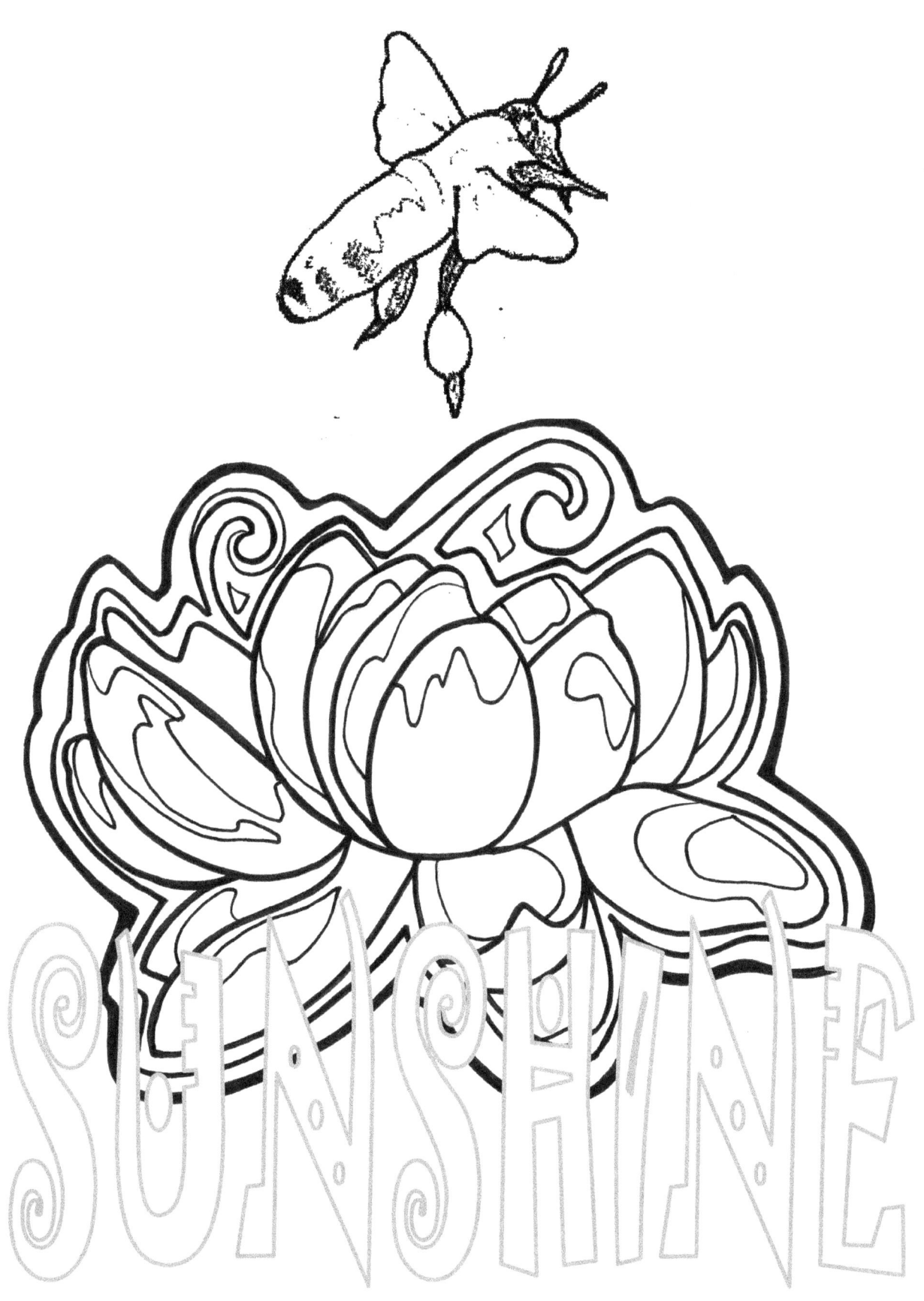

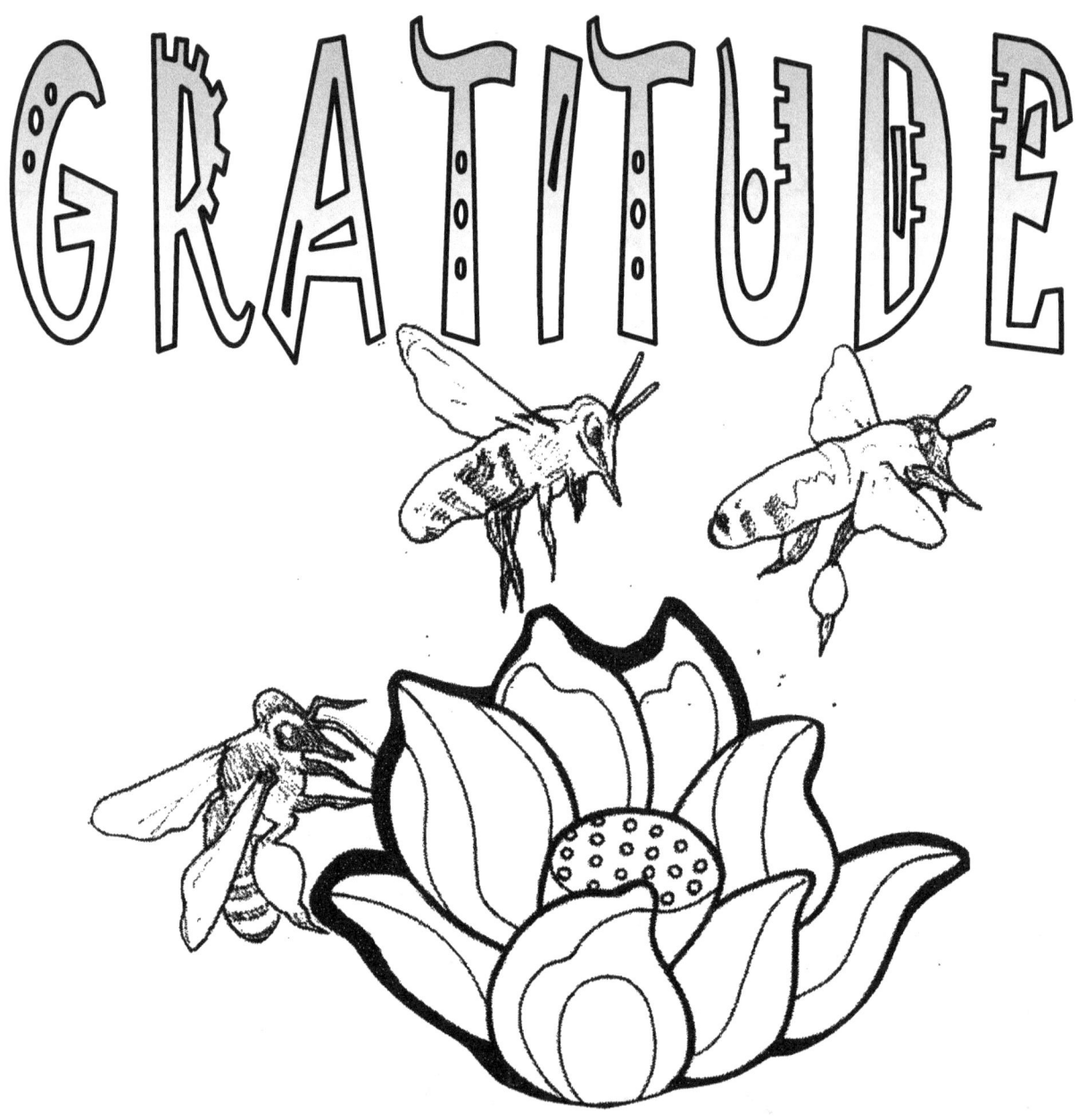

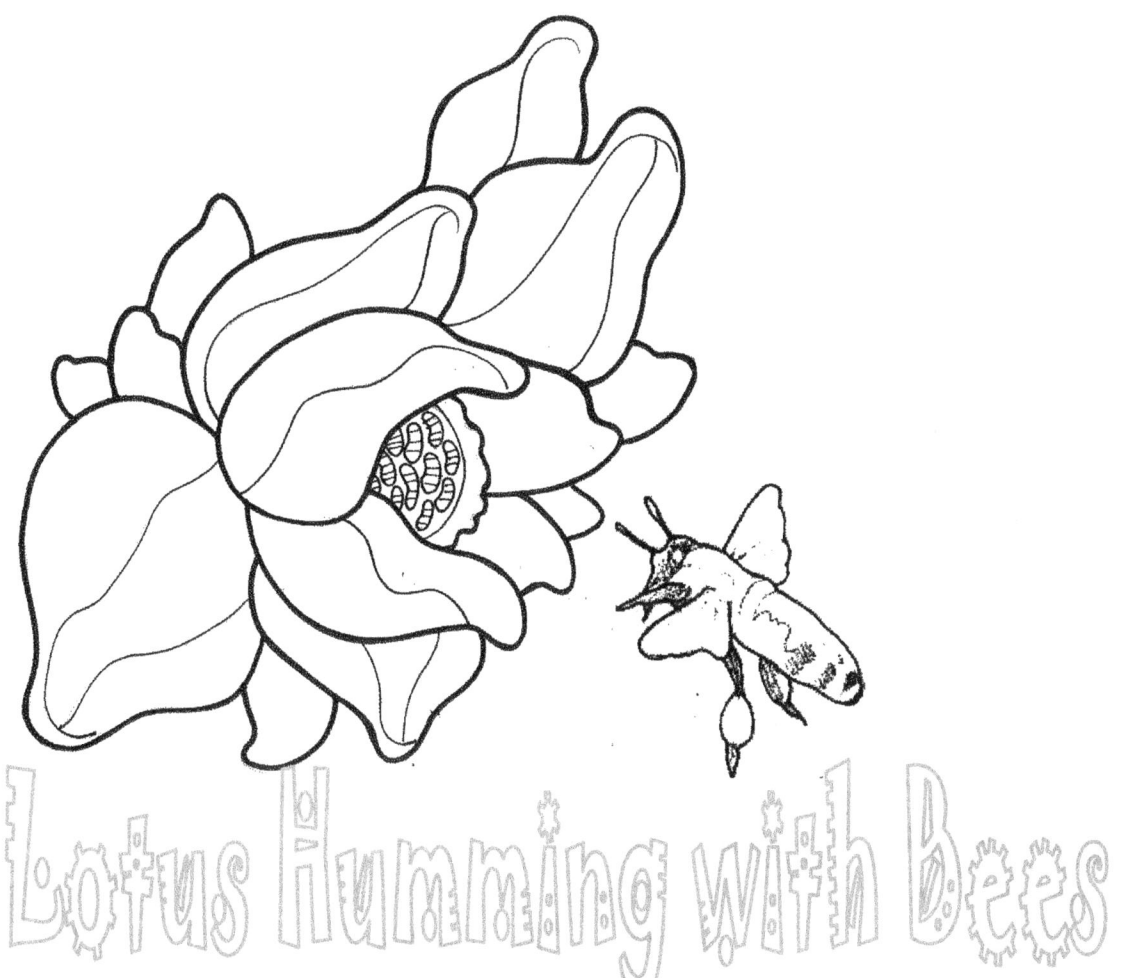

Lotus Humming with Bees

This illustration inspiration came from two things an Old Lithograph Print of Lotus Flowers and an Ancient Prayer that says in one verse to offer a handful of flowers Humming with Bees to the Enlightened one.
I Love That Line.

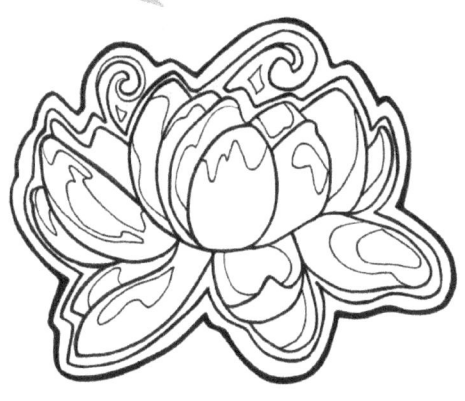

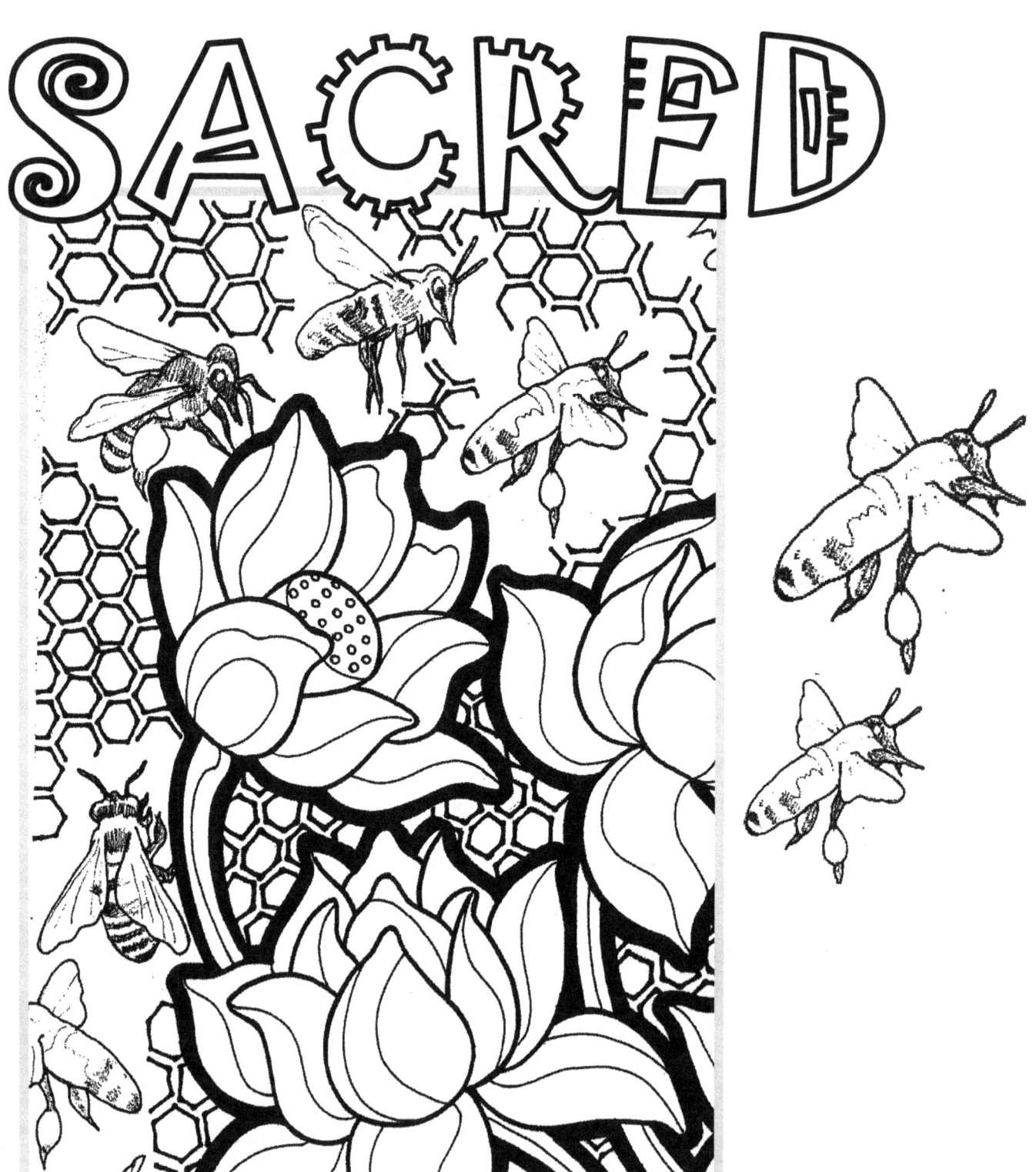

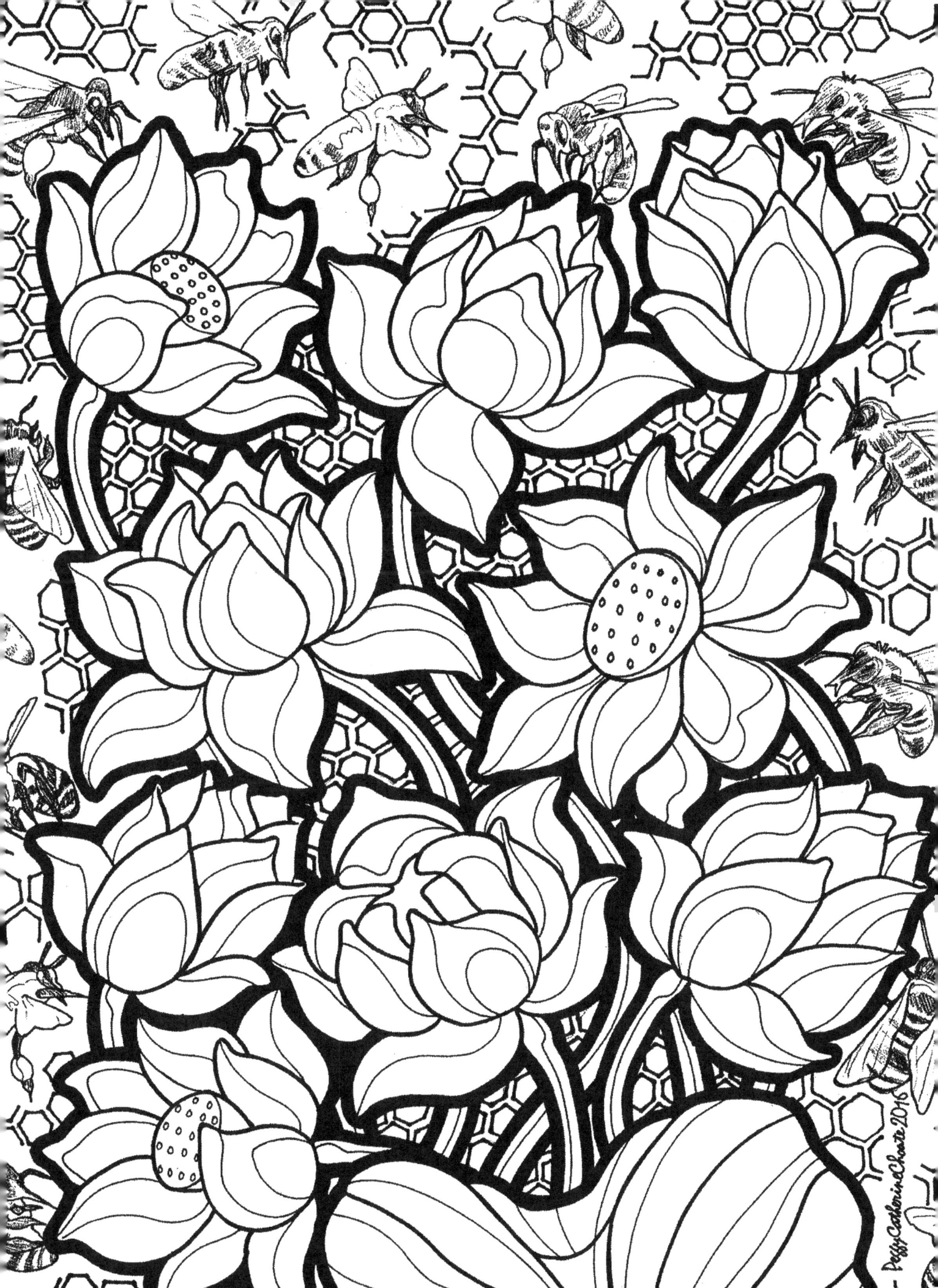

HONEY BEES

BUZZ

BUZZ

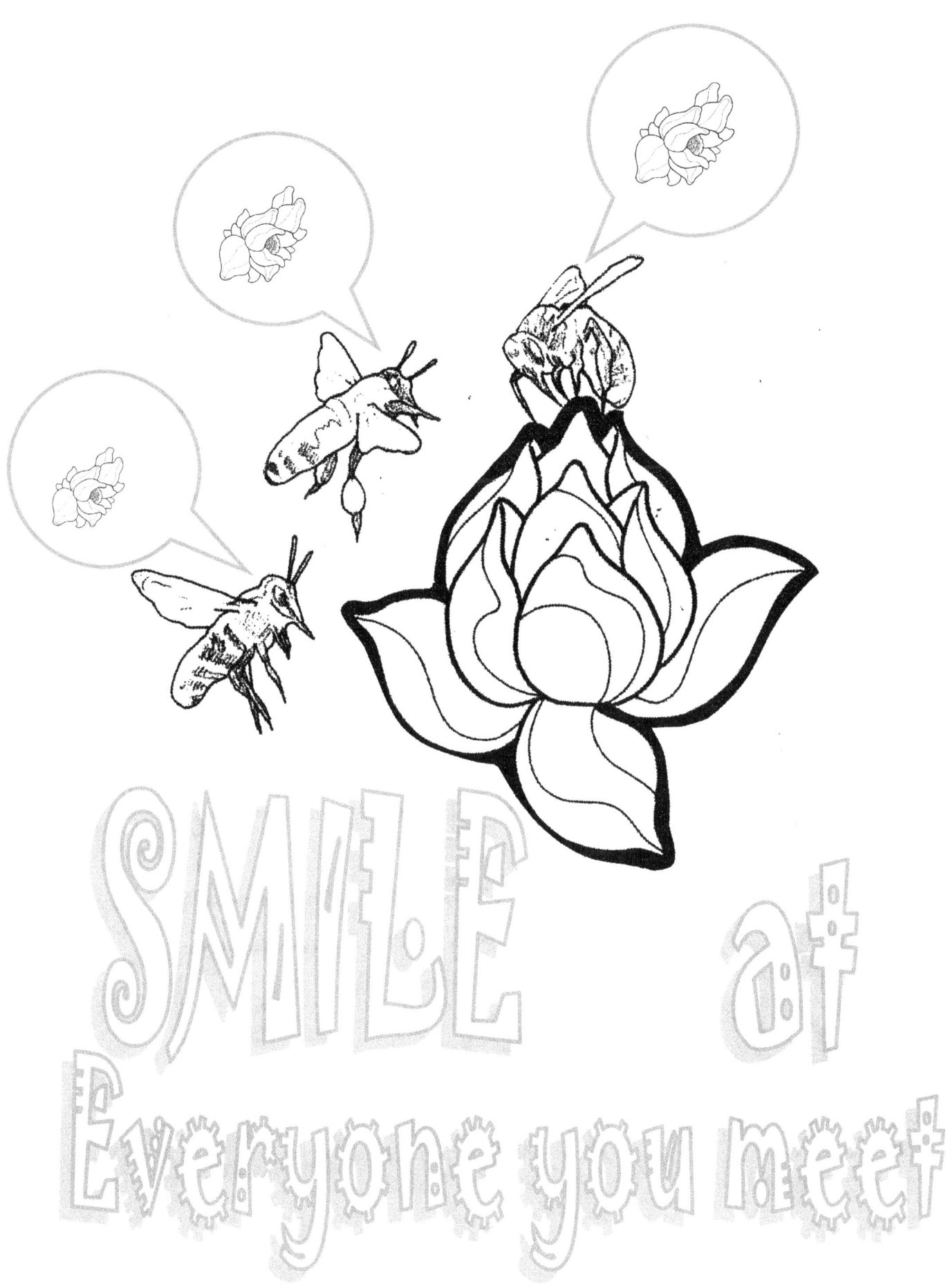

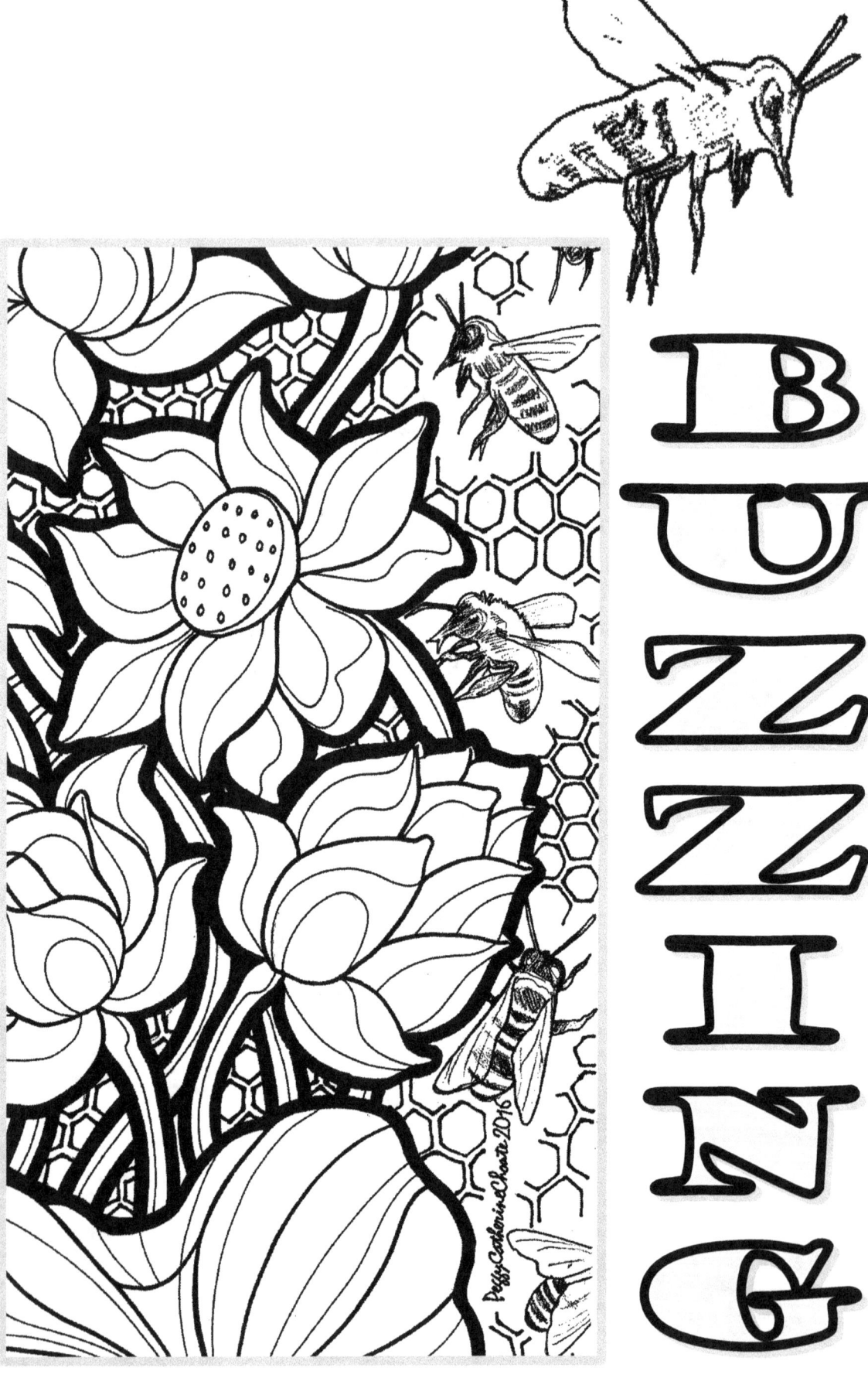

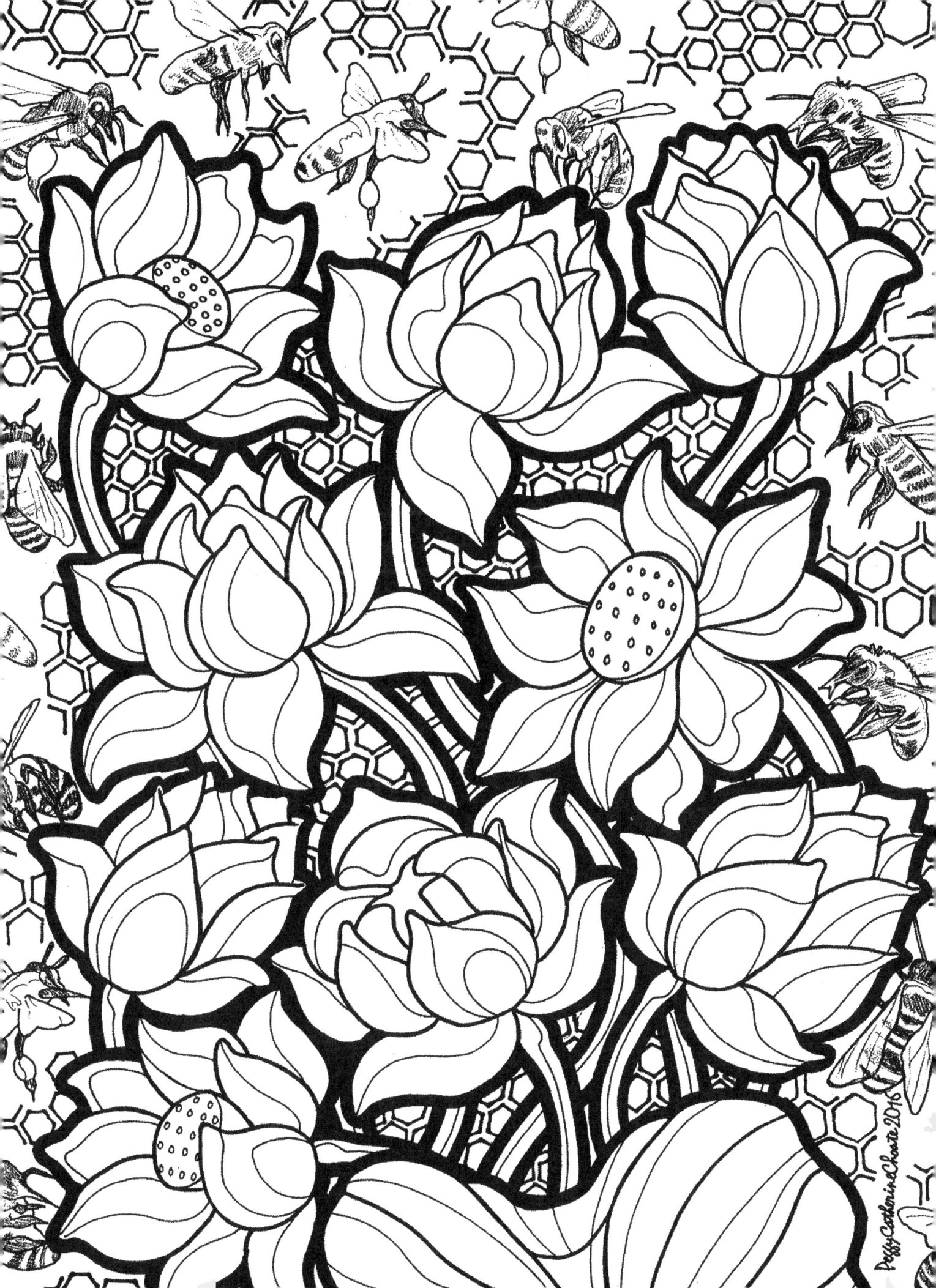

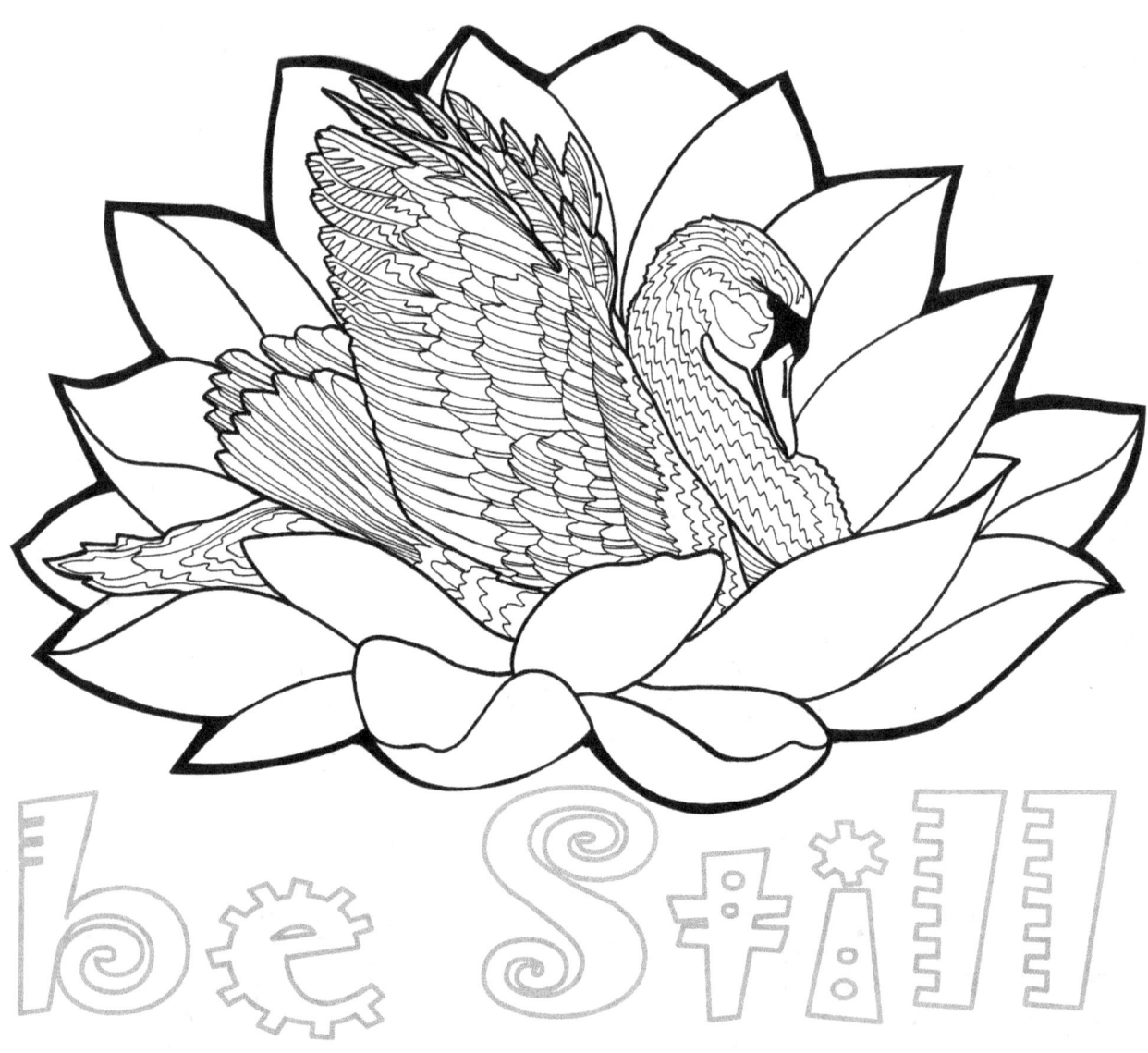

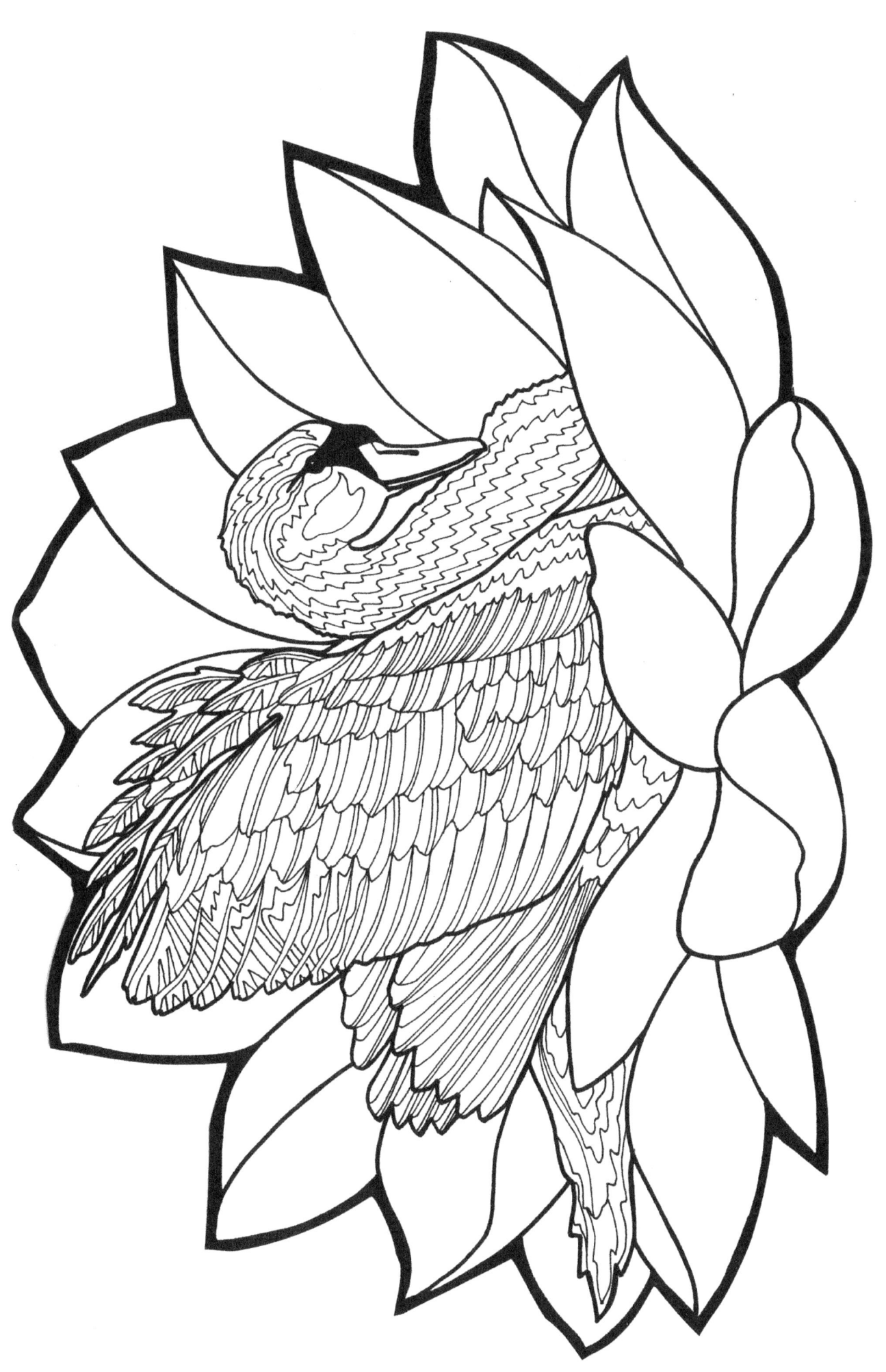

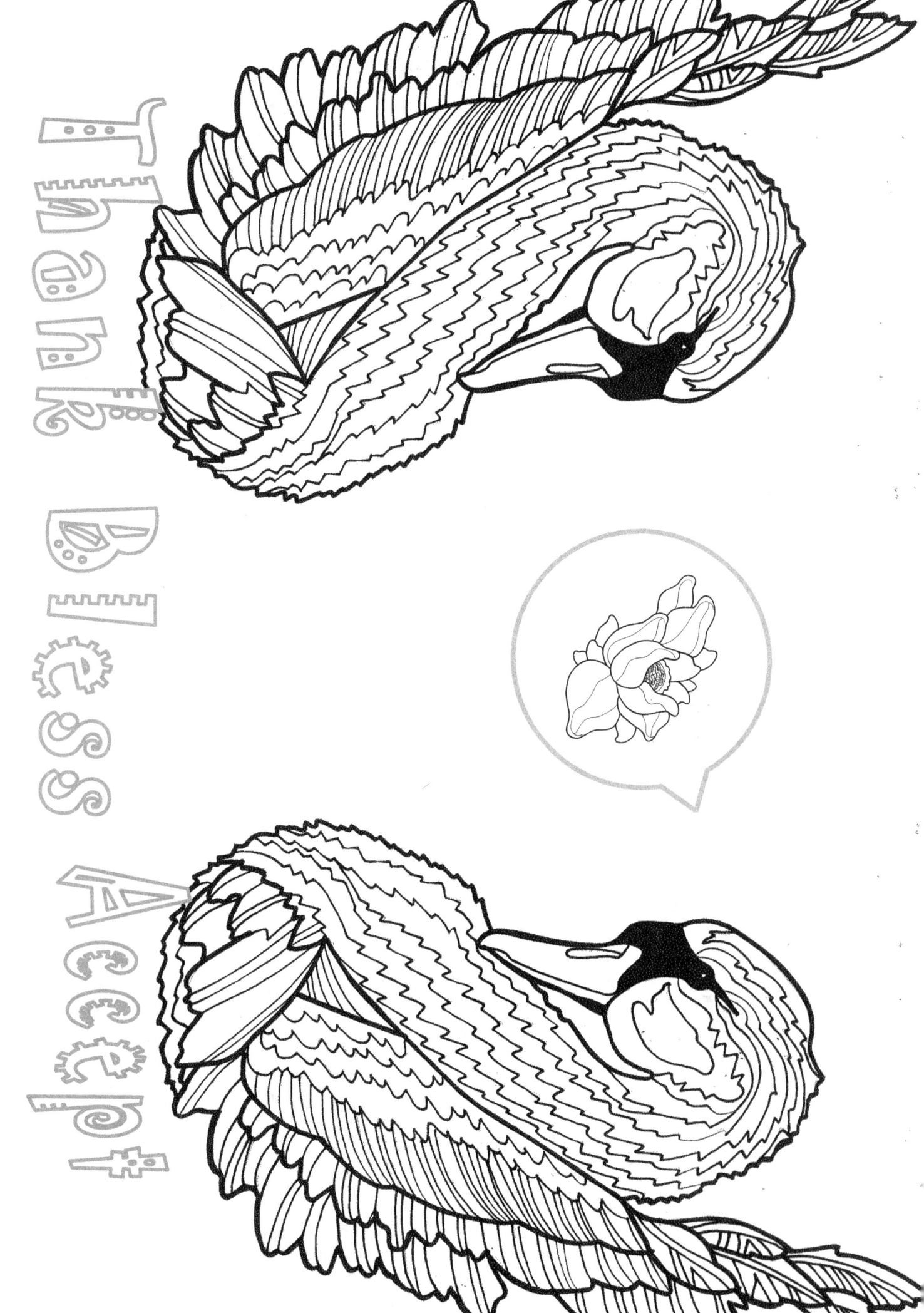

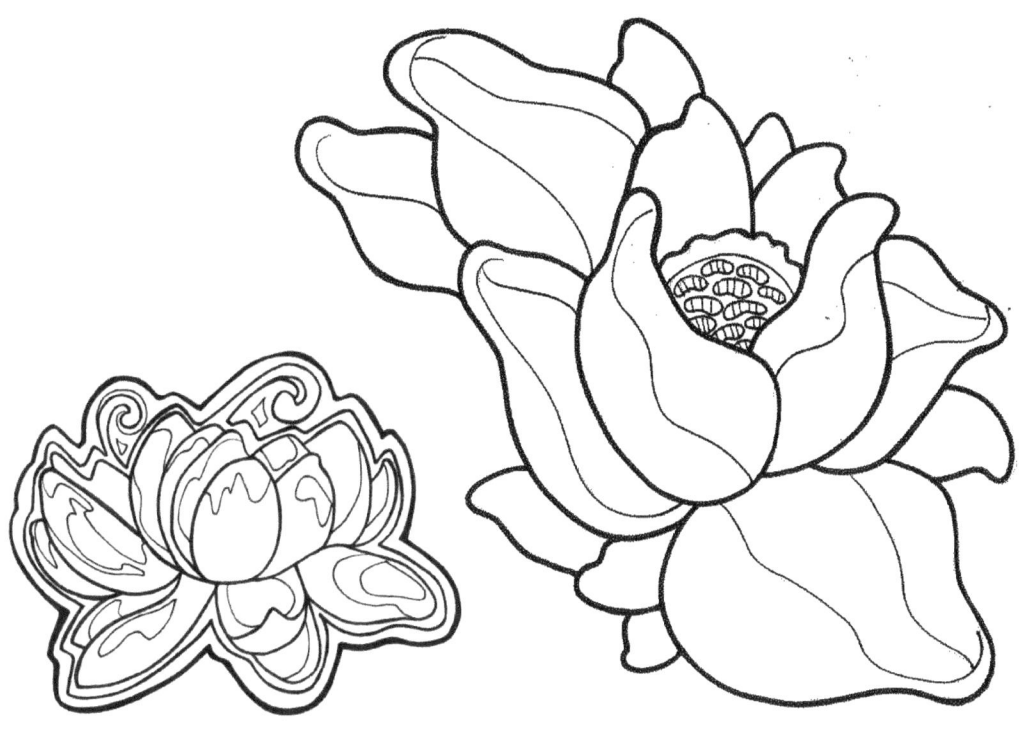

There are two Swans that come every
Spring to Nest on my neighbor's pond.
I know they are here when I Hear their Wings
as they circle past my house. They have a
distinct Sound. Swans Mate for Life
This year when I heard the sound
I looked up and saw only
One Swan...

Swan Sitting on Lotus

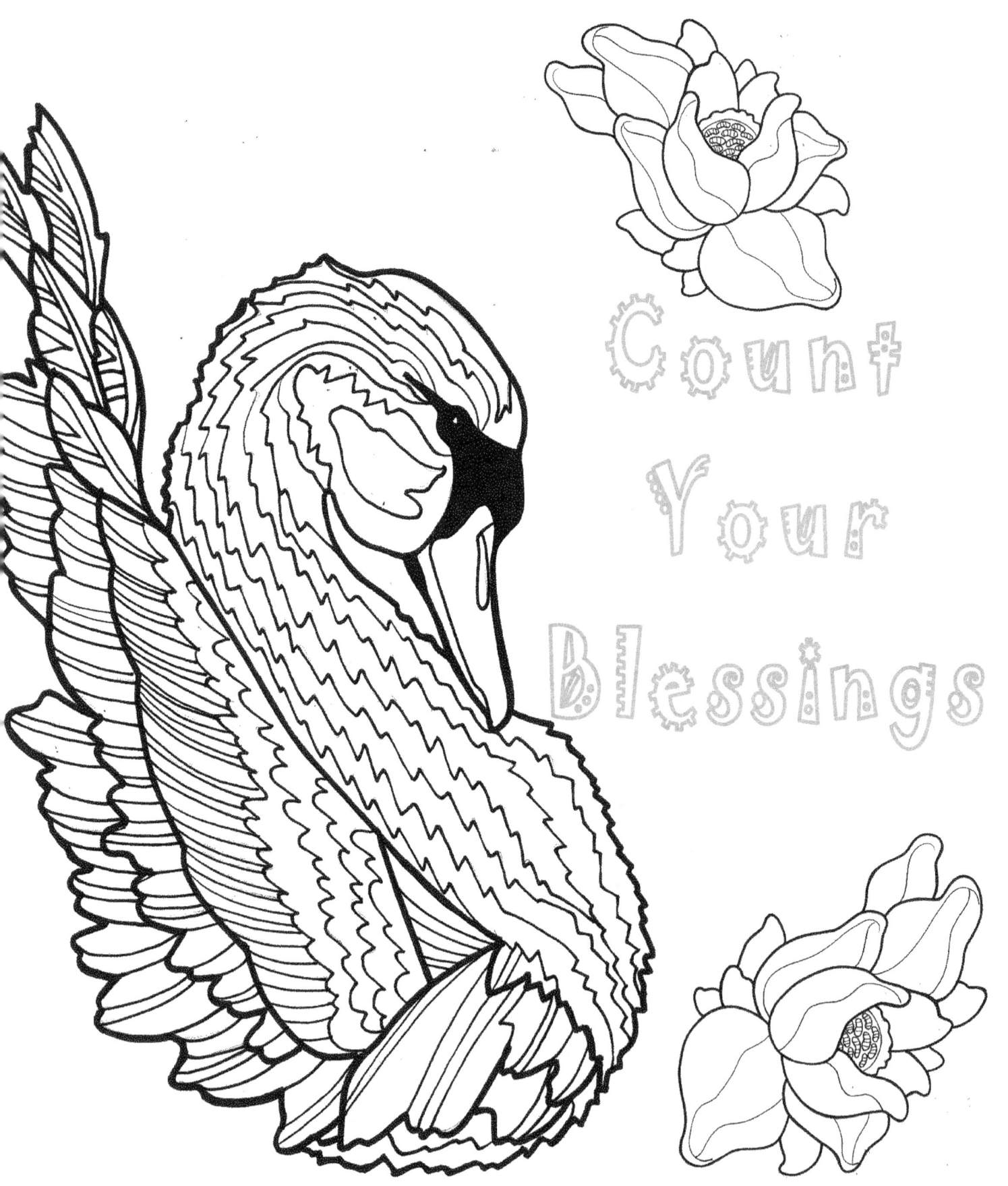

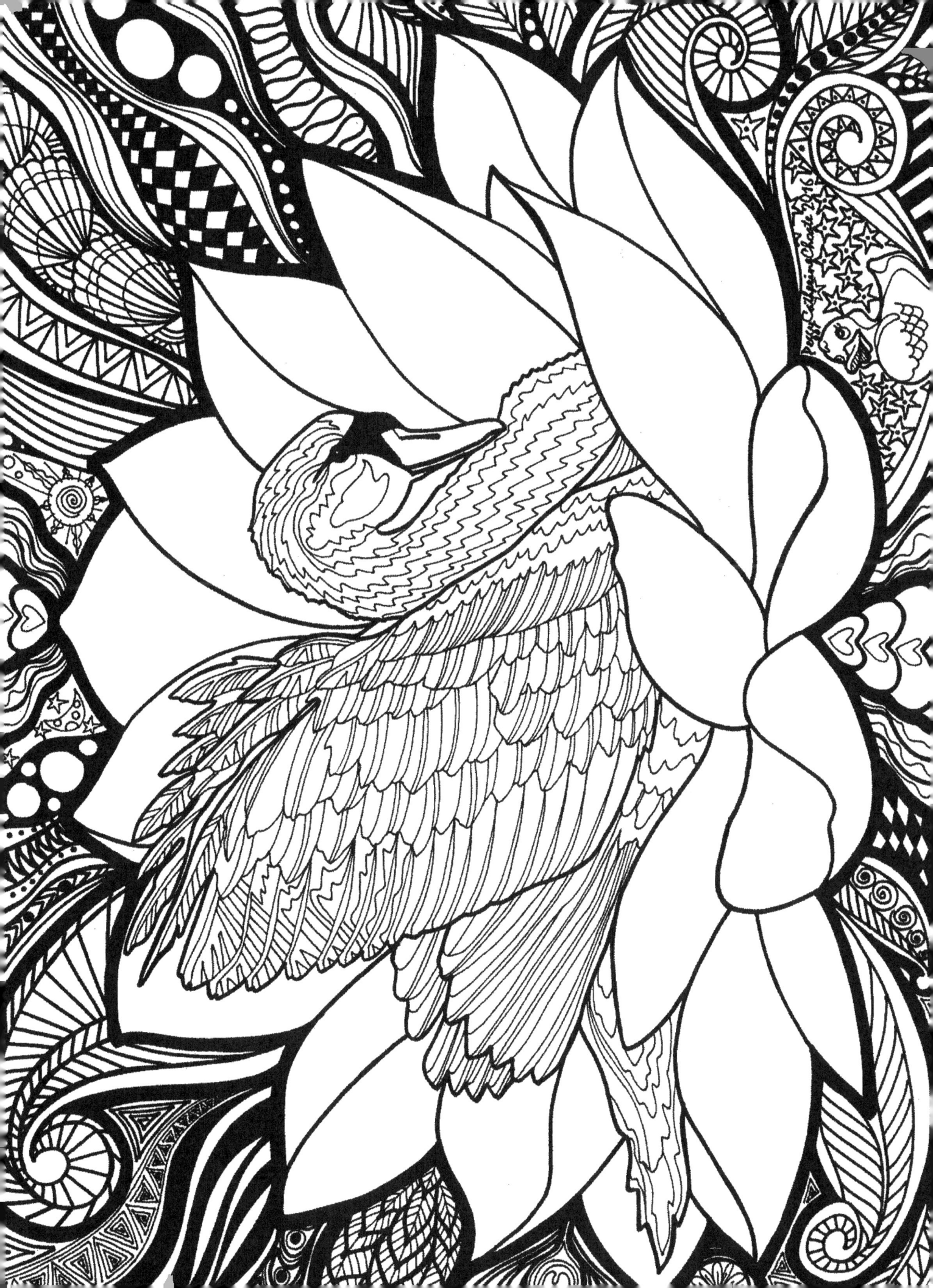

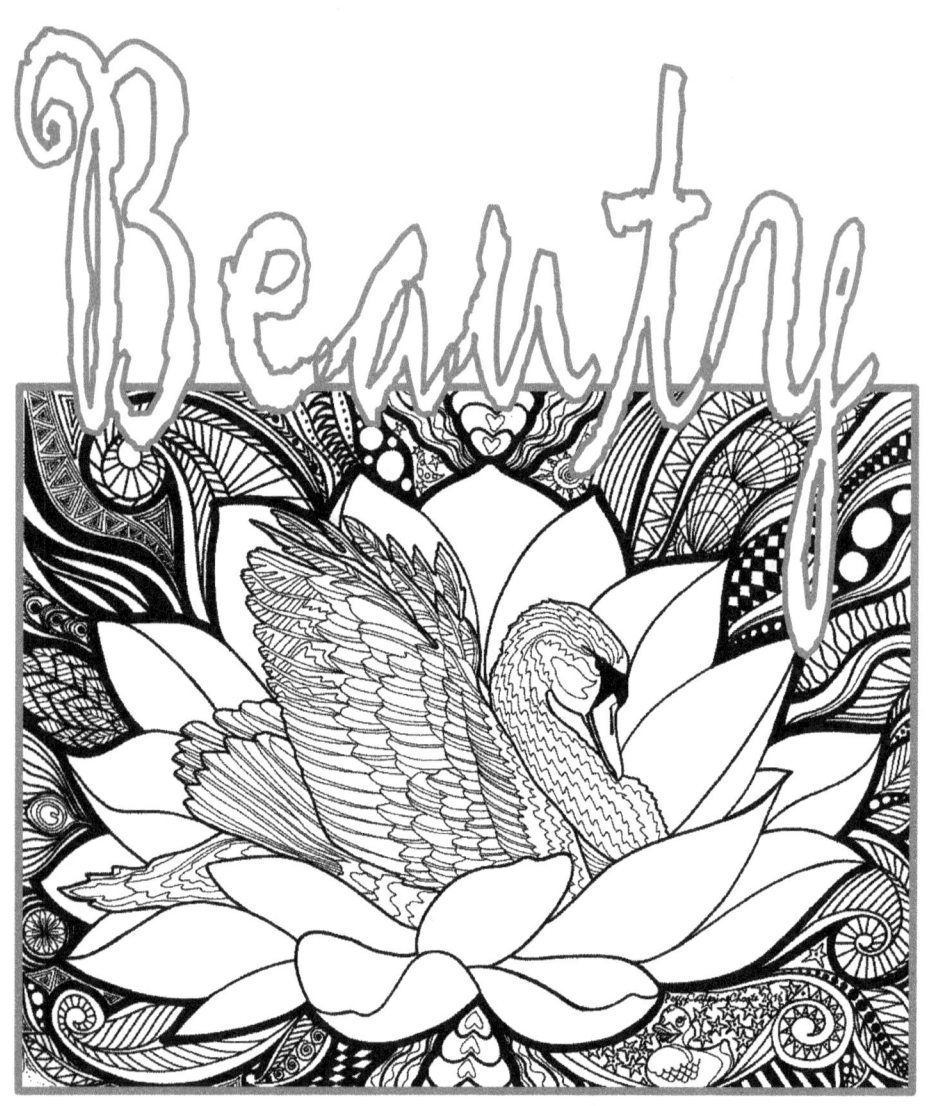

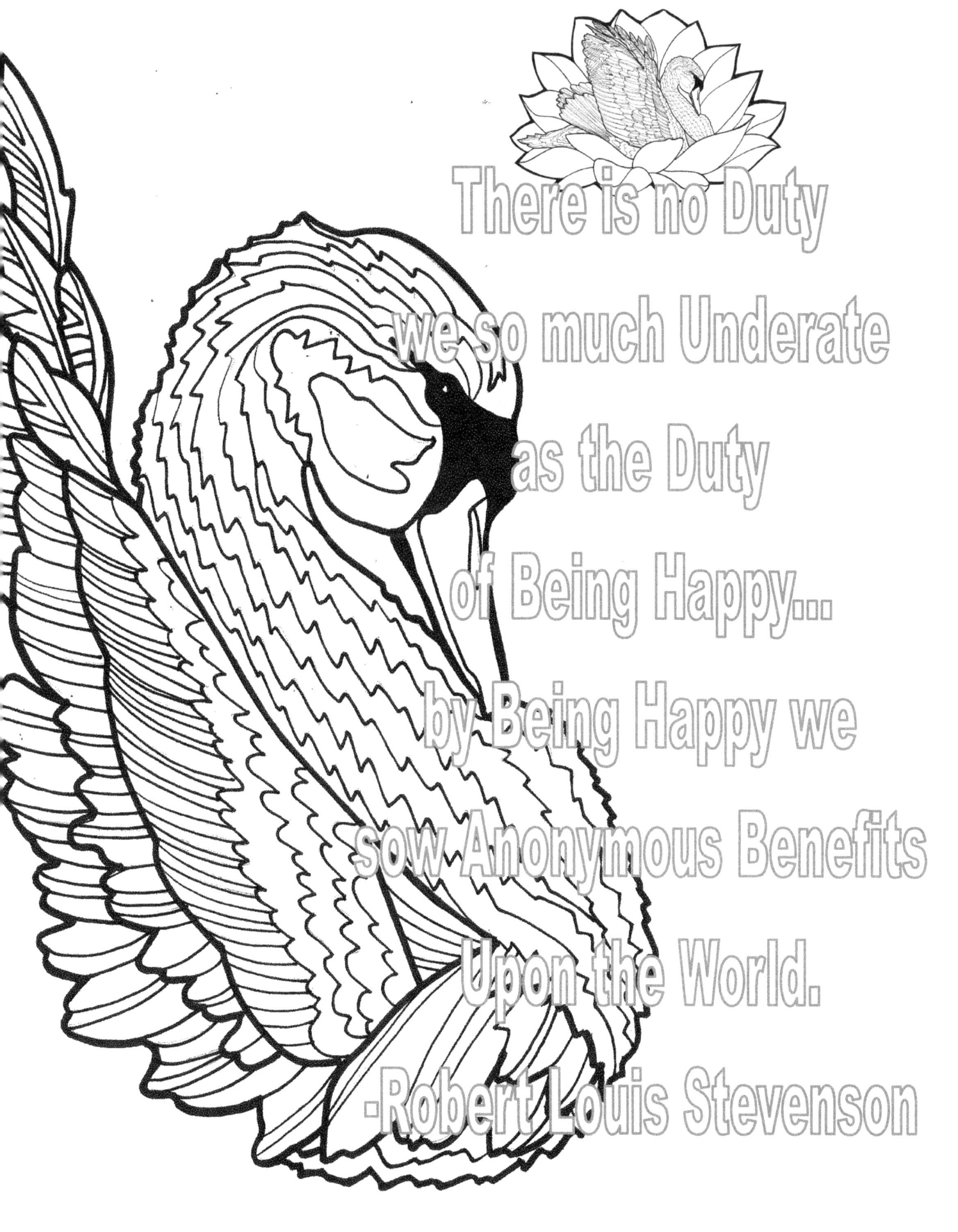

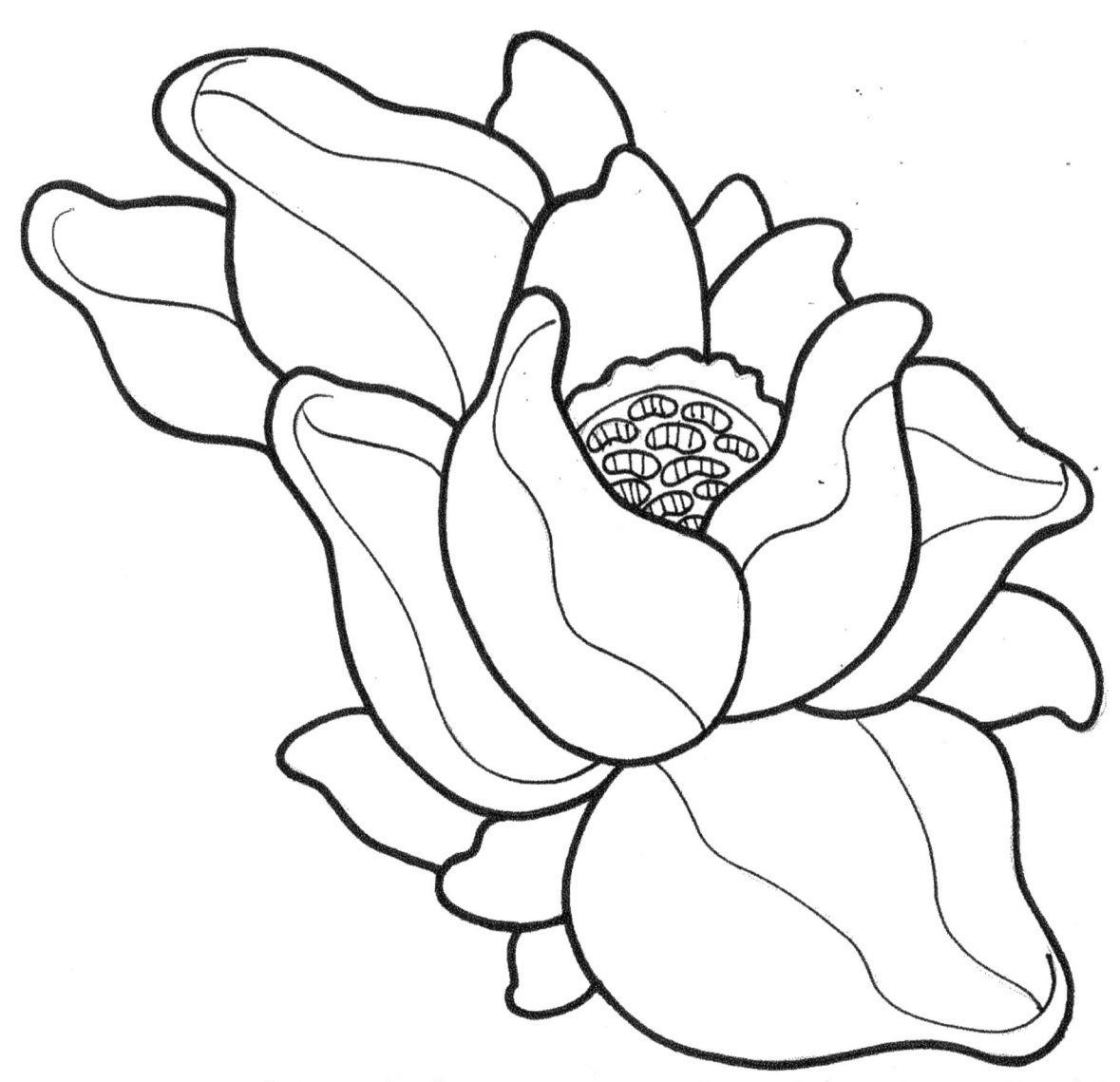

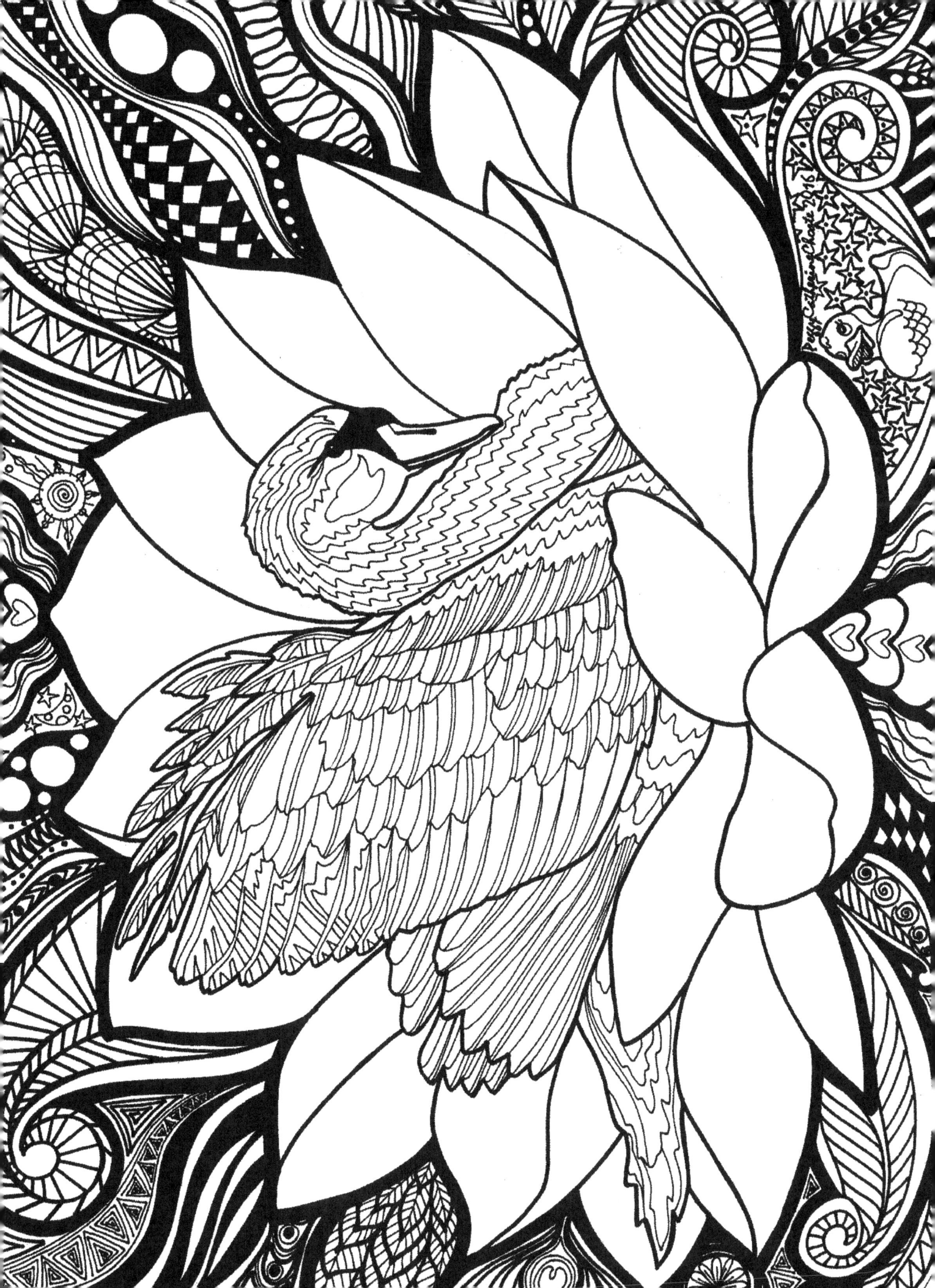

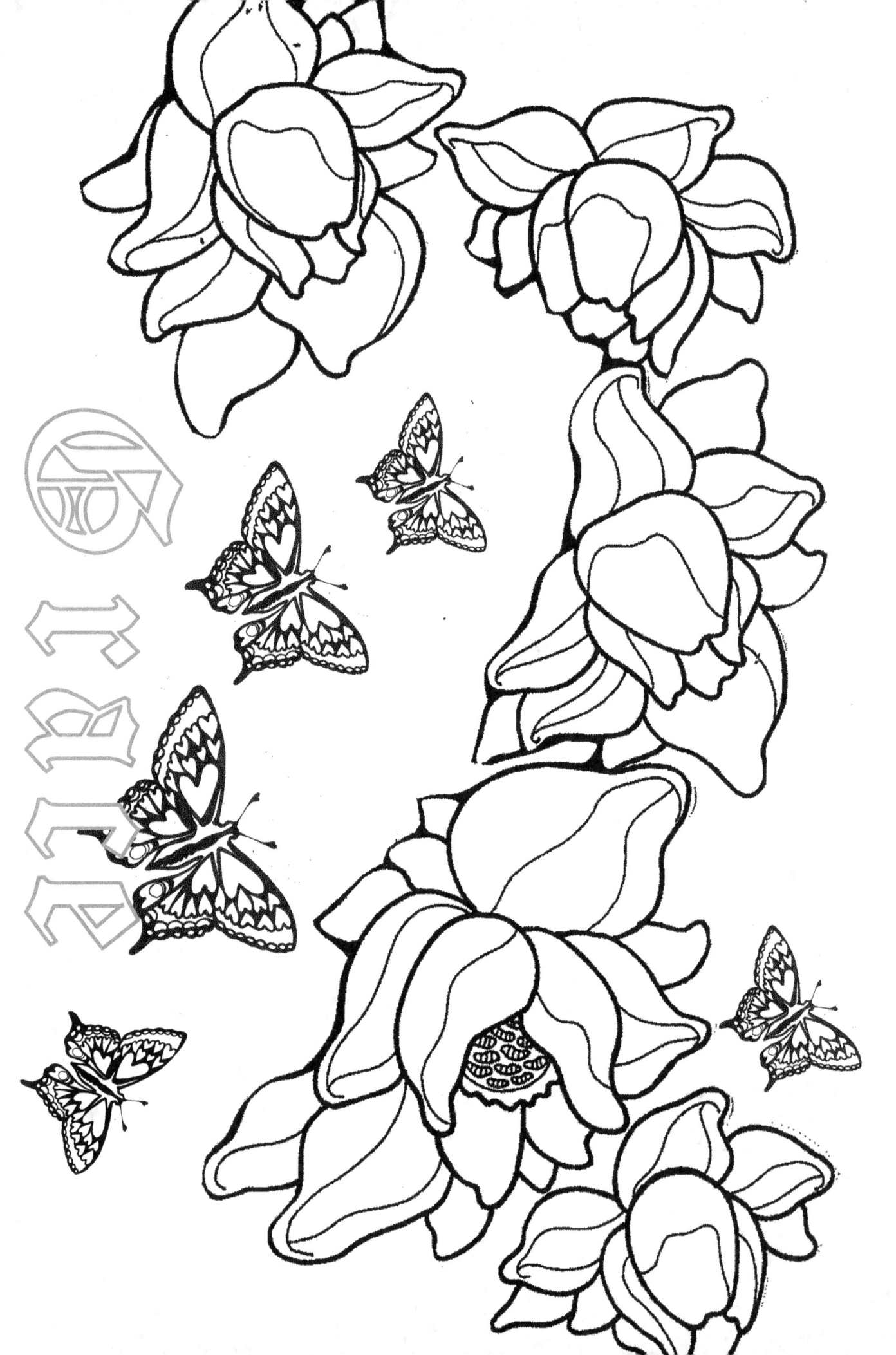

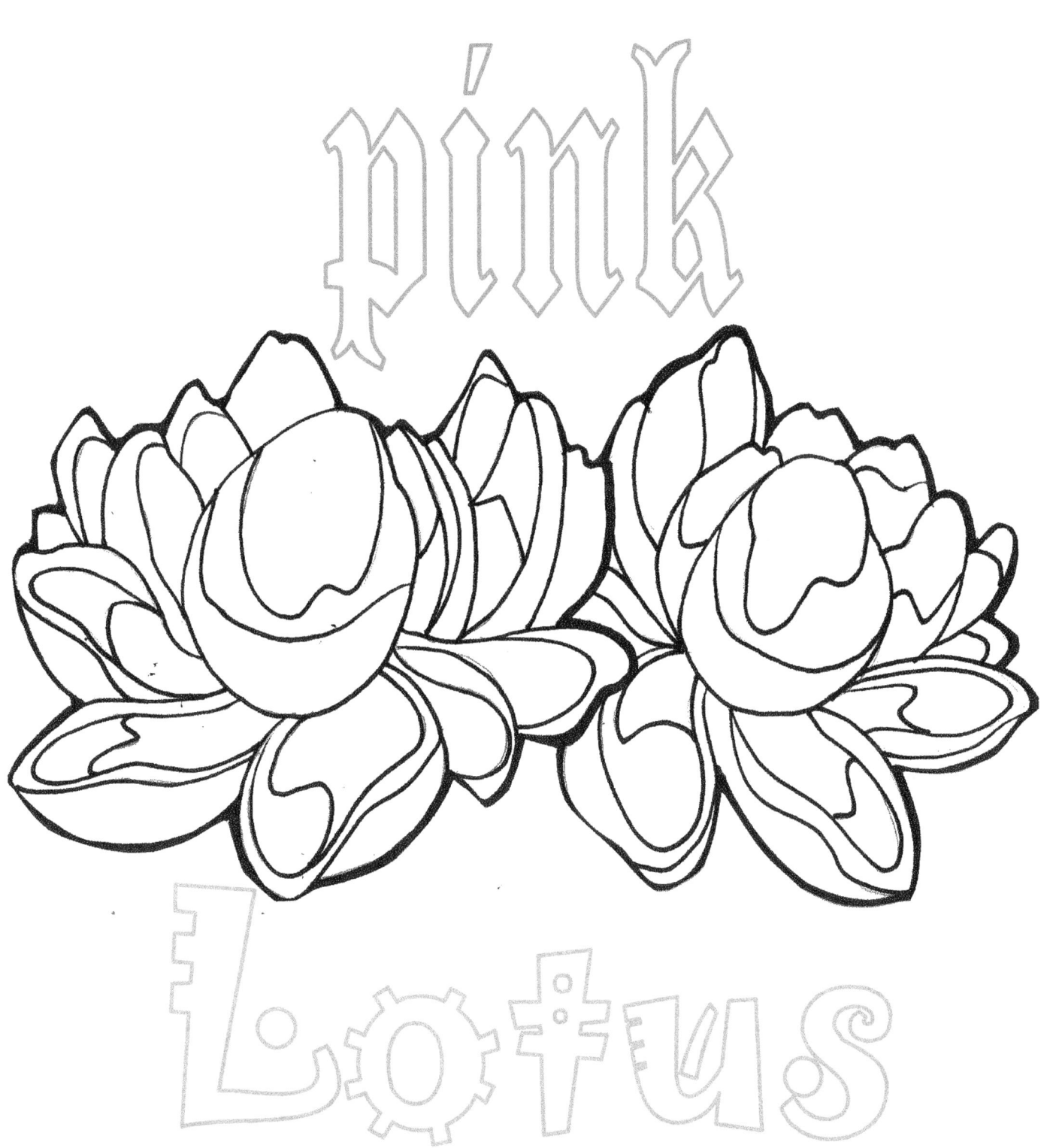

Lotus Meditation

This Illustration was inspired by the Pink Lotuses that grow in Innesfree Gardens Lake in Millbrook, New York. When the Wind blows they Sway in a way that makes you Feel like you are in a Dream.

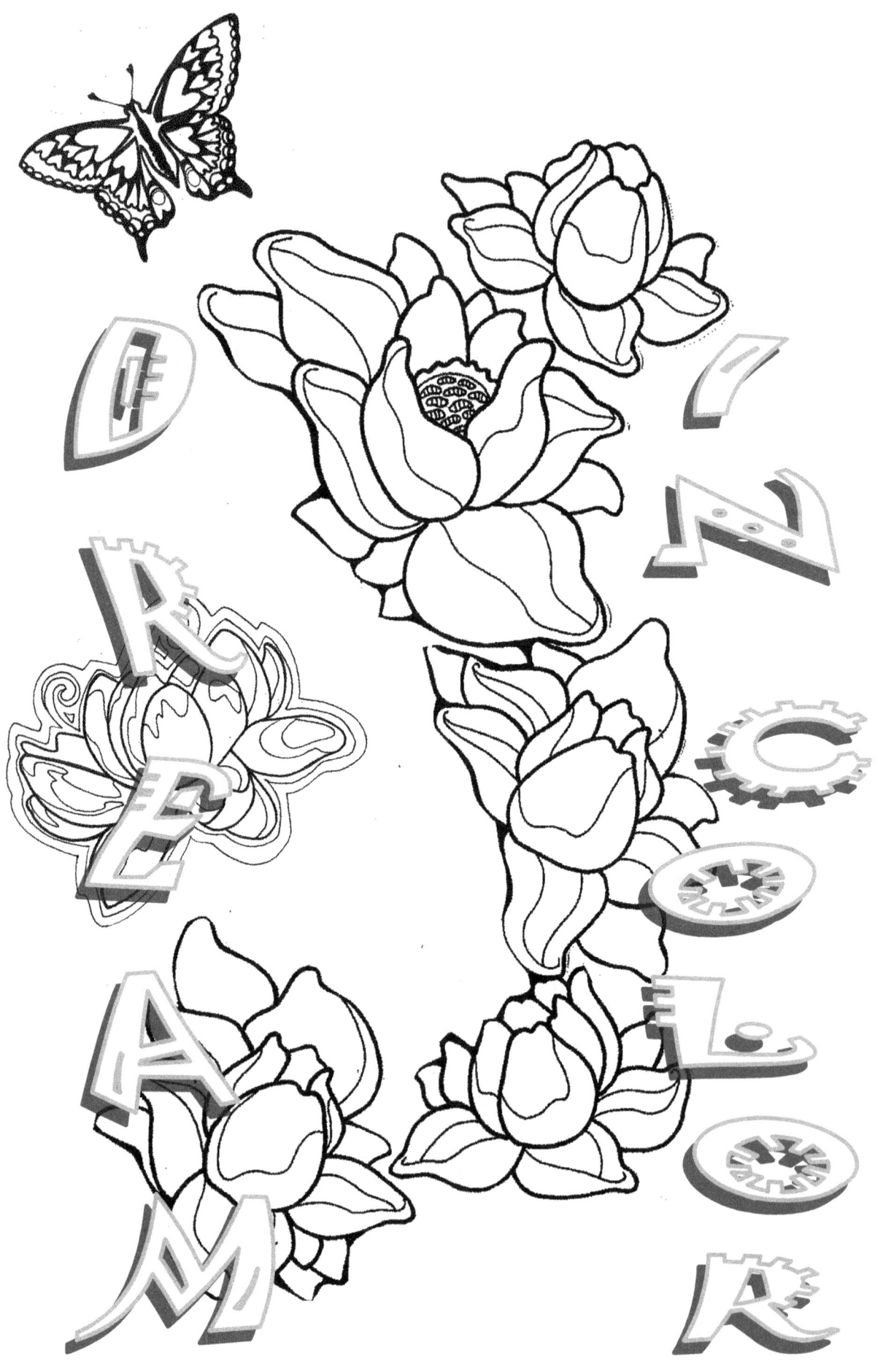

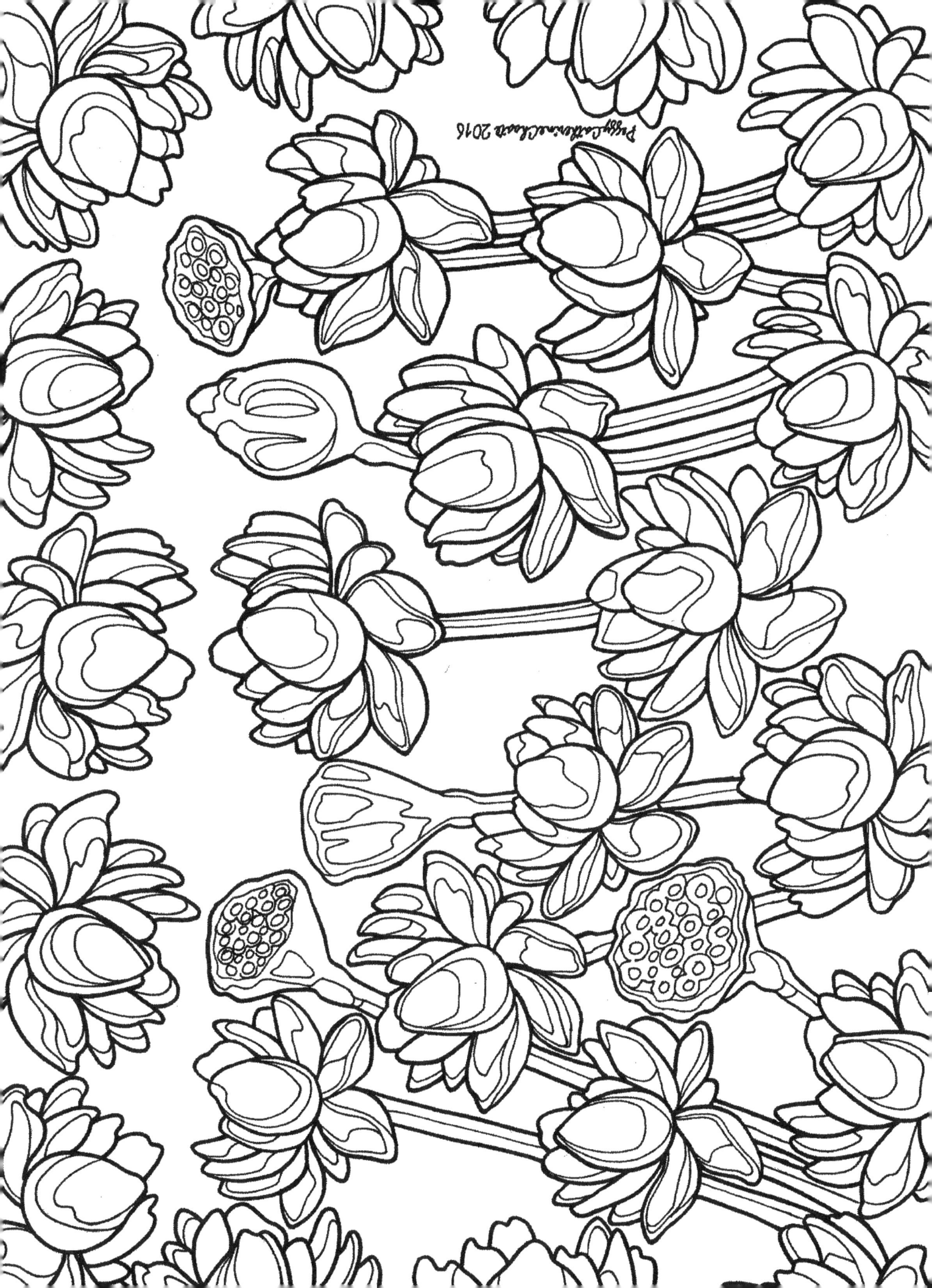

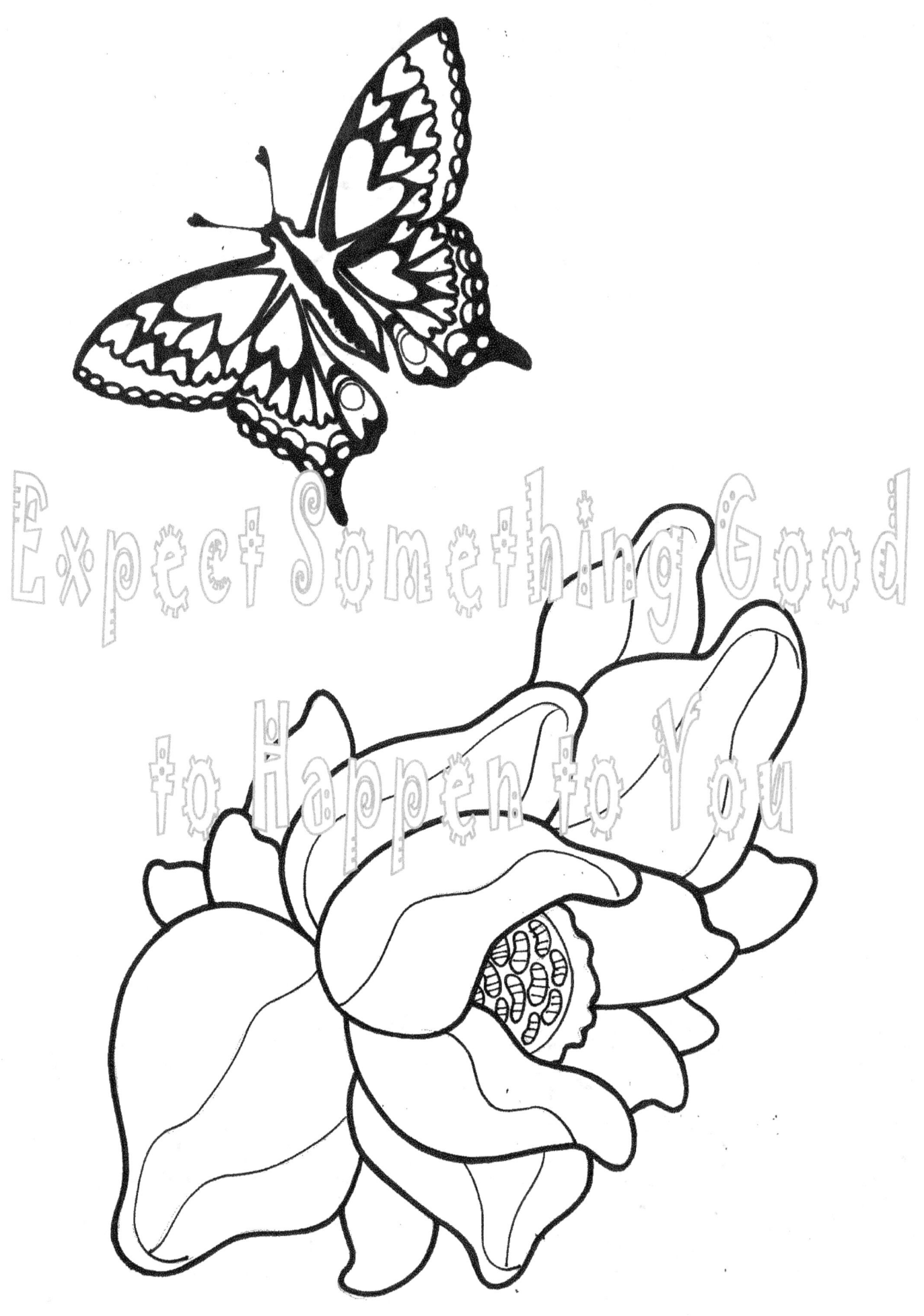

Lotus Meditation

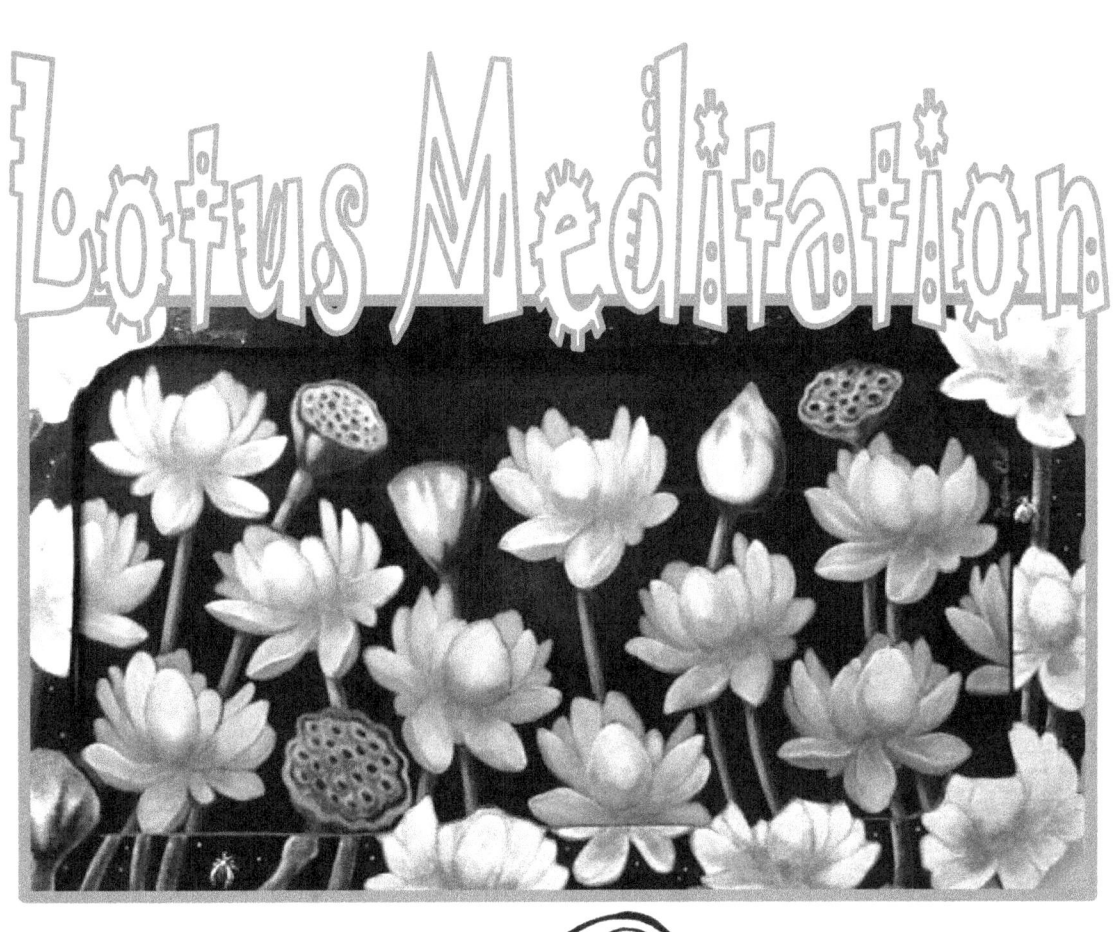

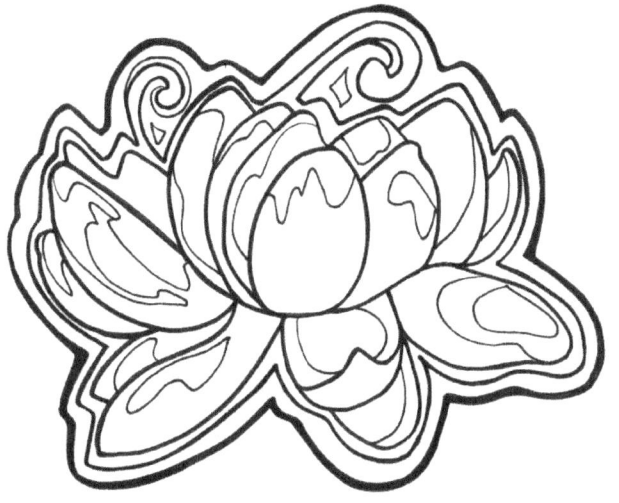

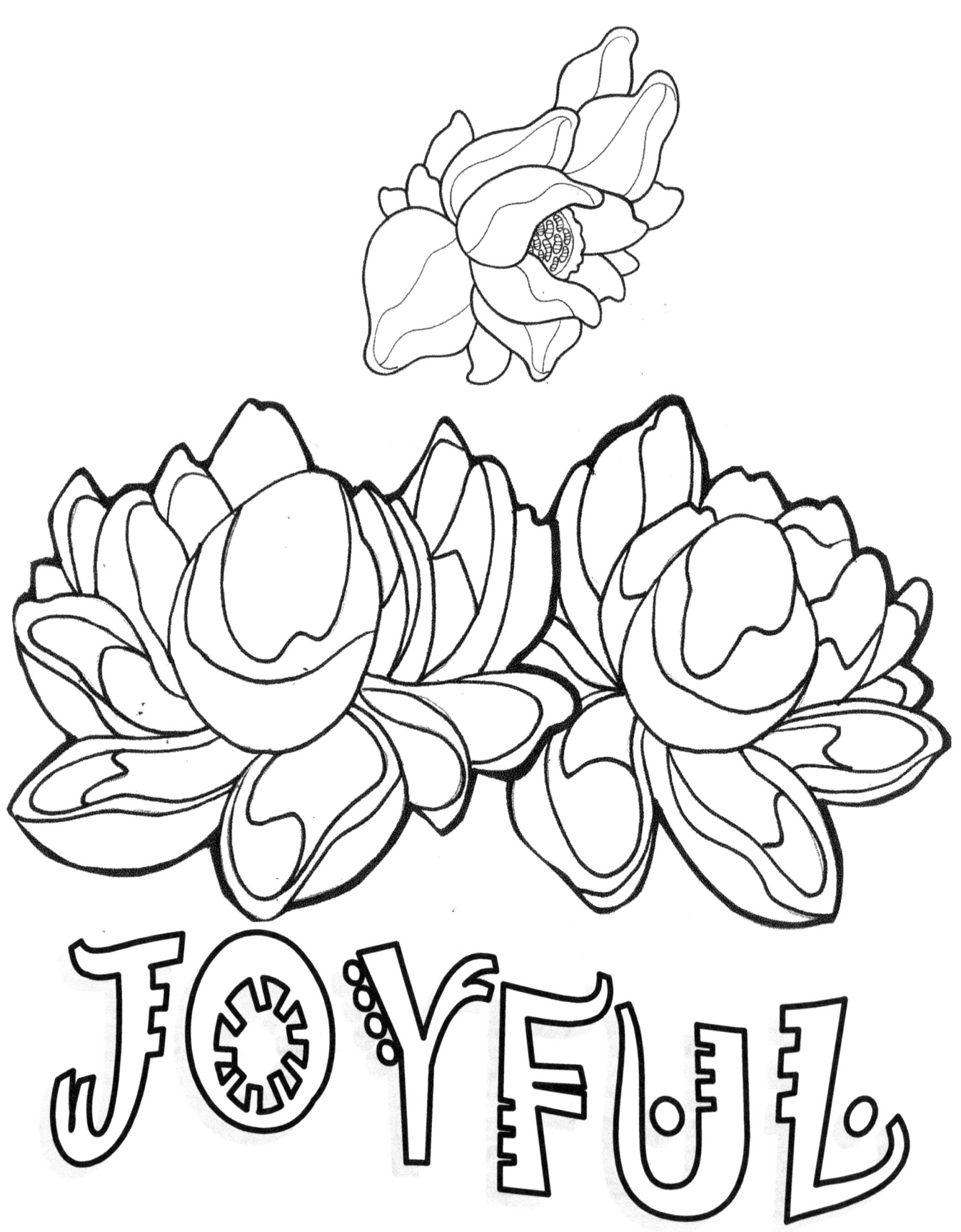

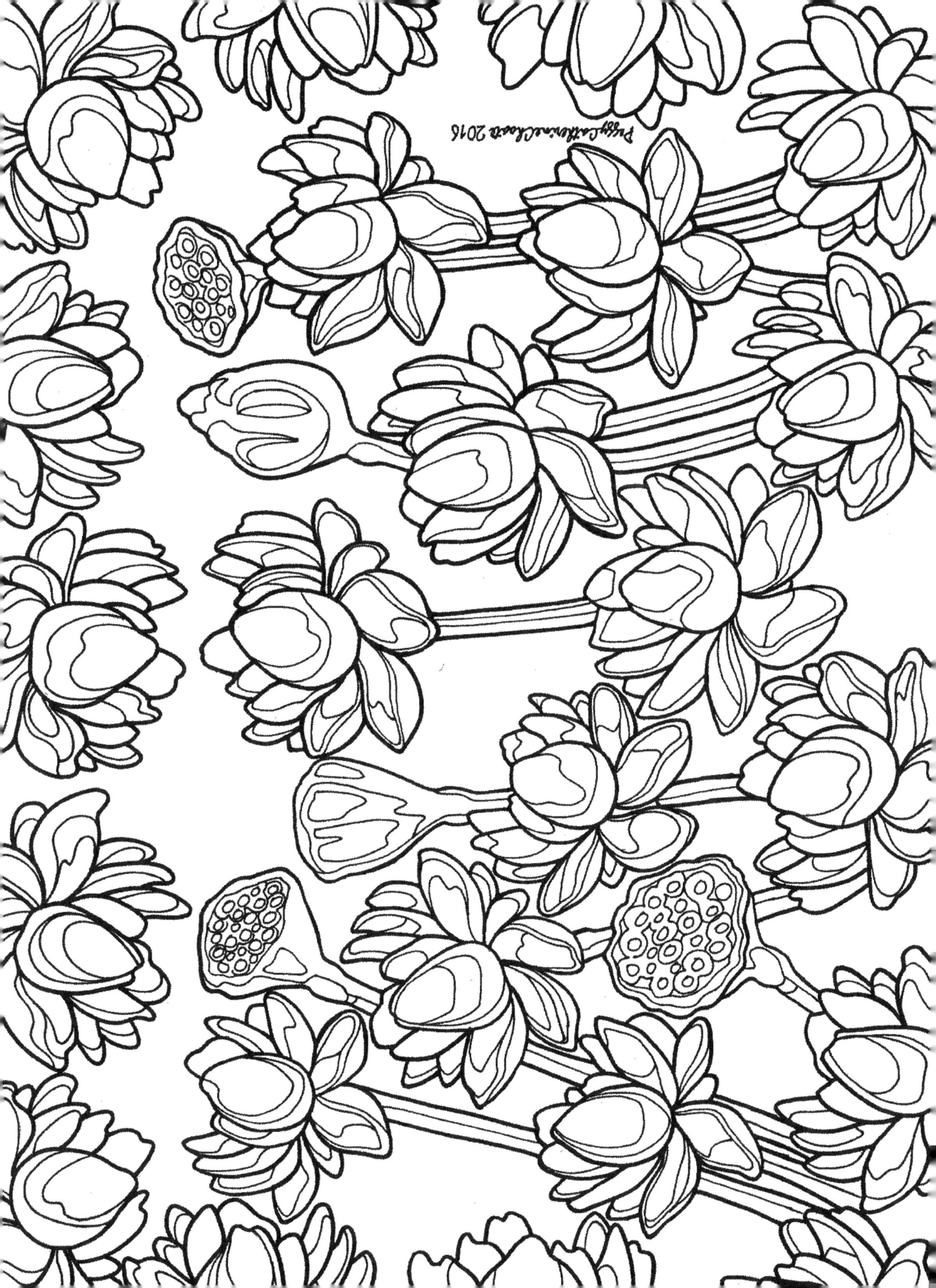

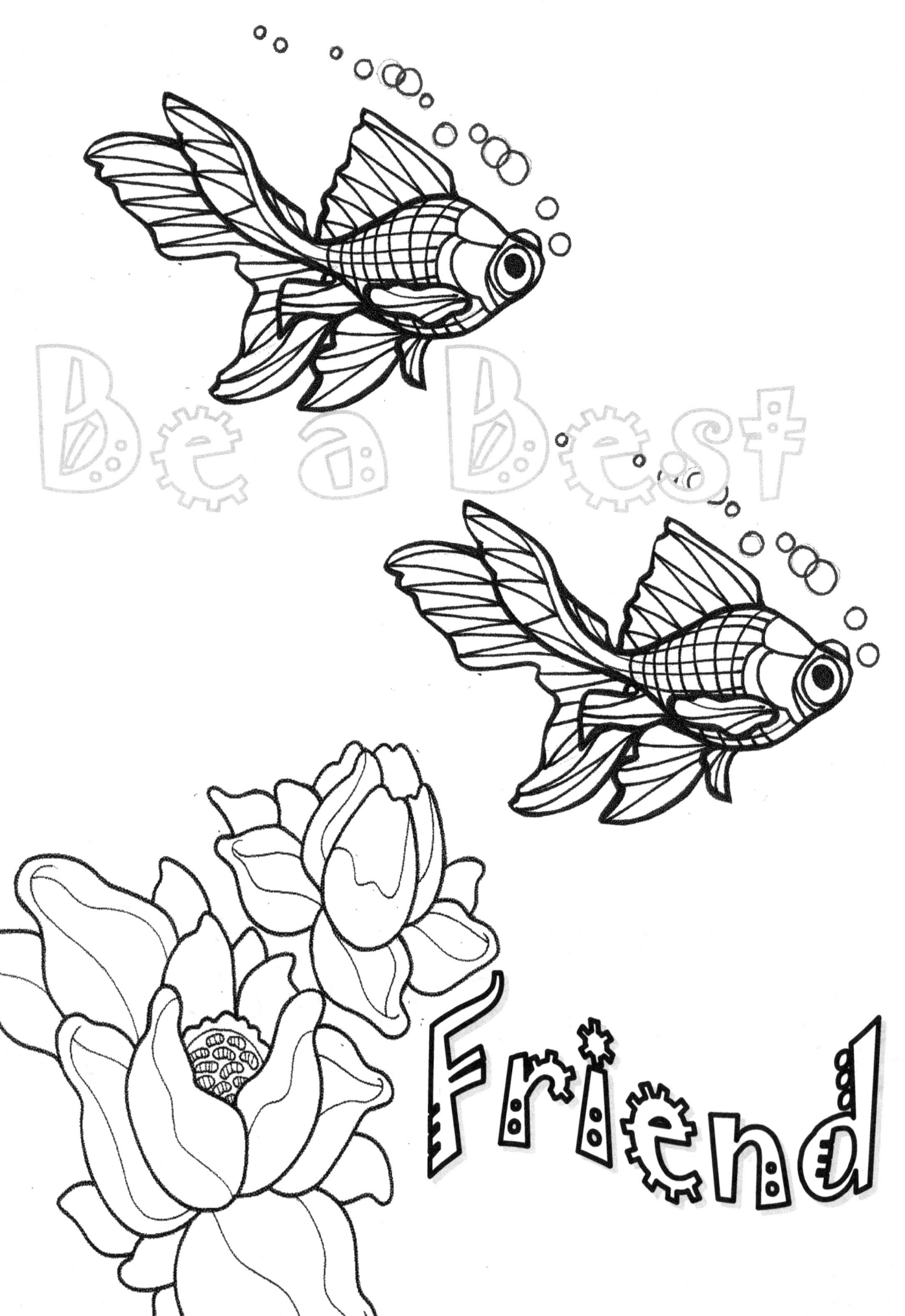

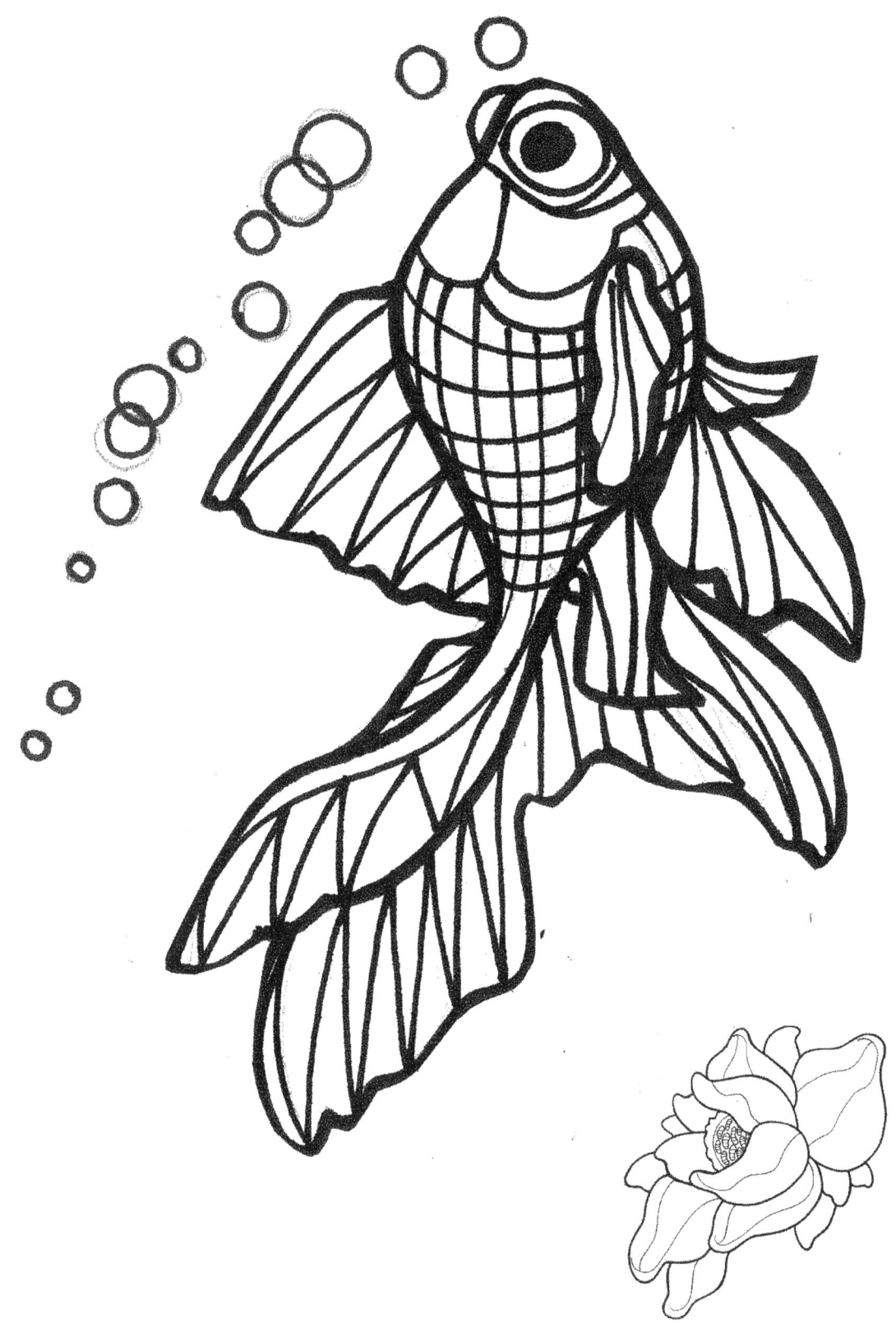

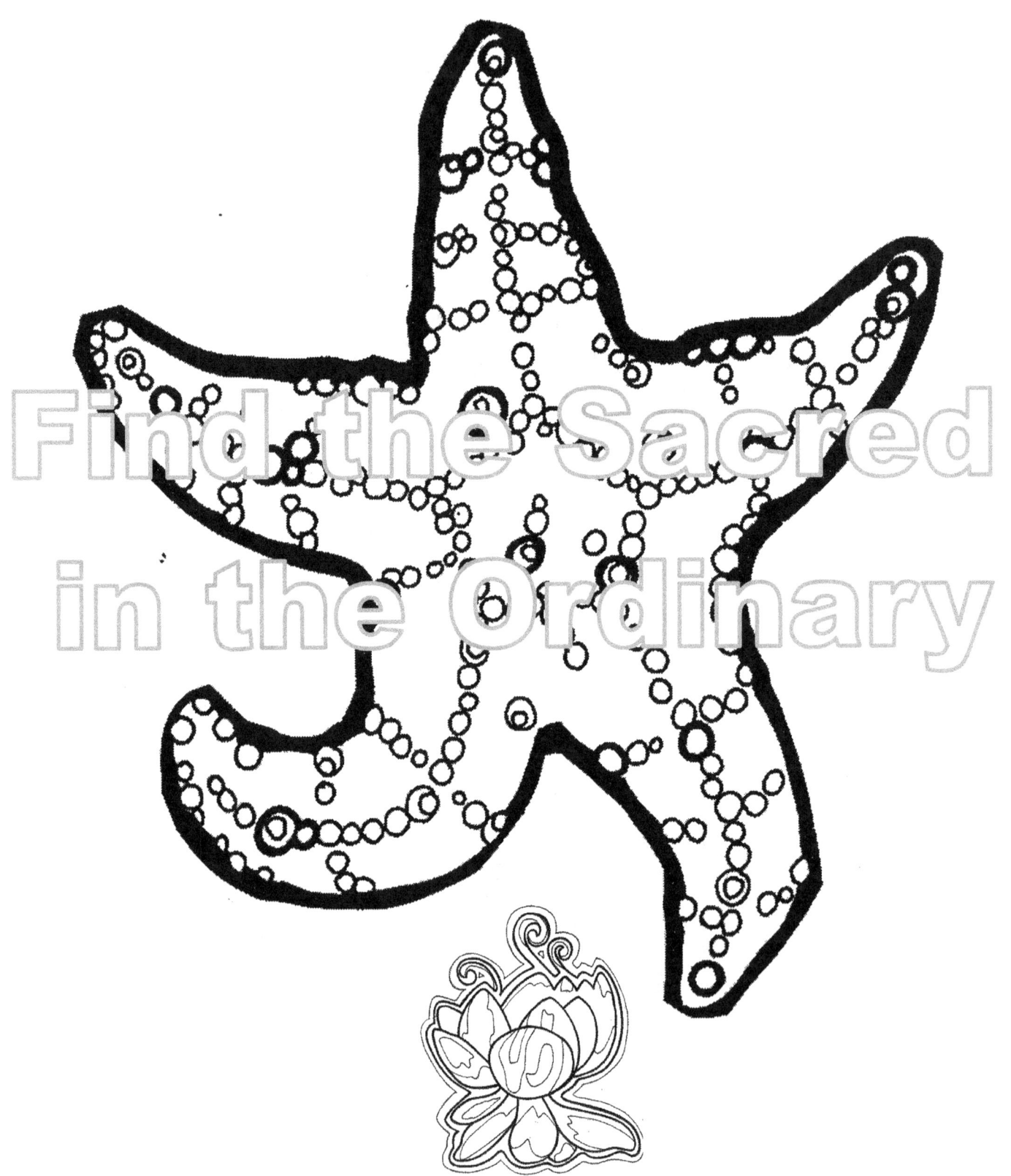

RED STARFISH

> While visiting Family in California we took a trip to Laguna Beach. It was the time of year the Red Starfish or Sea Stars gather in the Tide pools on the Pacific Coast. We were very Lucky to see them.

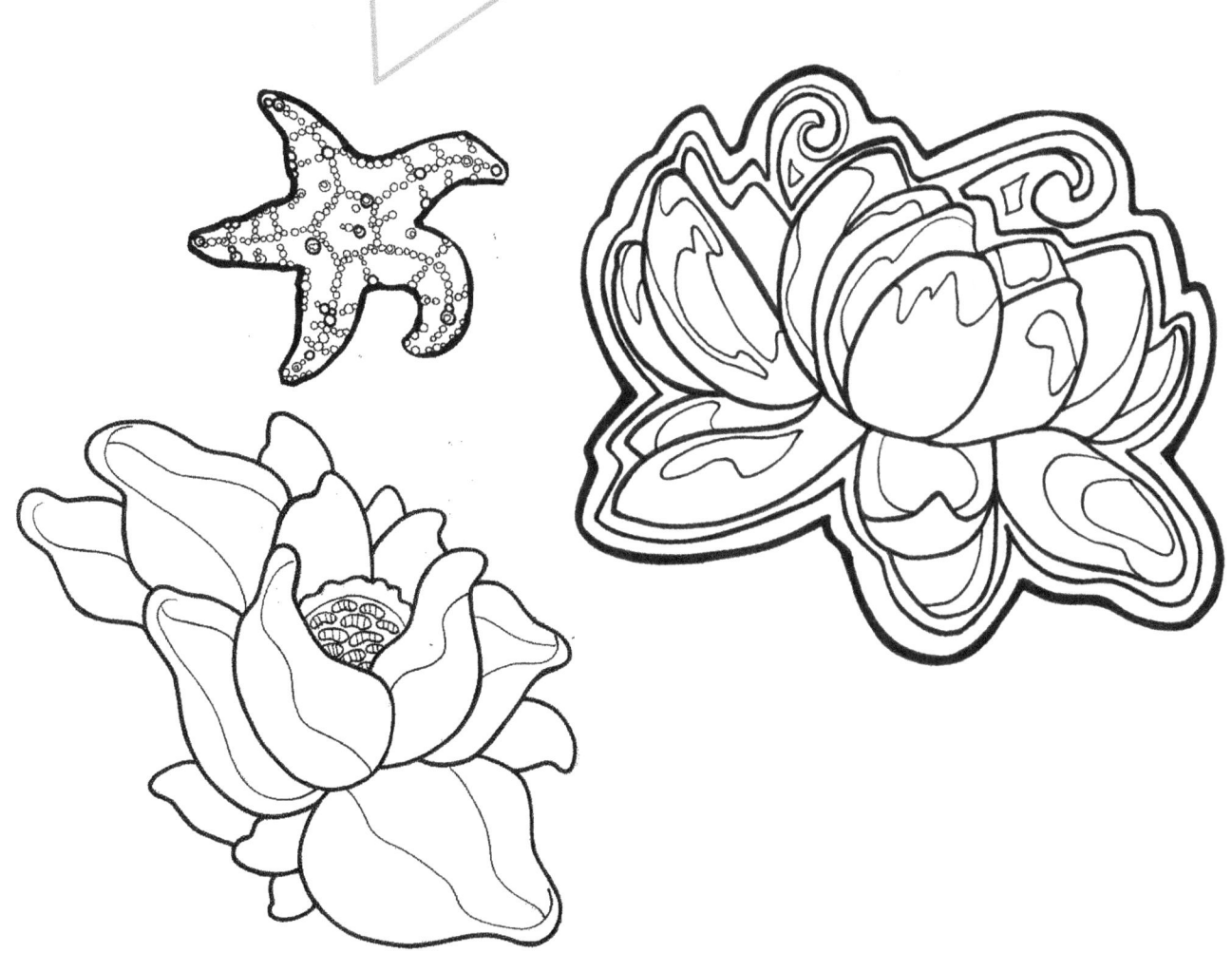

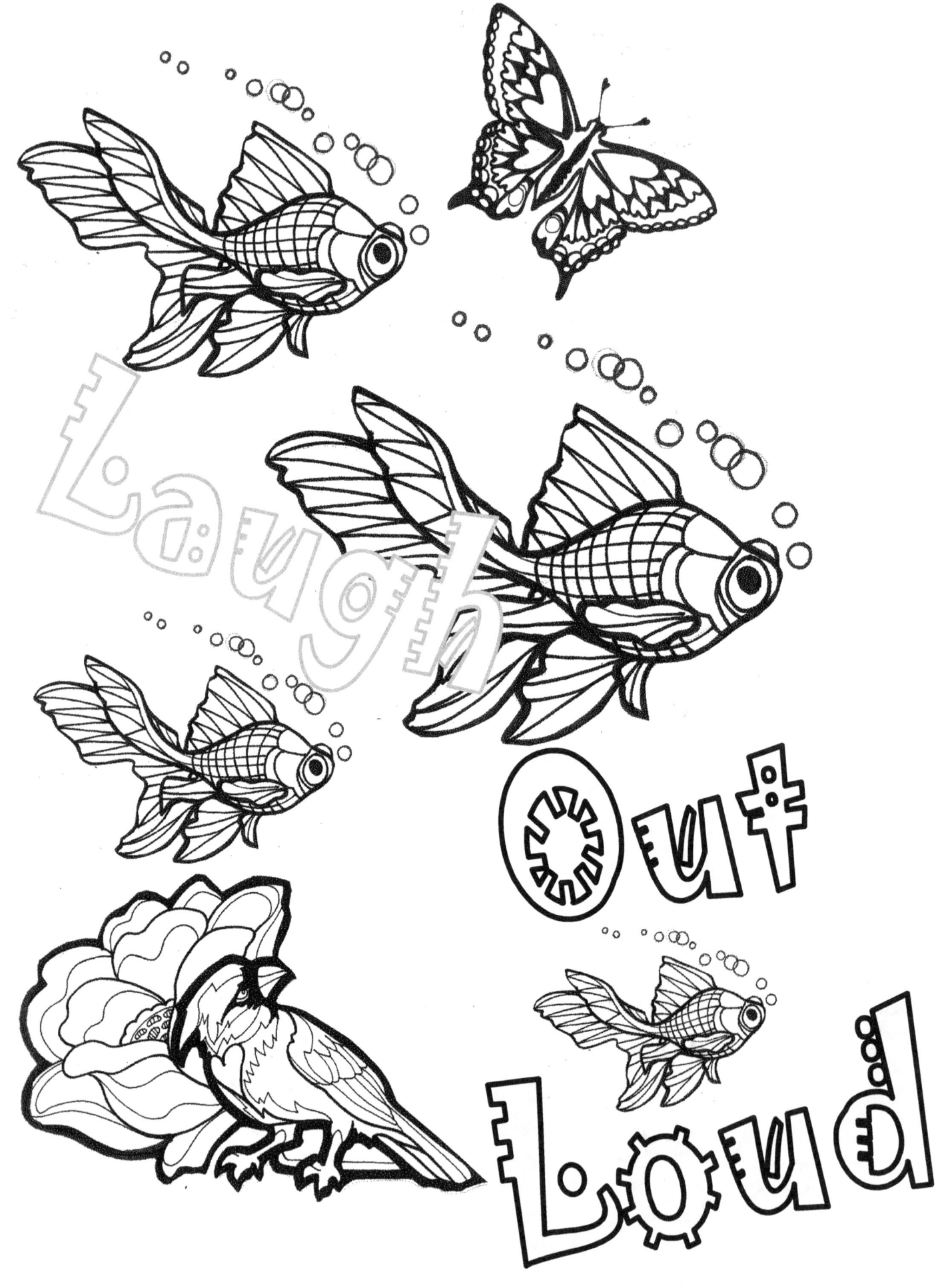

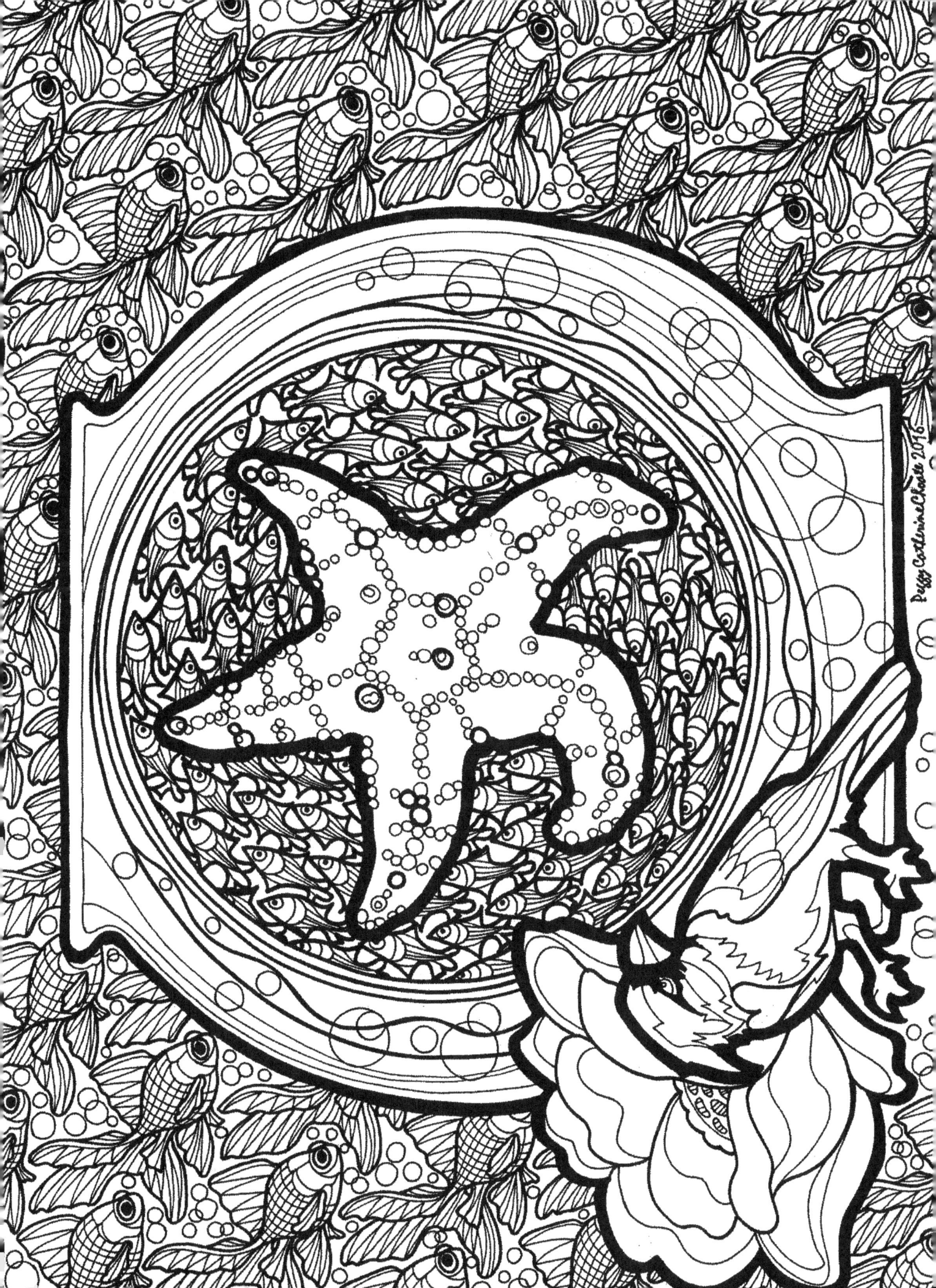

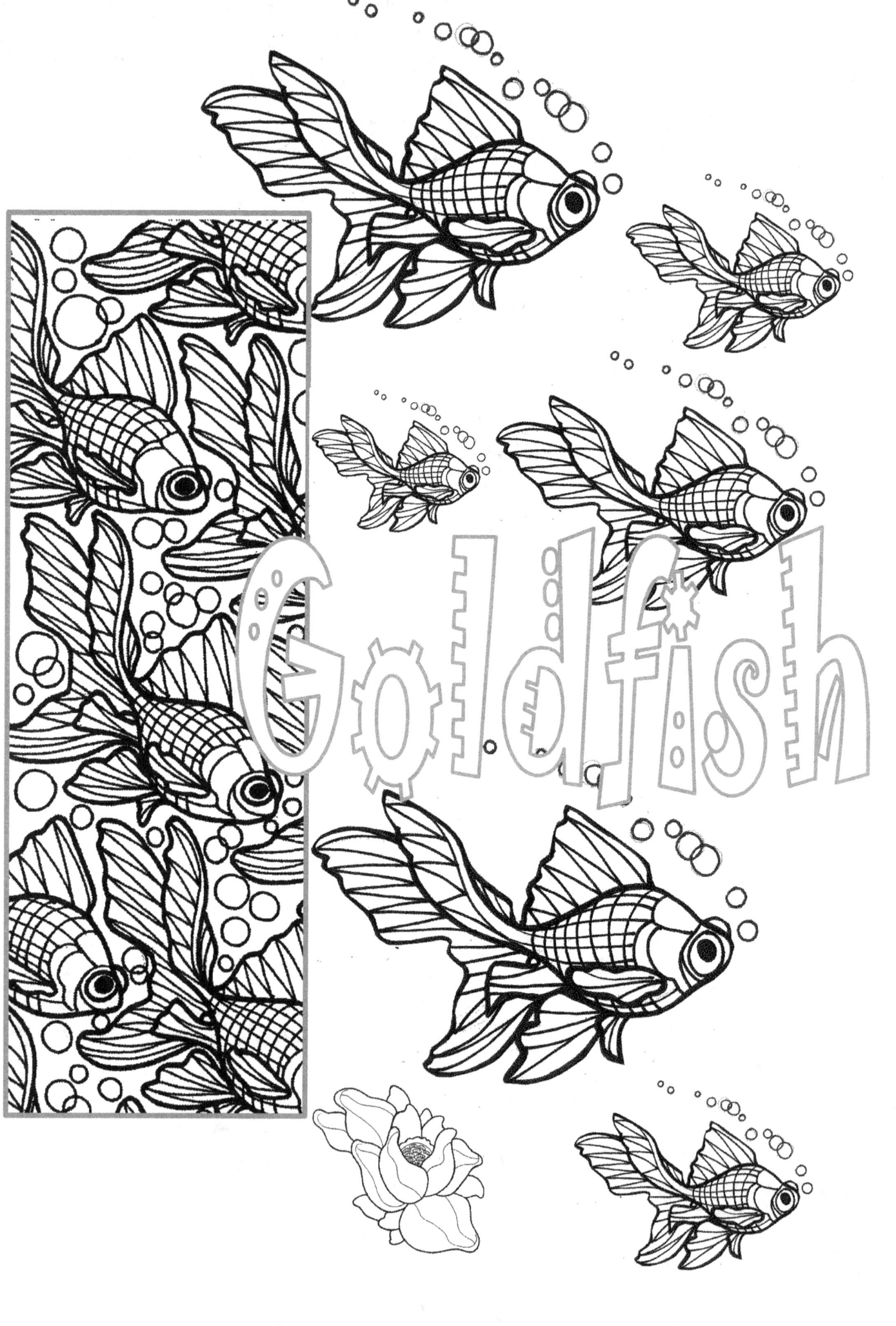

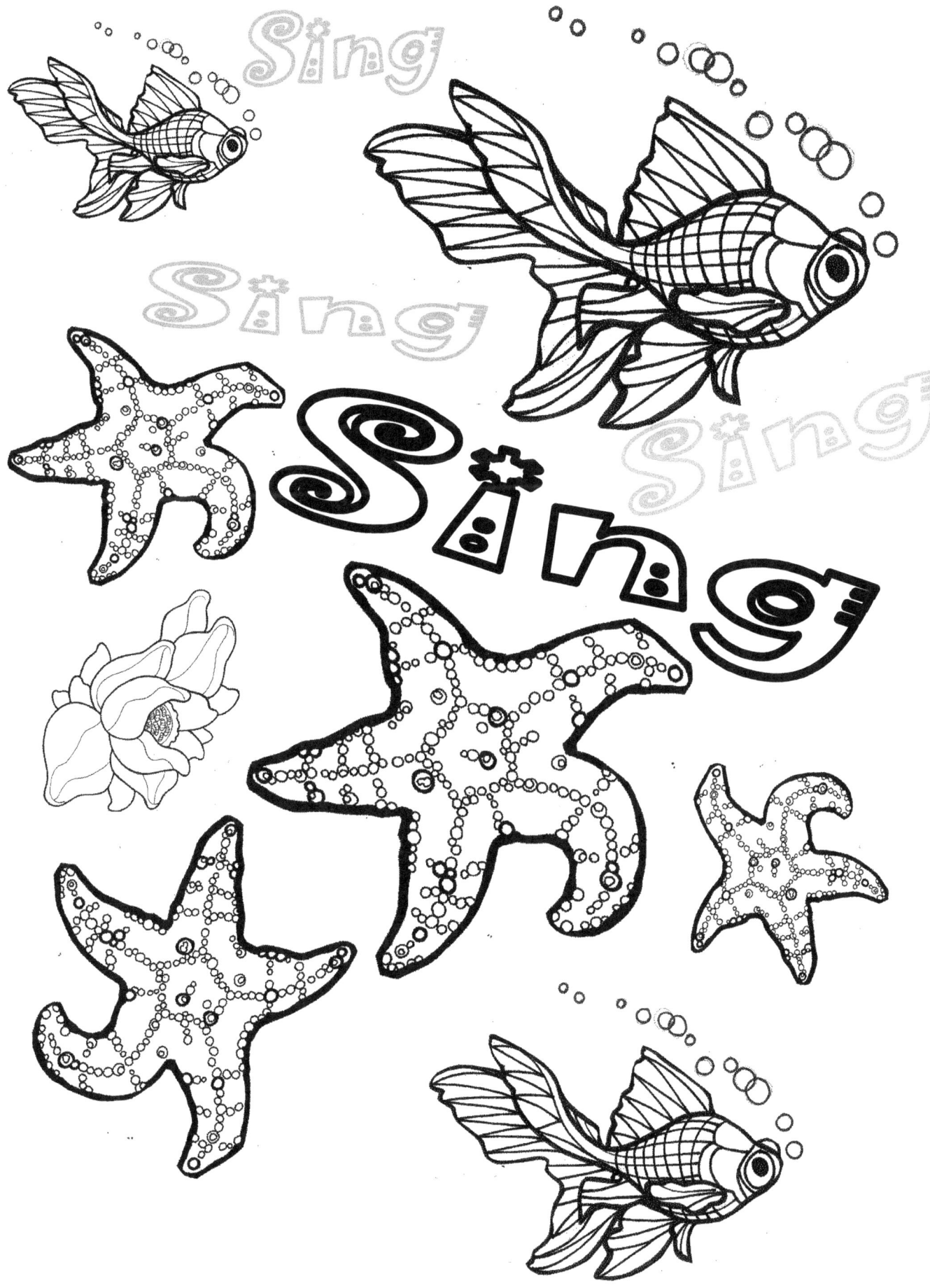

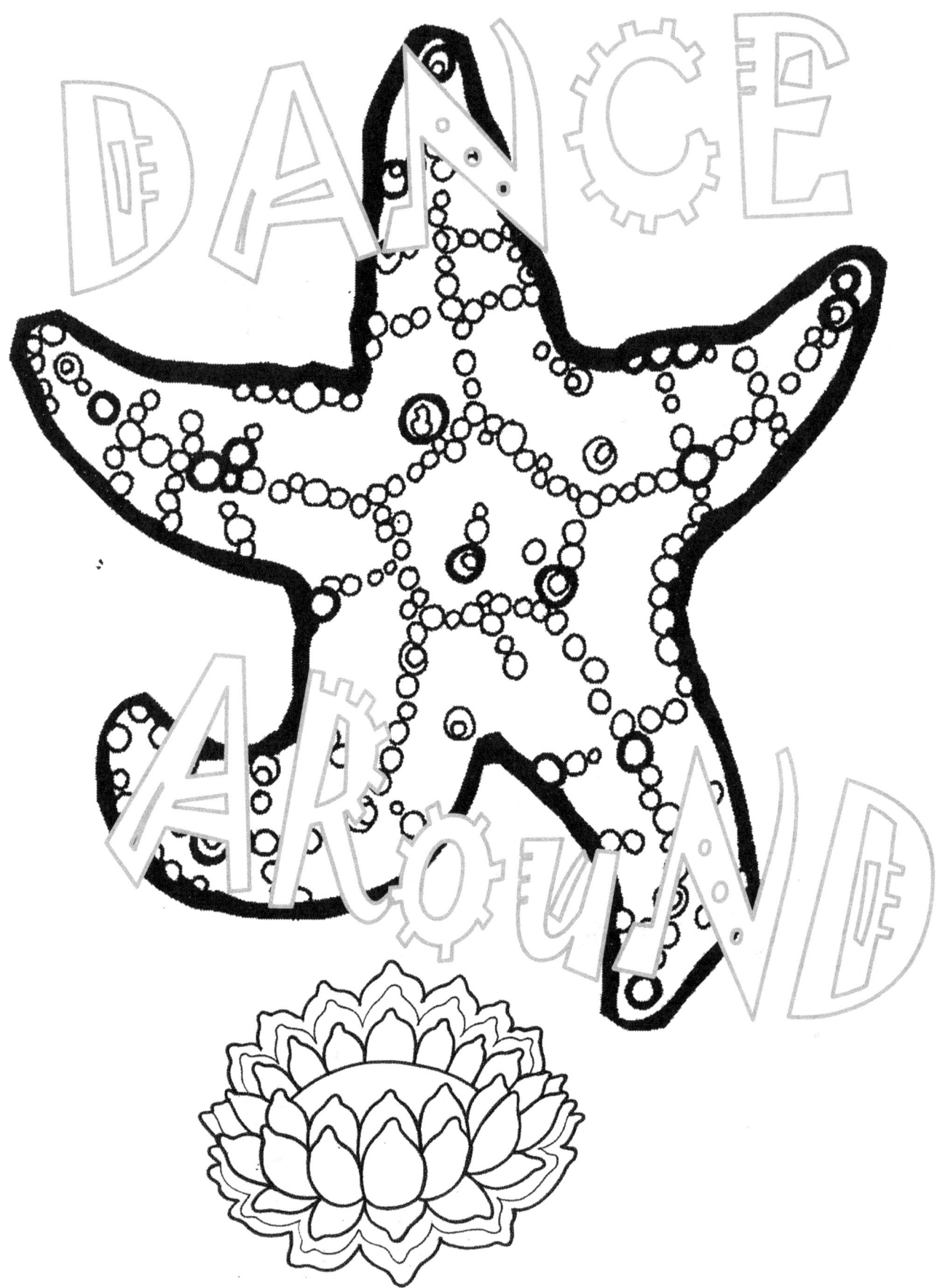

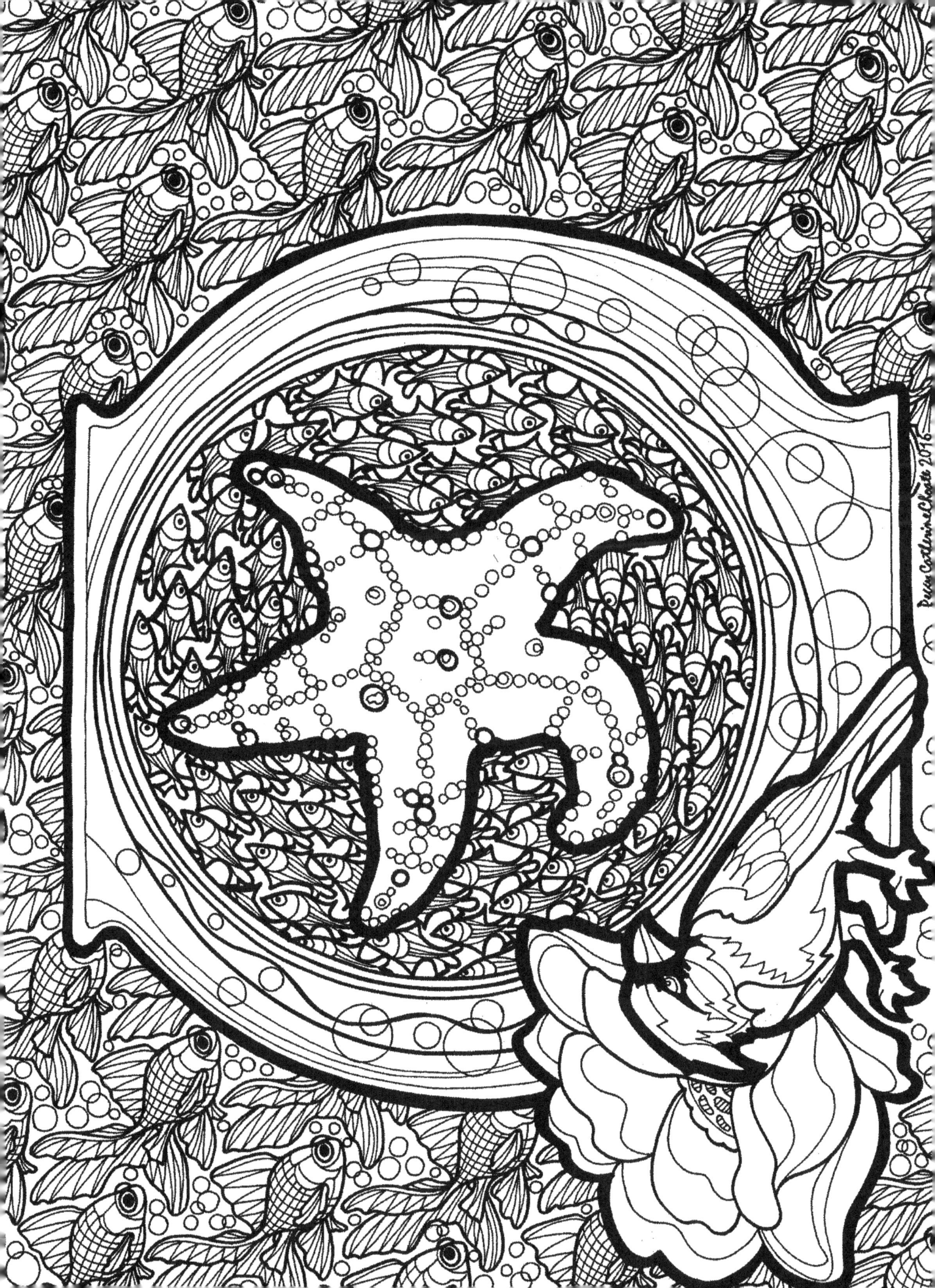

Move Forward

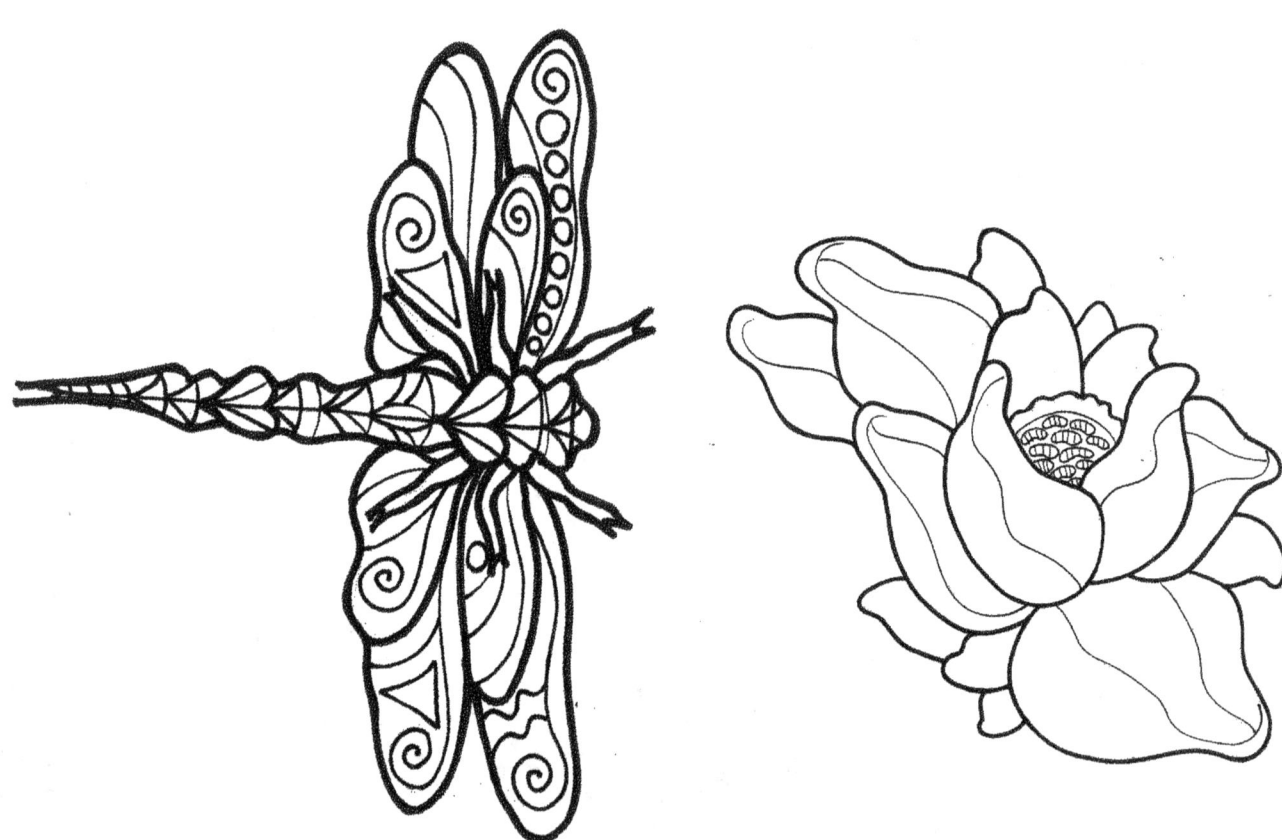

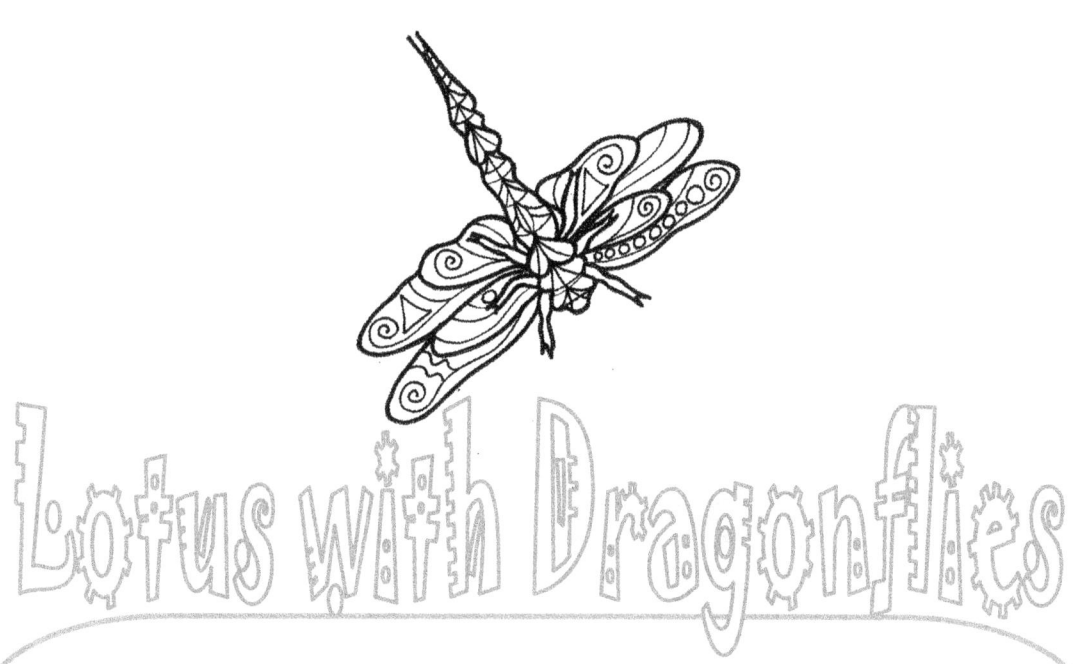

Lotus with Dragonflies

This illustration was inspired by watching Dragonflies hatch with my Son at Lily Cove in Lake George, New York. There is an abundant amount of Lily Flowers growing there.

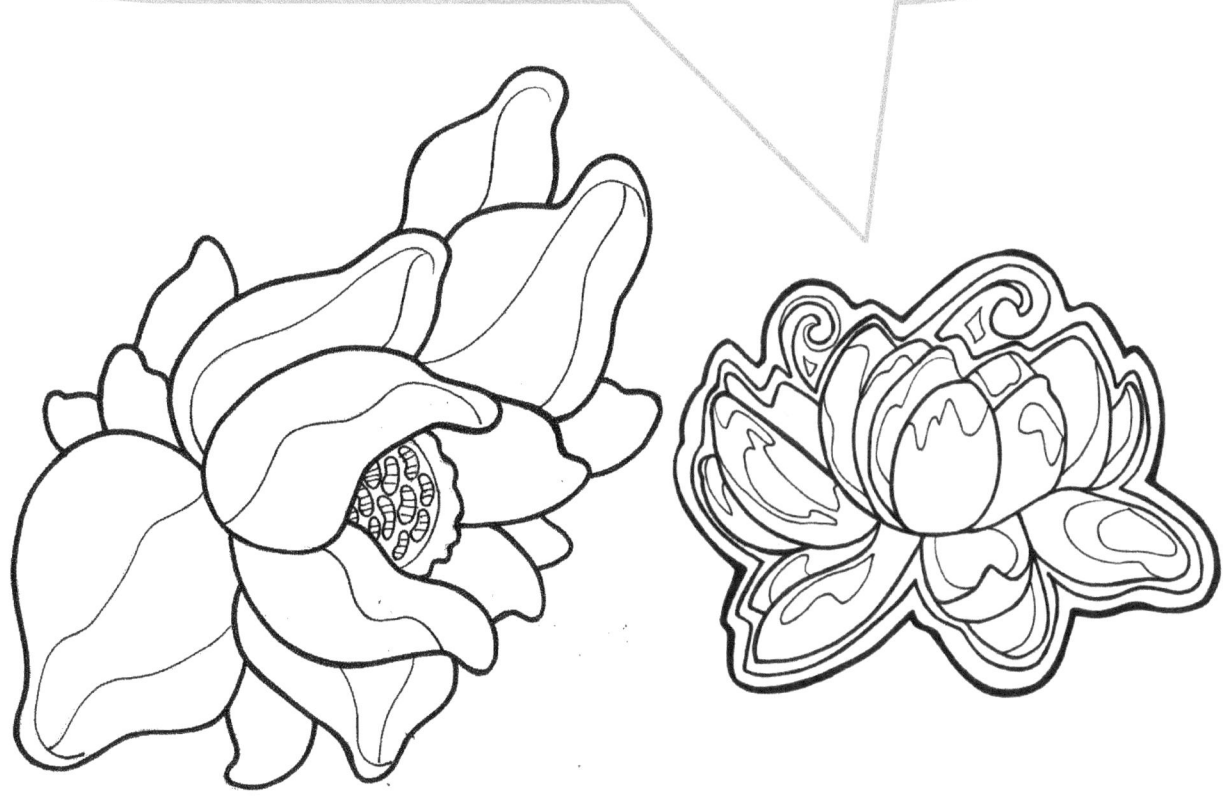

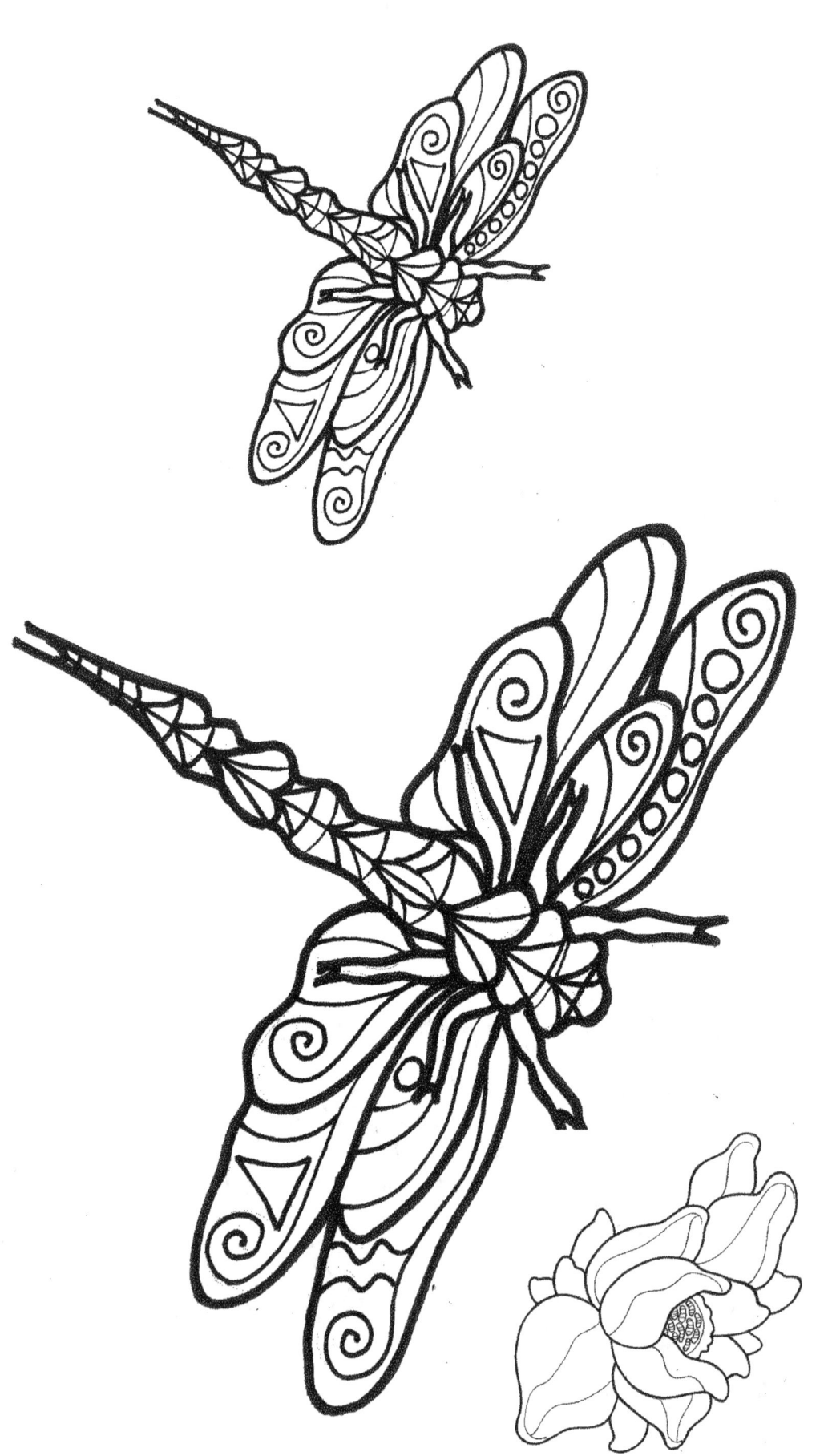

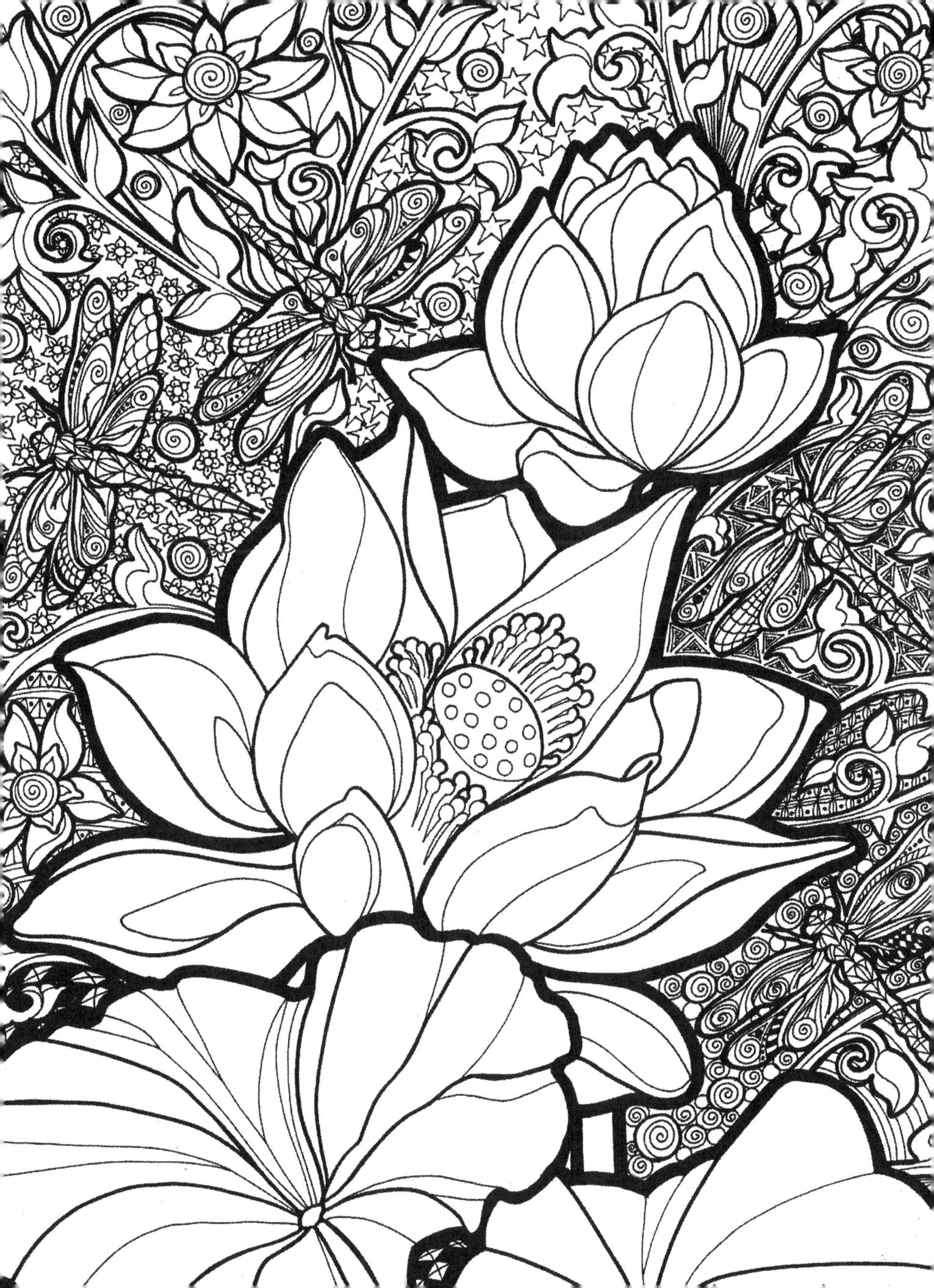

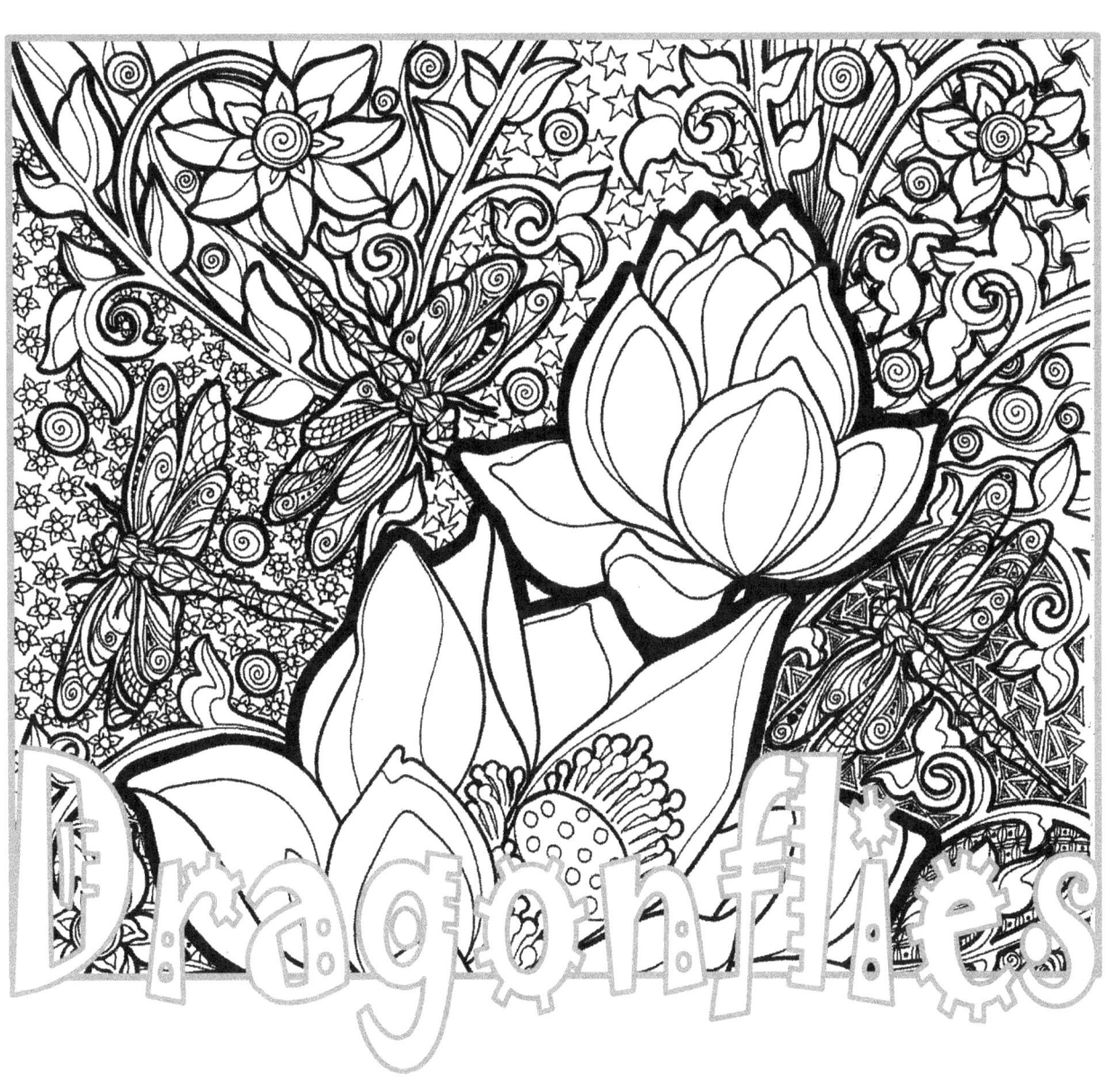

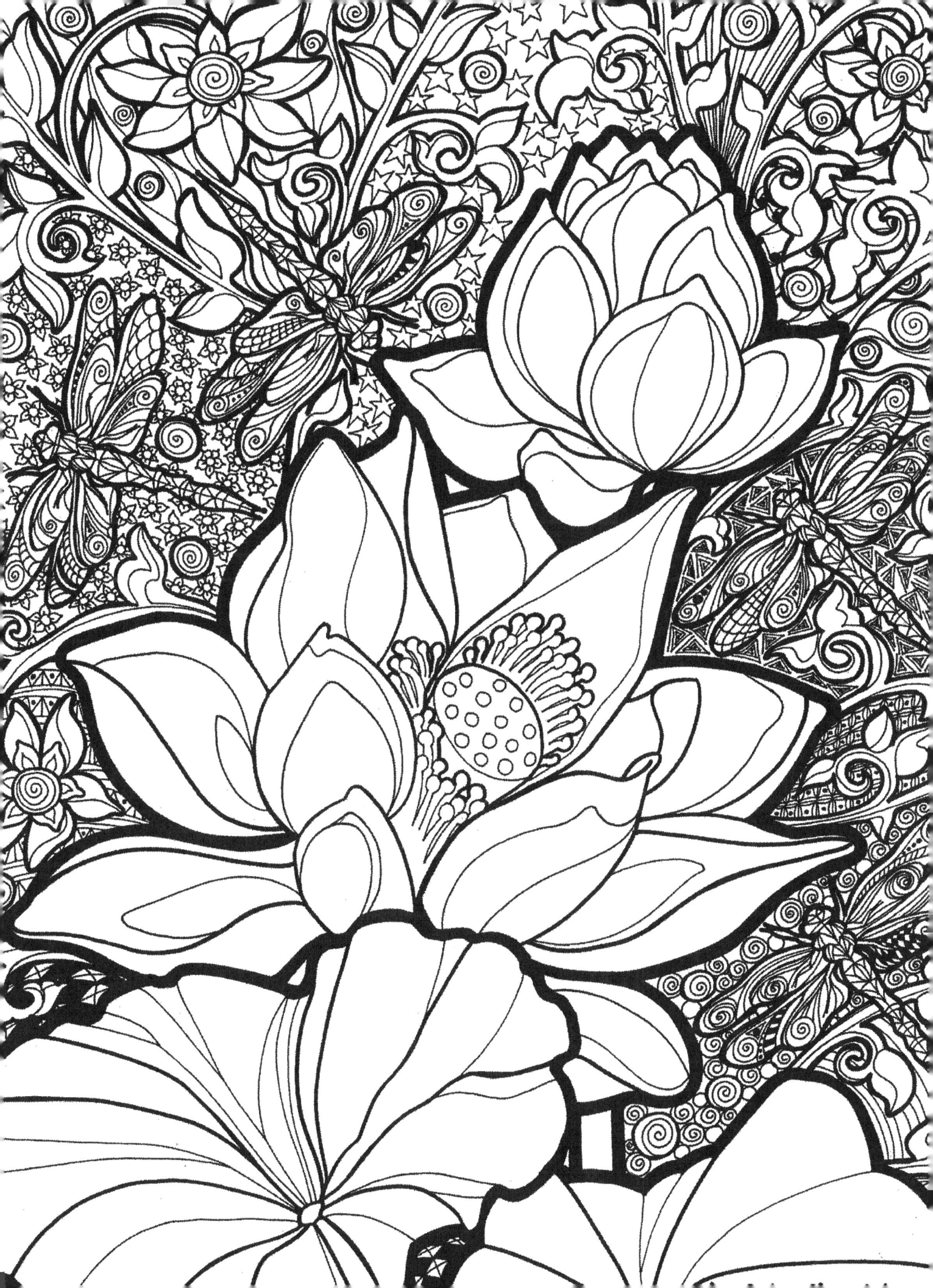

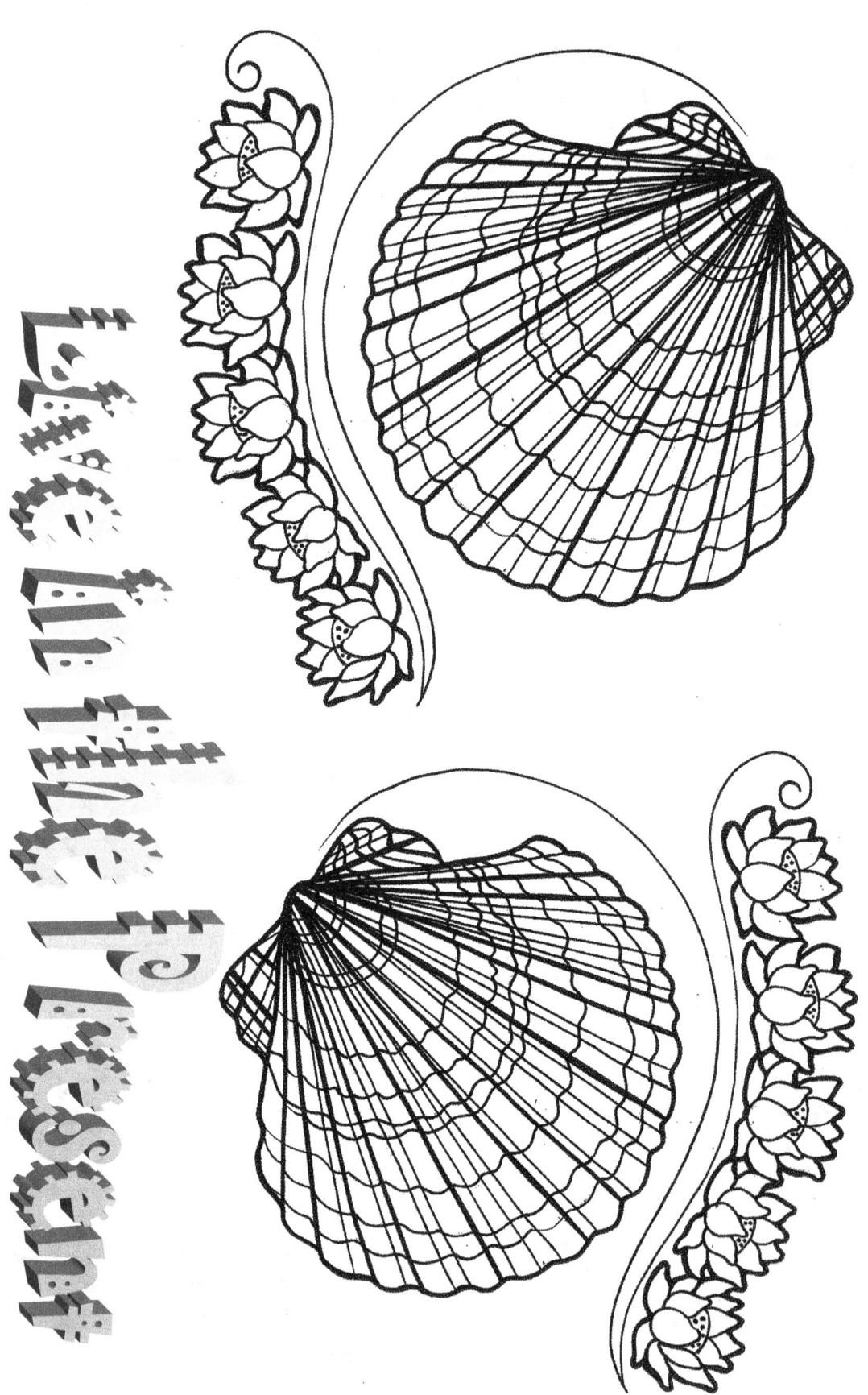

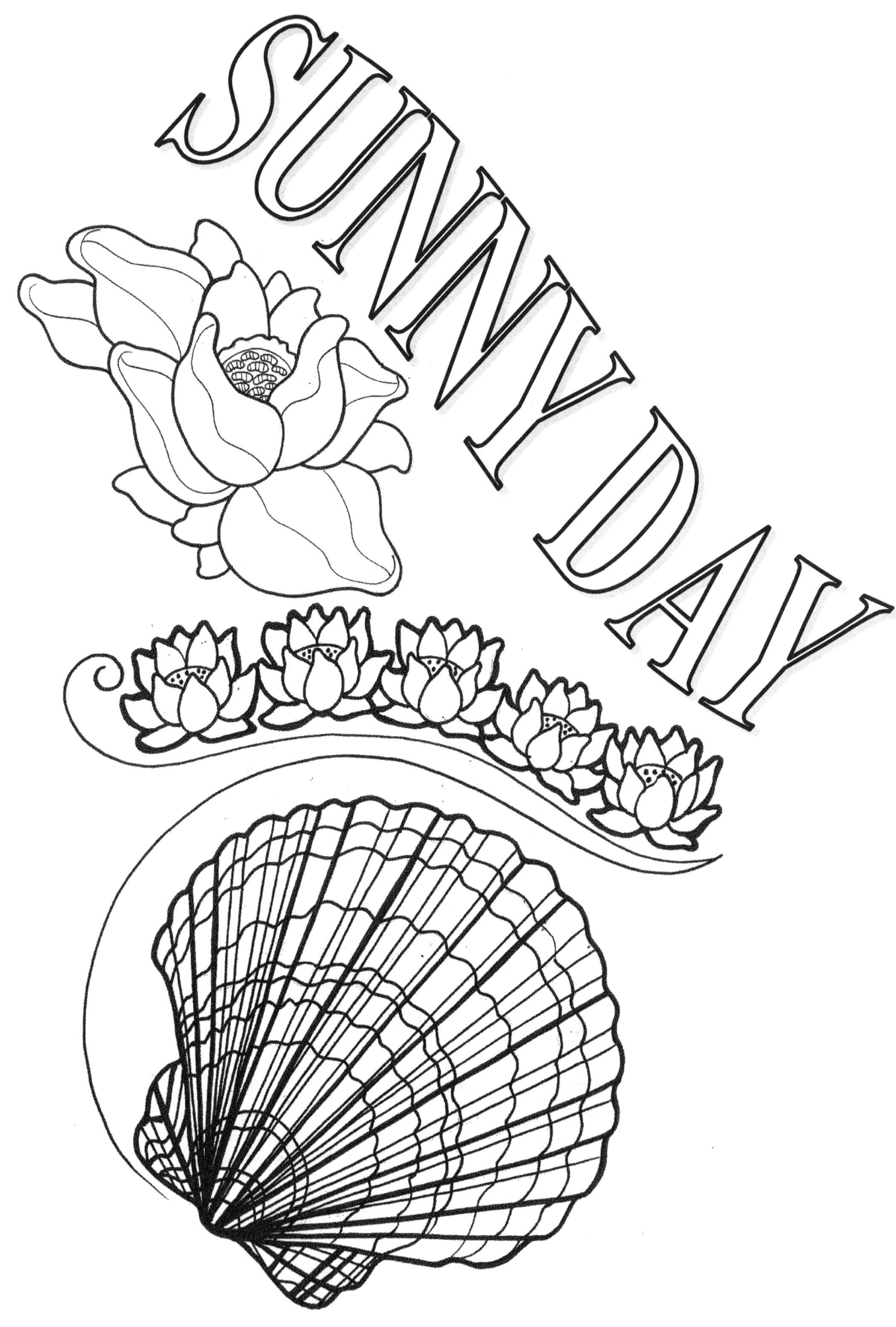

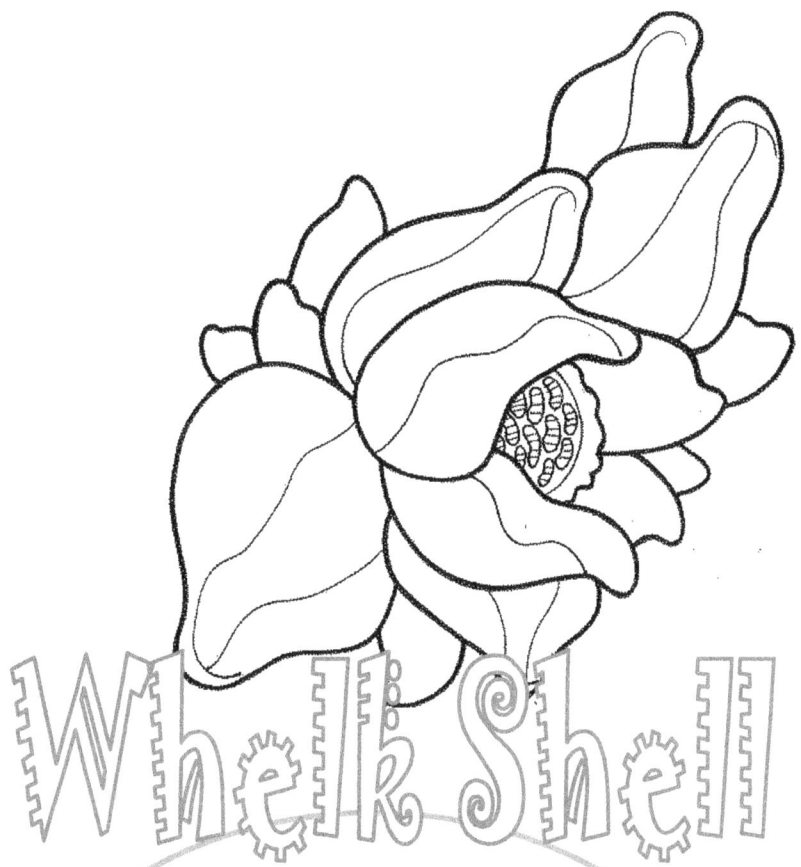

Whelk Shell

This is one of my
Favorite illustrations.
I collect Seashells.
I Love the grids that form in
them the way they grow
and Love the 3D effect
that happened when
I drew them.

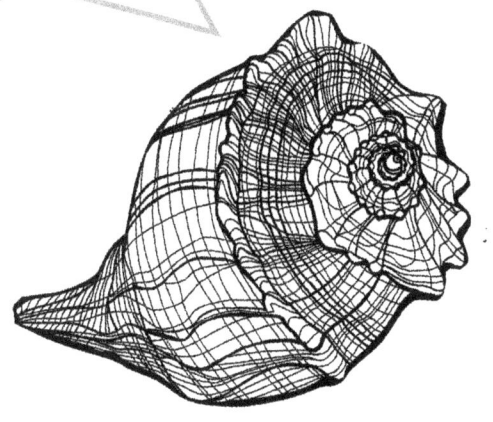

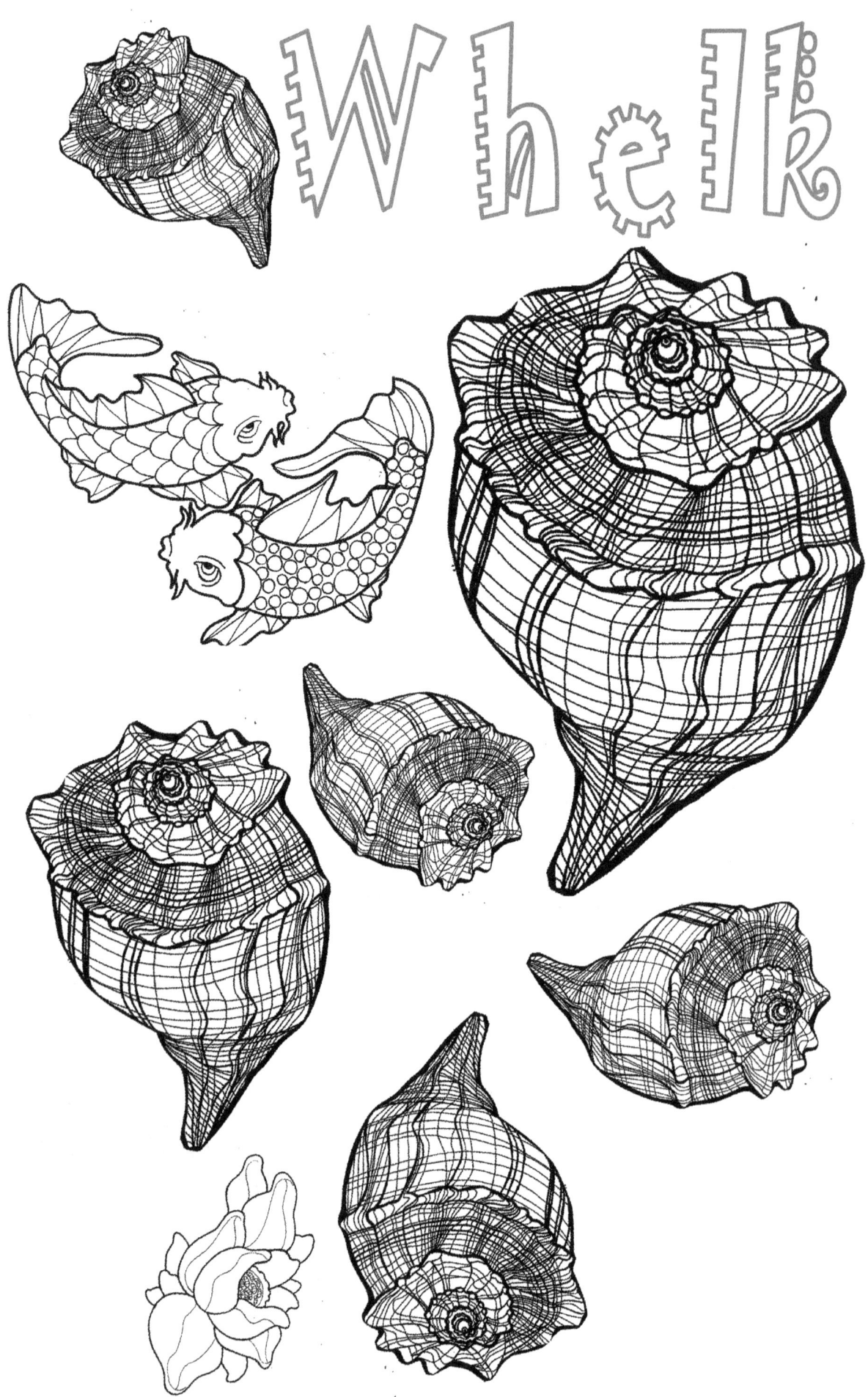

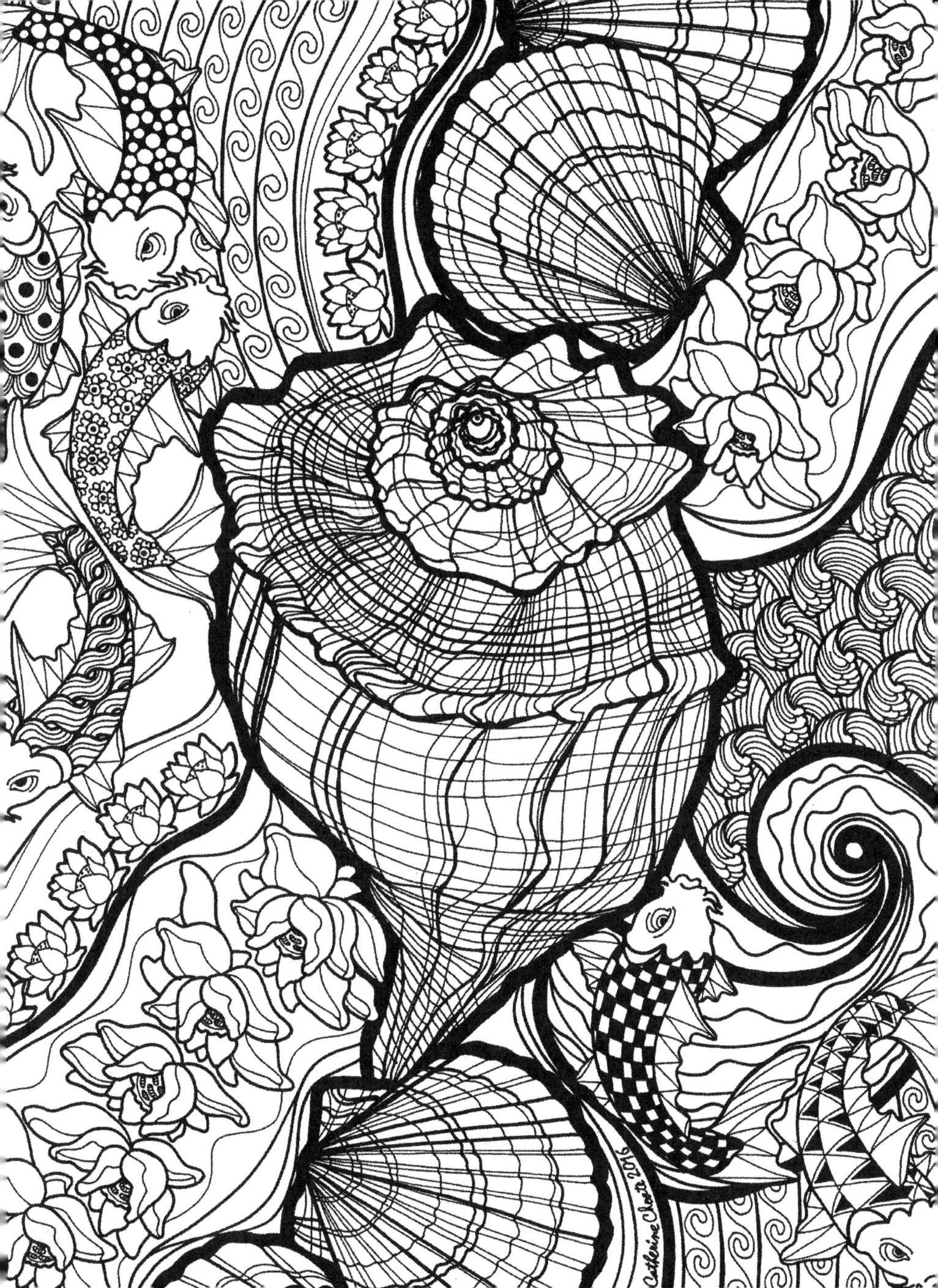

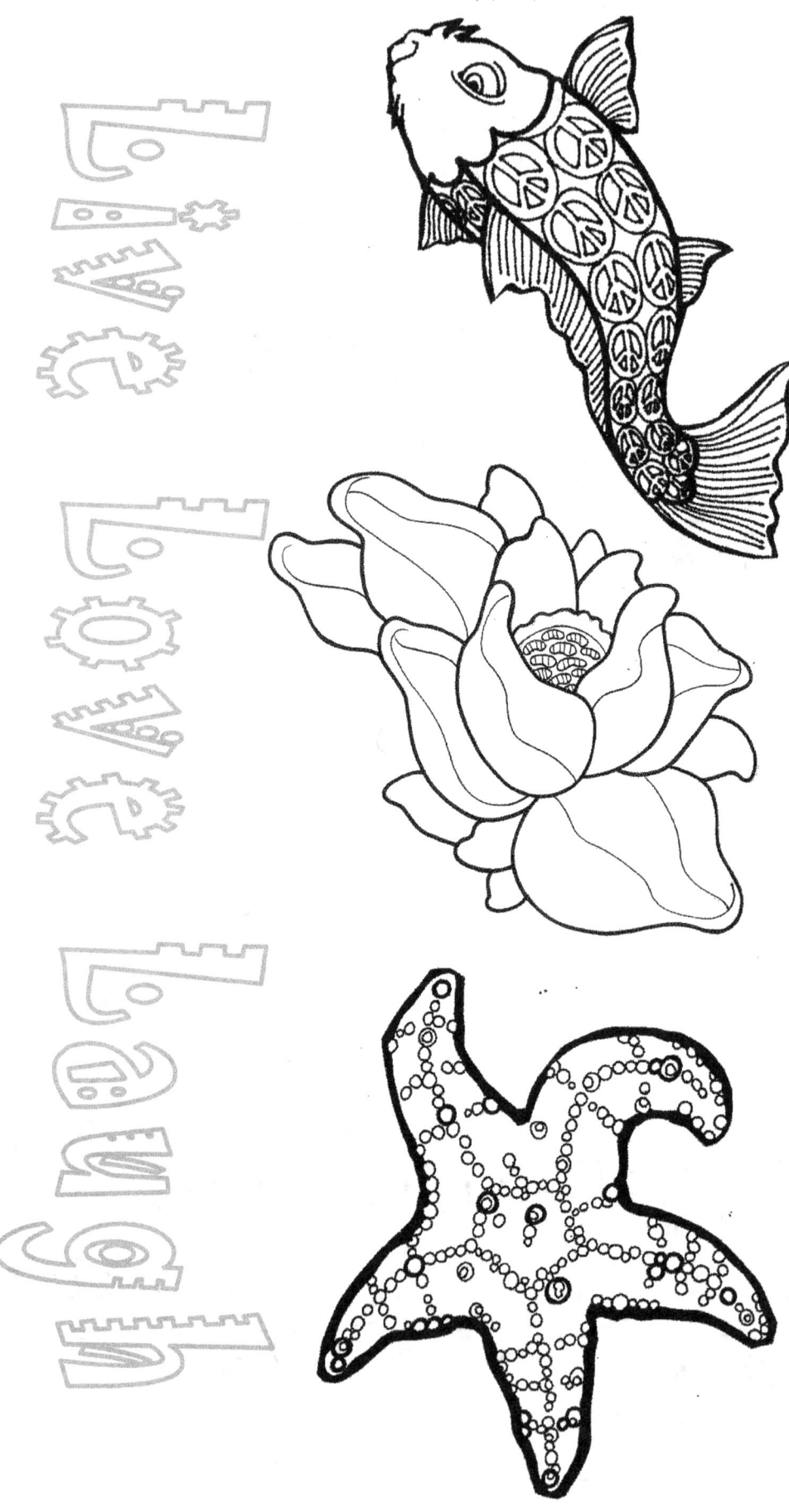

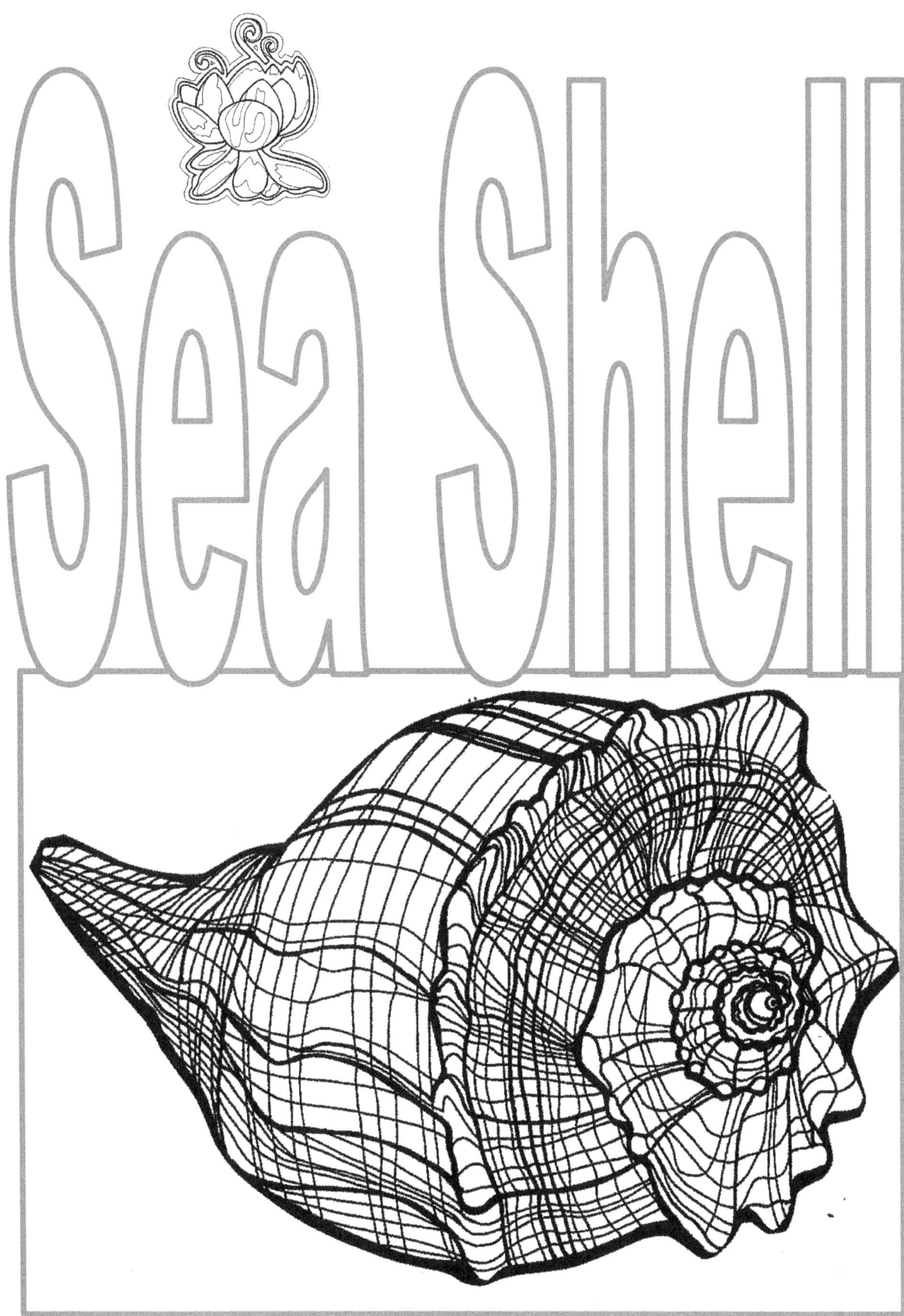

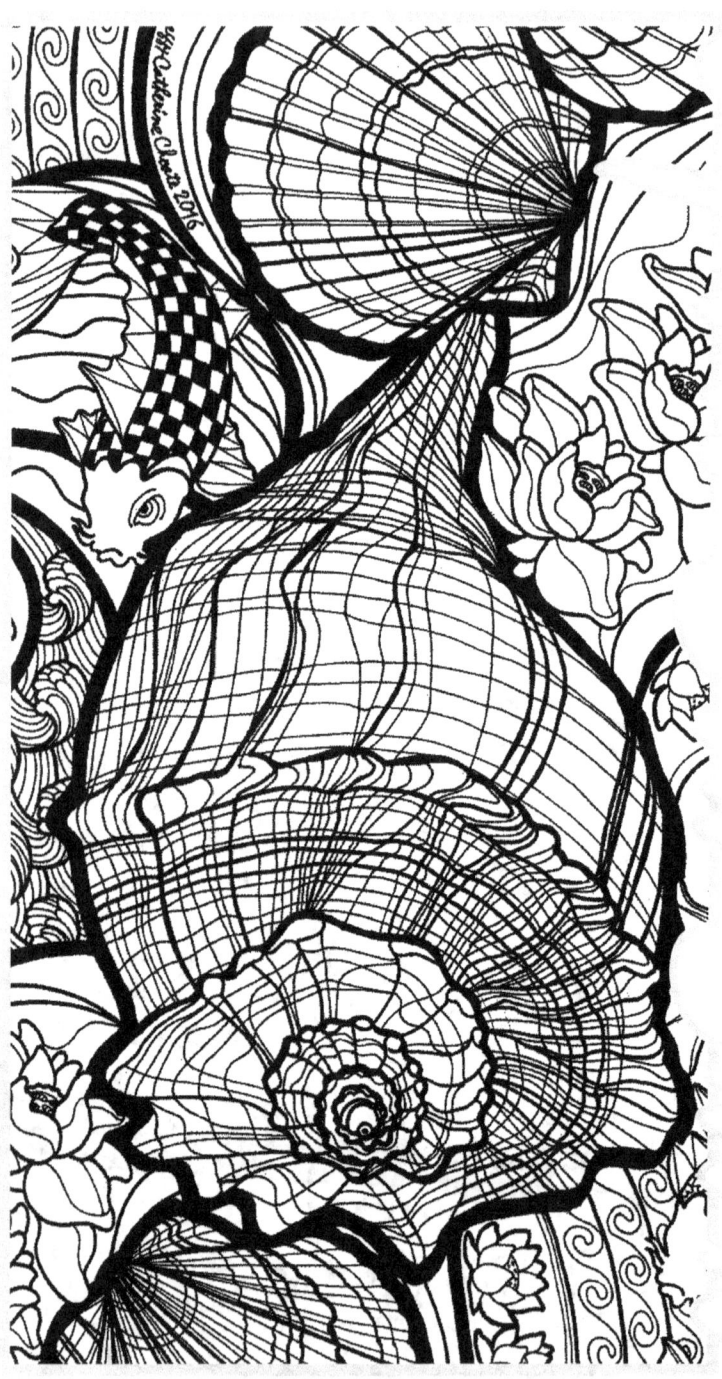

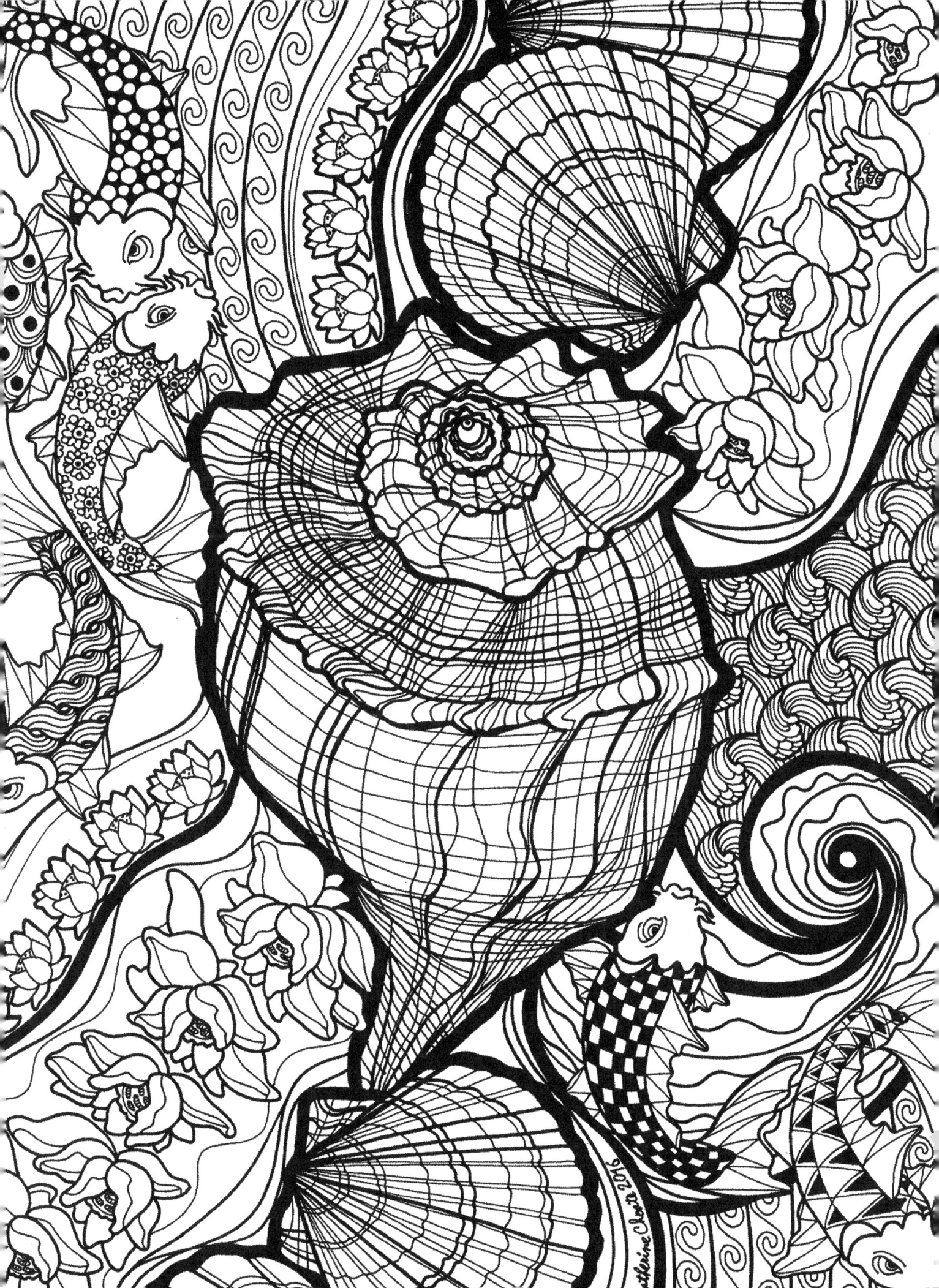

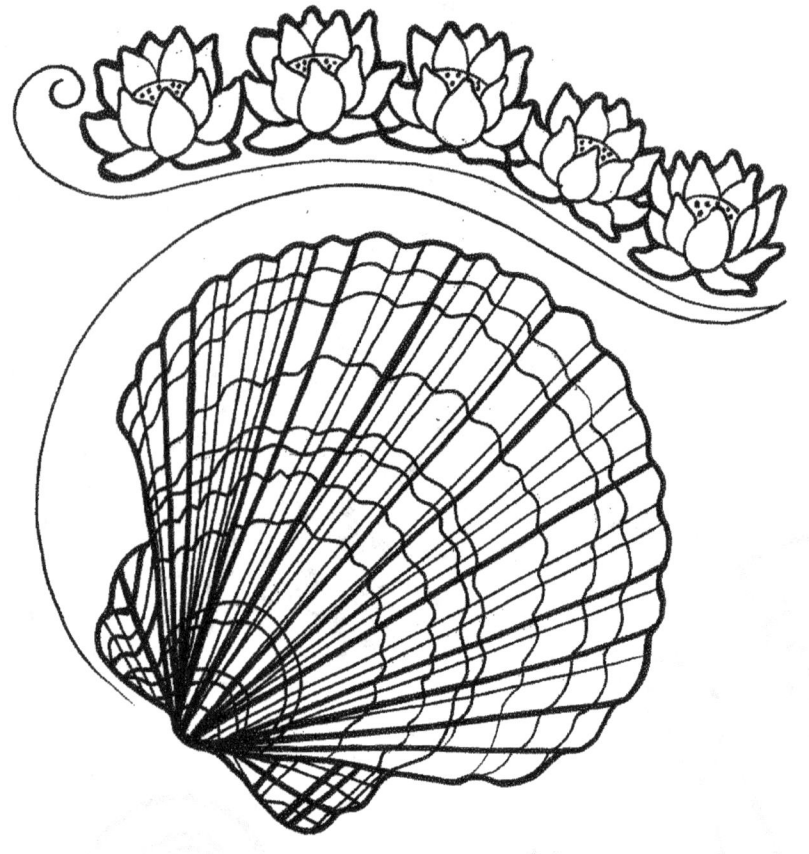
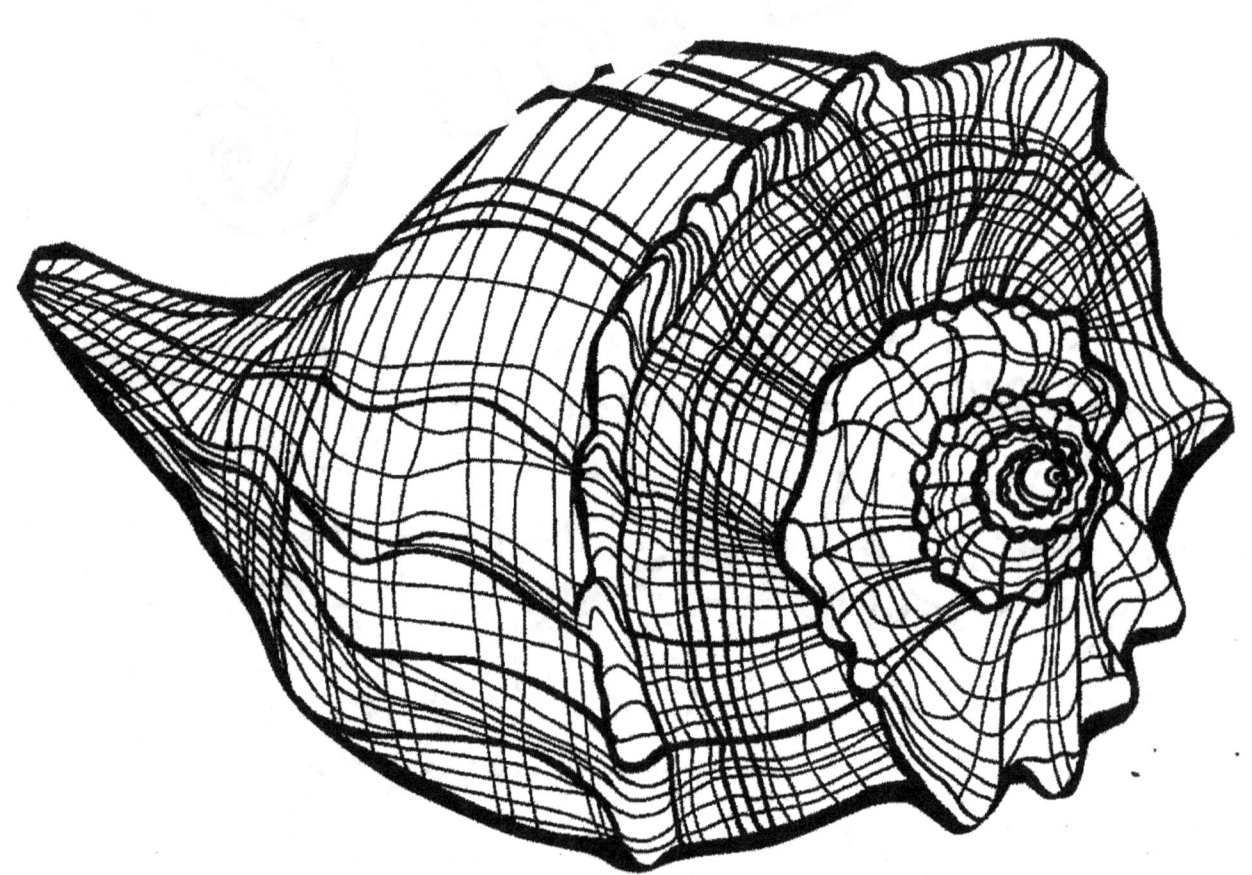

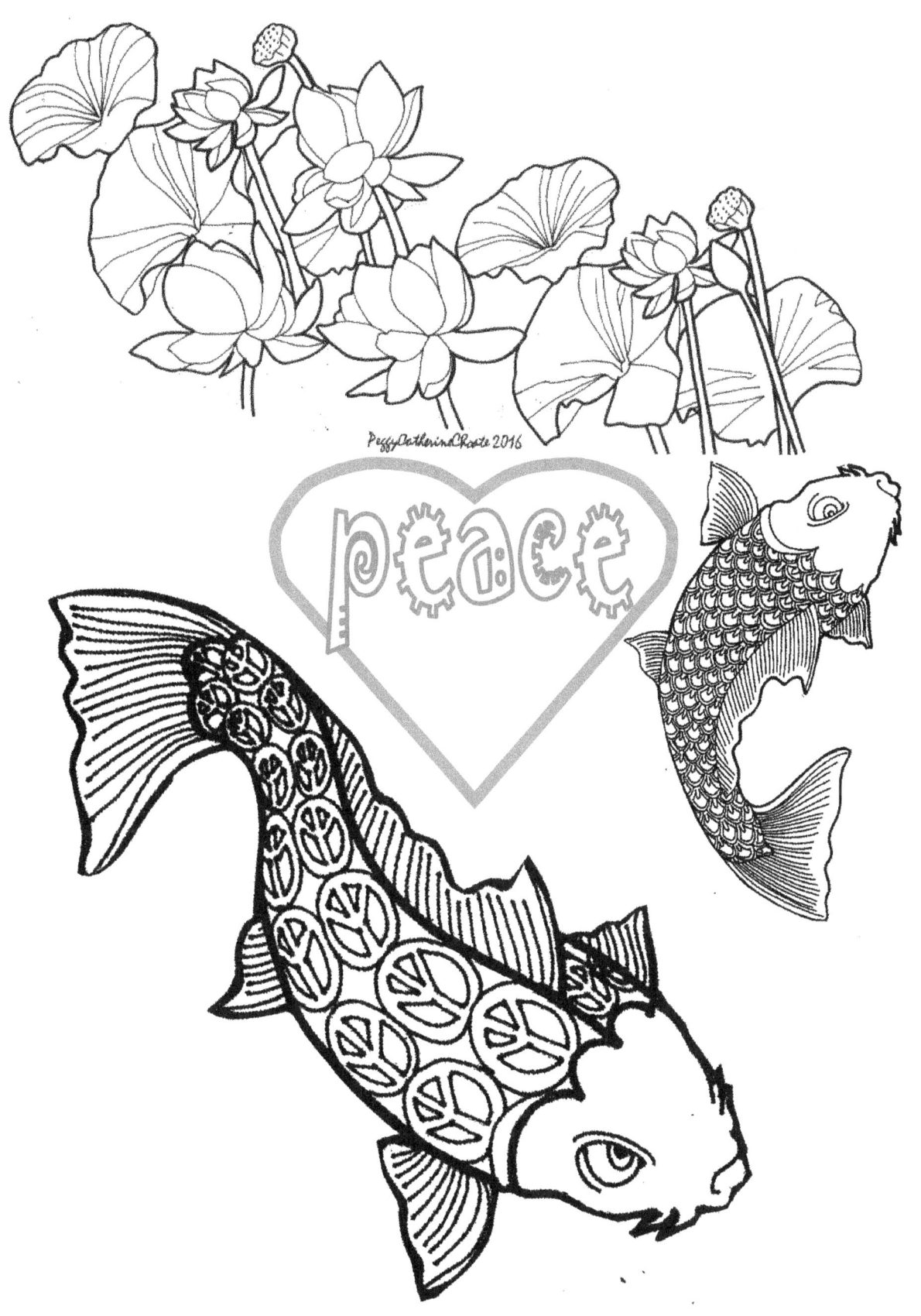

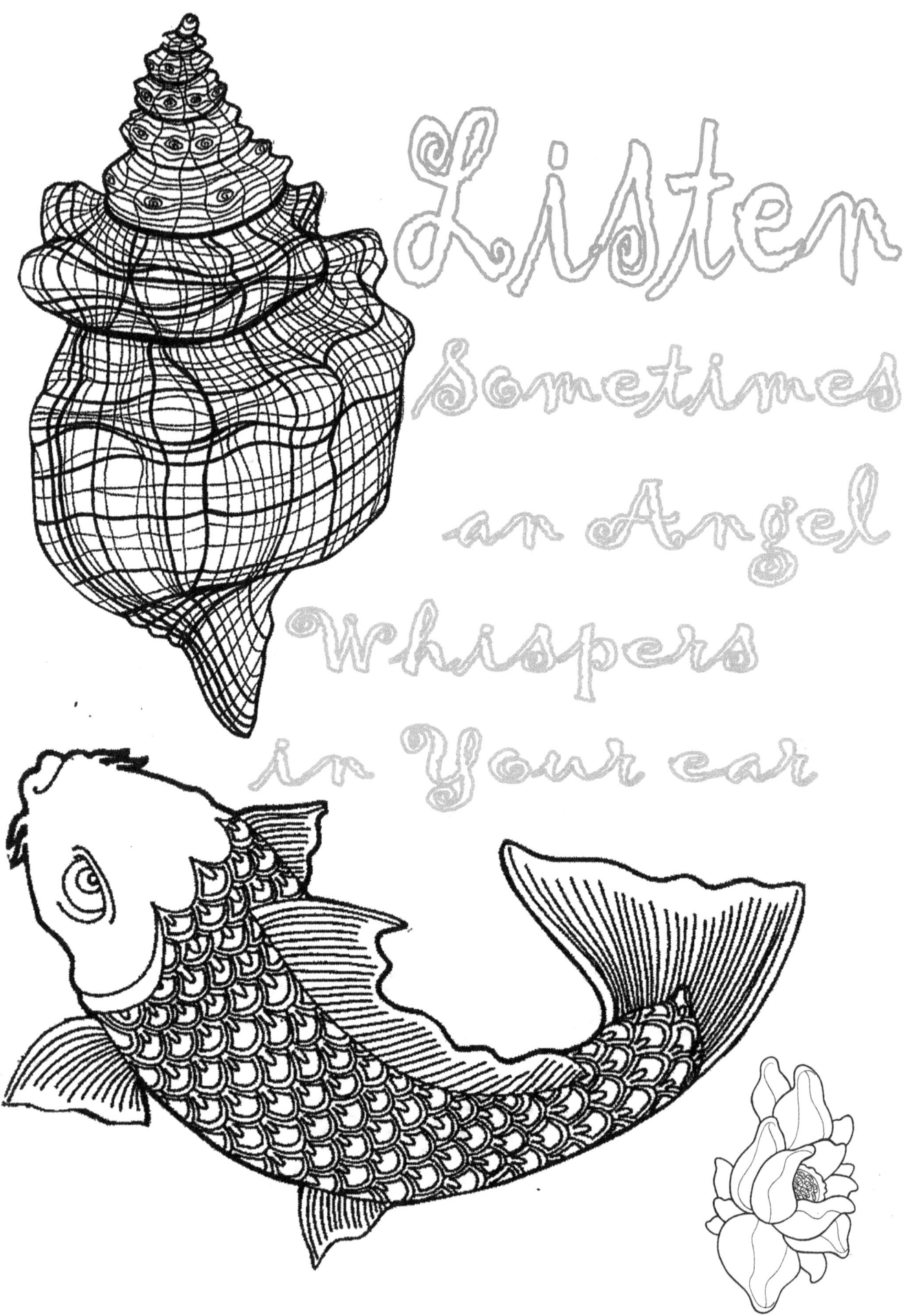

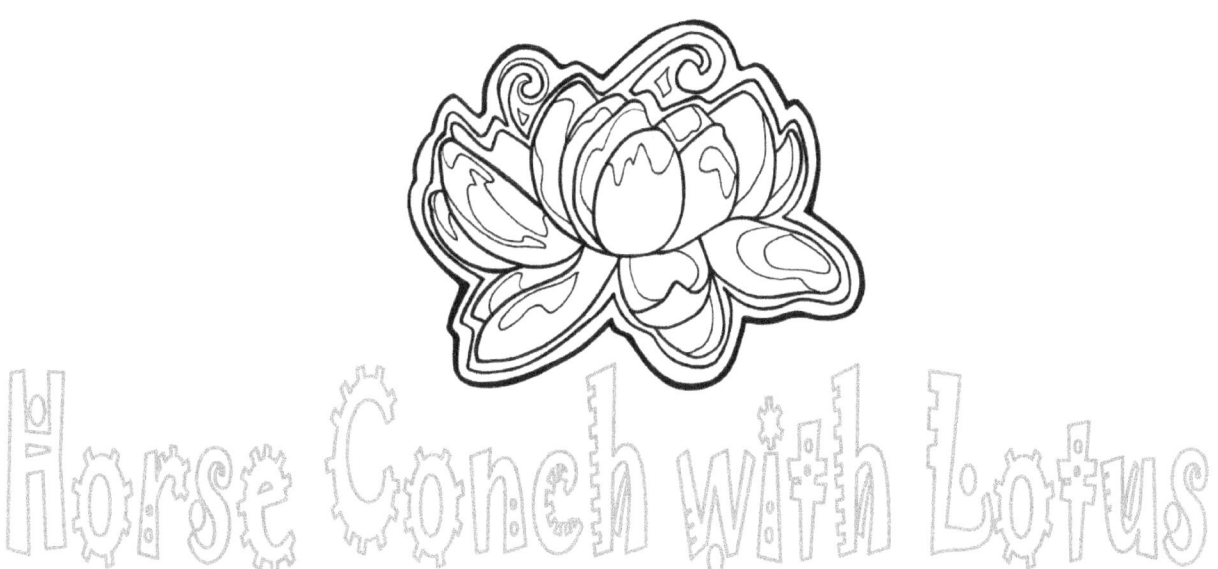

Horse Conch with Lotus

This is a Beautiful Horse Conch Seashell. I Found it at an Antique shop at the Jersey Shore. The Lotuses were illustrated from Photographs I took at Innesfree Gardens.

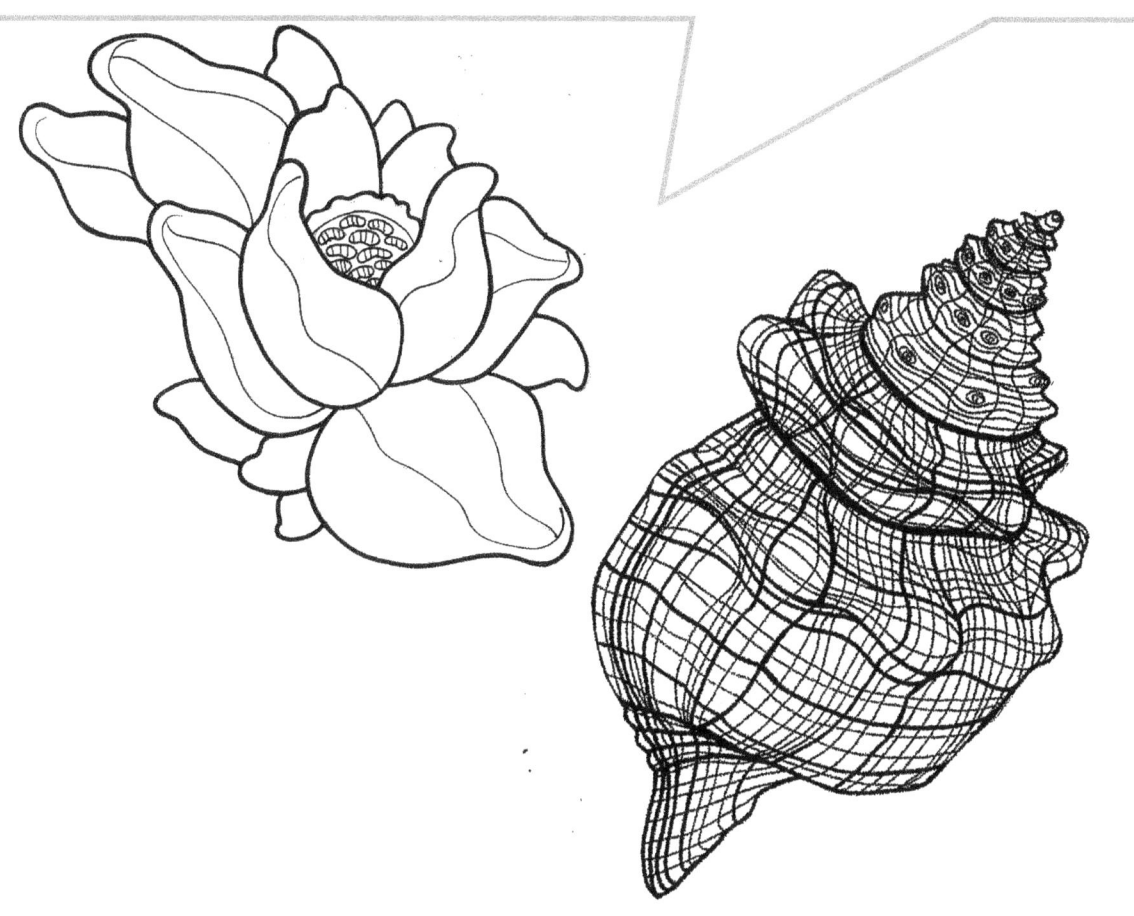

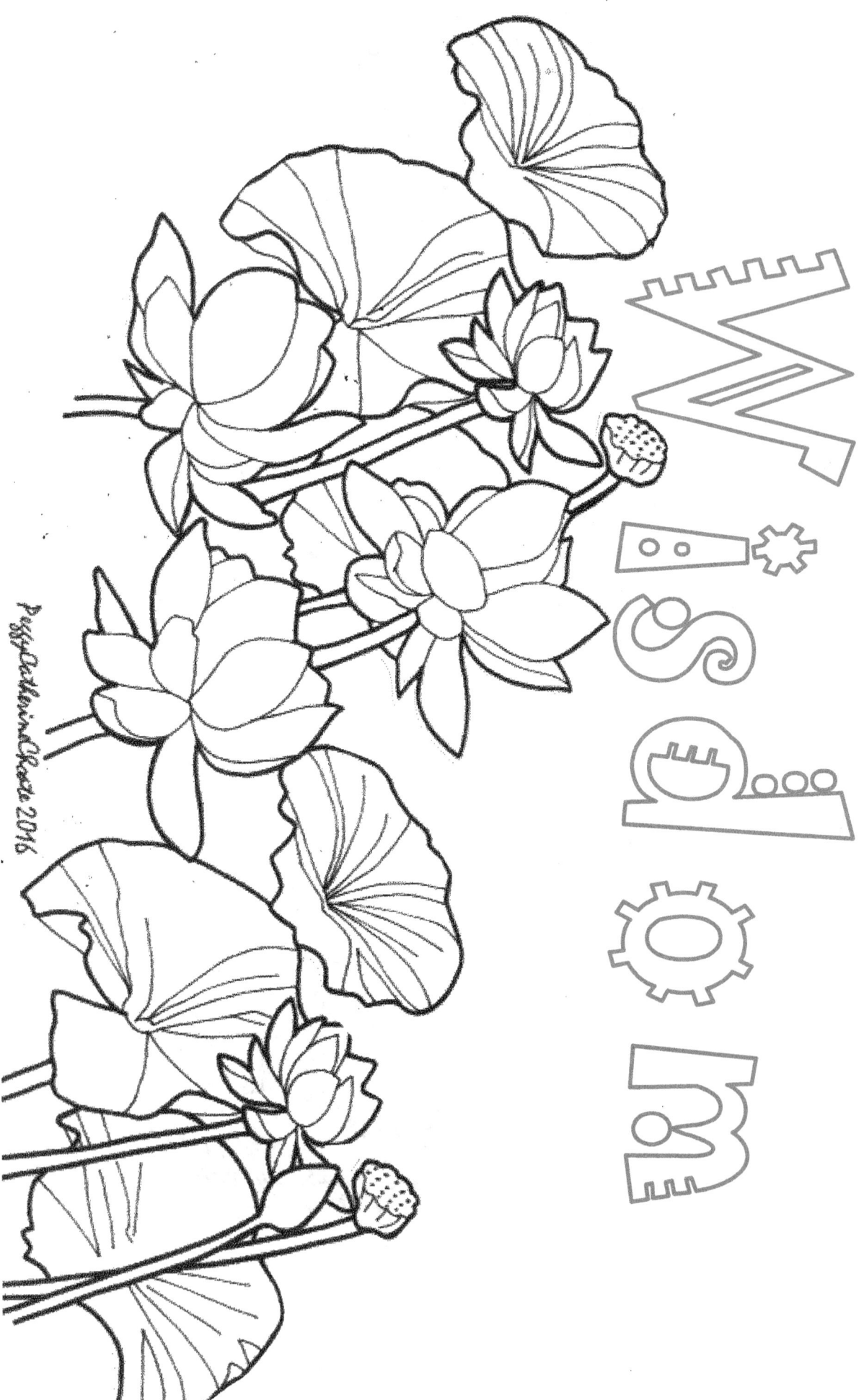

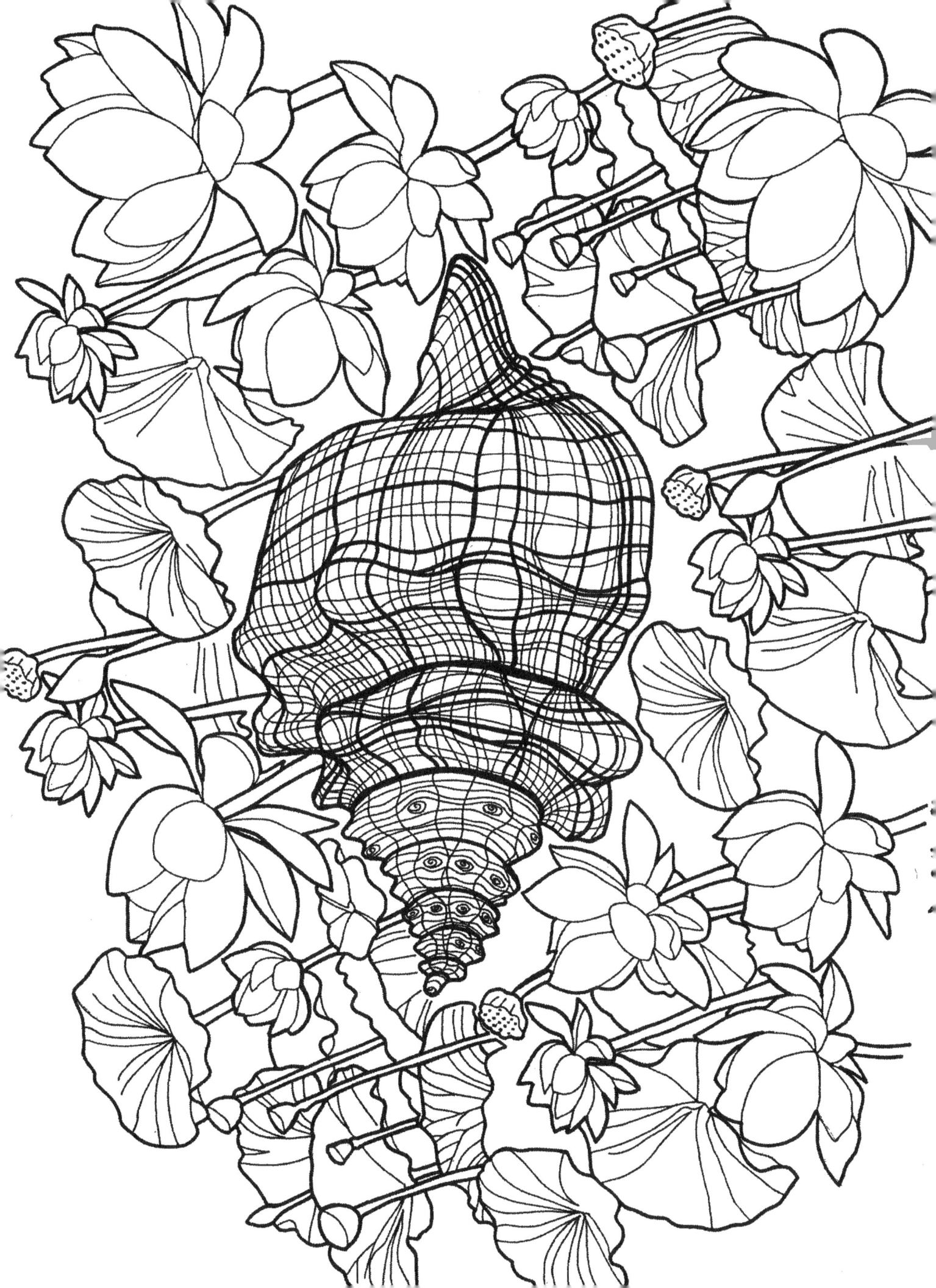

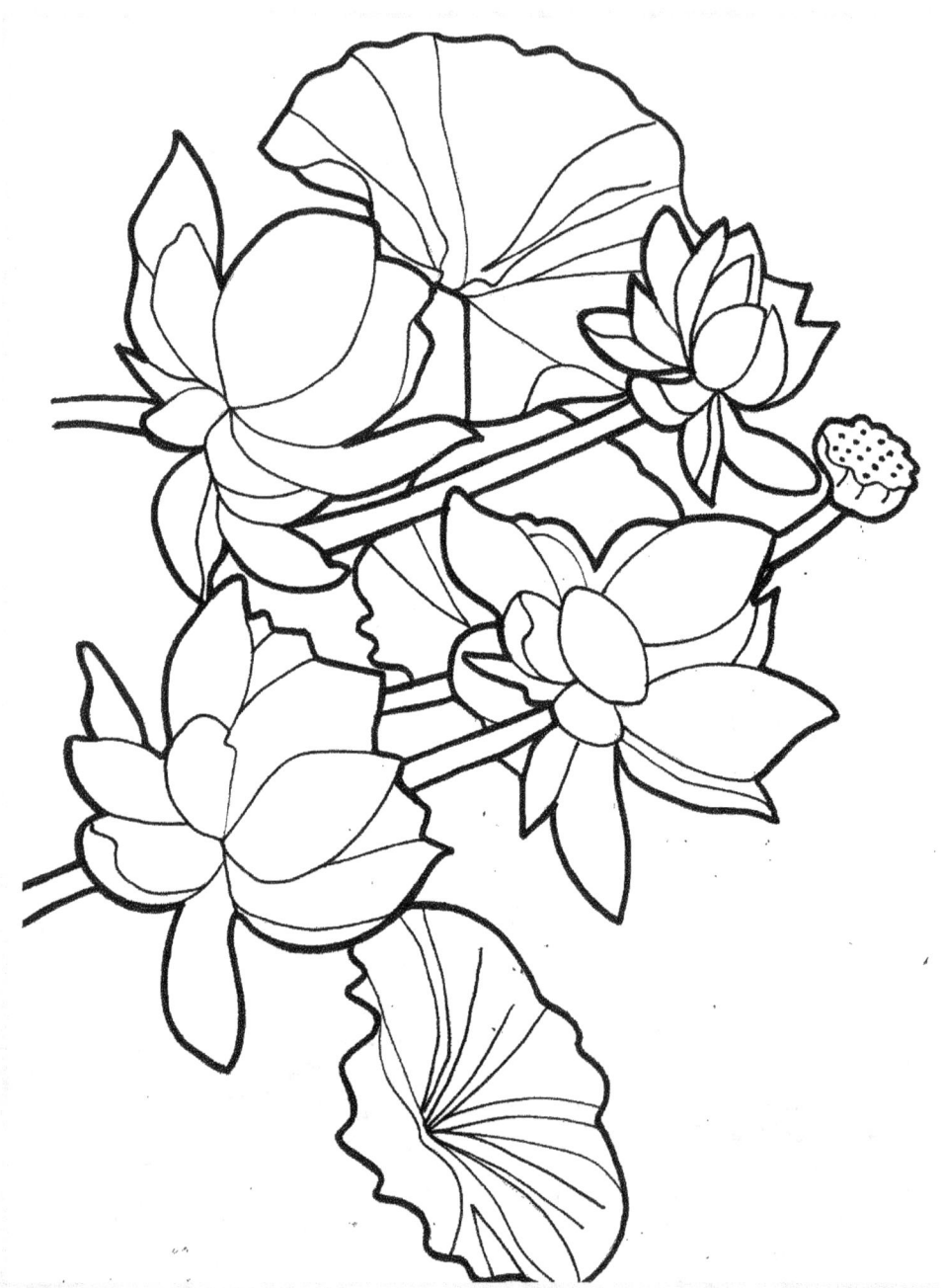

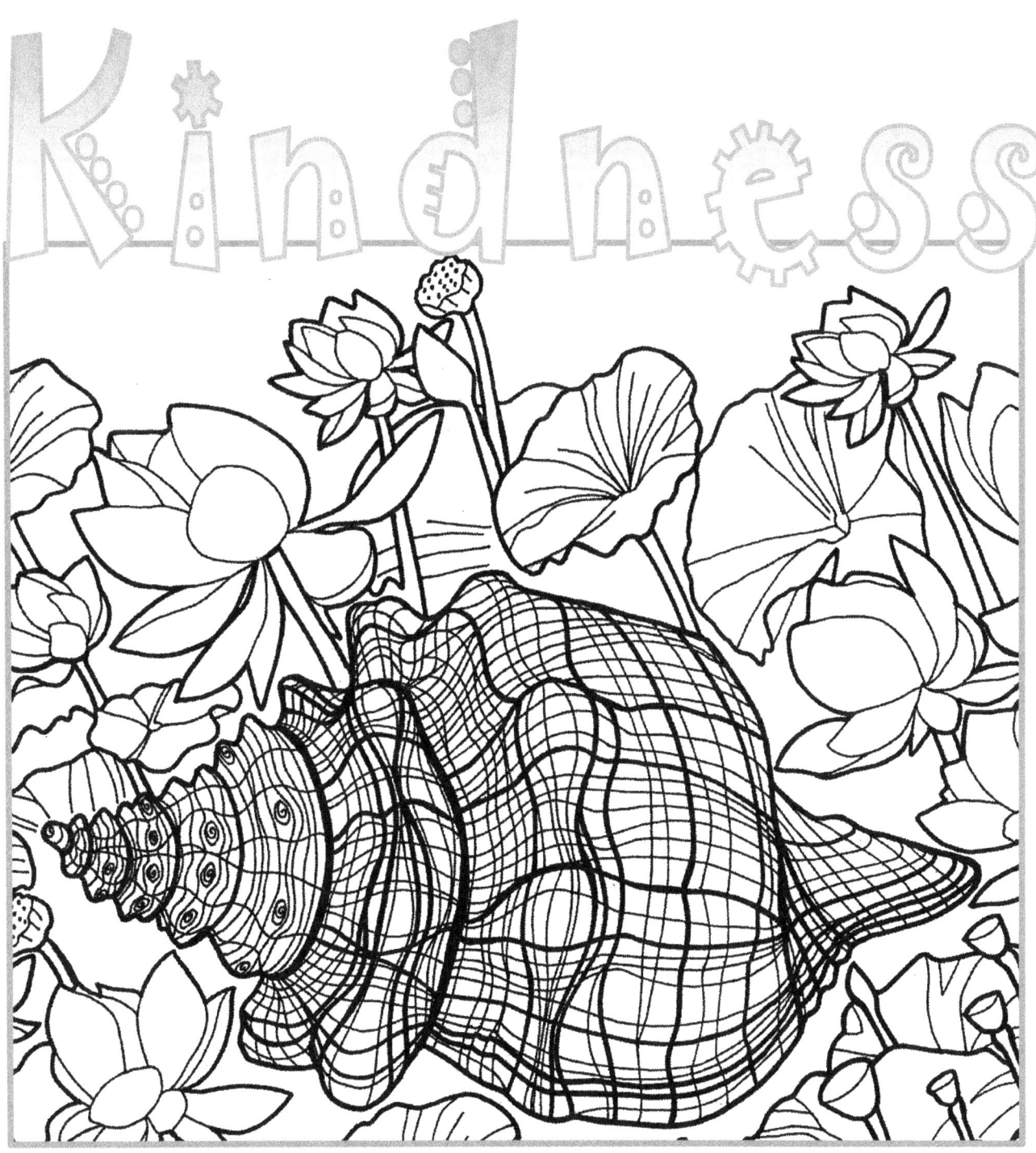

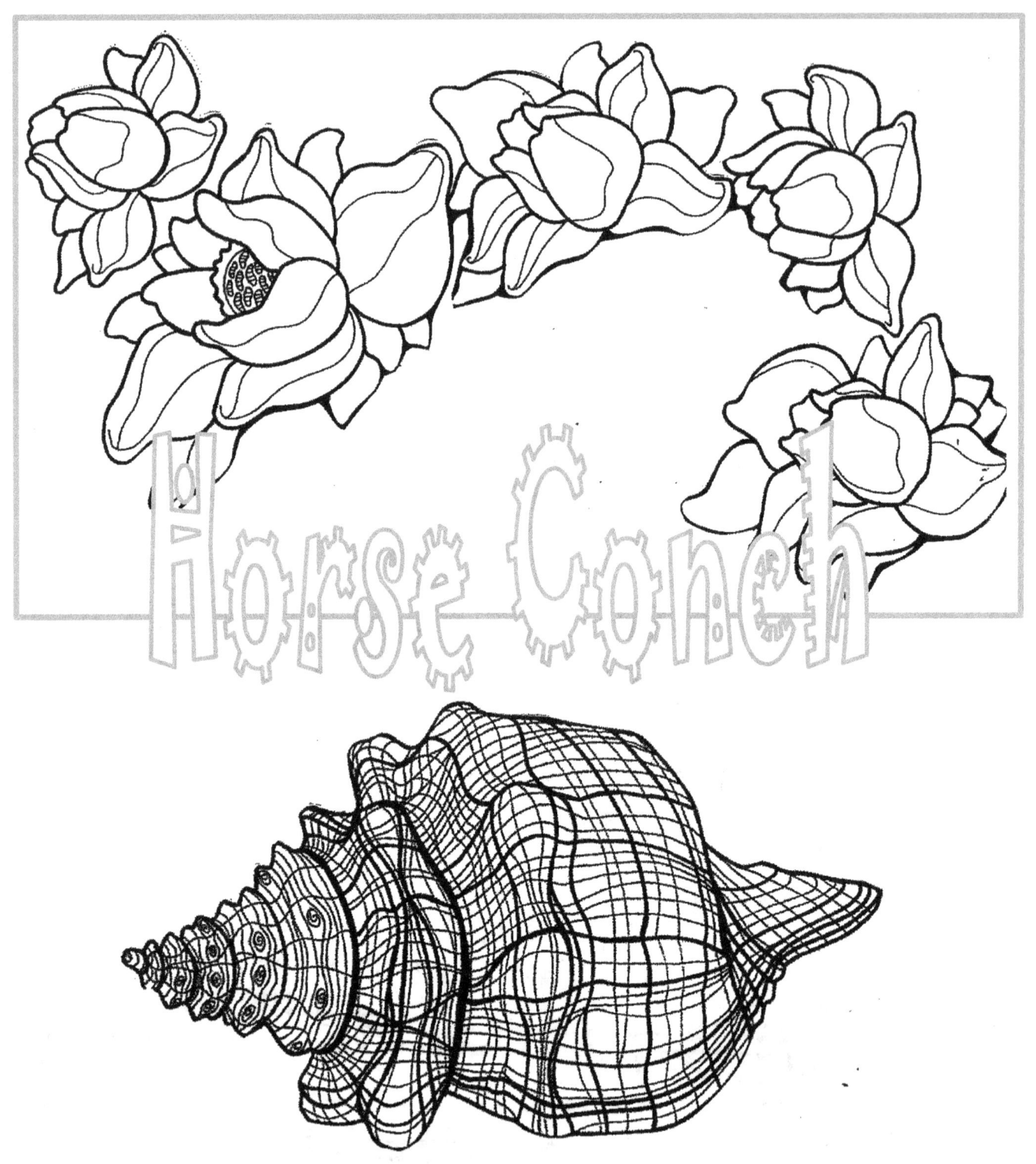

Horse Conch

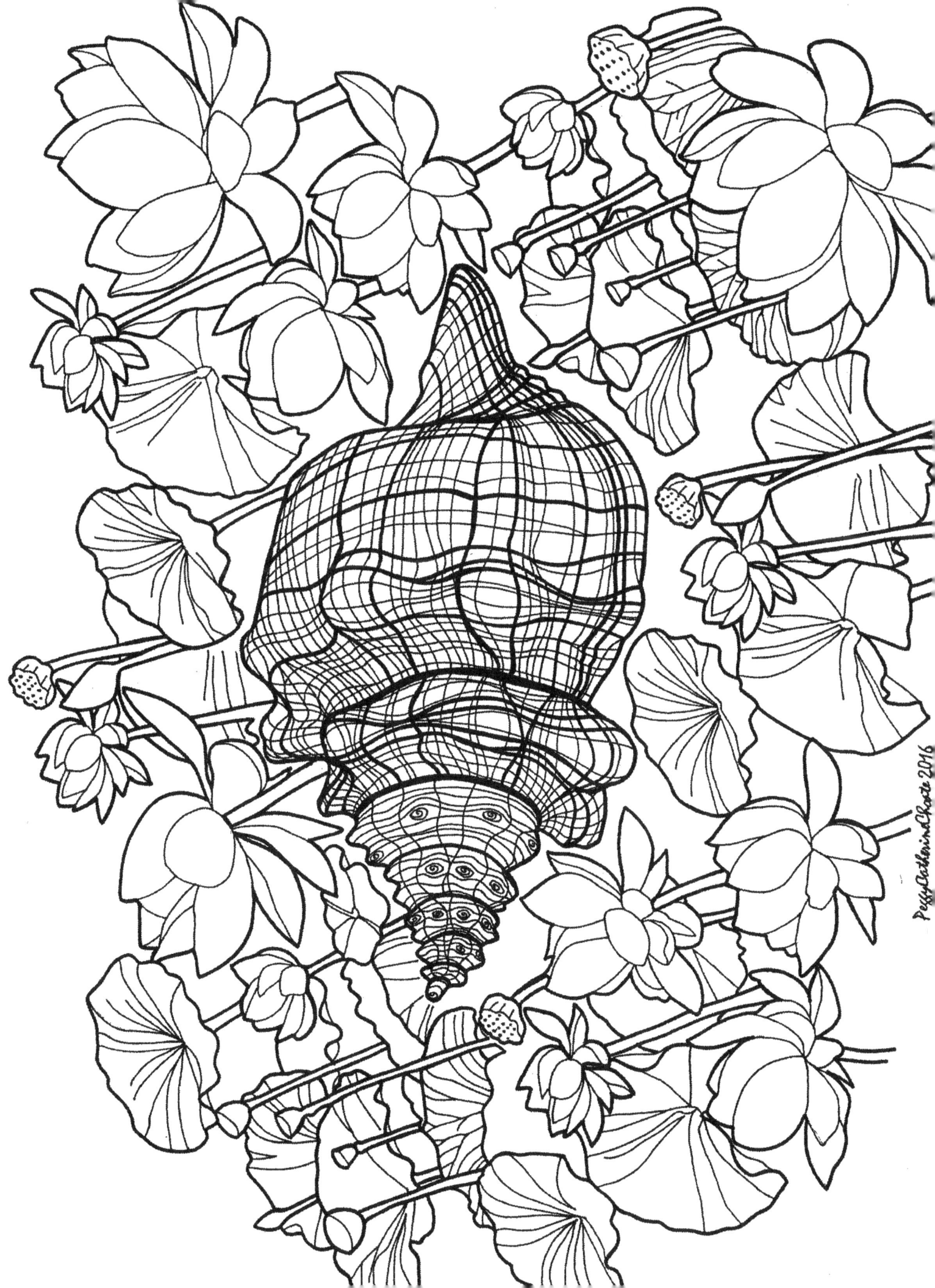

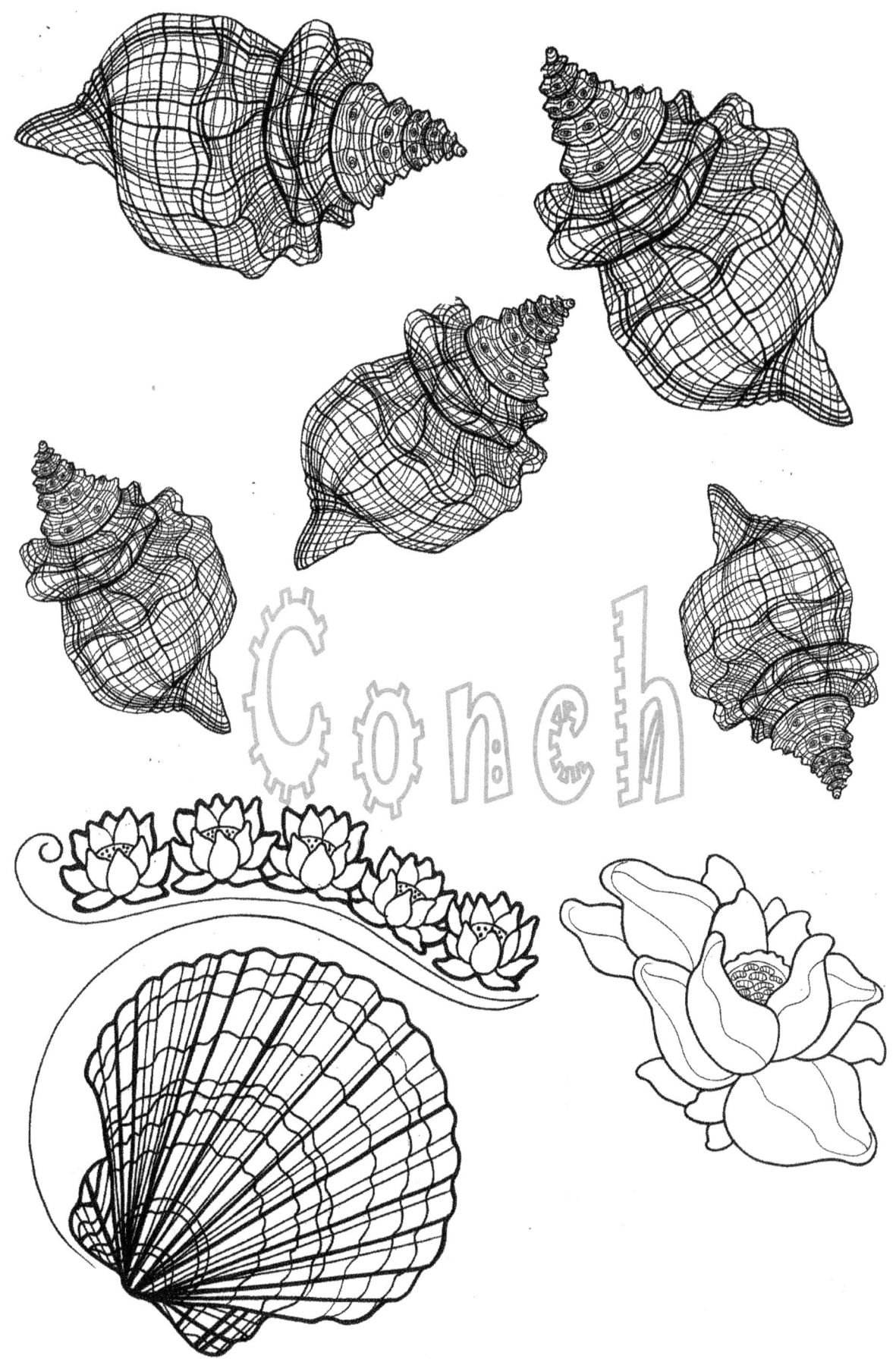

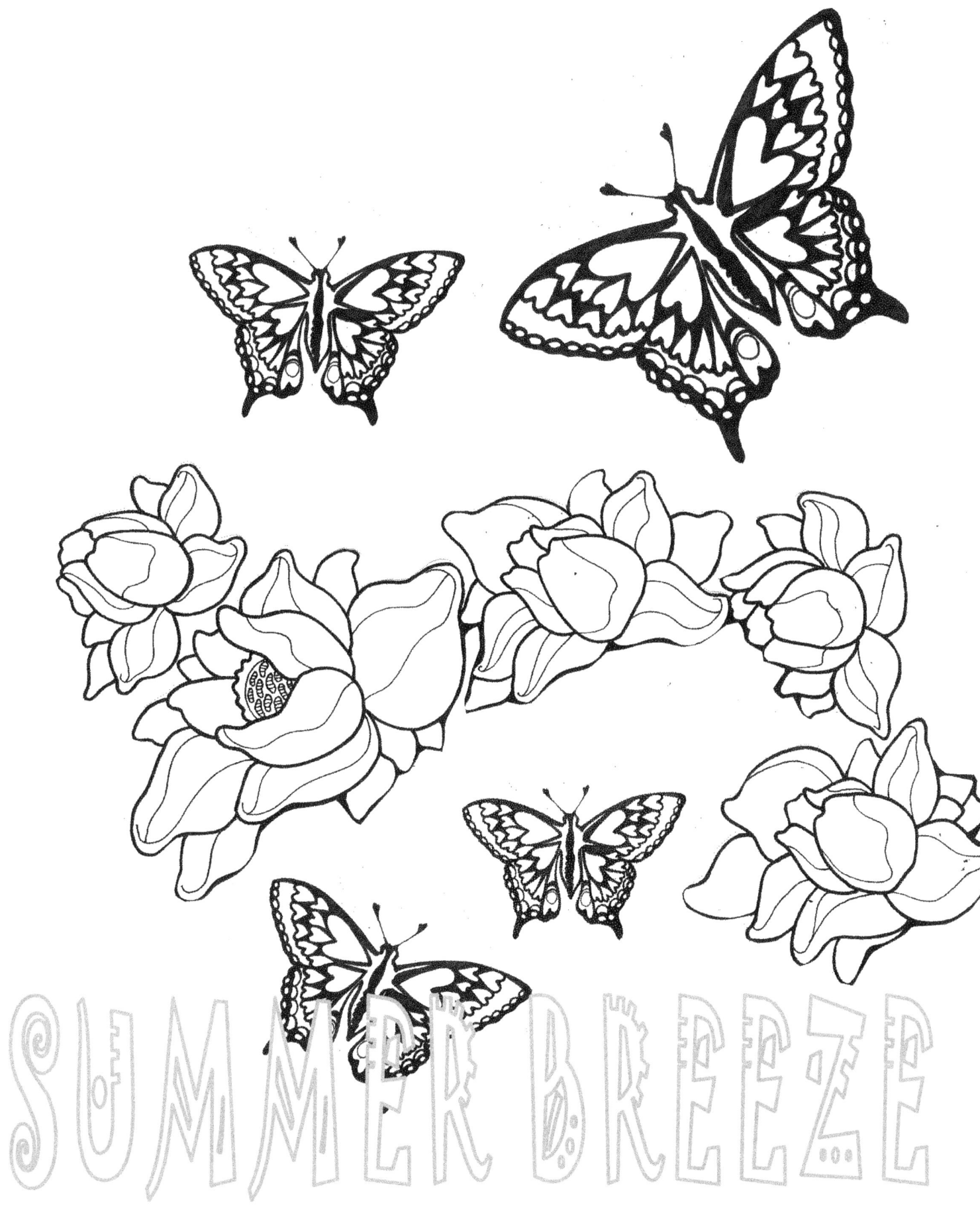

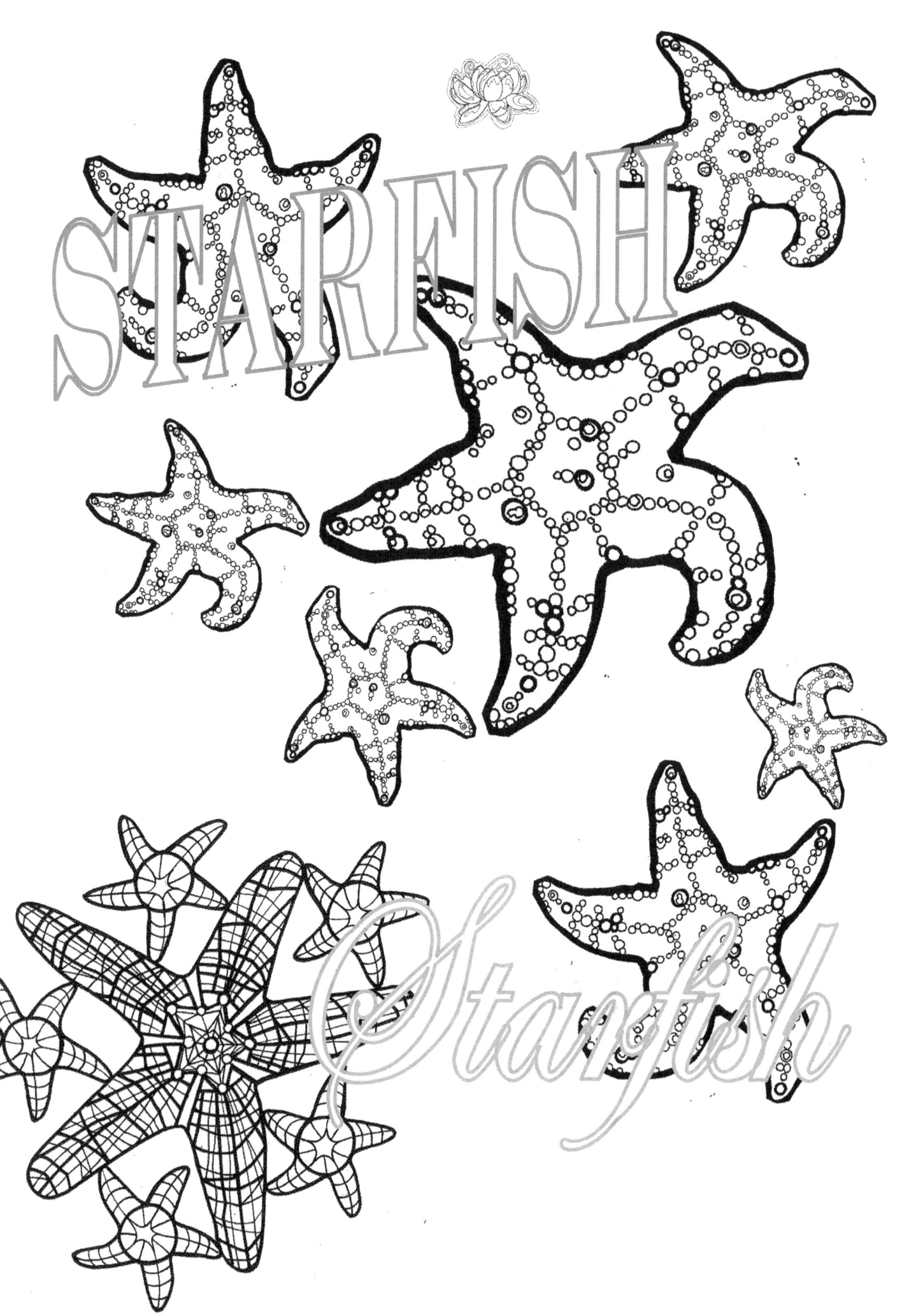

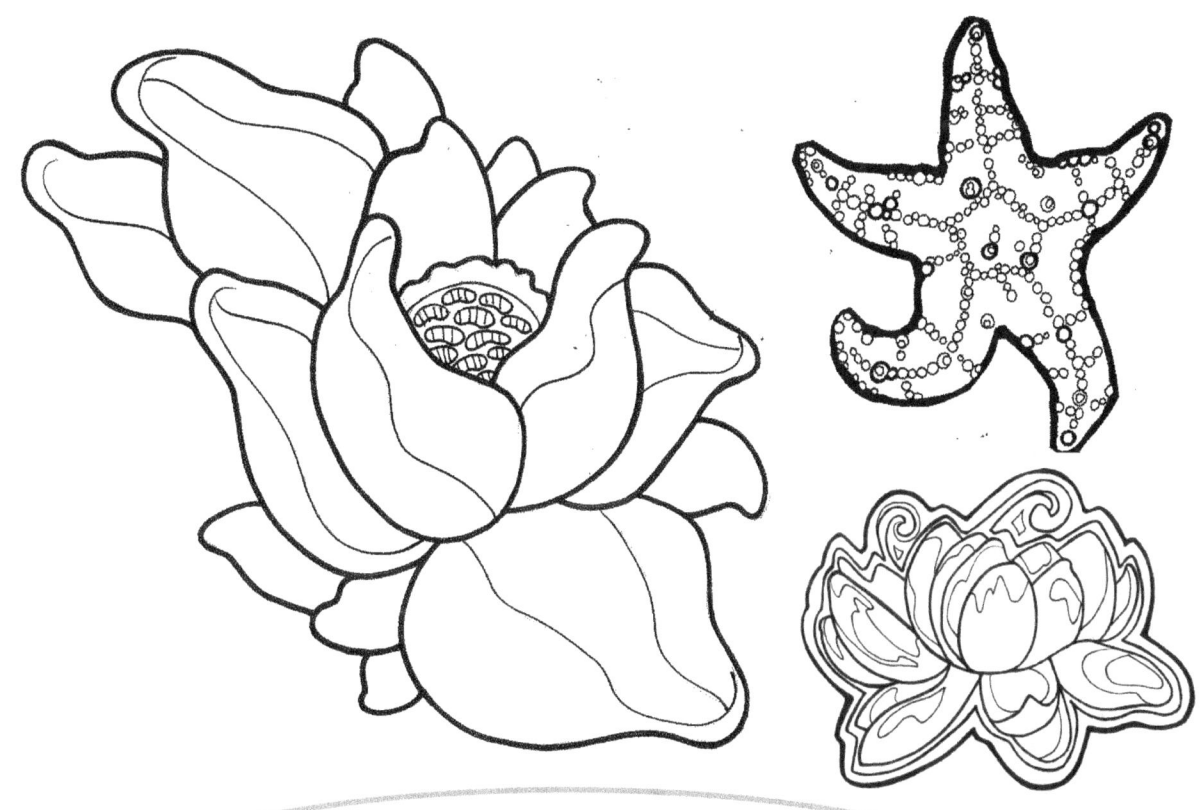

My inspiration for this is my Summers in Cape Cod where we find pink and blue Starfish and Moon Stars filled with Hermit Crabs walking along the sandbars on the Beach. We go with Friends and Family and the Memories are very Special.

Starfish with Moonstars

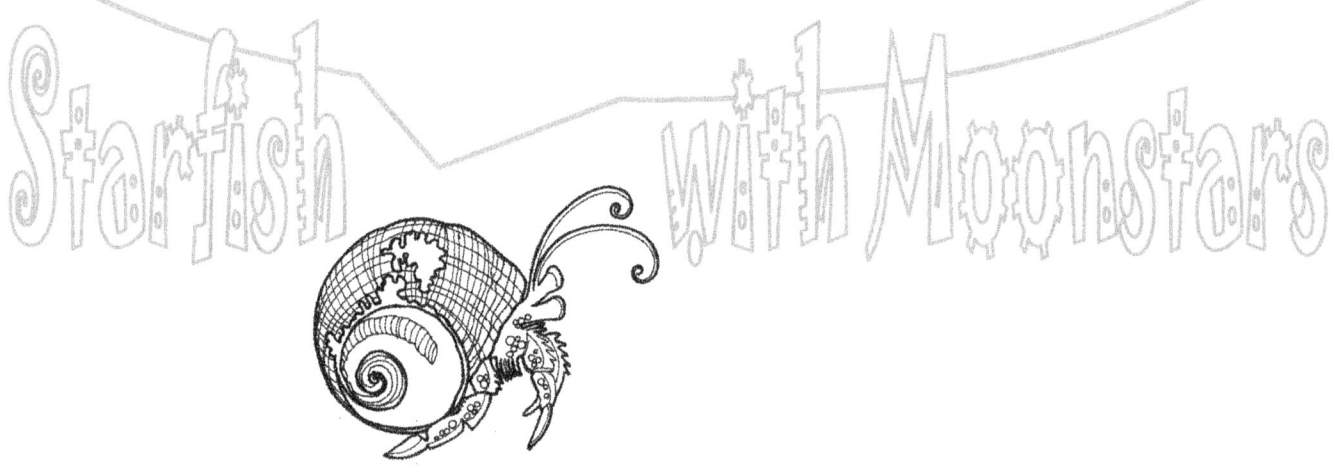

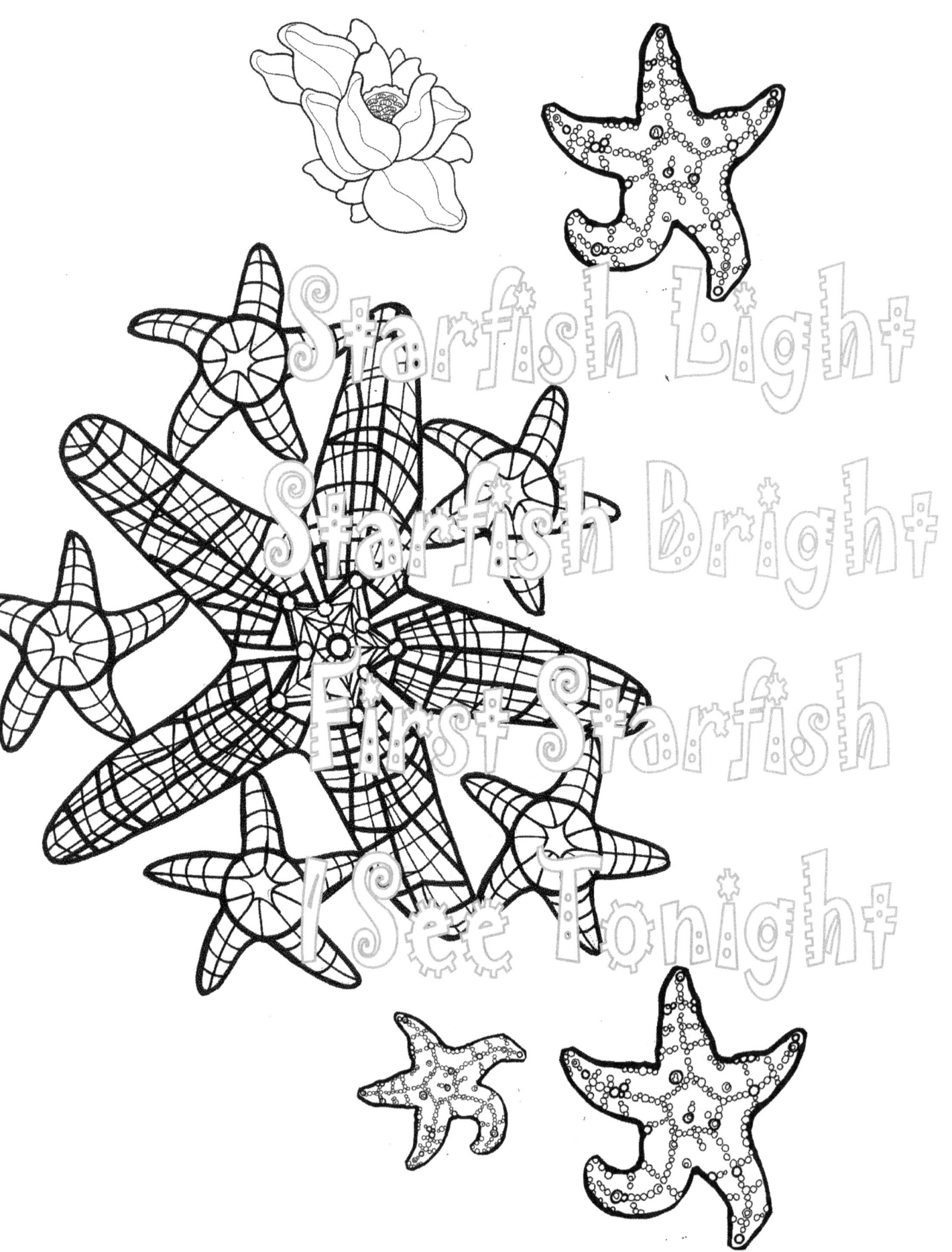

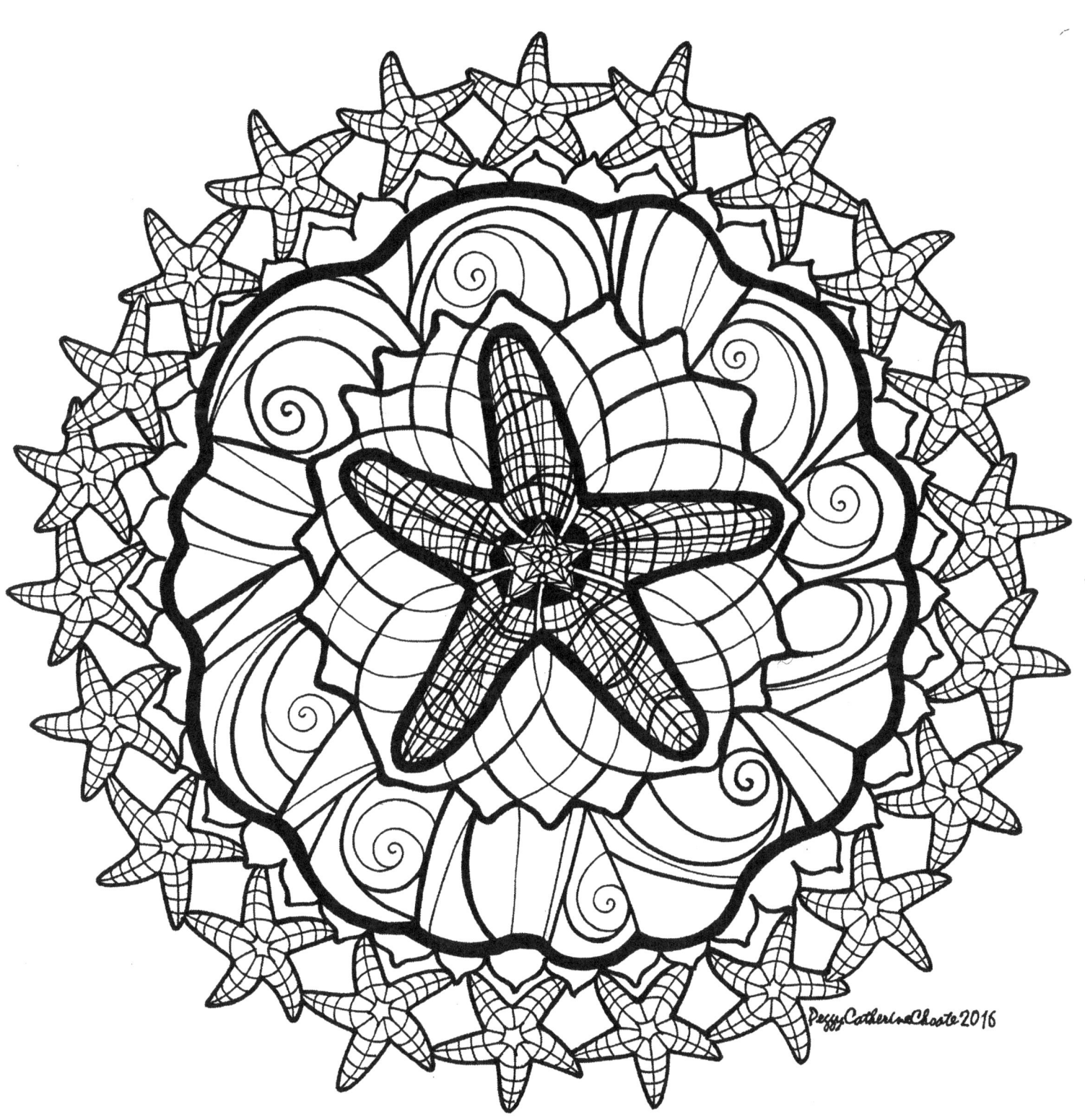

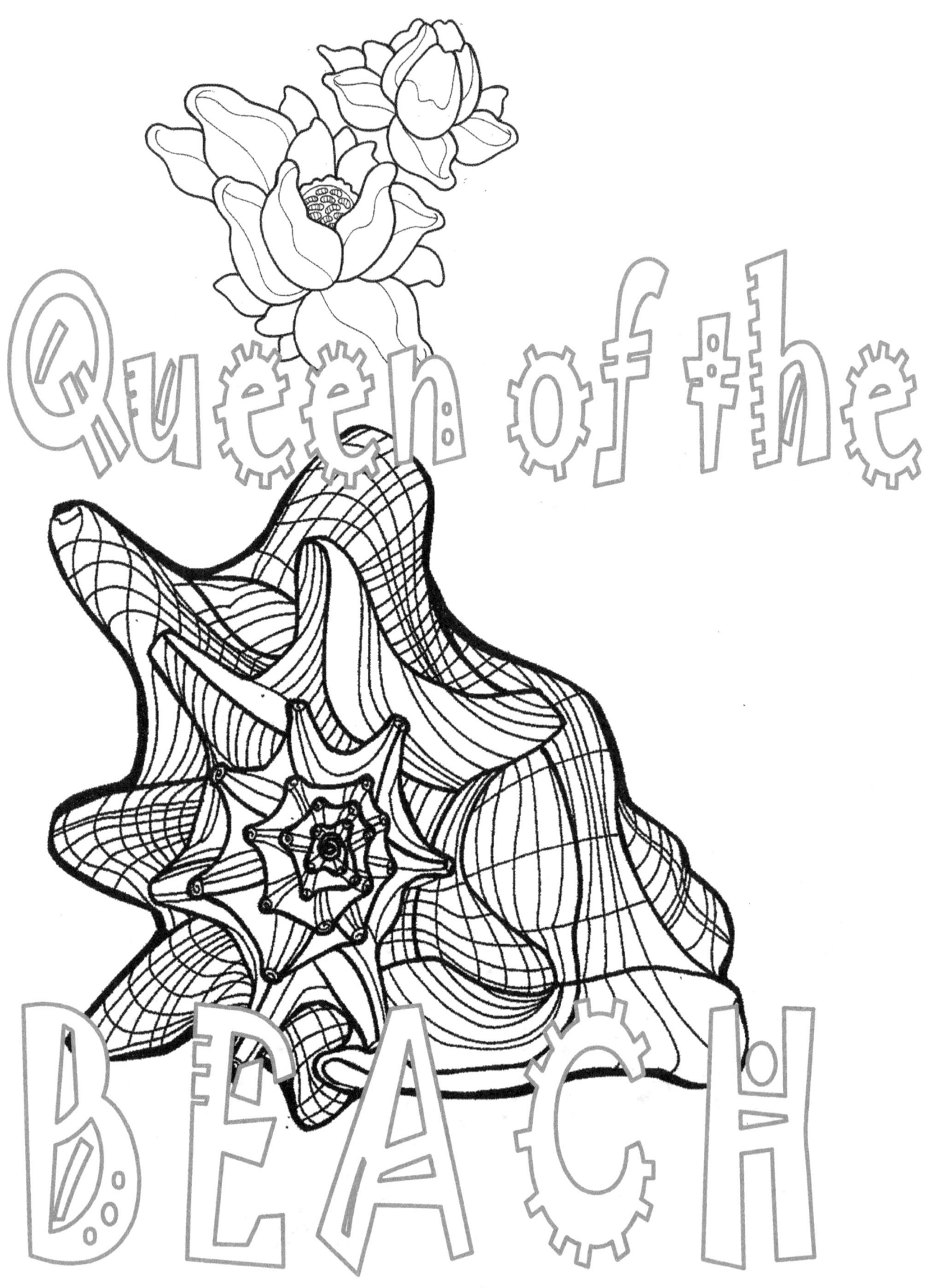

Shells in my Pockets & Sand in My Shoes makes my Heart sing

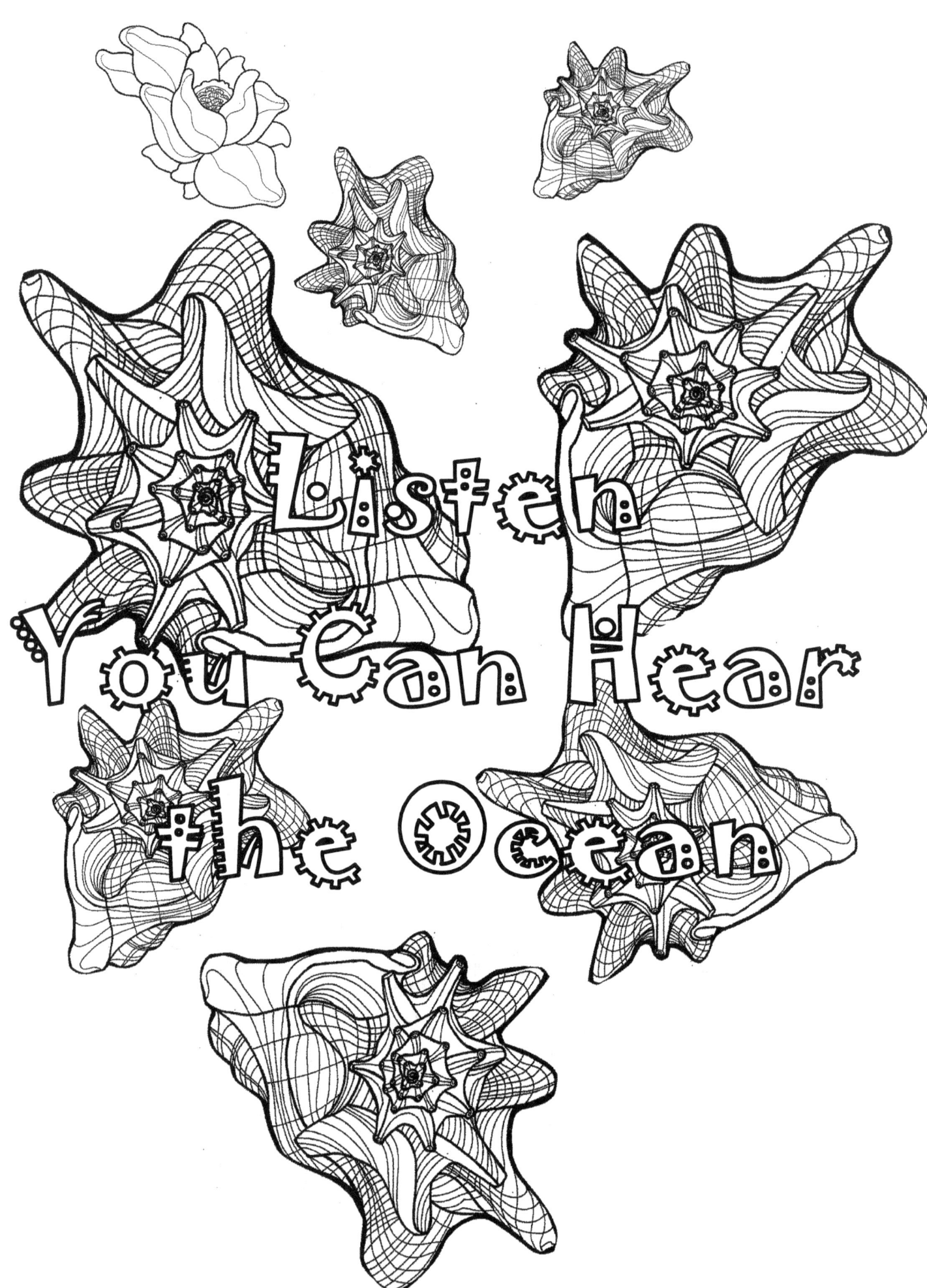

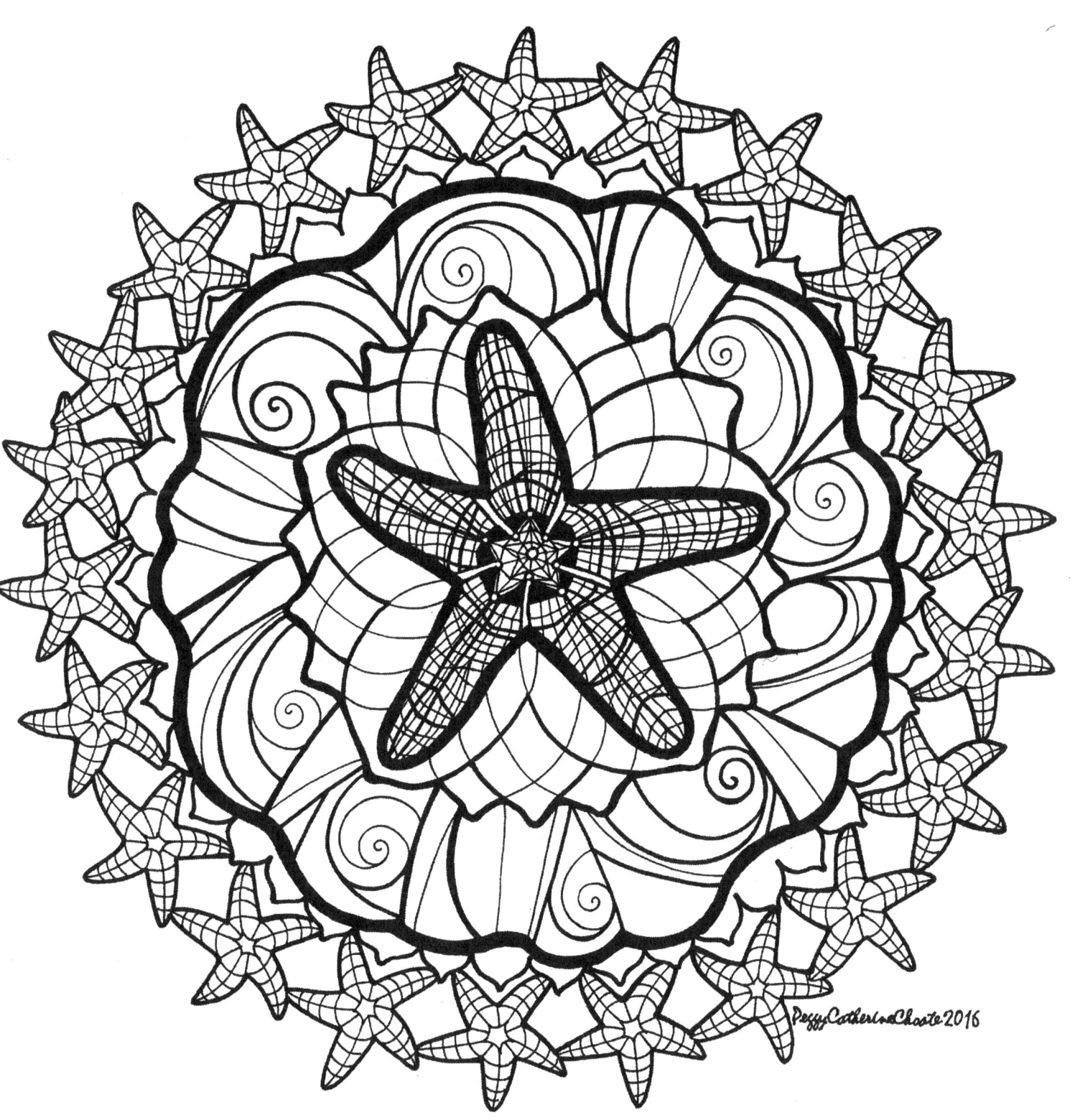

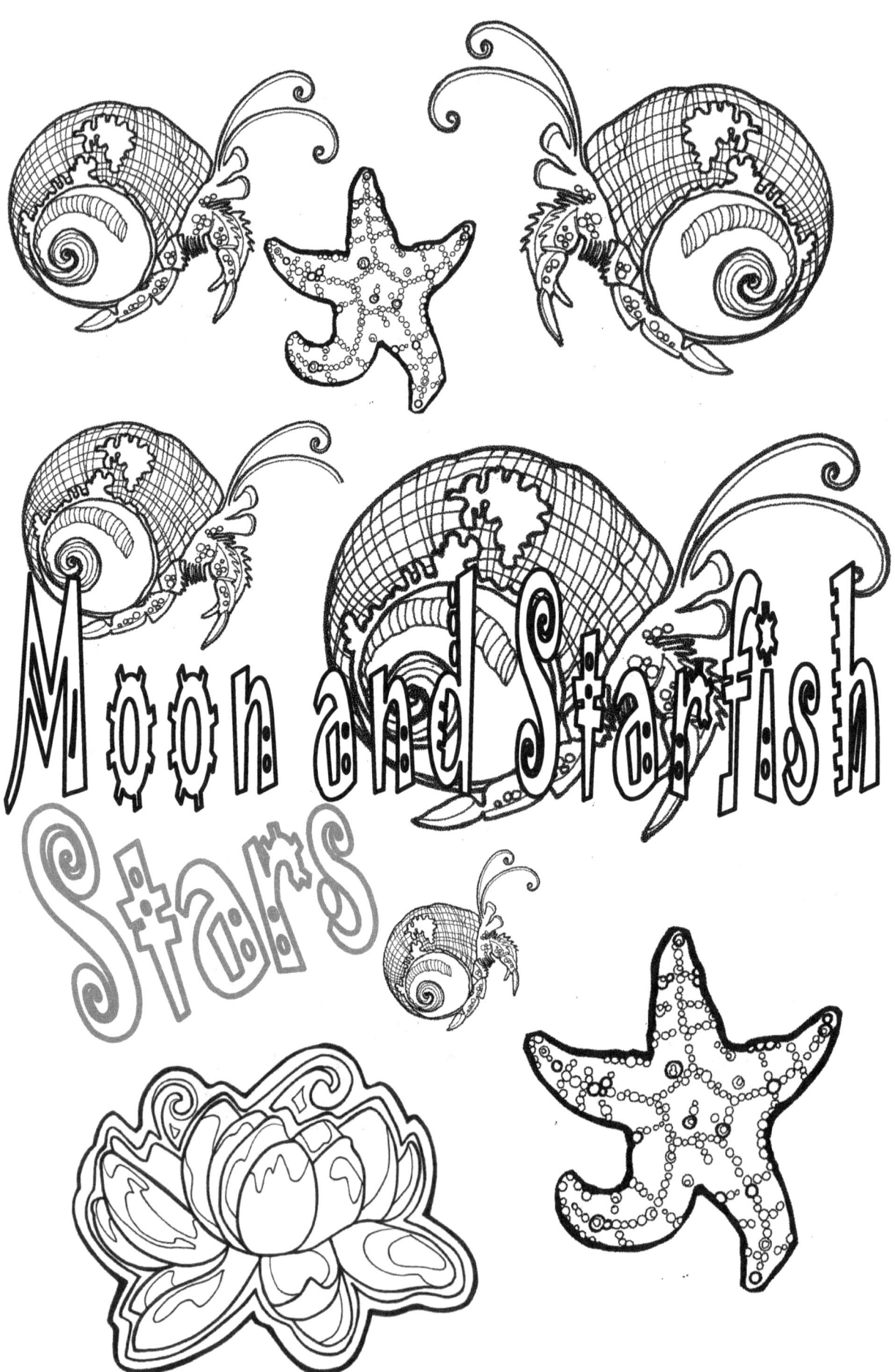

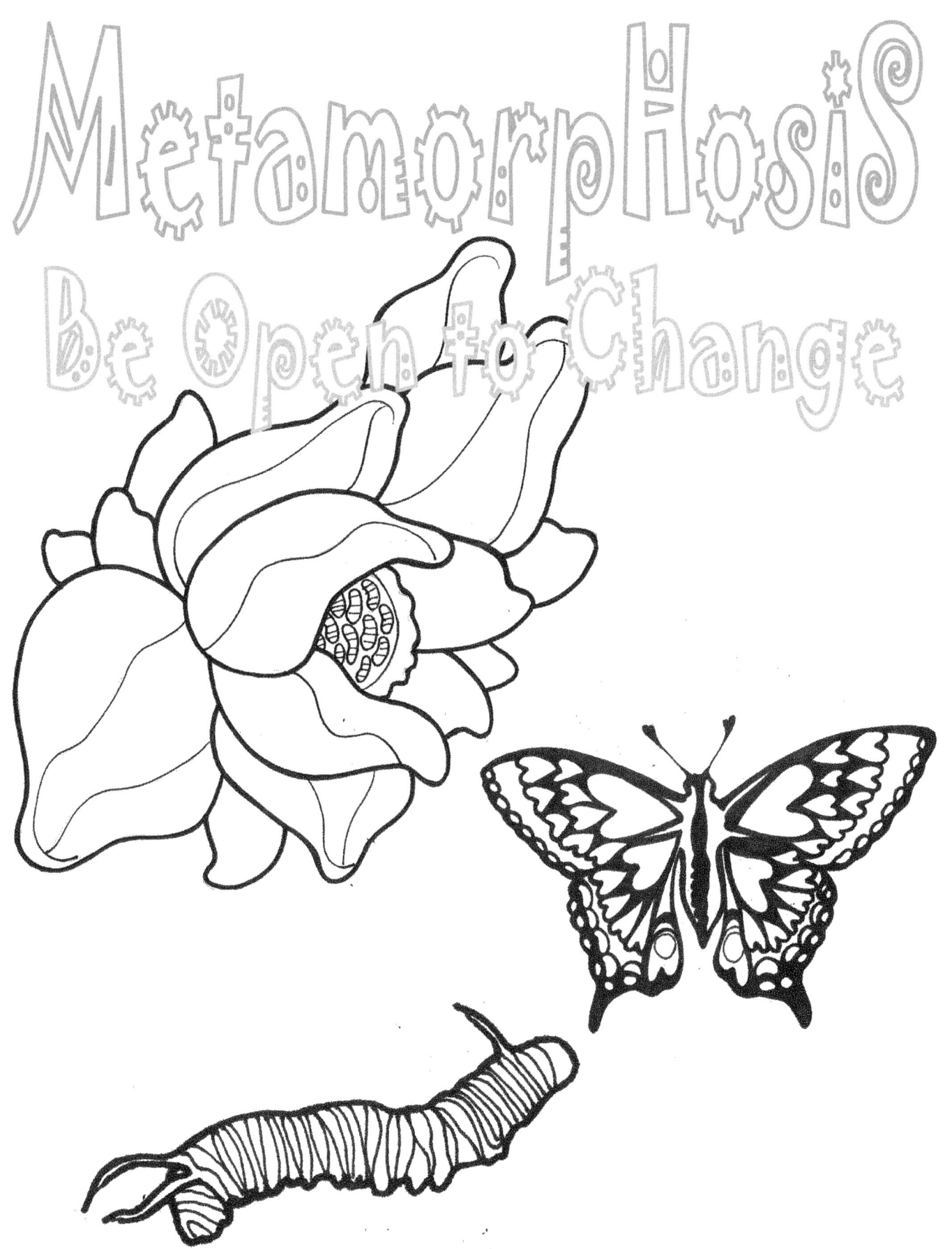

QUEEN CONCH

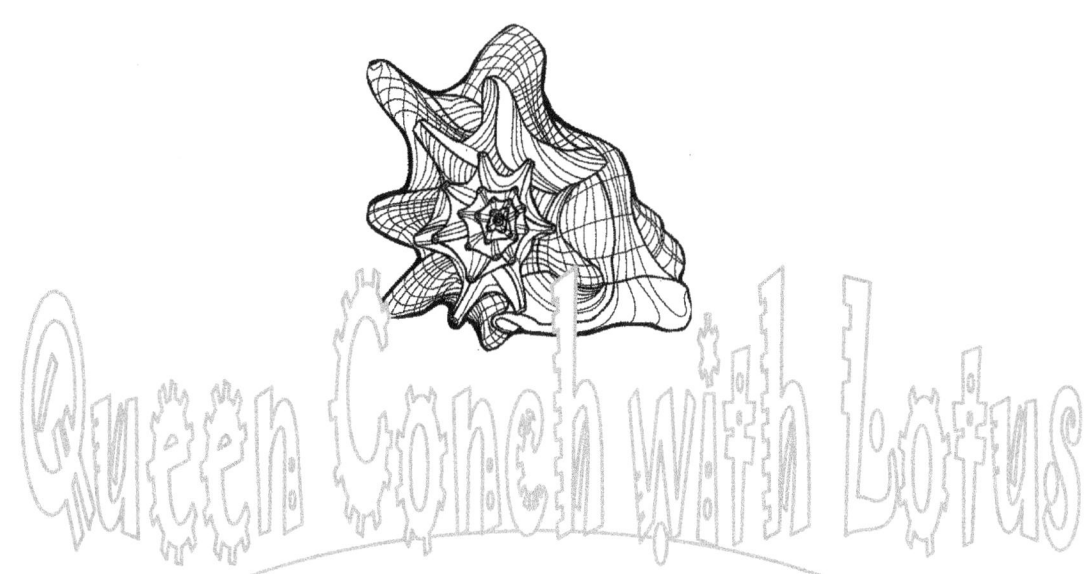

Queen Conch with Lotus

> Queen Conches are my Favorite Seashell. It is the Seashell I have the most of. You will find them all around my home. The Pink inside matches that of the Pink Lotus Flower.

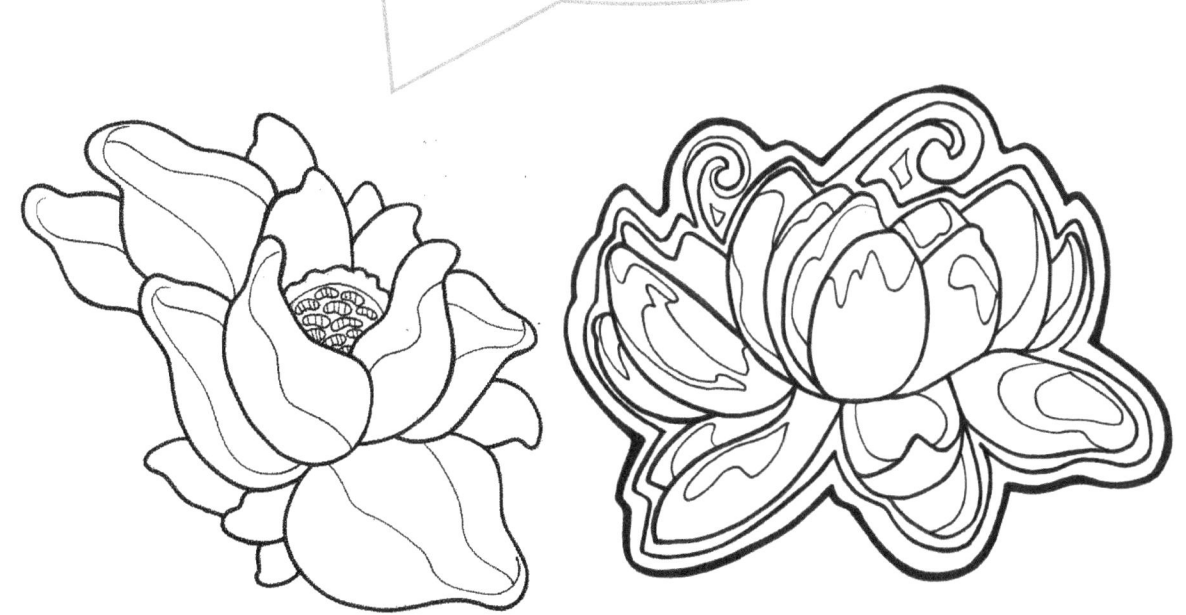

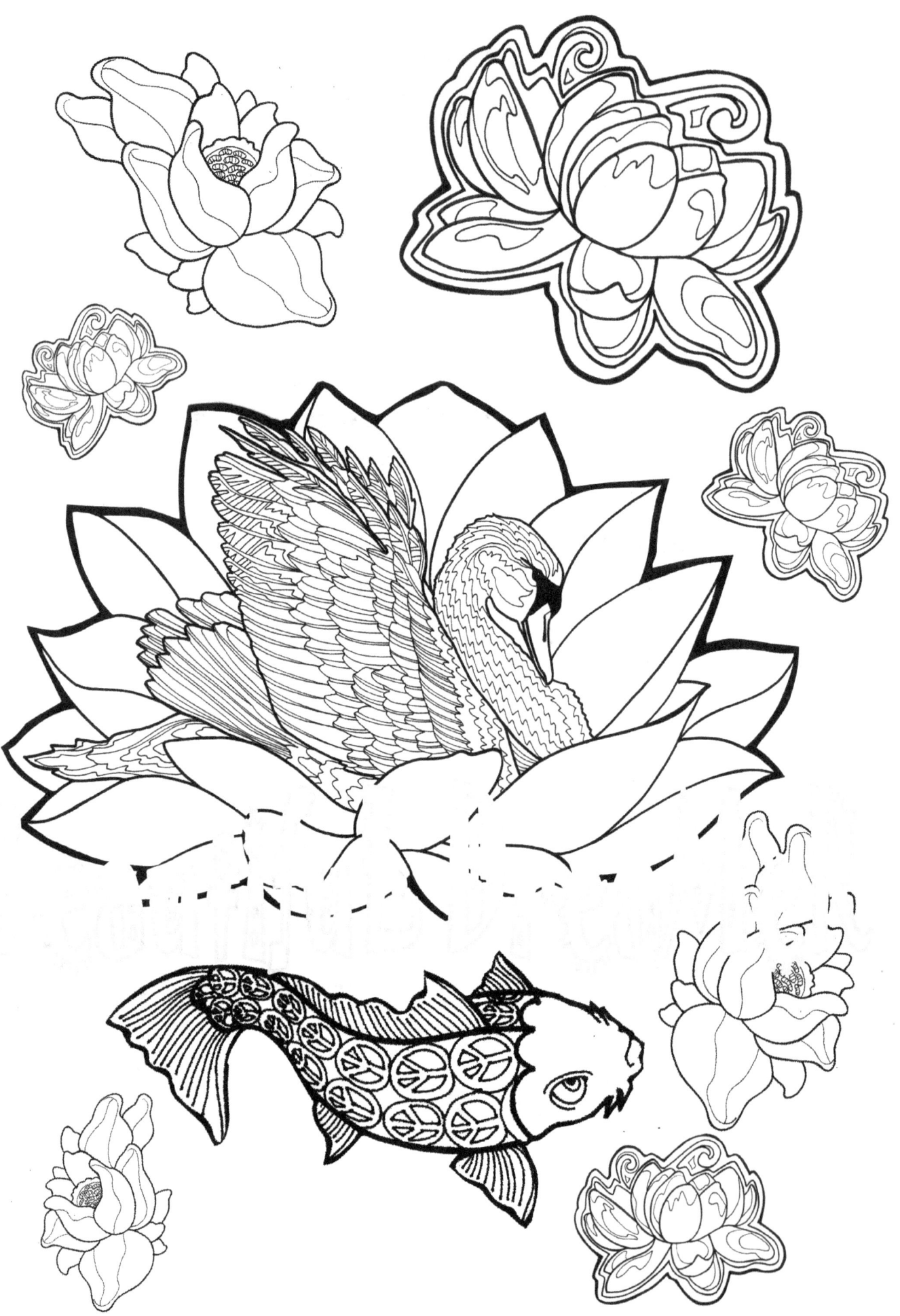

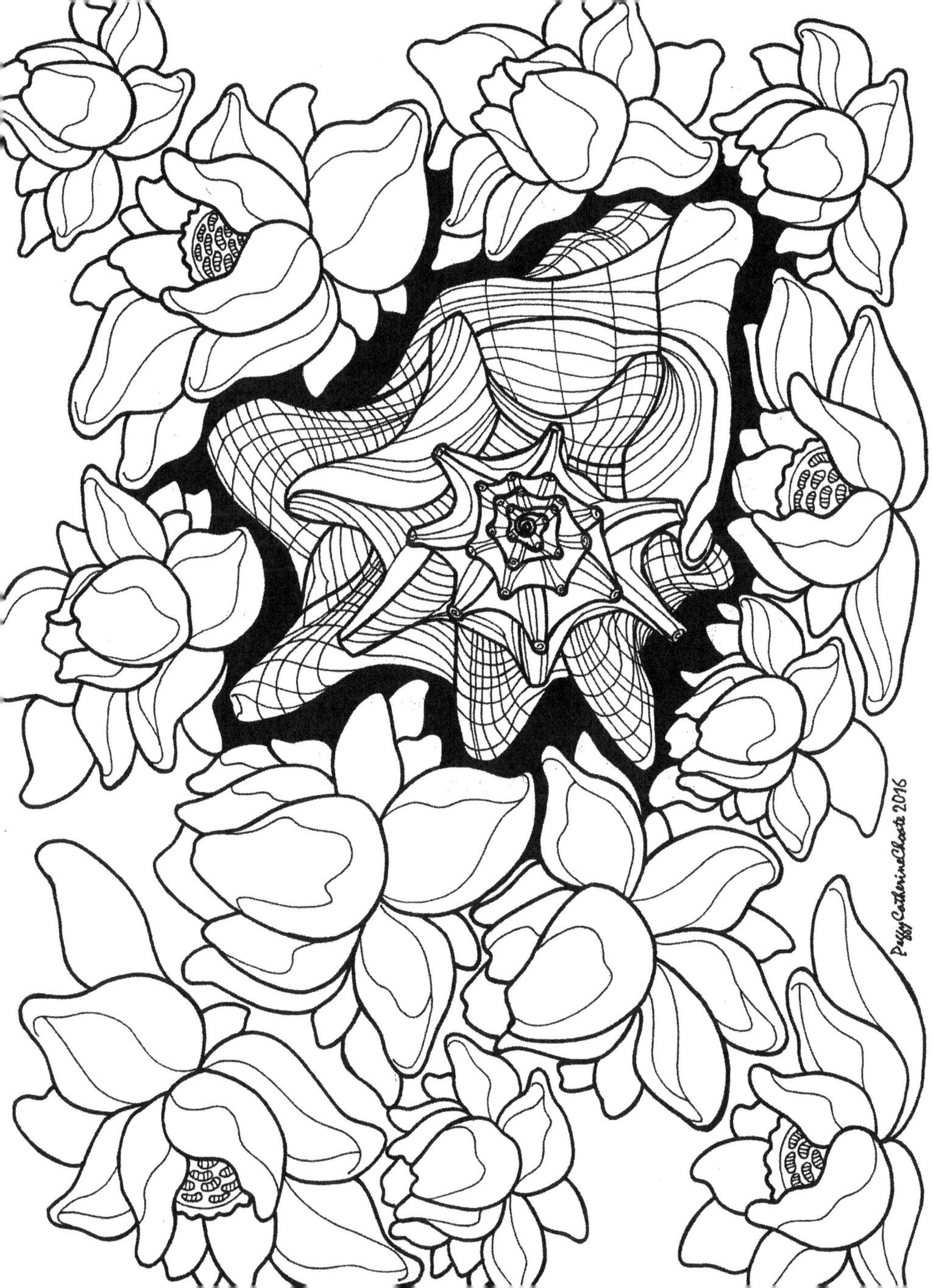

Please Don't Talk to the LifeGuard

THE QUEEN

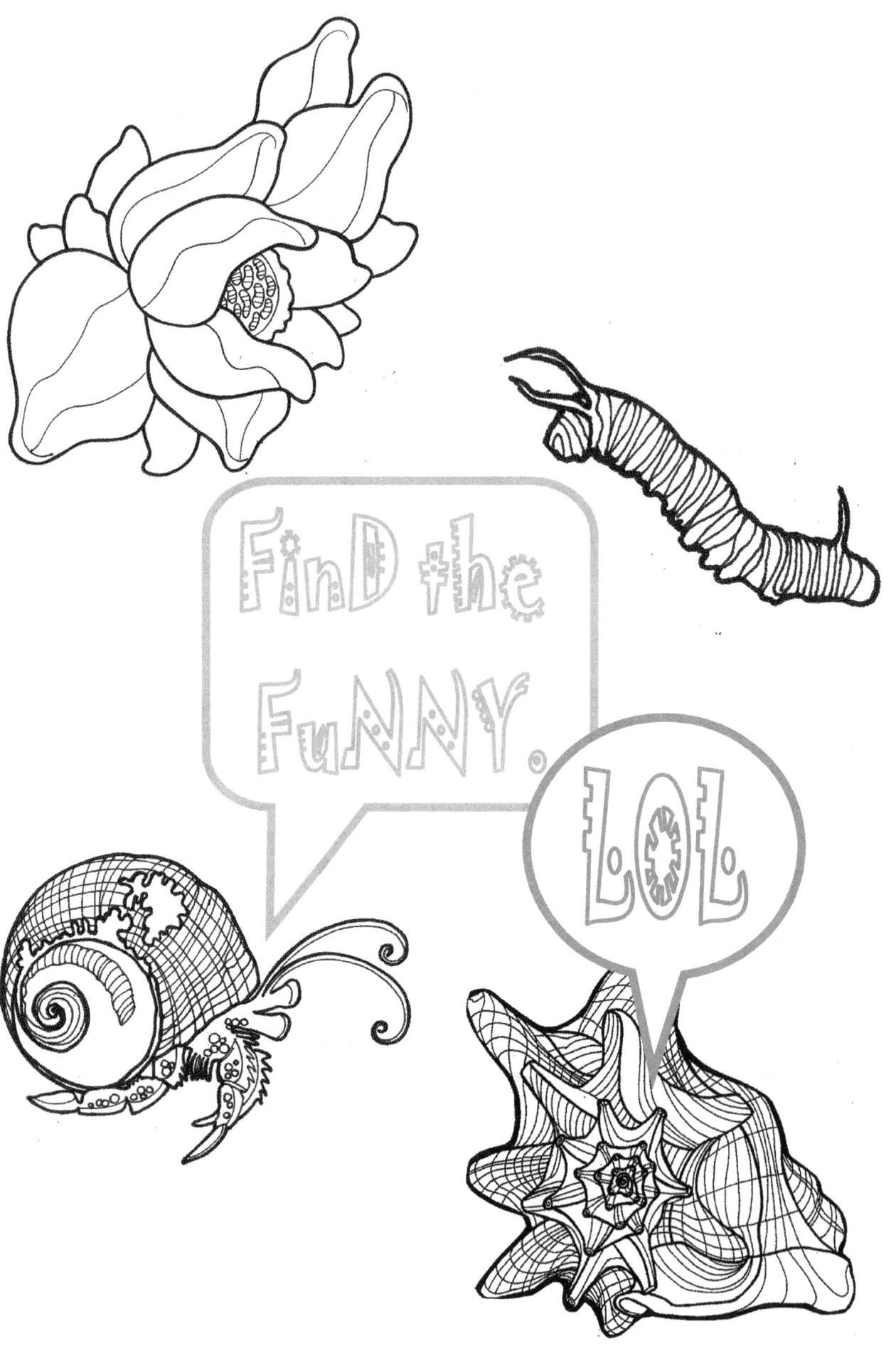

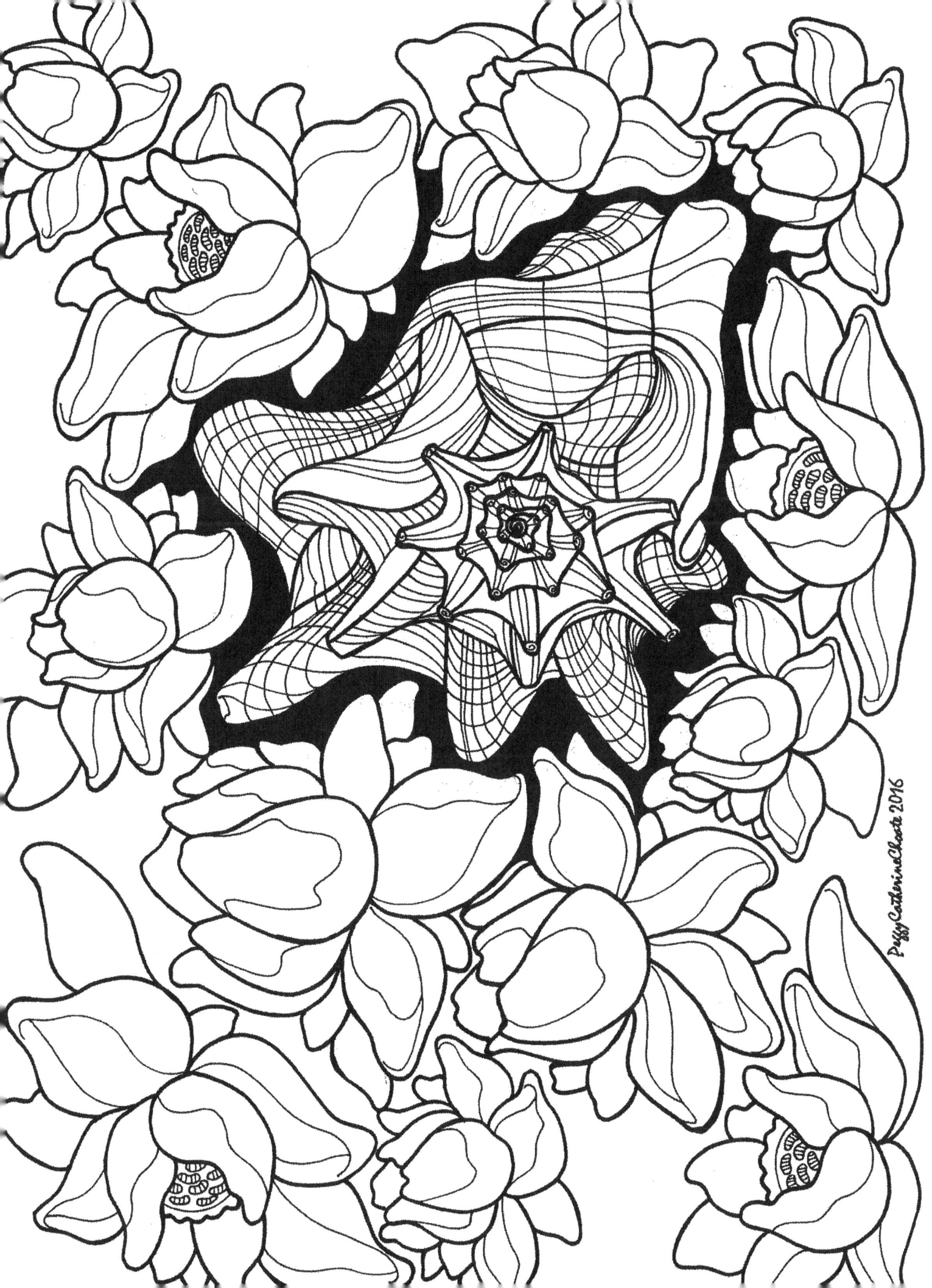

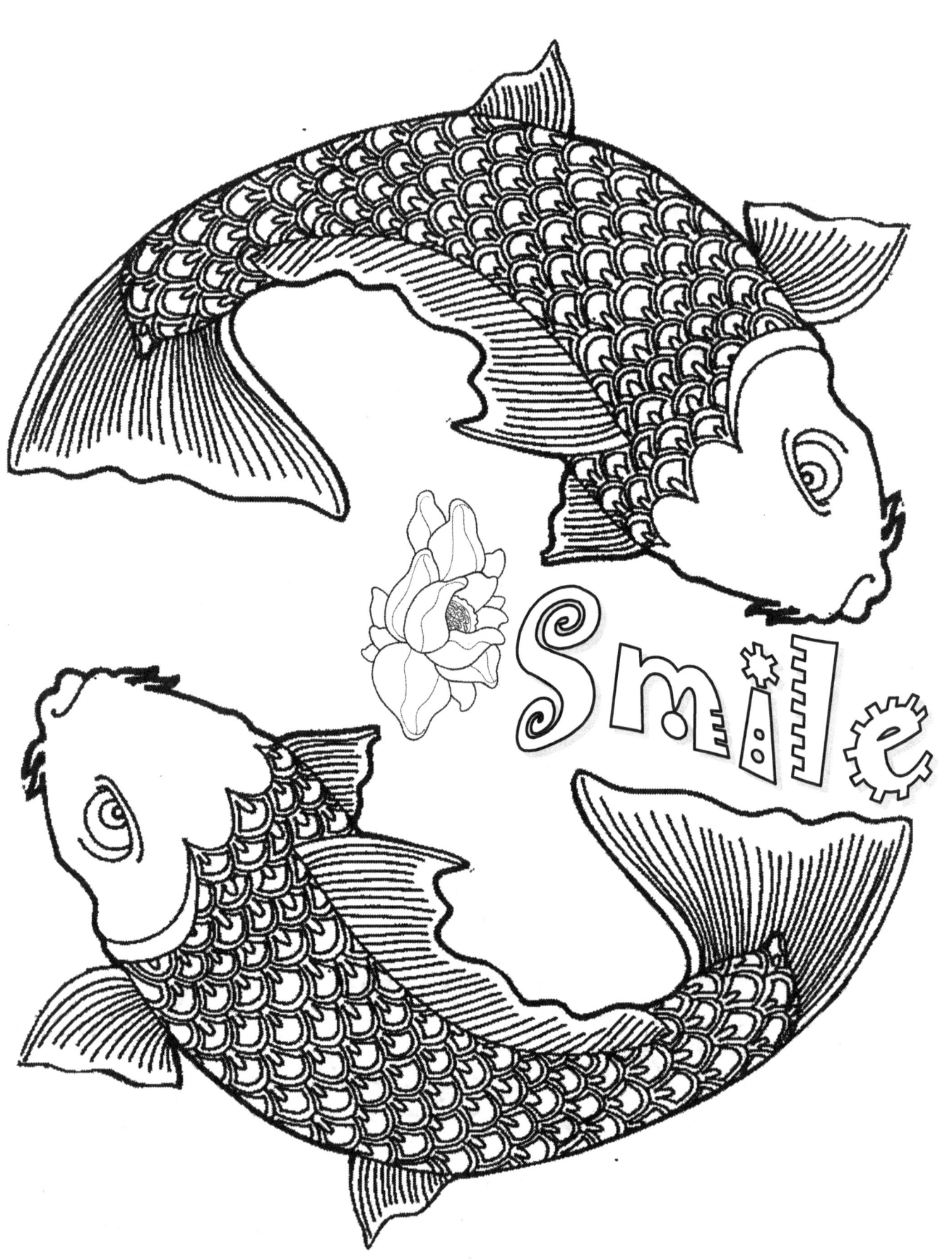

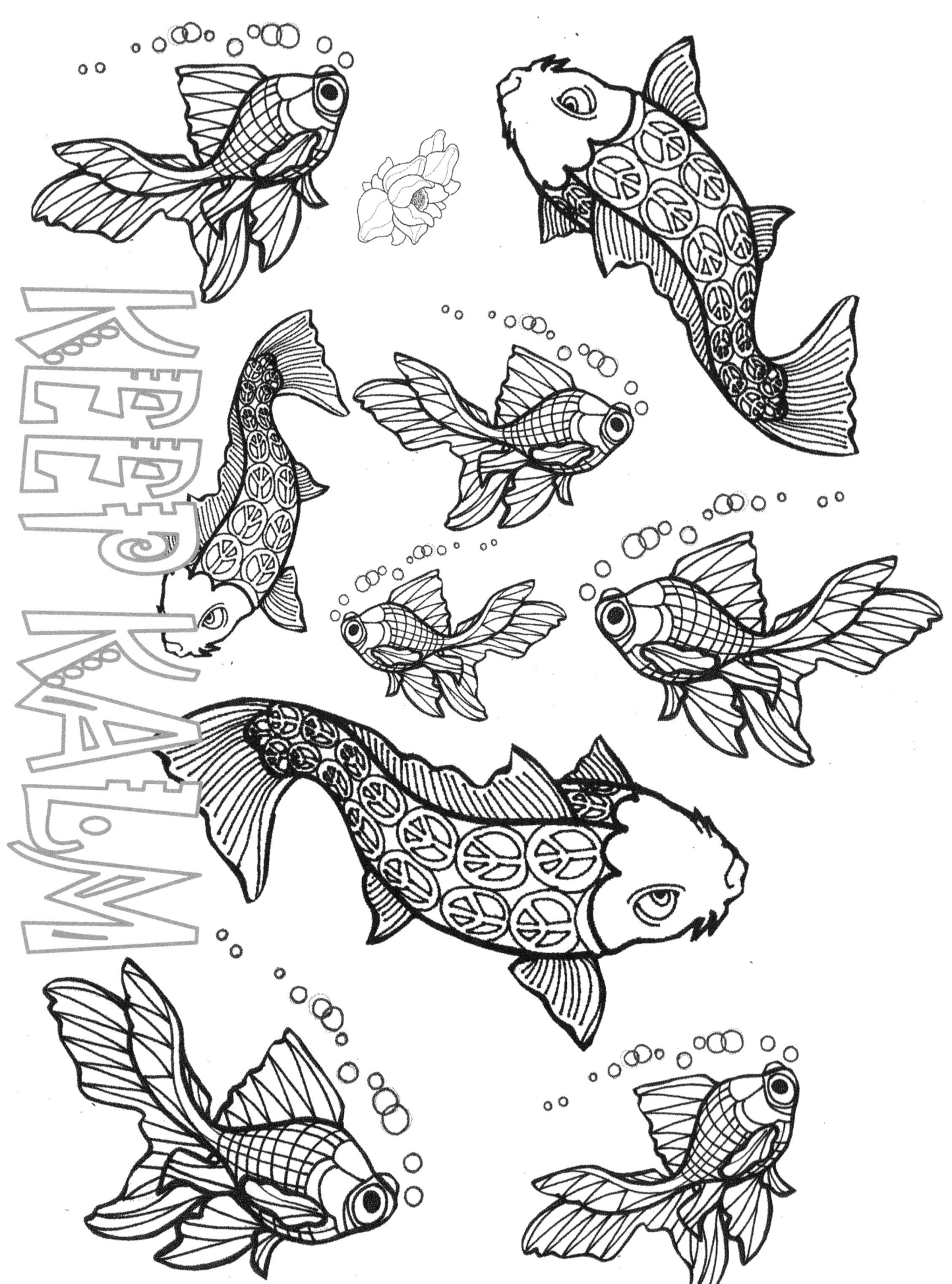

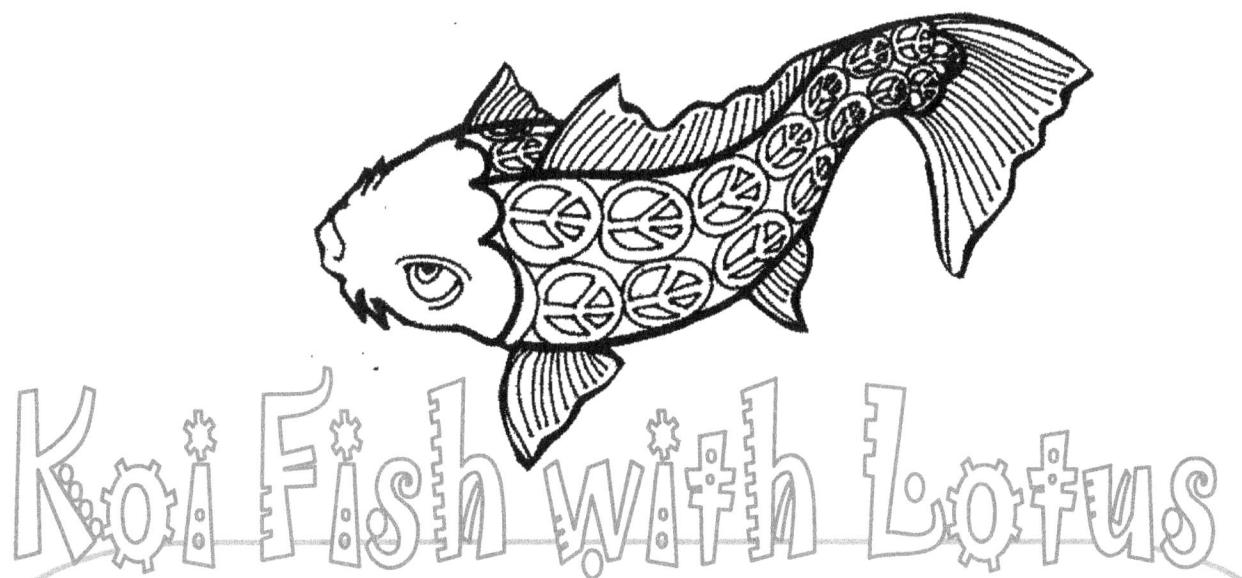

Koi Fish with Lotus

We used to have a pet Koi Fish his name was Herby. We rescued him from a pond where I lived being drained for weed removal and put him in my Sister's pond. When we went to the Pond with her dogs He would get excited and He would come over to See us. He grew very Large. He was Orange, Black and white. He lived in the pond Fifteen years. One Winter it was so cold the pond Ice Froze Solid to the ground.

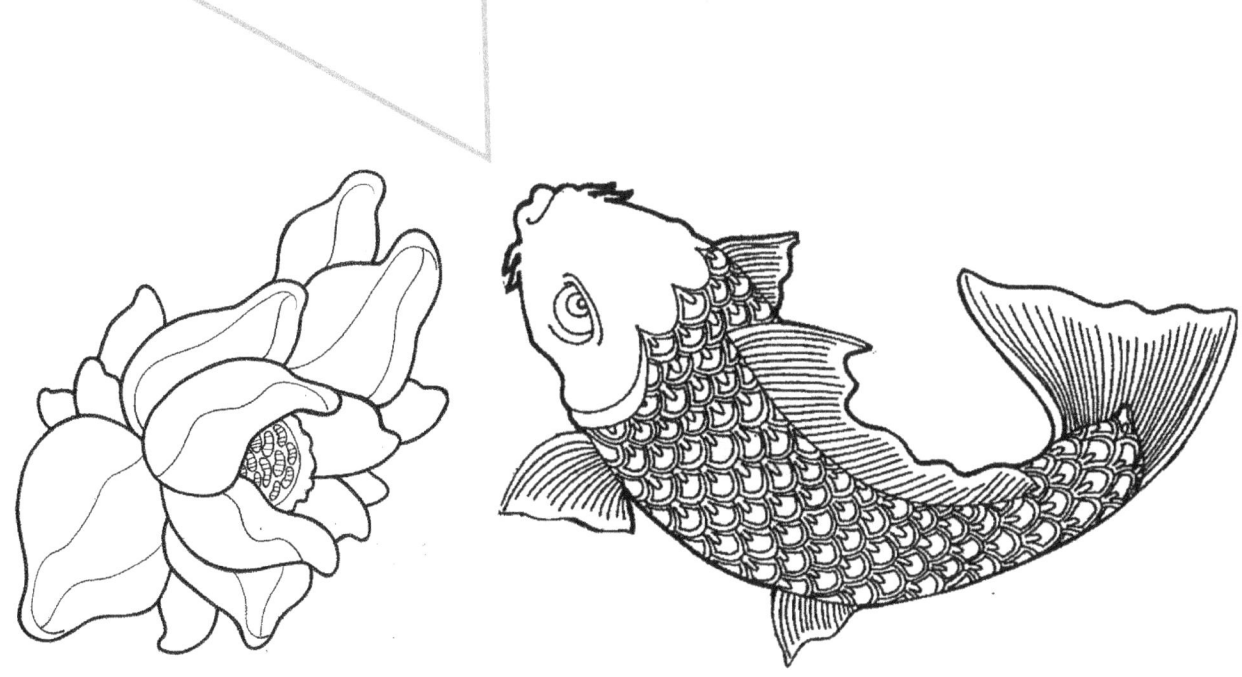

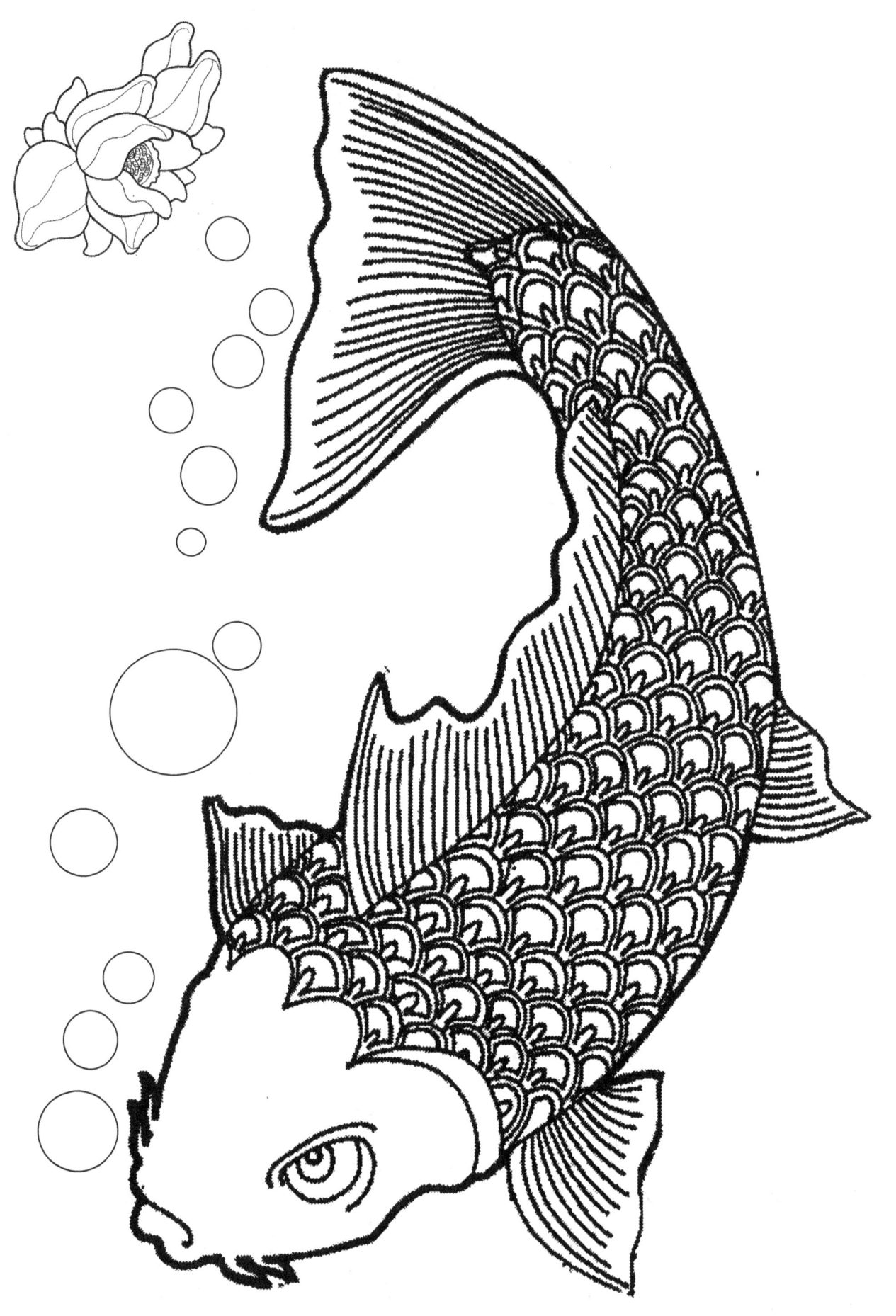

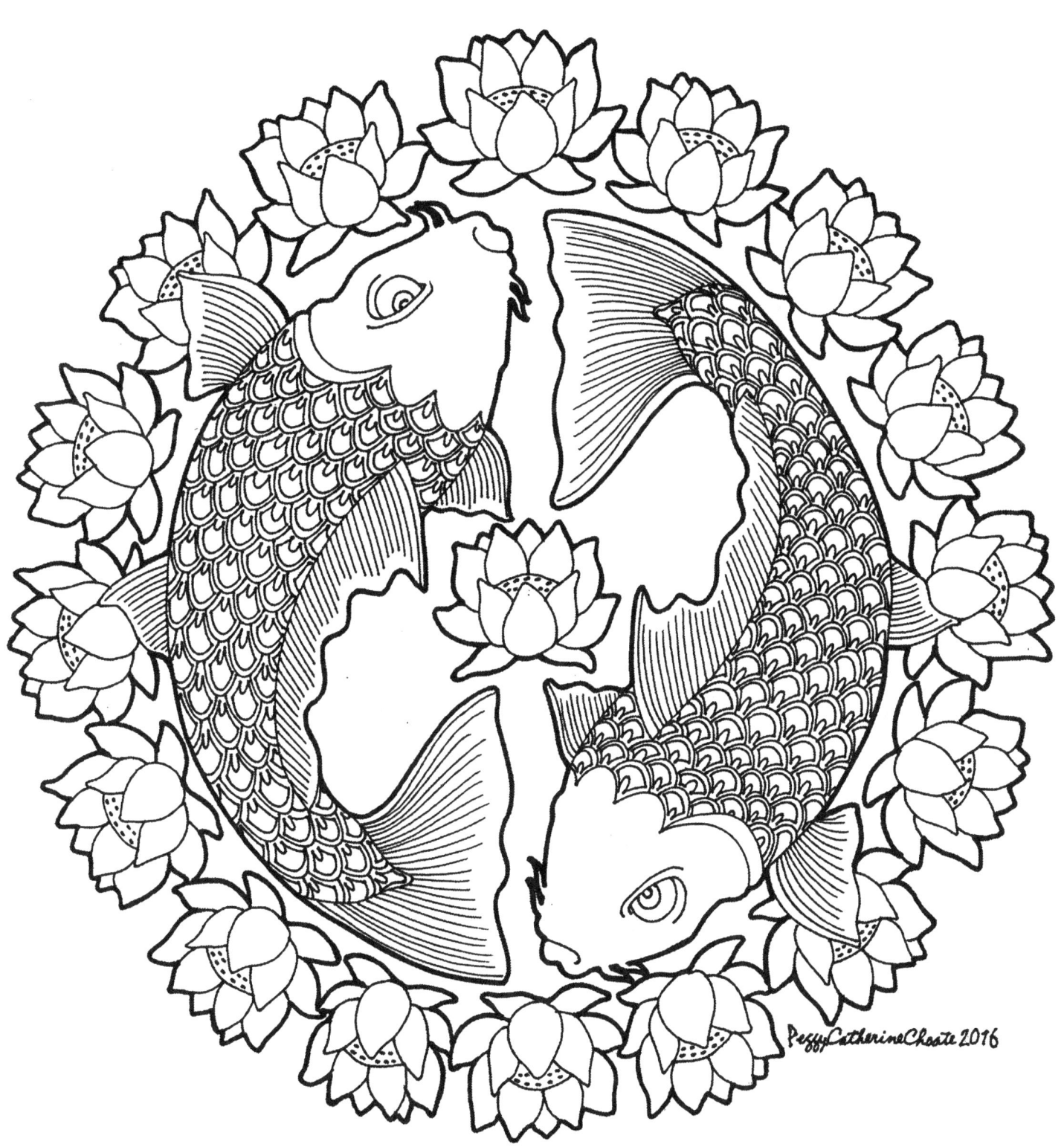

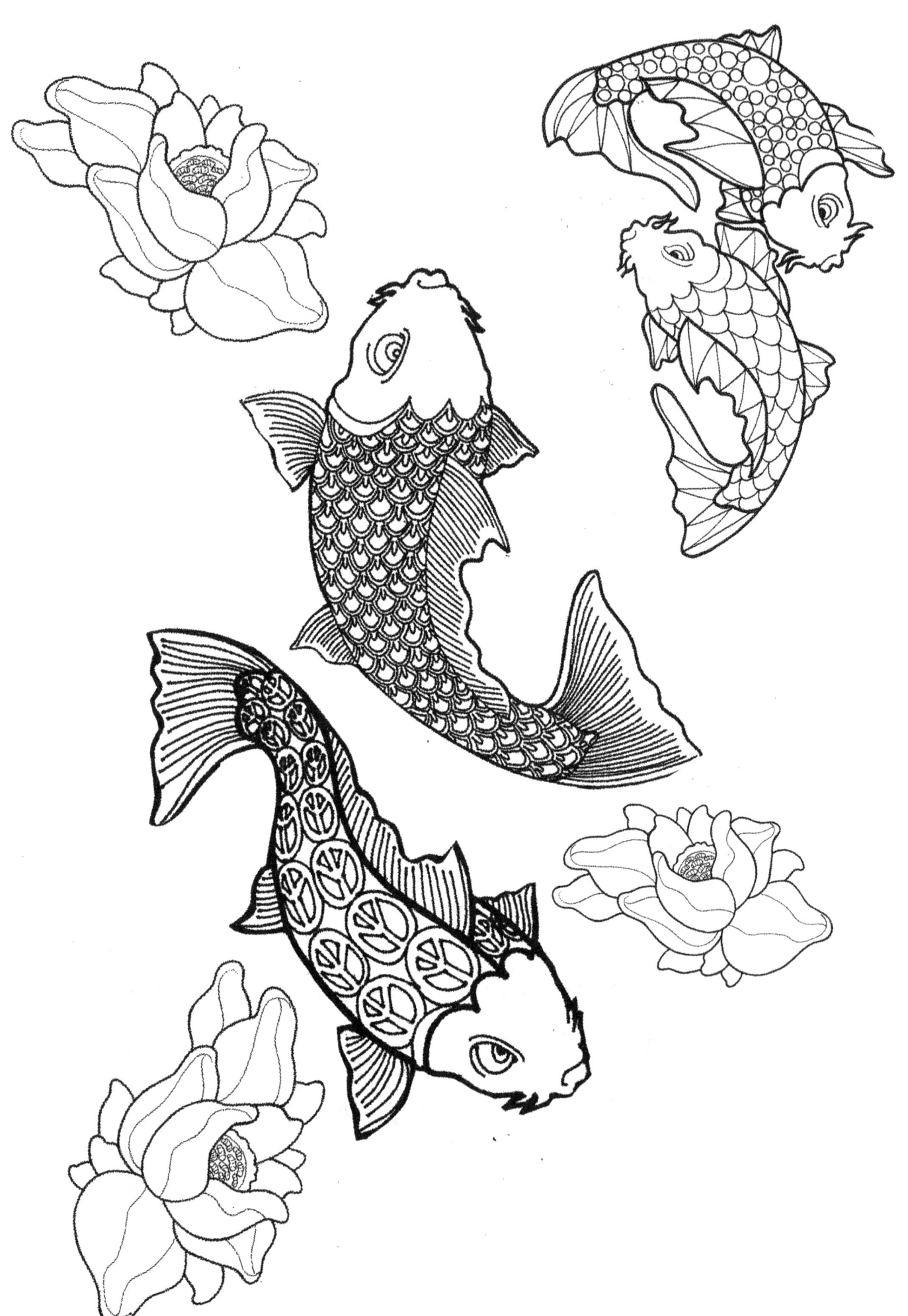

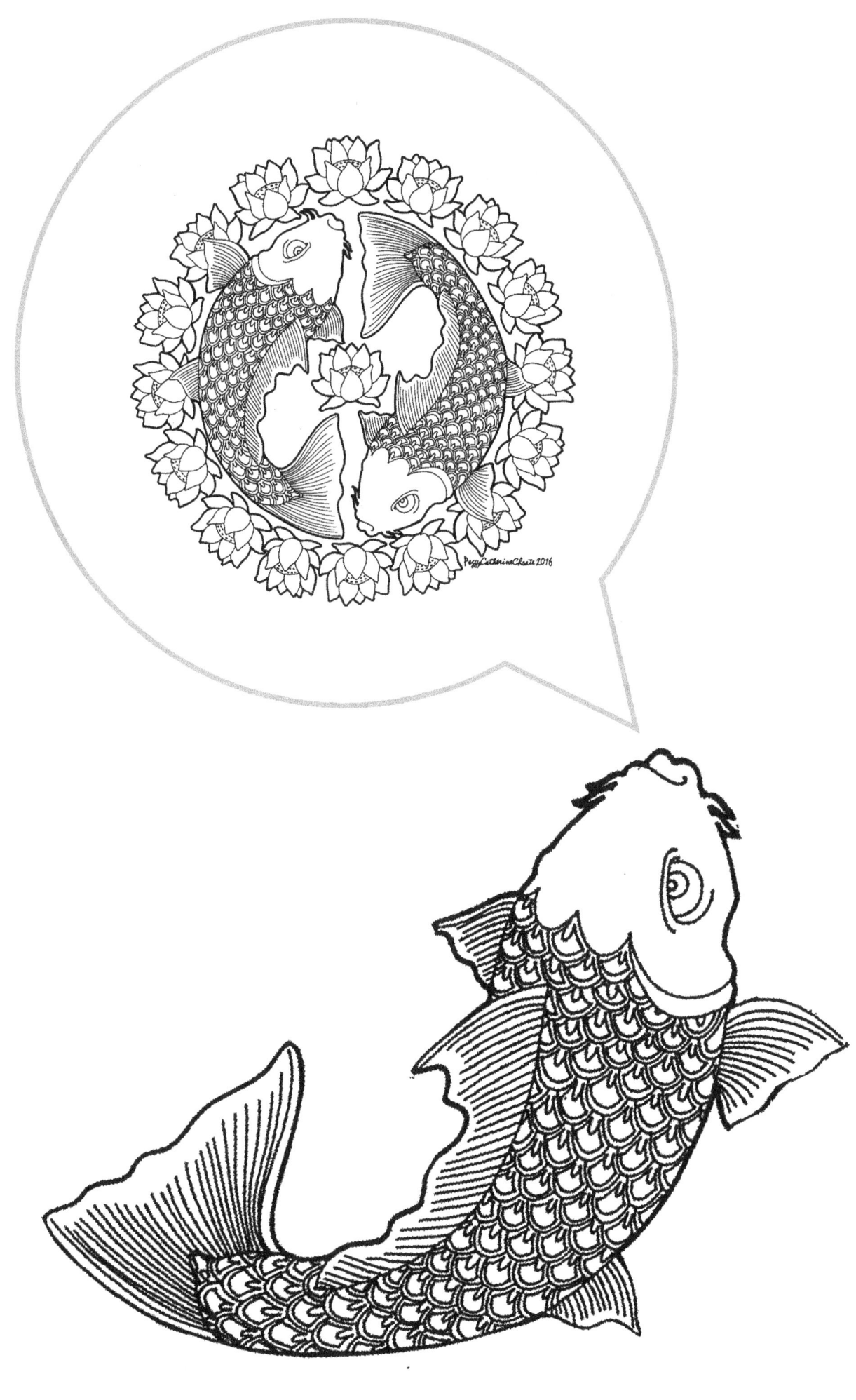

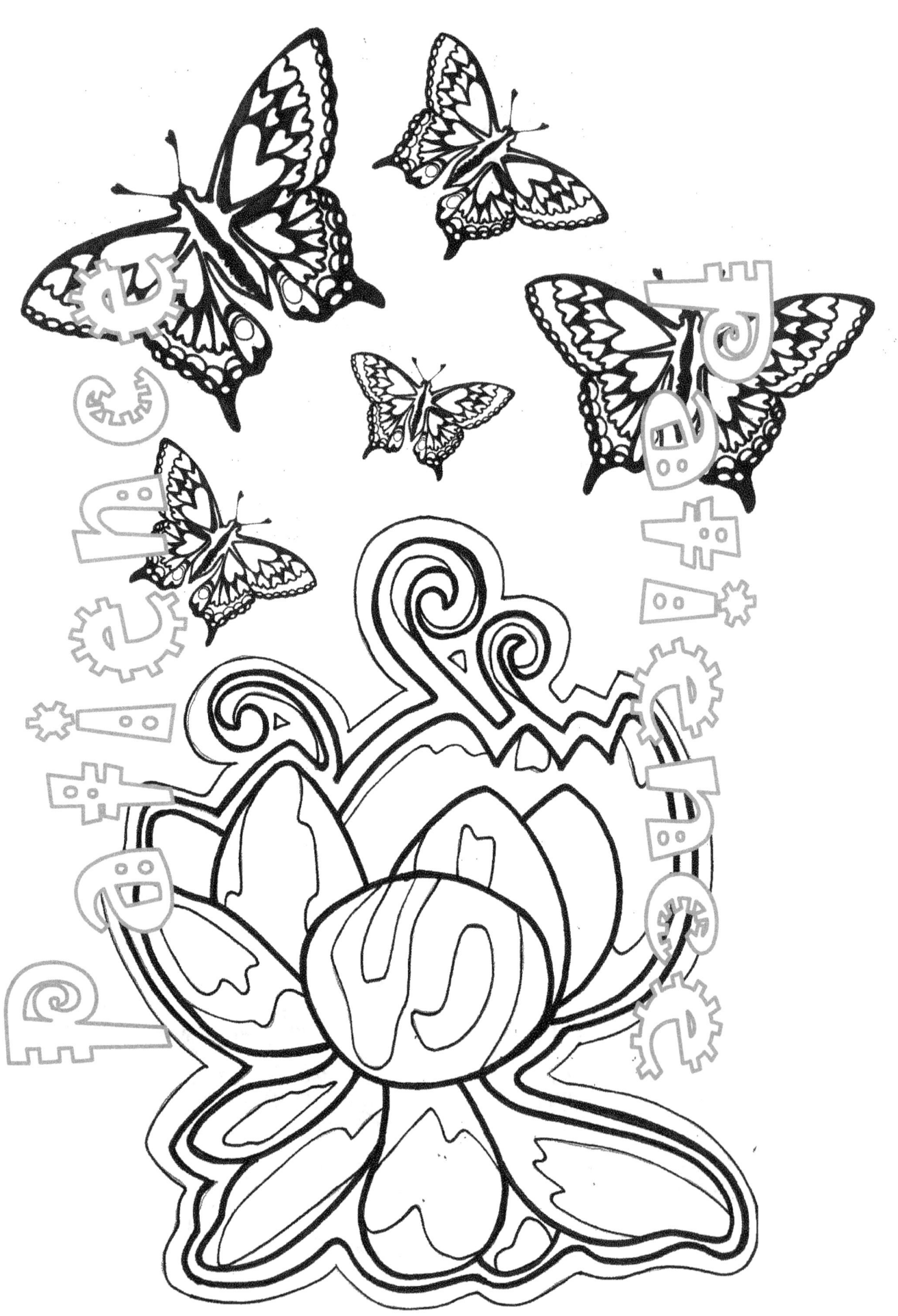

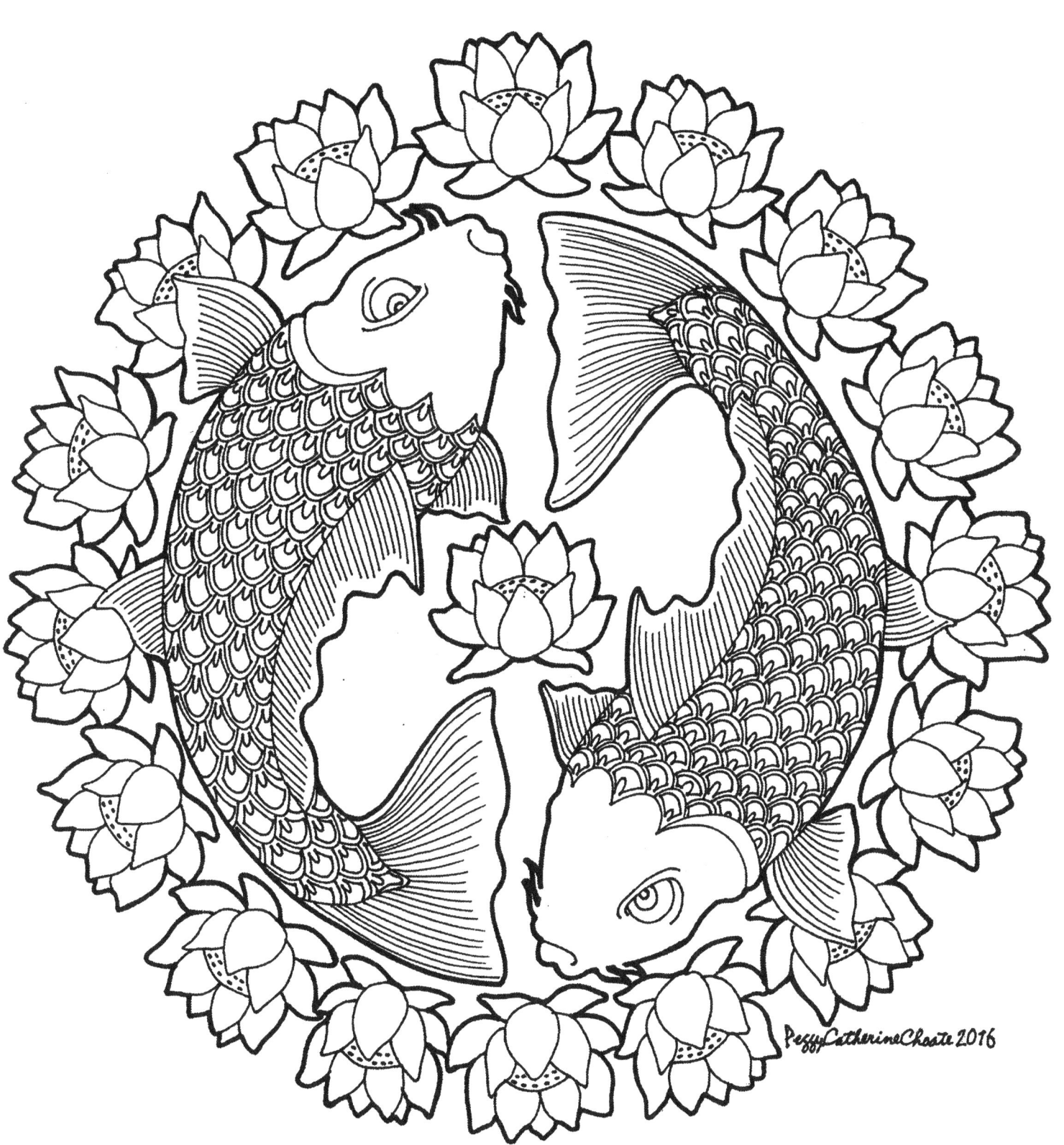

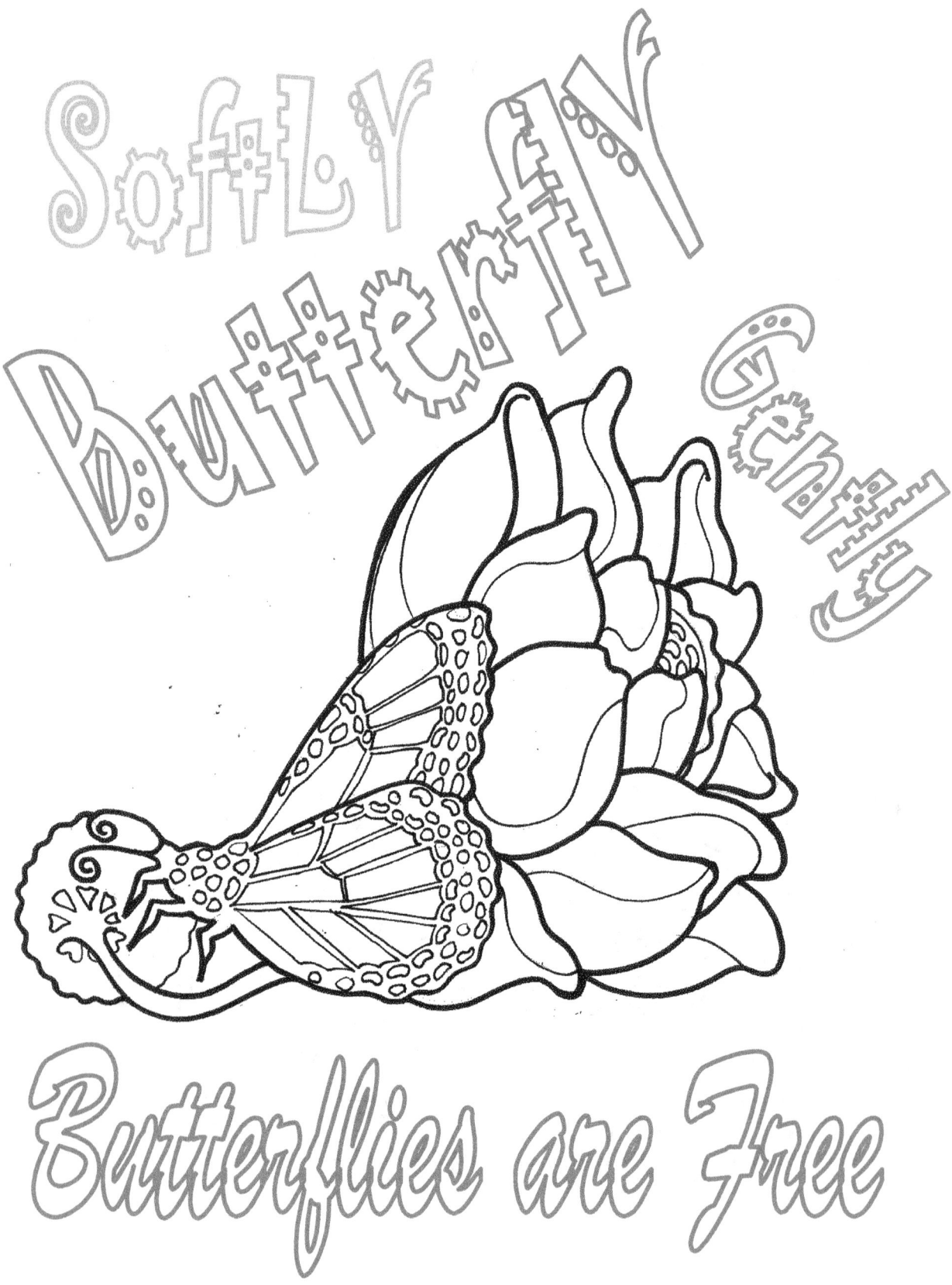

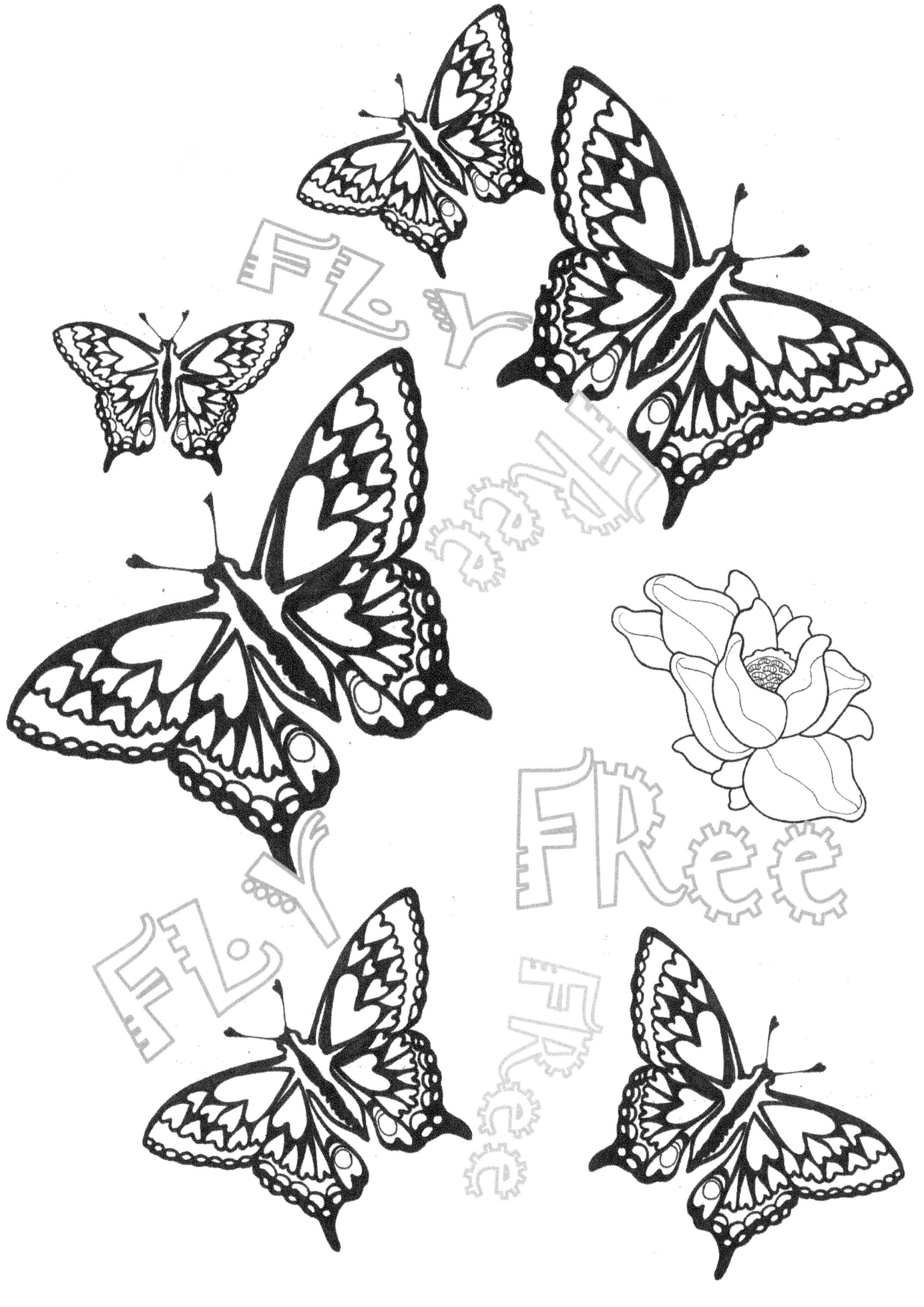

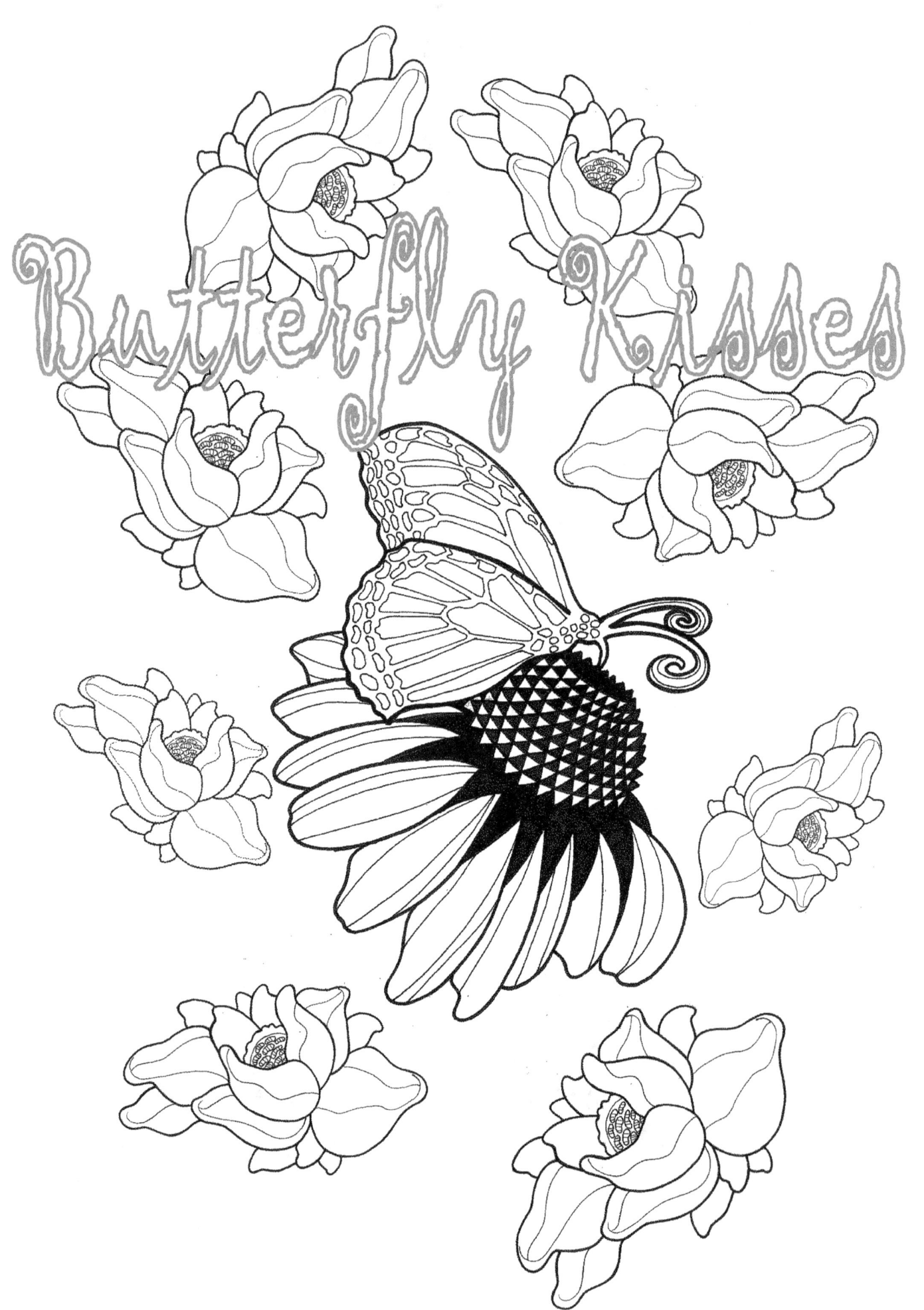

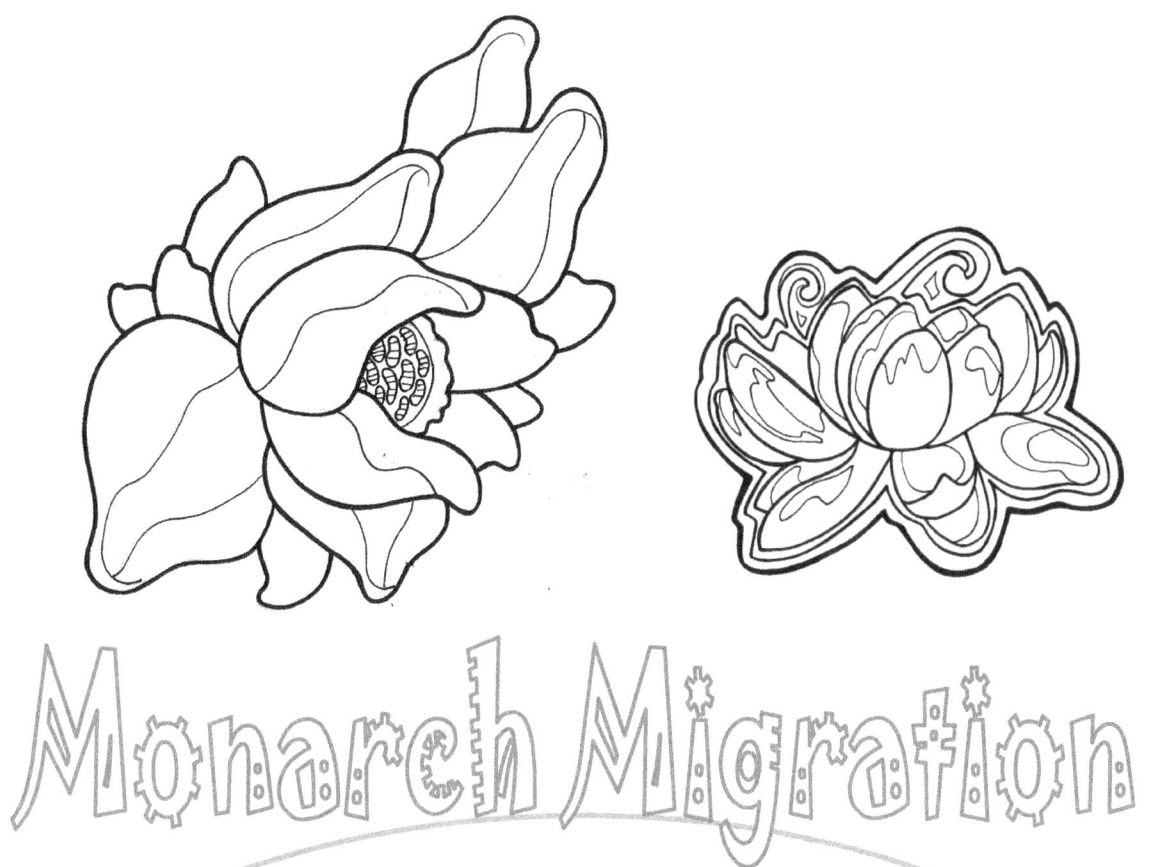

Monarch Migration

I grow Milkweed Plants in my yard. The Purple Flowers smell amazing when they bloom. It is the only plant Monarch Butterflies Lay their eggs on. When I was little Mom and I found a chrysalis on a Milkweed. We brought it home - took care of it until the Monarch emerged and dried its wings. We fed it sugar water and set it free. Monarchs are still my favorite Butterfly.
Thanks Mom.

Butterflies in My Stomach

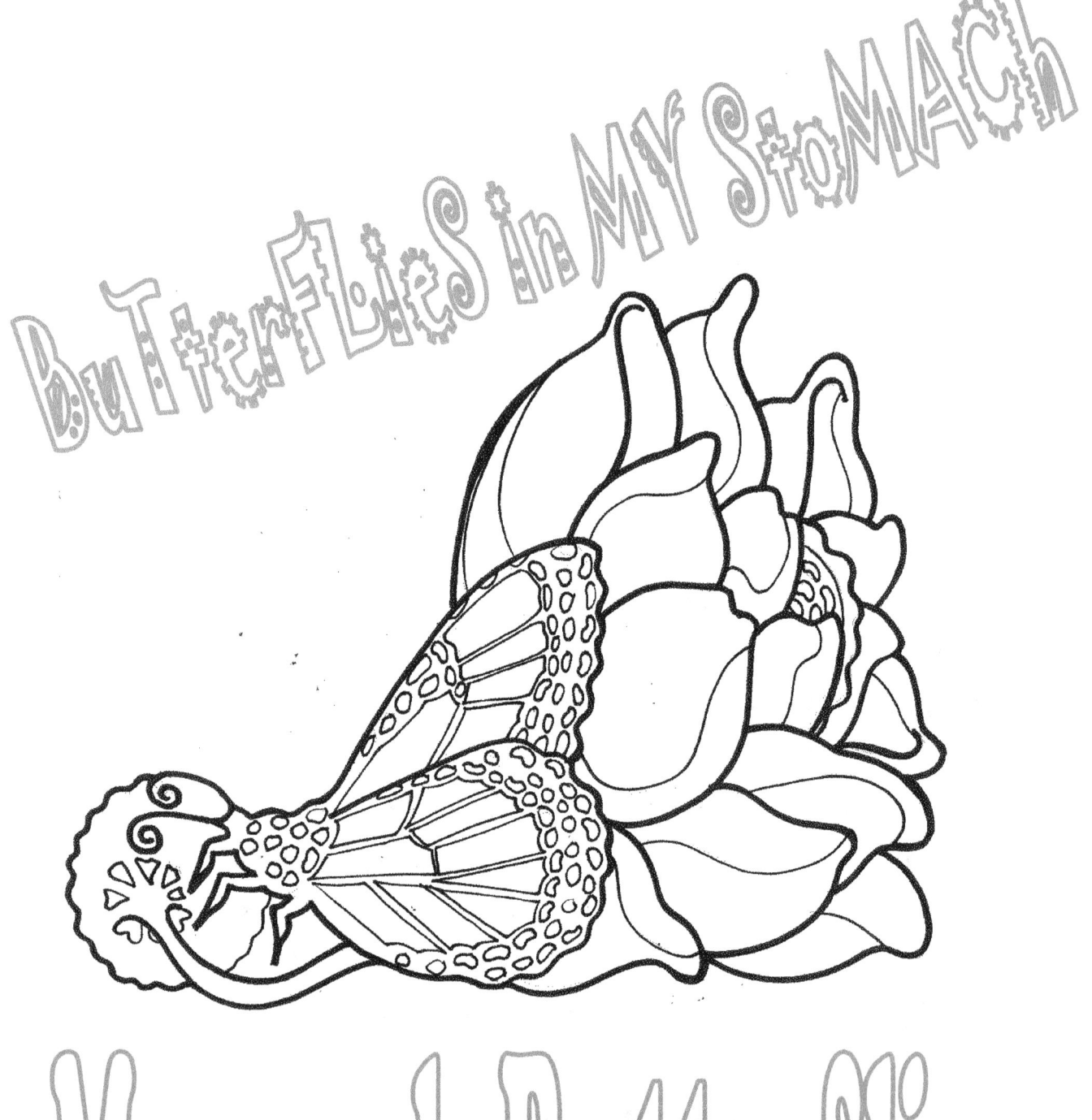

Monarch Butterflies

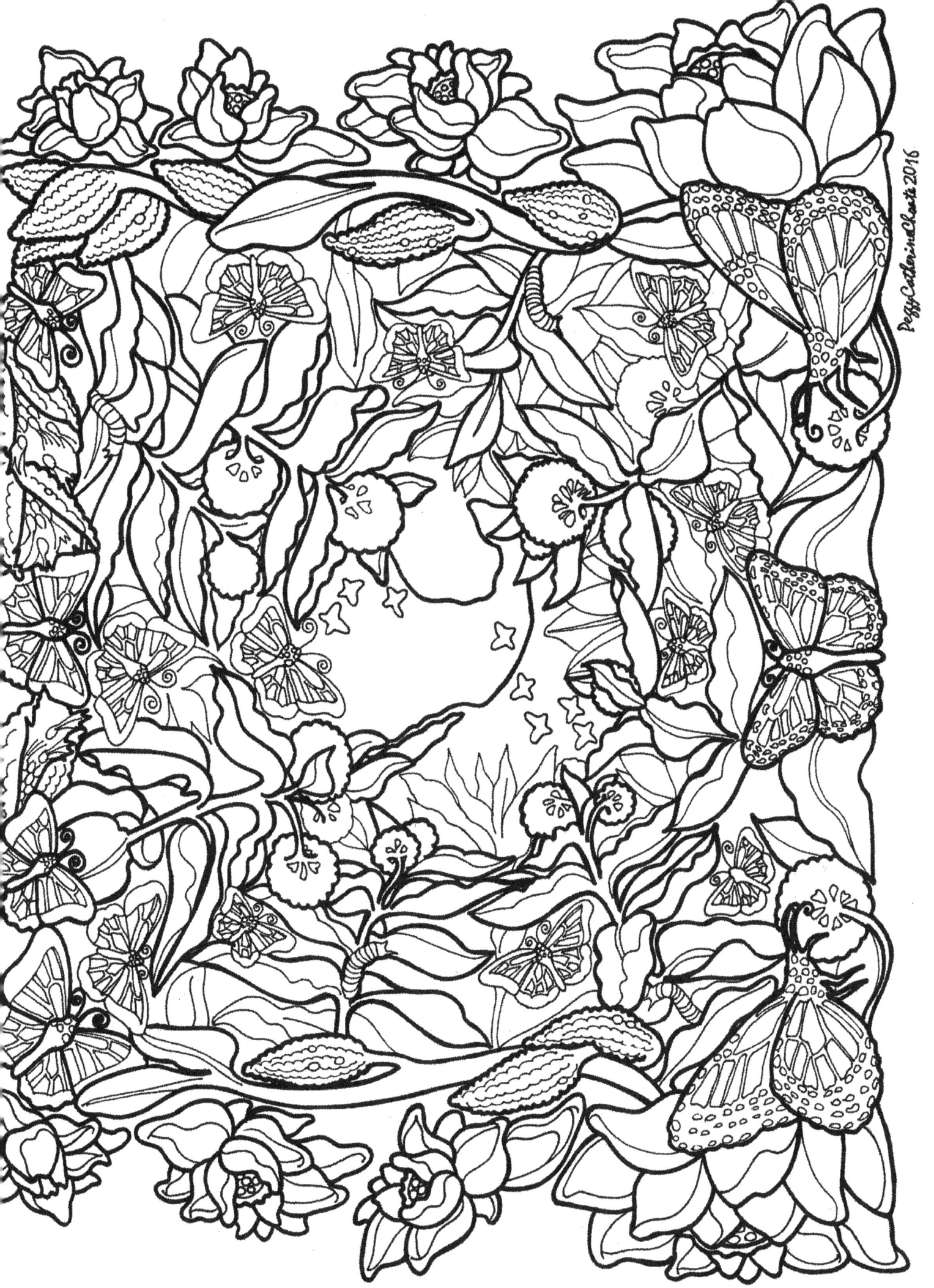

Monarch Migration

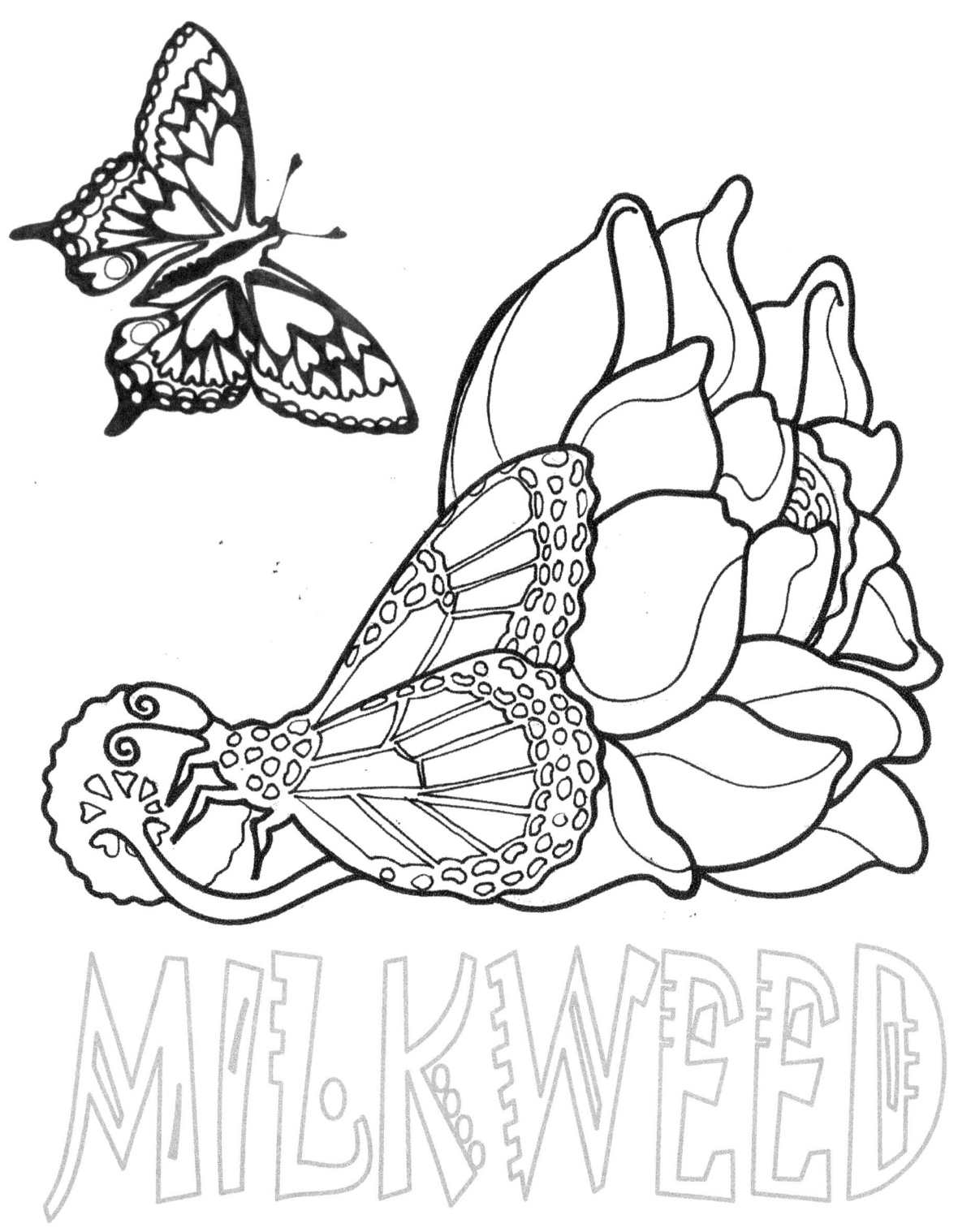

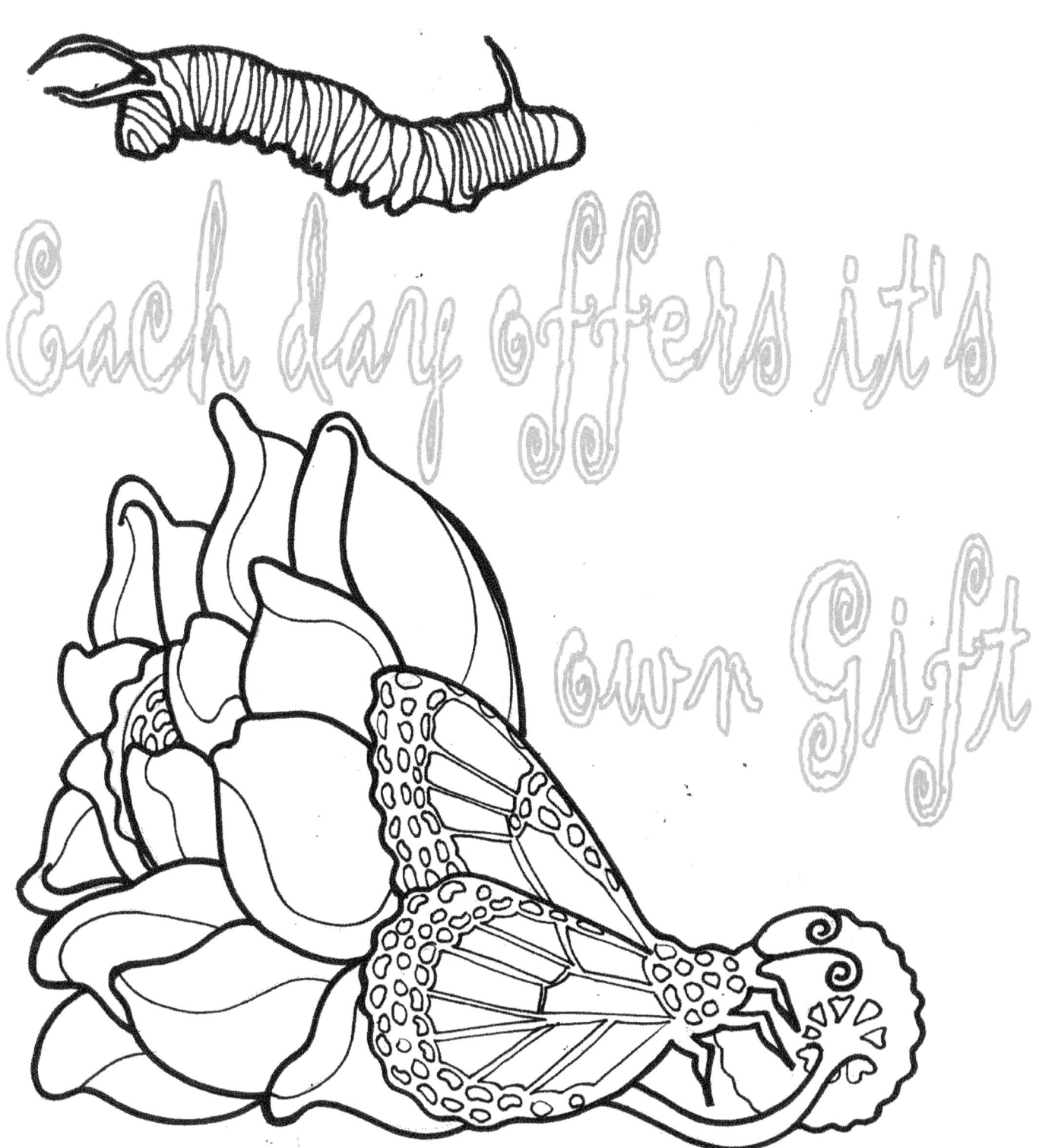

Each day offers it's own Gift

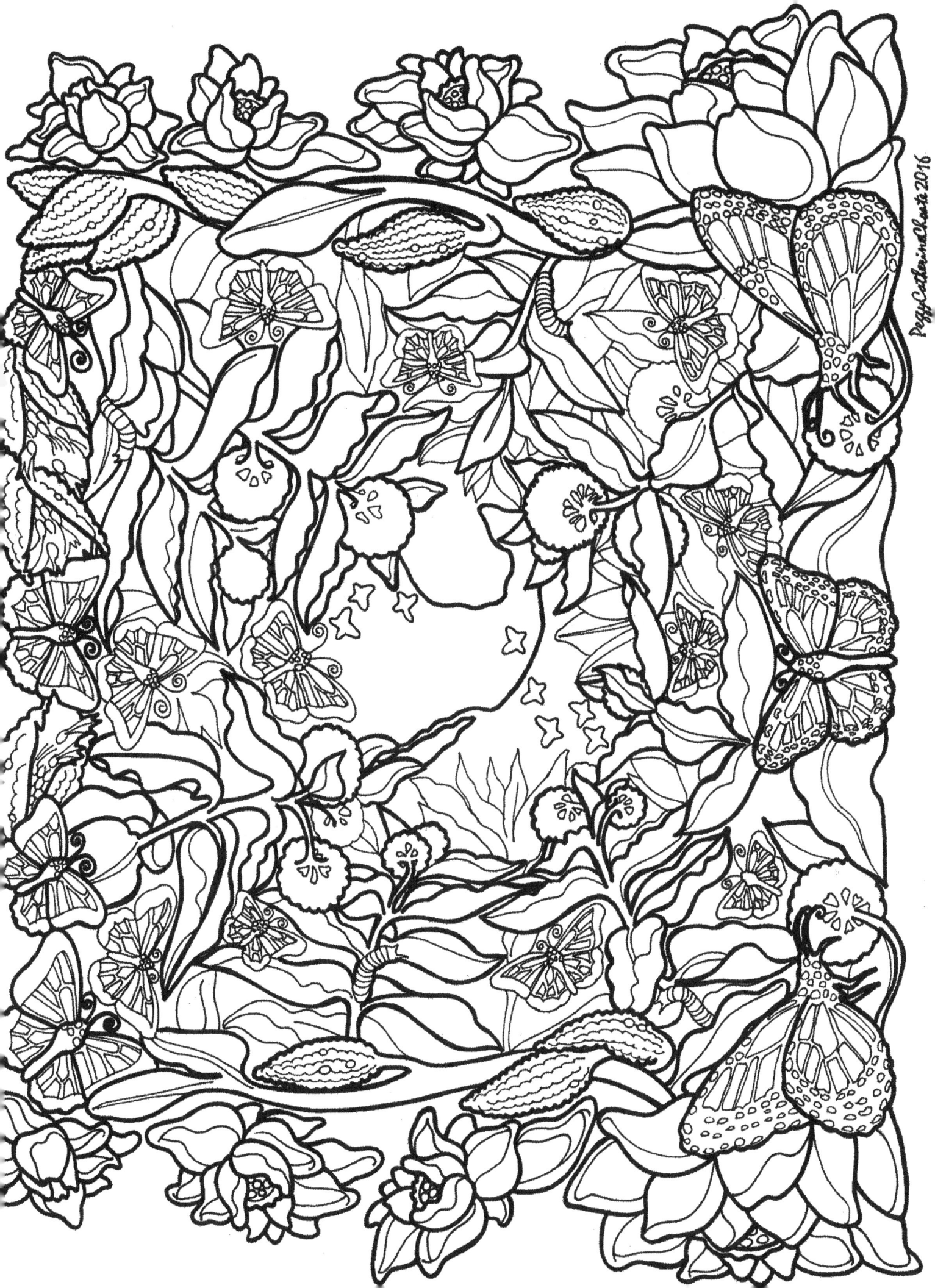

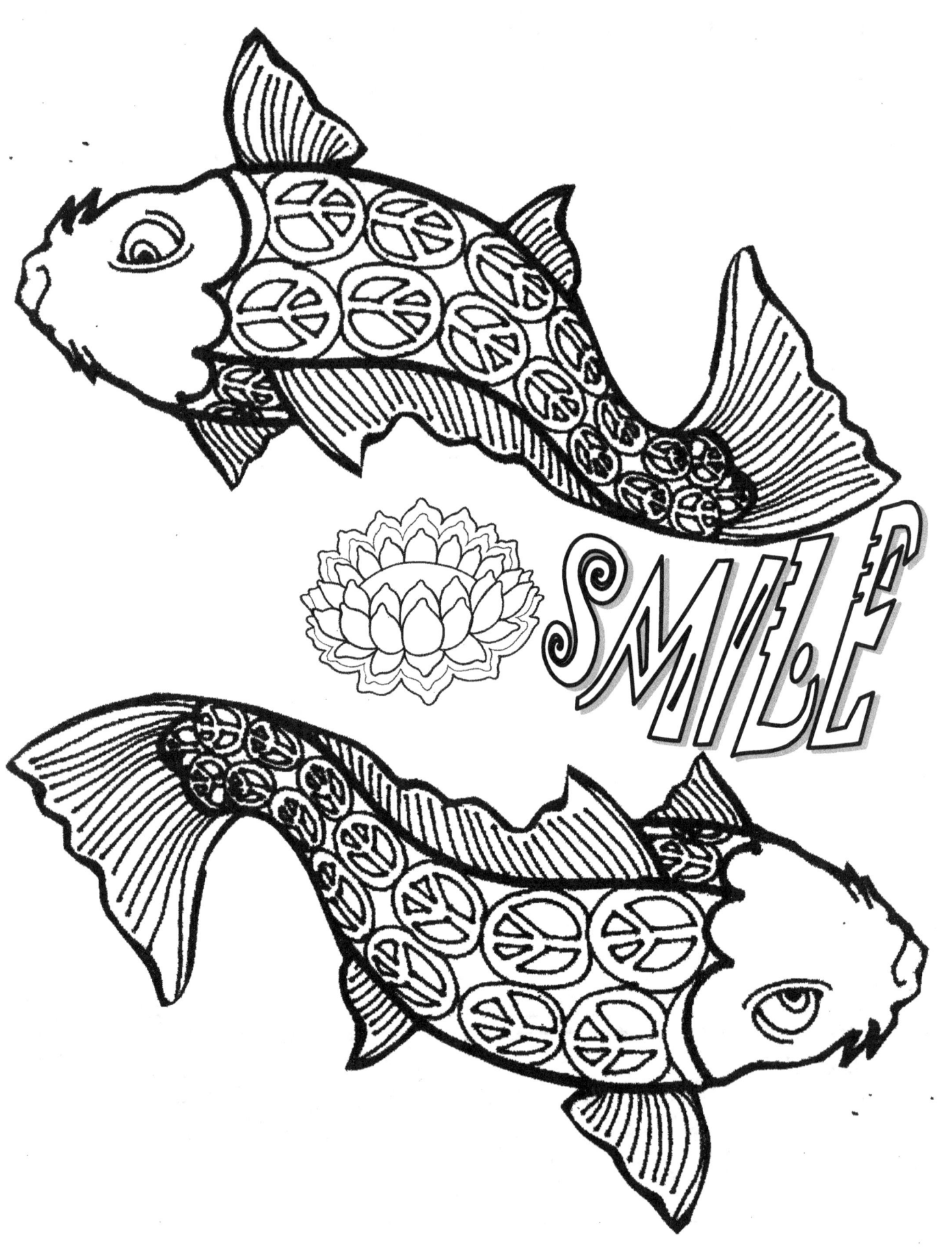

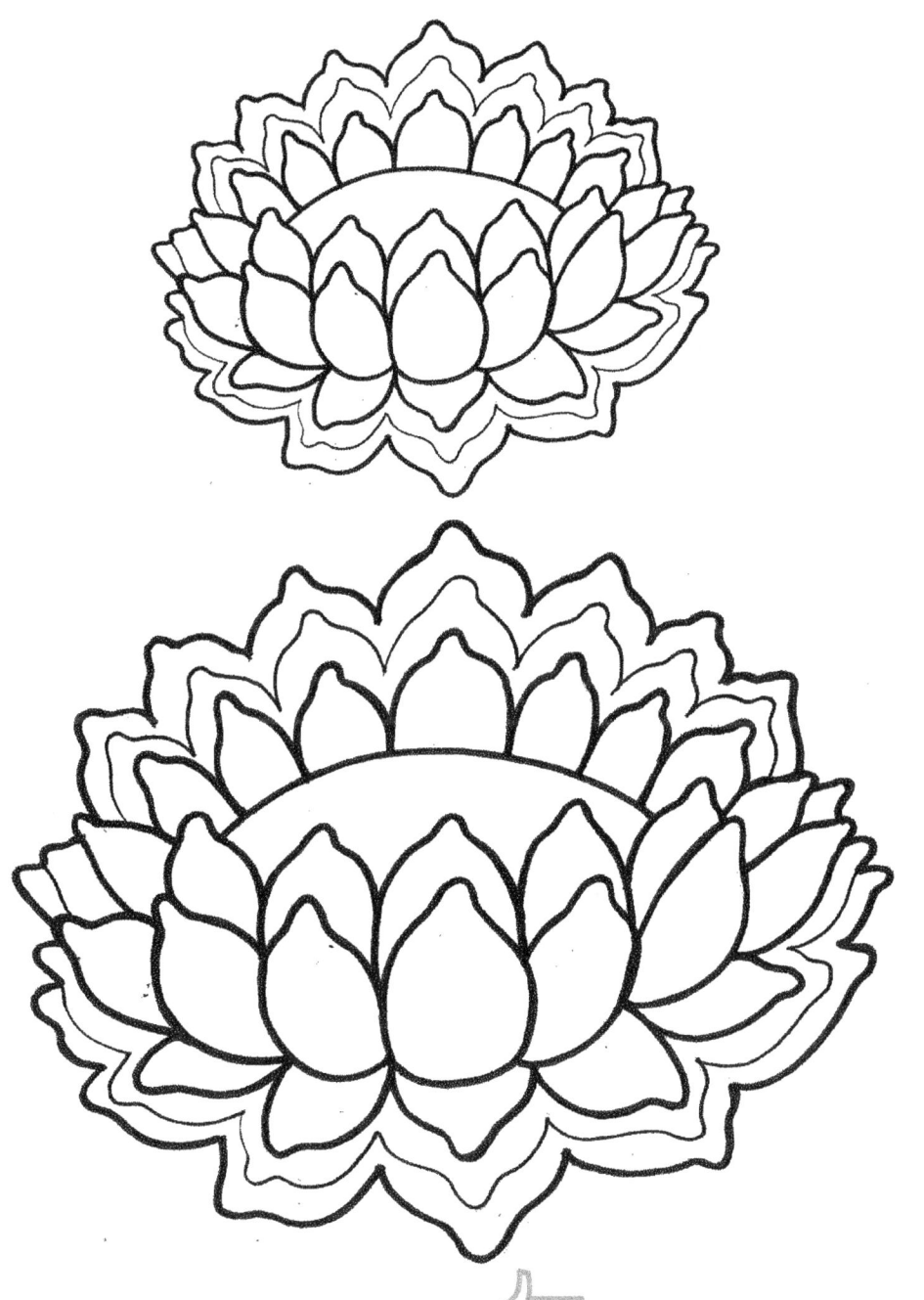

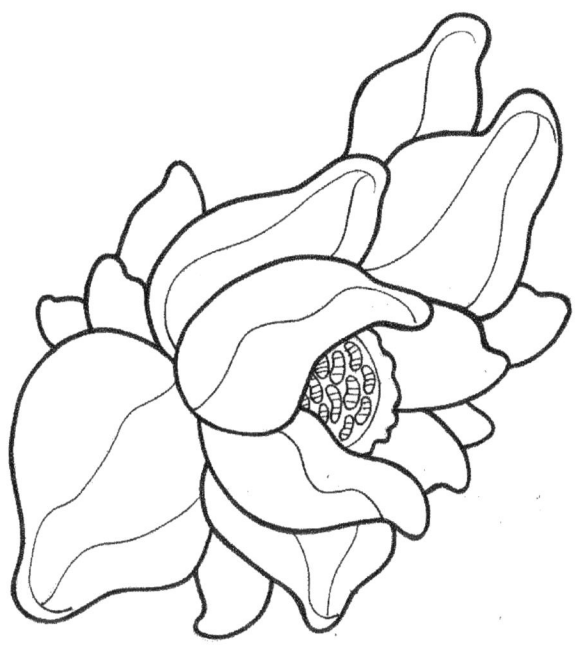

Buddha is Liberty

I did a painting of the same name and sold it and afterward many more people requested to purchase it. This is inspired by that Painting. It was one of my favorites.

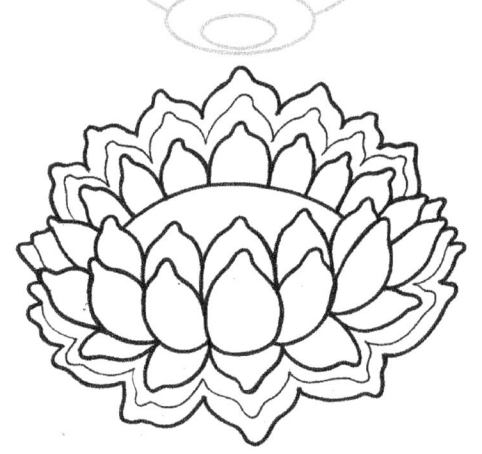

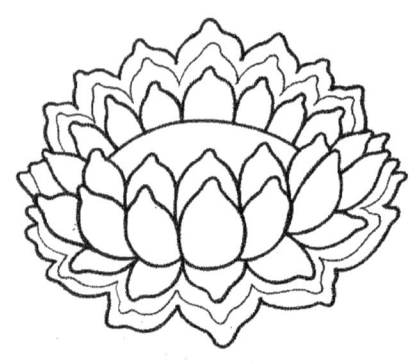

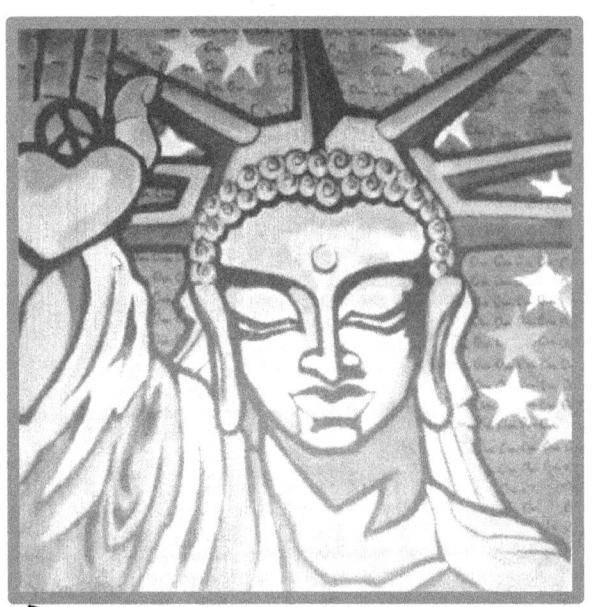

BUDDHA is LIBERTY

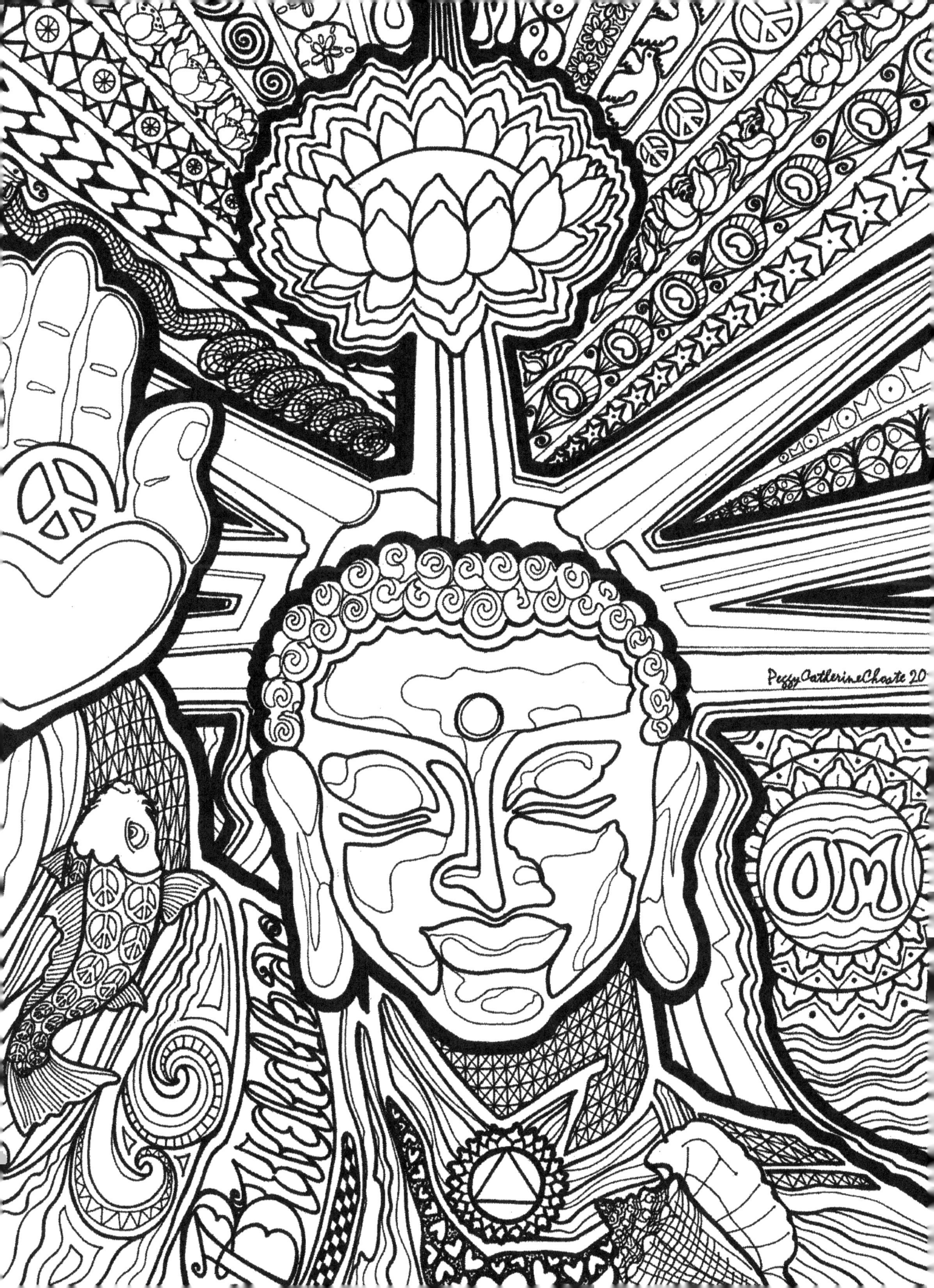

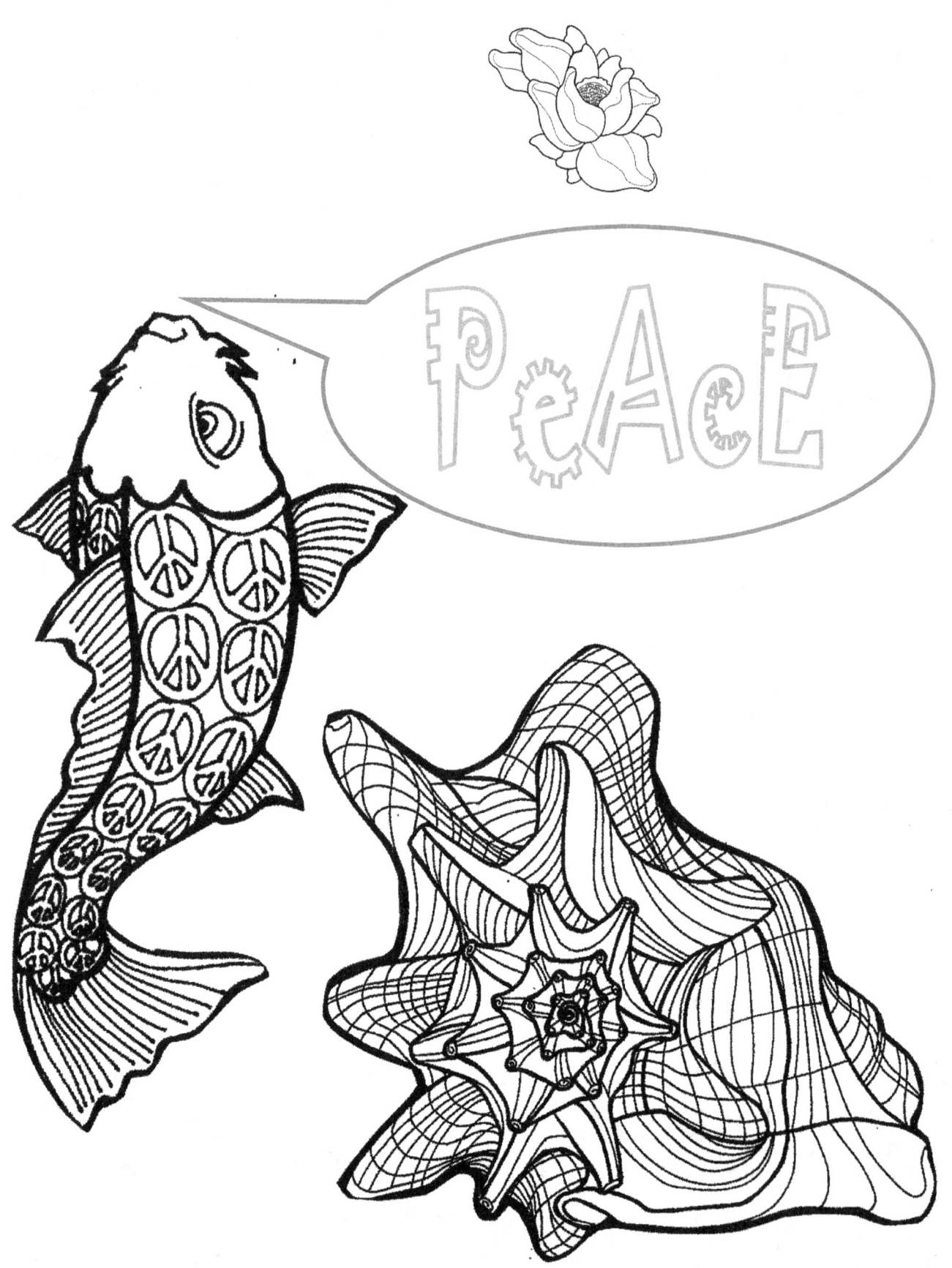

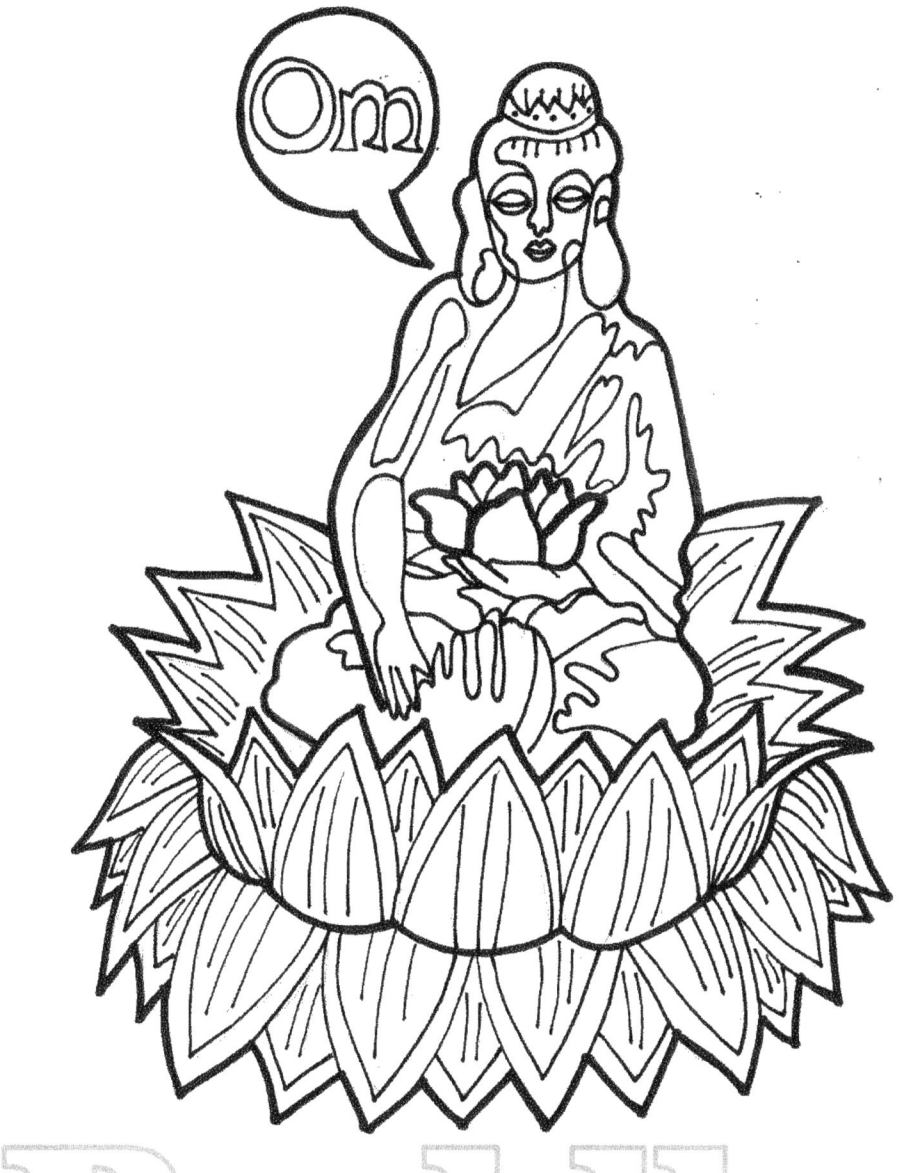

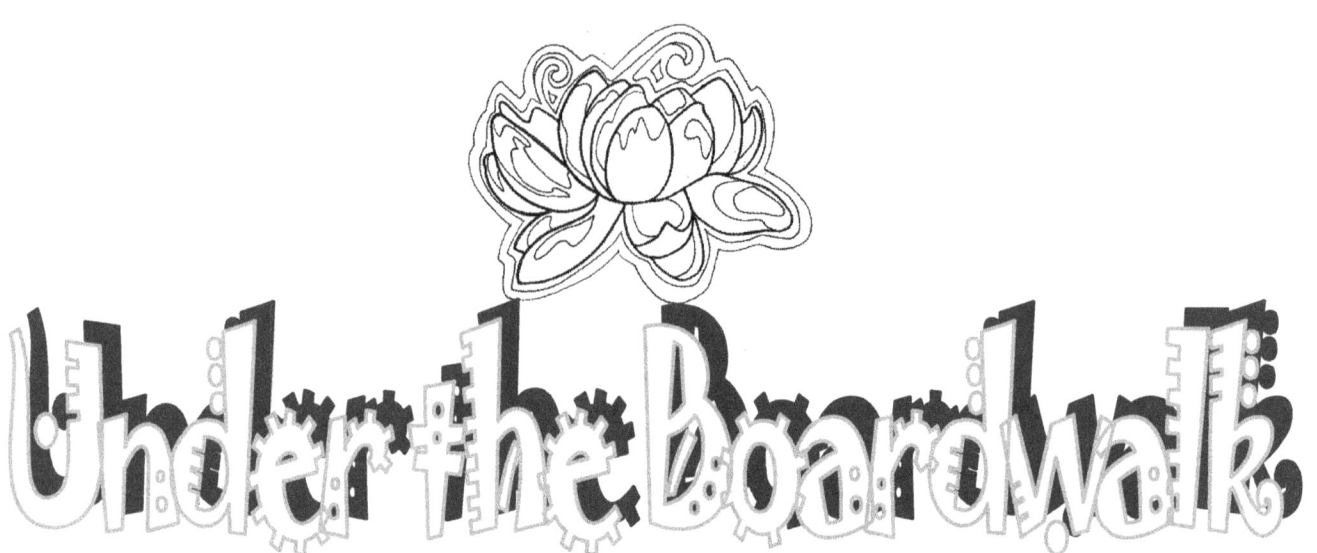

Under the Boardwalk, out of the Sun

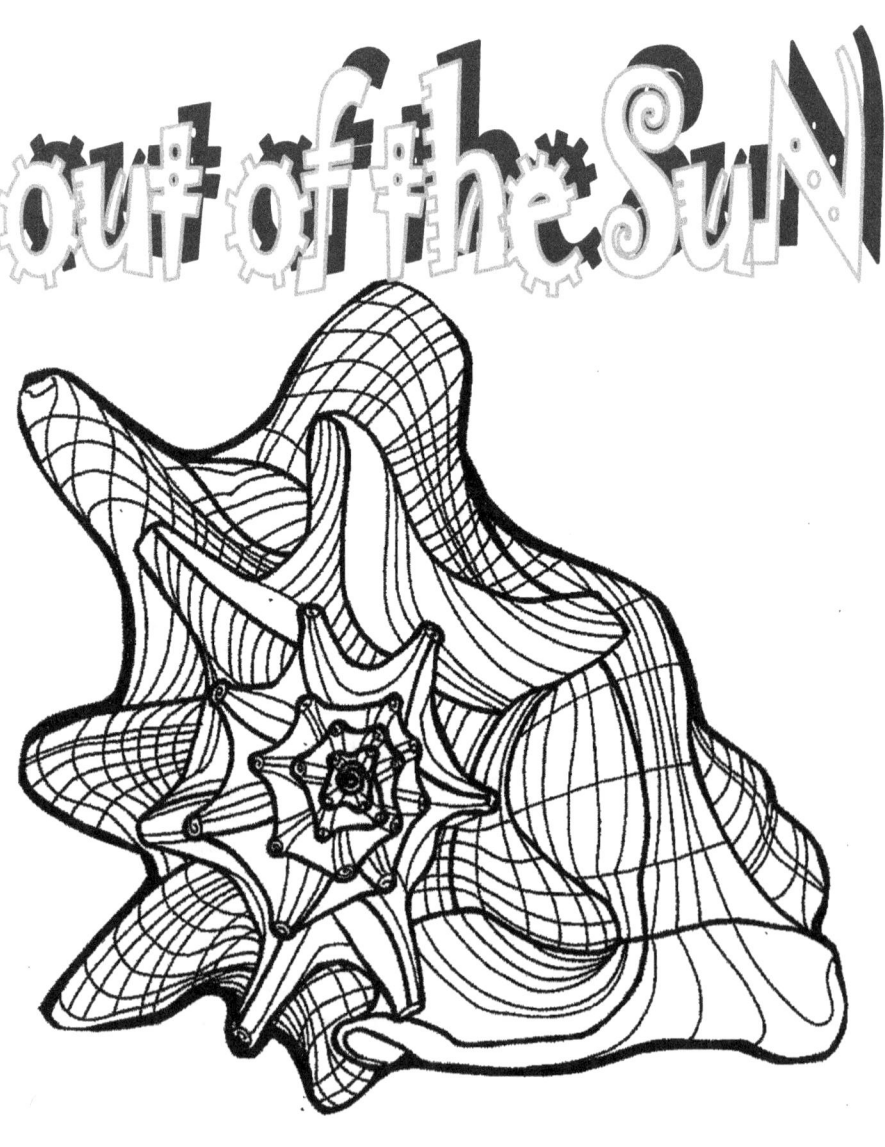

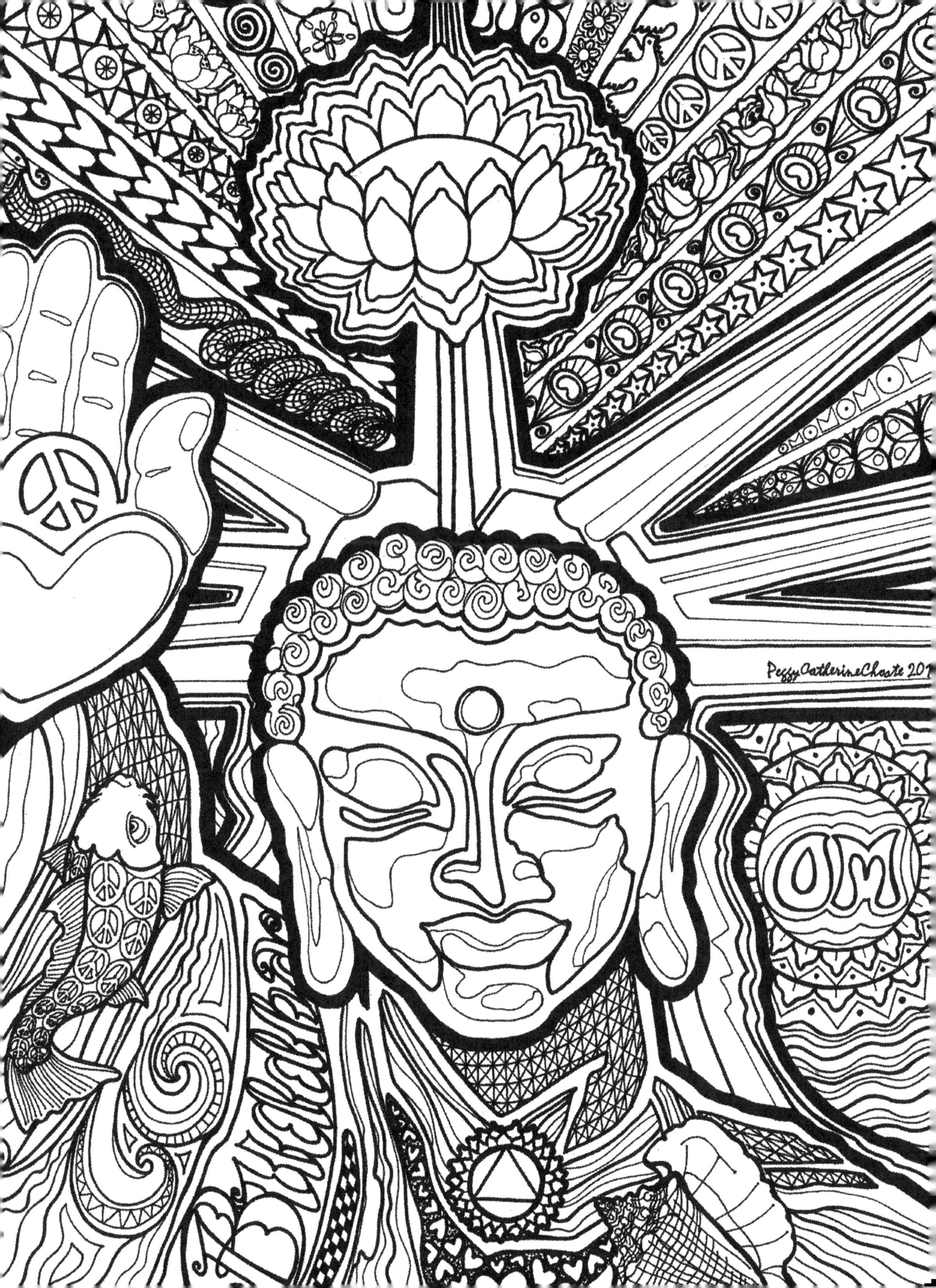

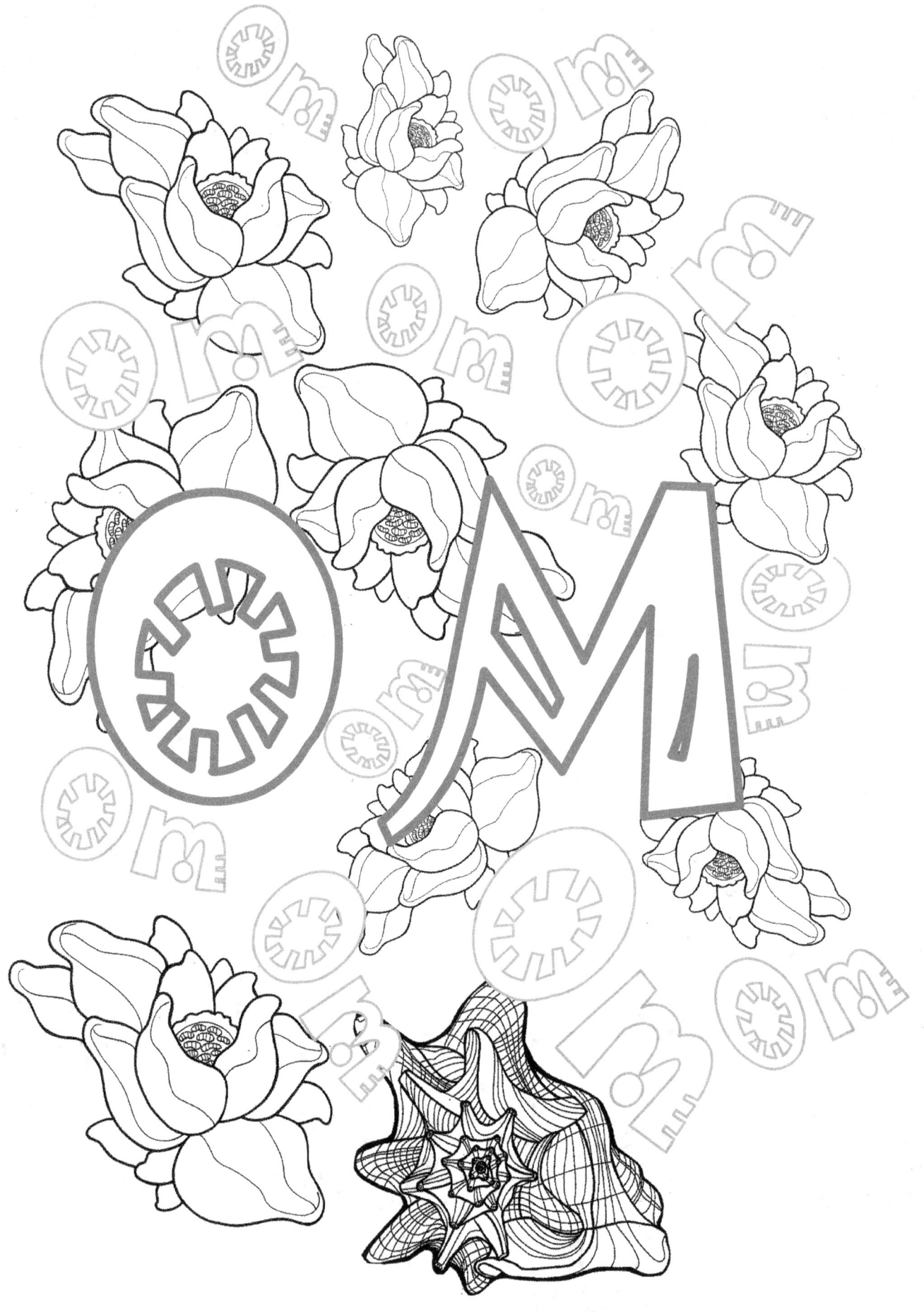

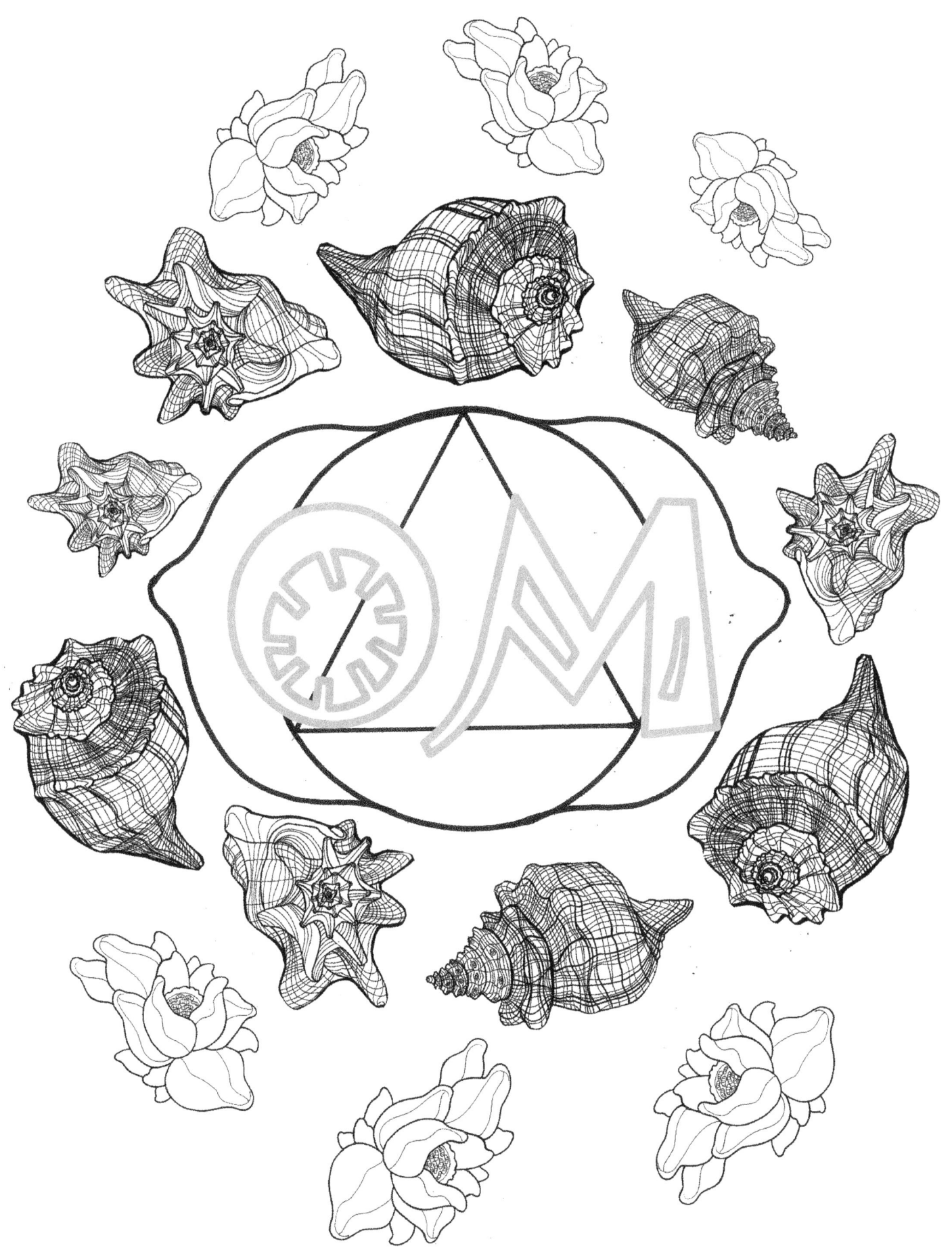

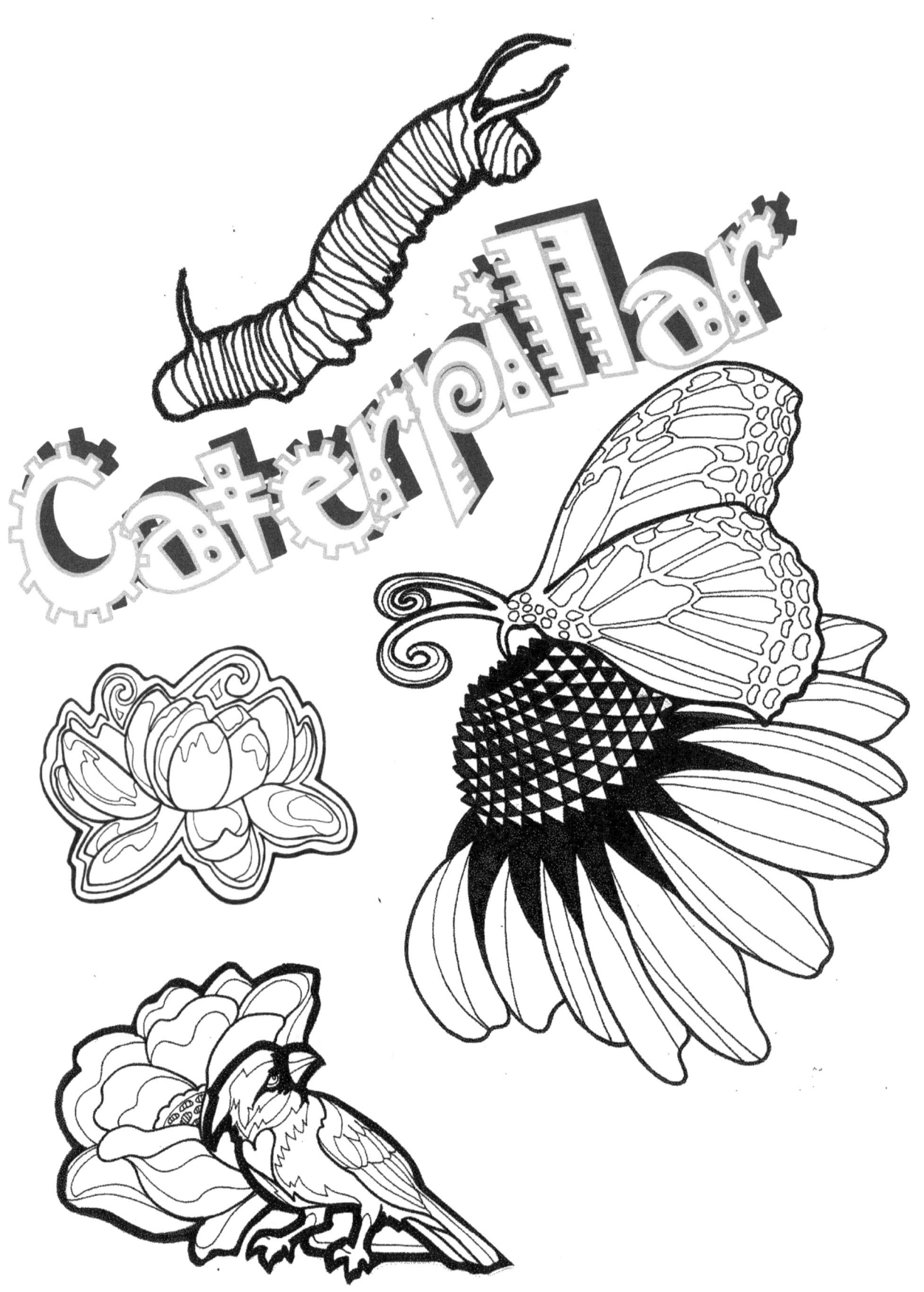

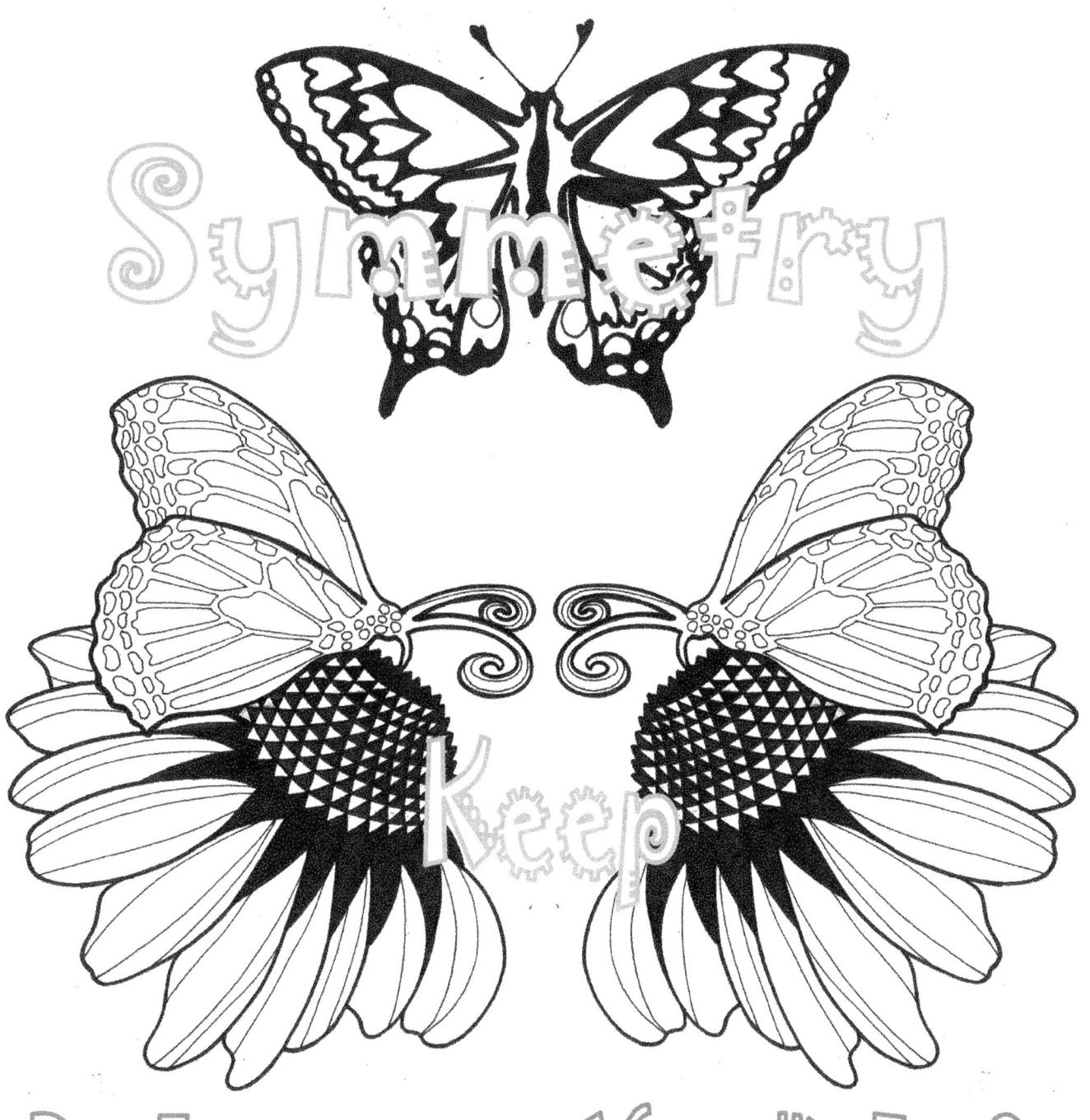

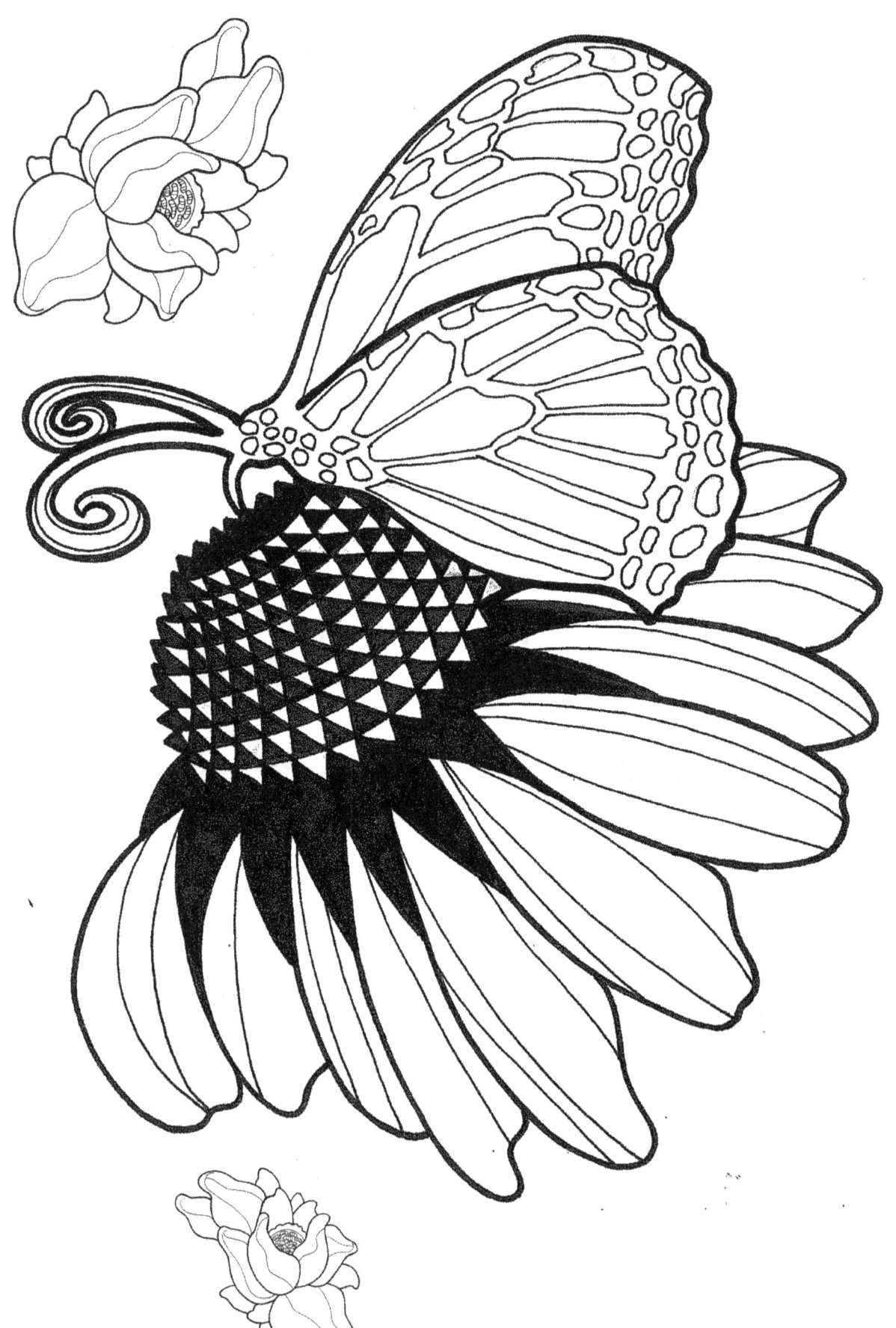

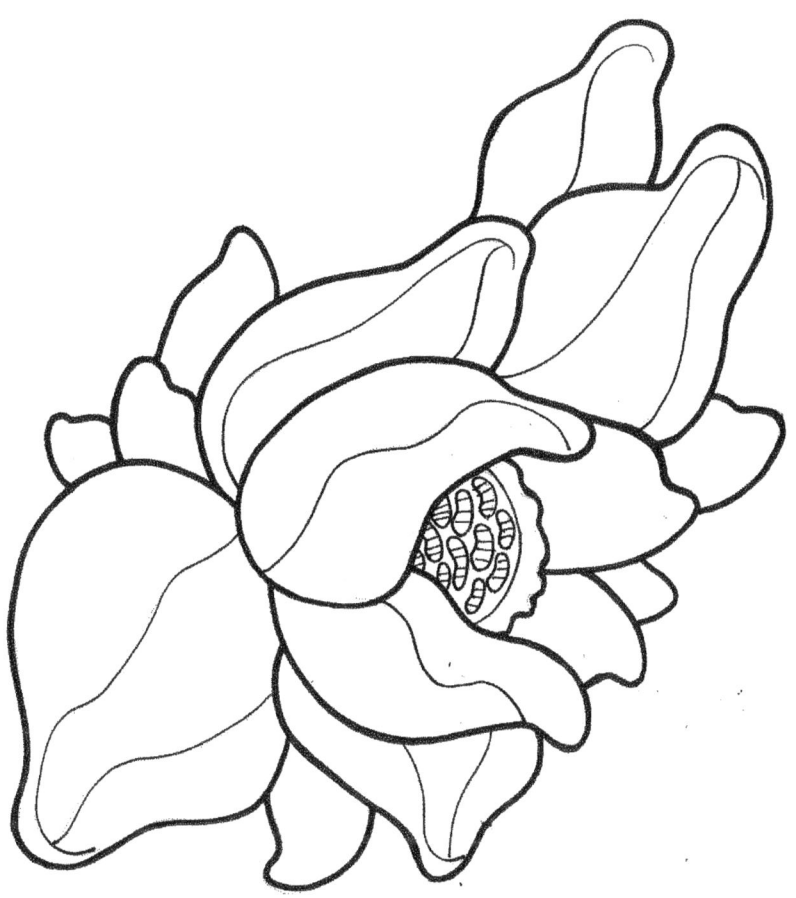

Heart Doodle

This illustration was inspired by a Doodle my Daughter did in her school note book. I kept it on the refridgerator for a long time. I feel Happy when I look at it.

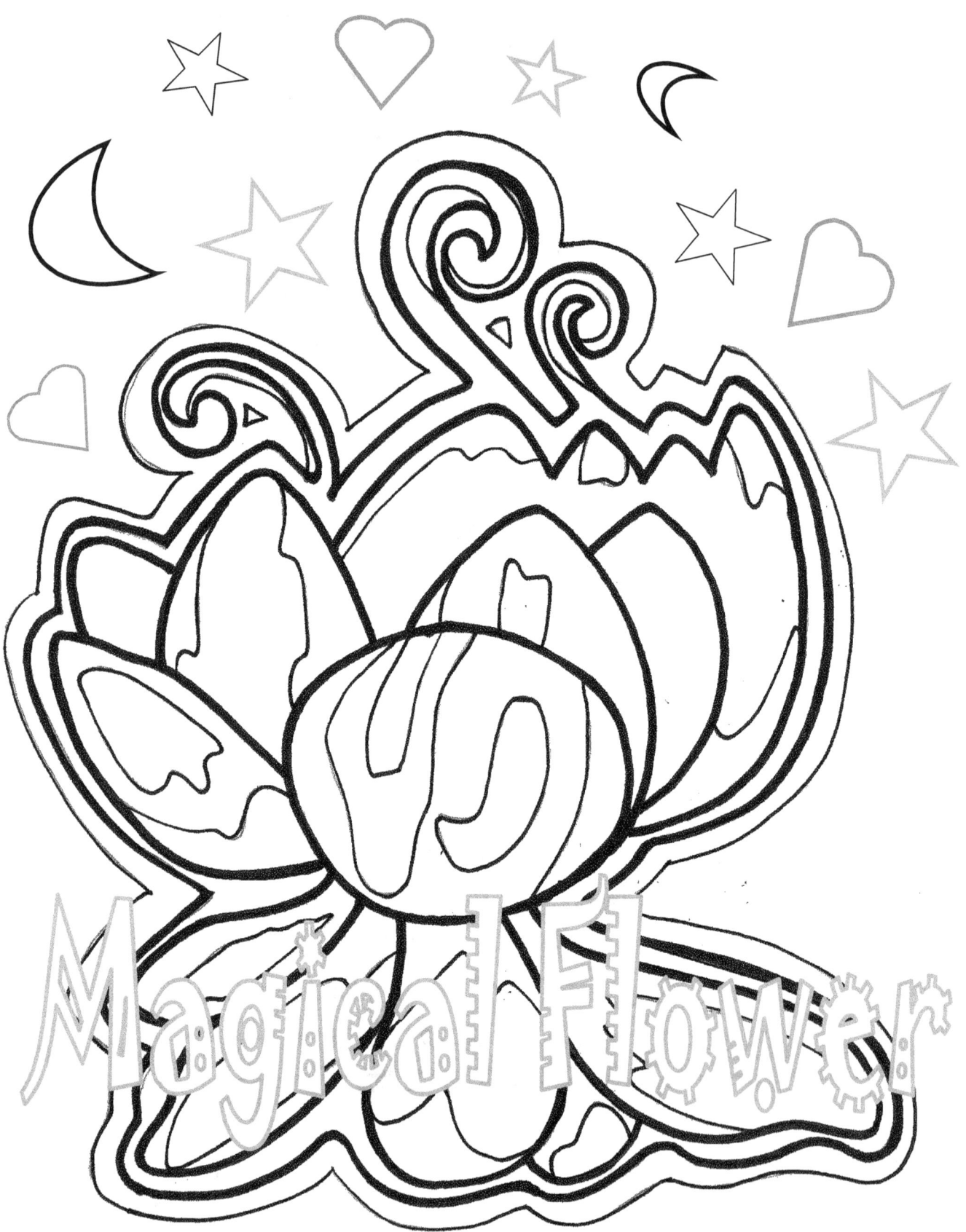

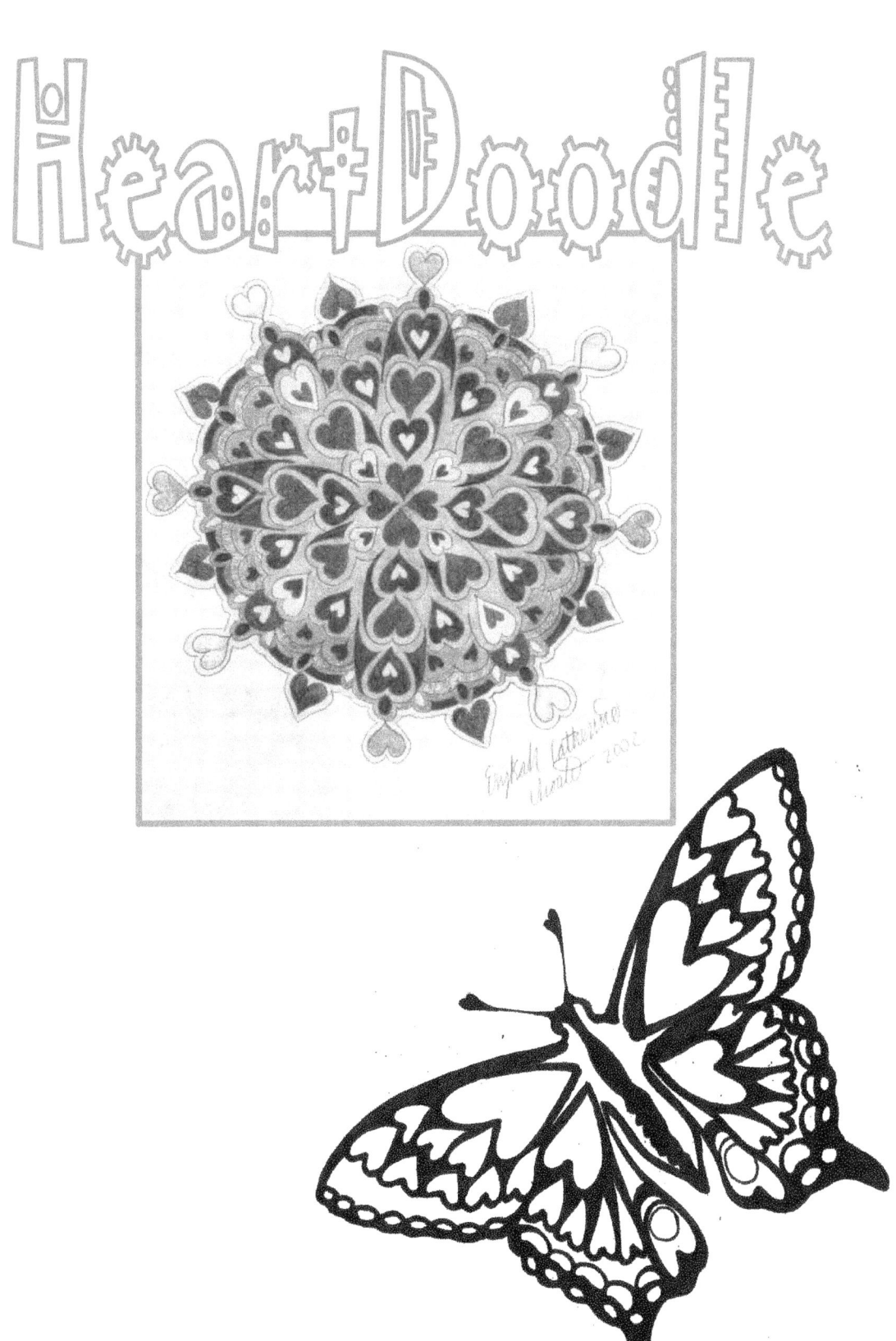

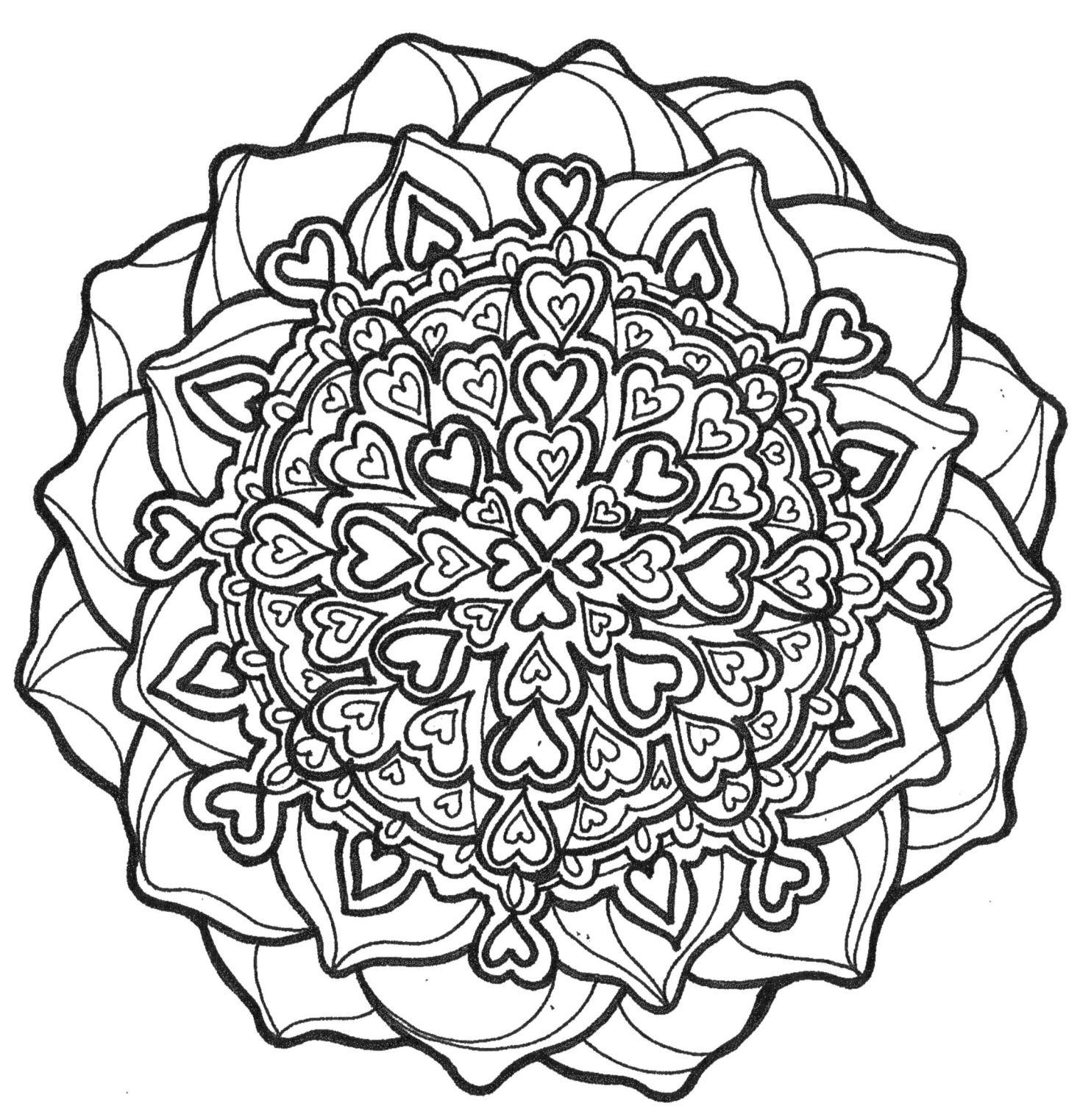

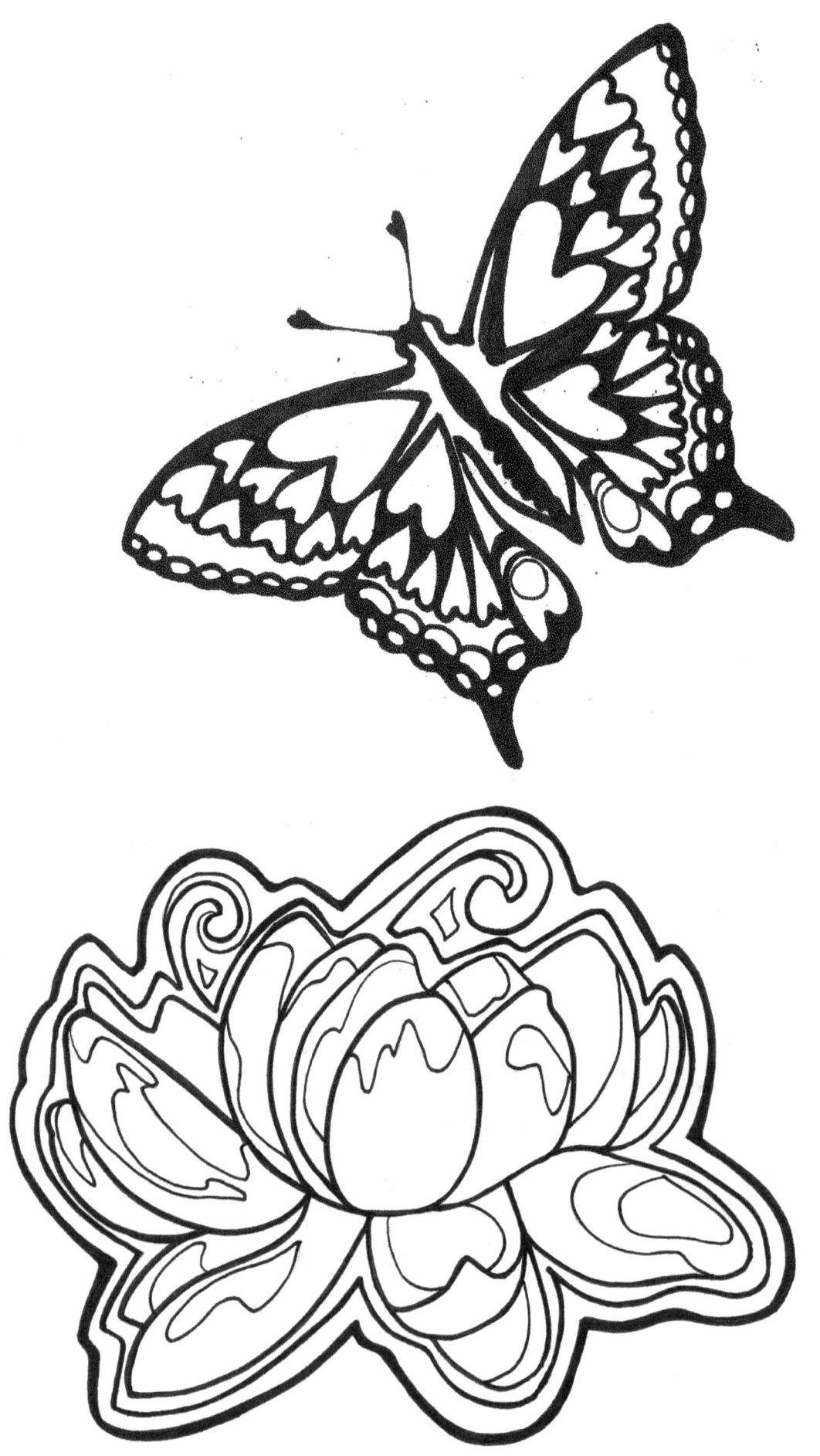

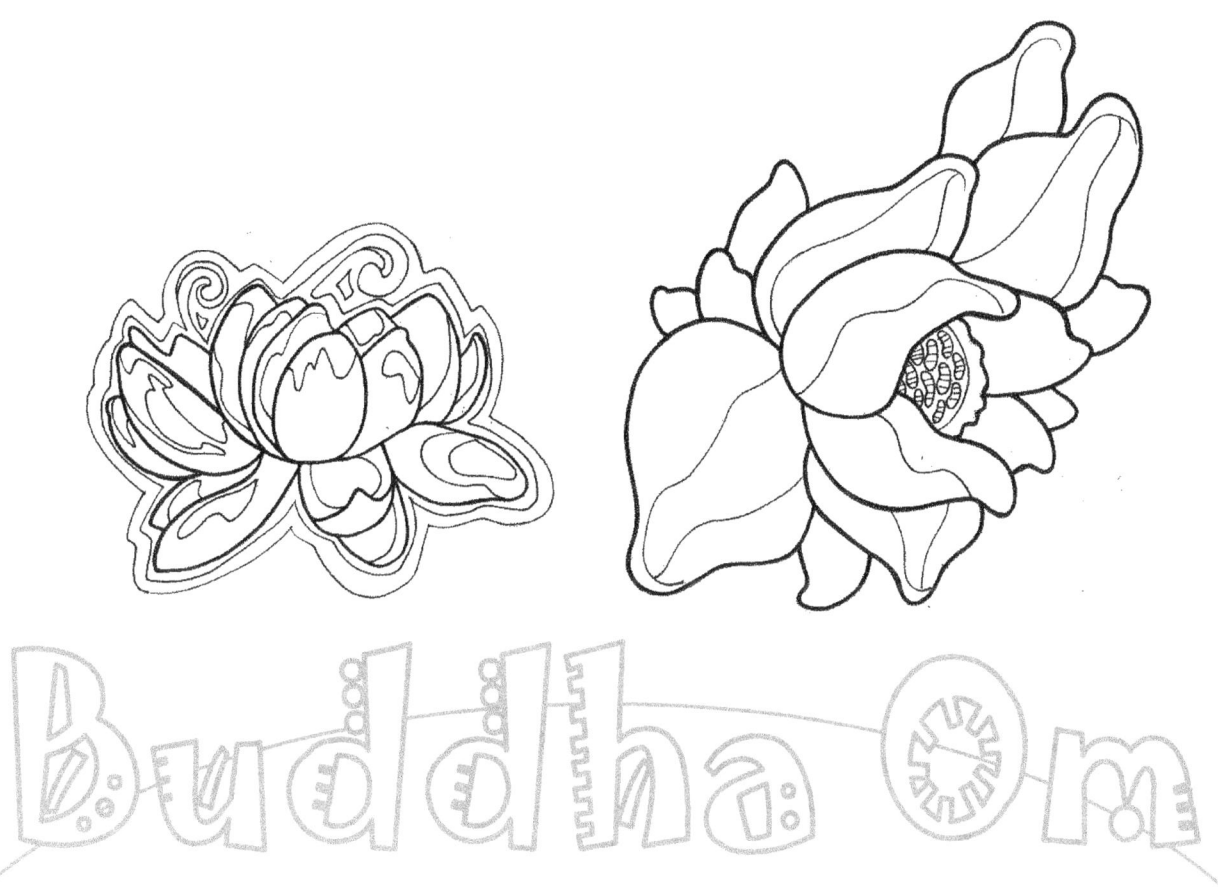

Buddha Om

I have a Buddha Statue on my kitchen counter given to me by a Close Friend. I Look at it every day. The Lotus Flower lights up. This is what unfolded when I was inspired to draw him. It makes me Smile. I hope my coloring pages make you Smile and Inspire you to Color them.

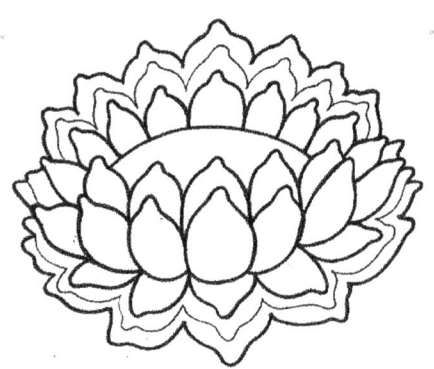

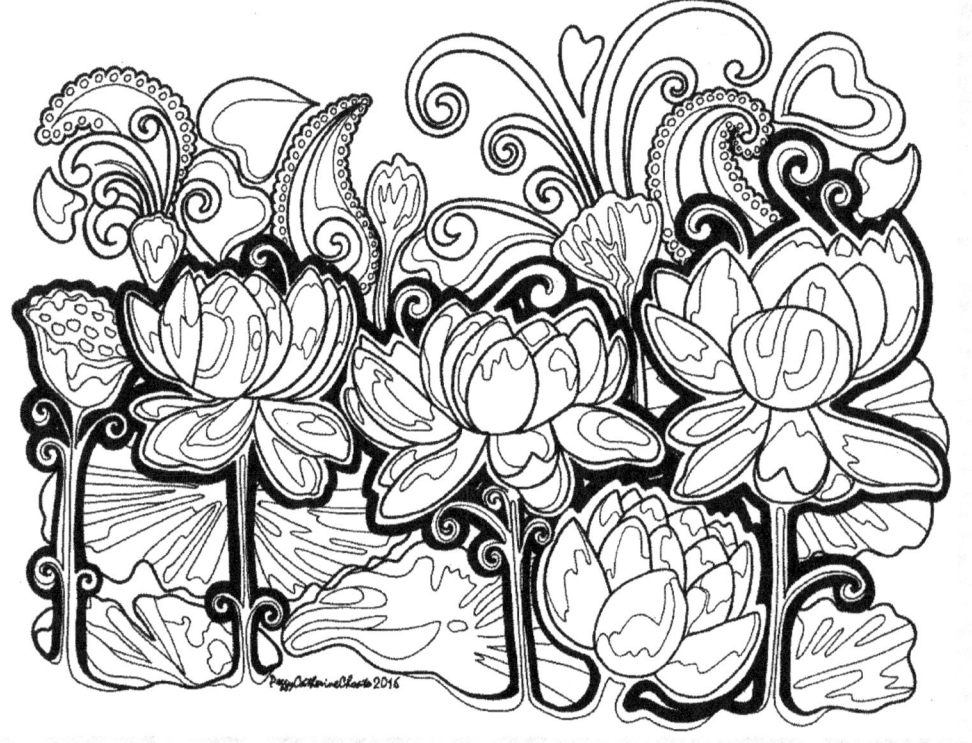
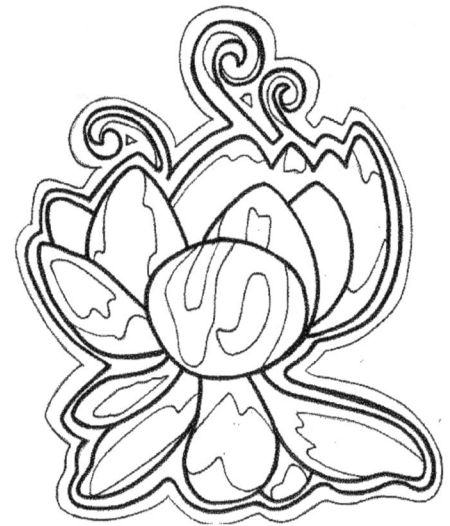

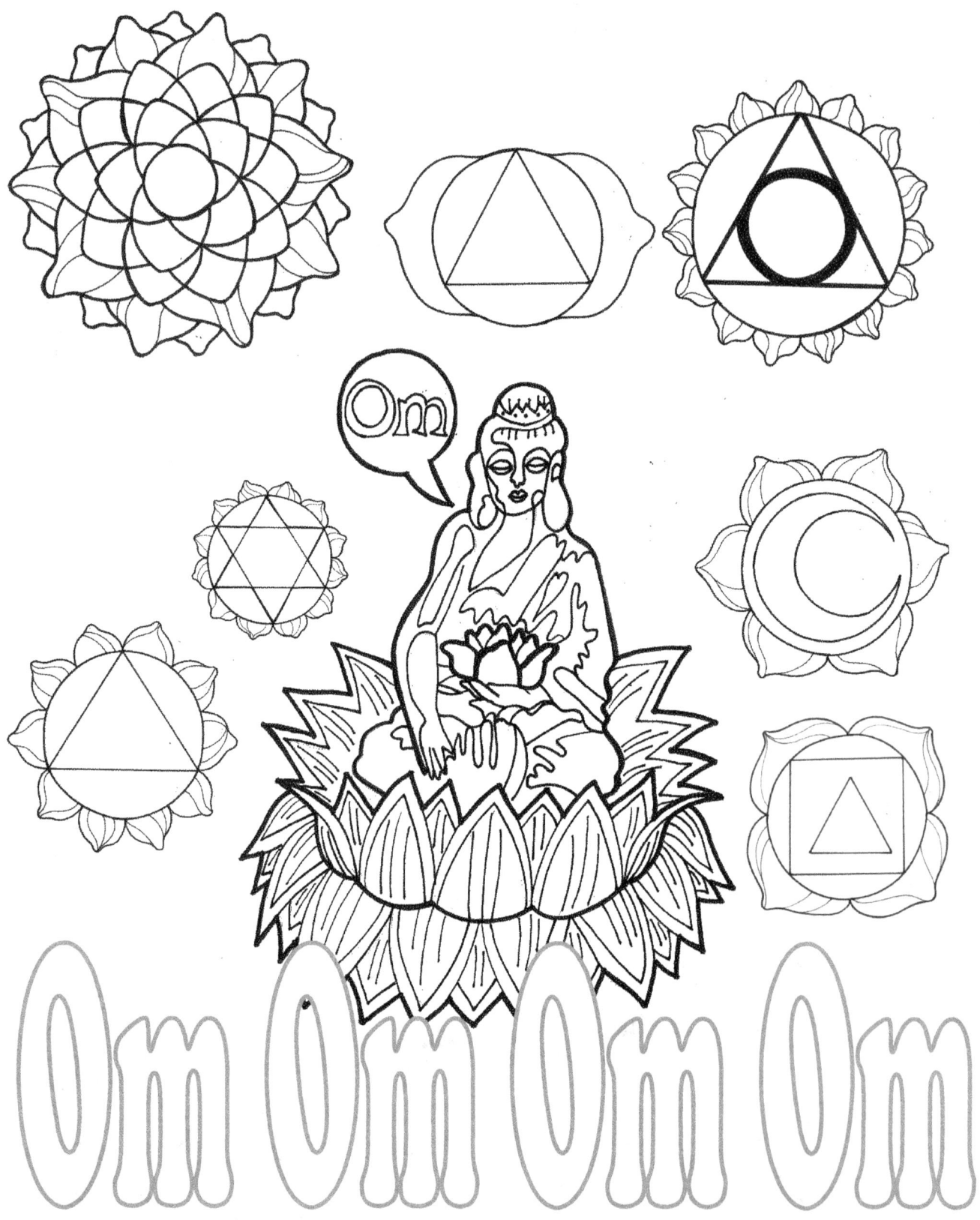

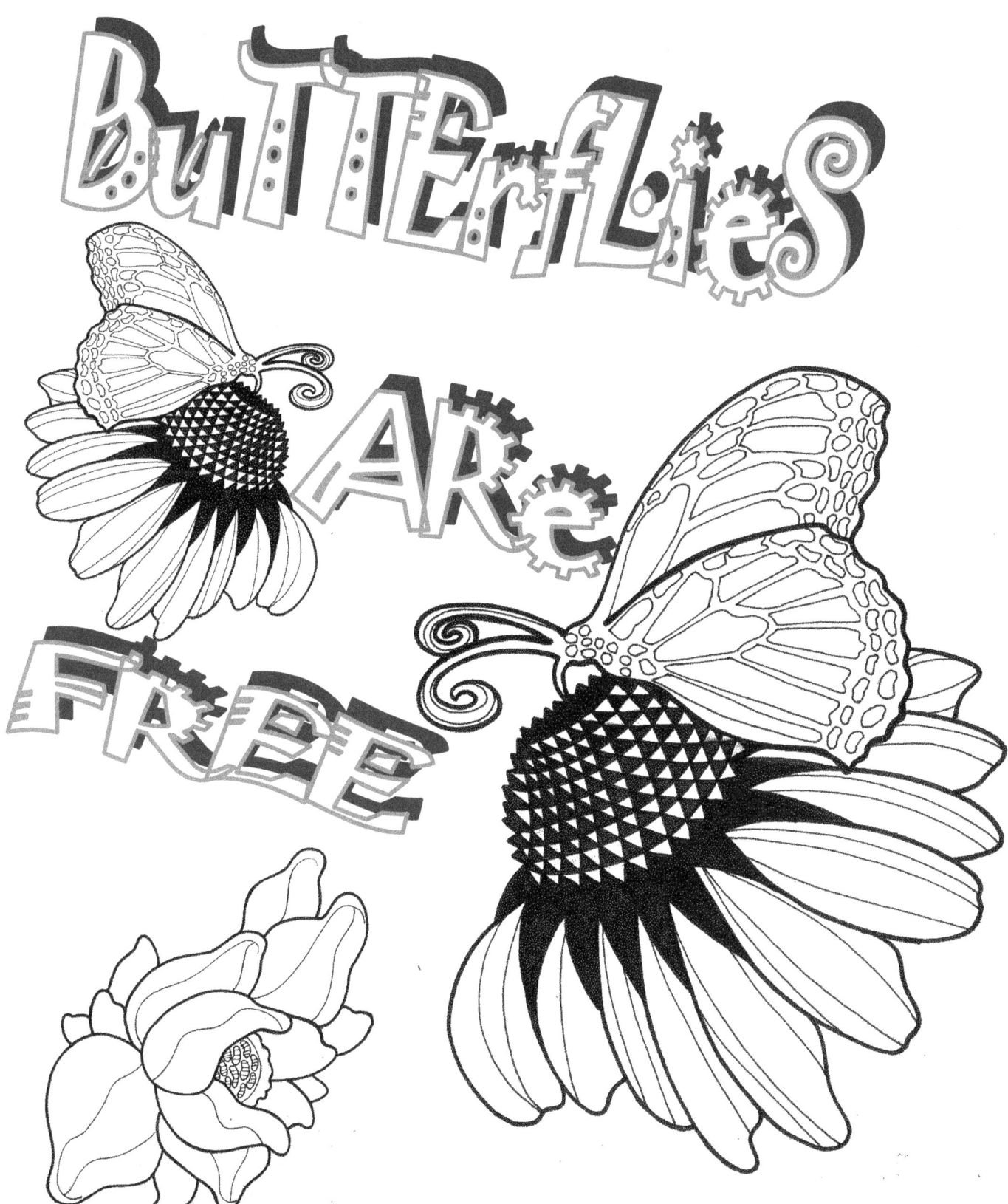

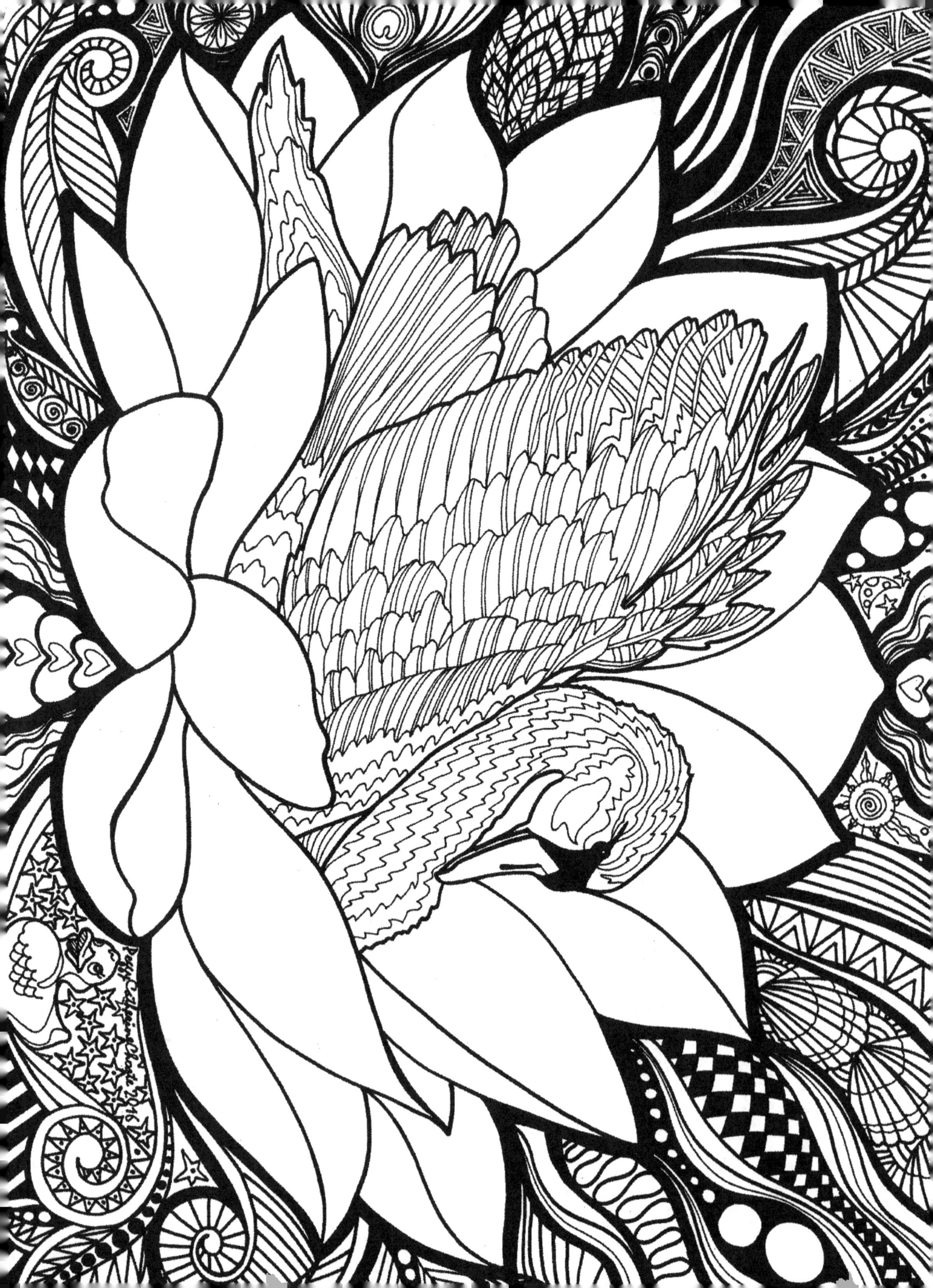

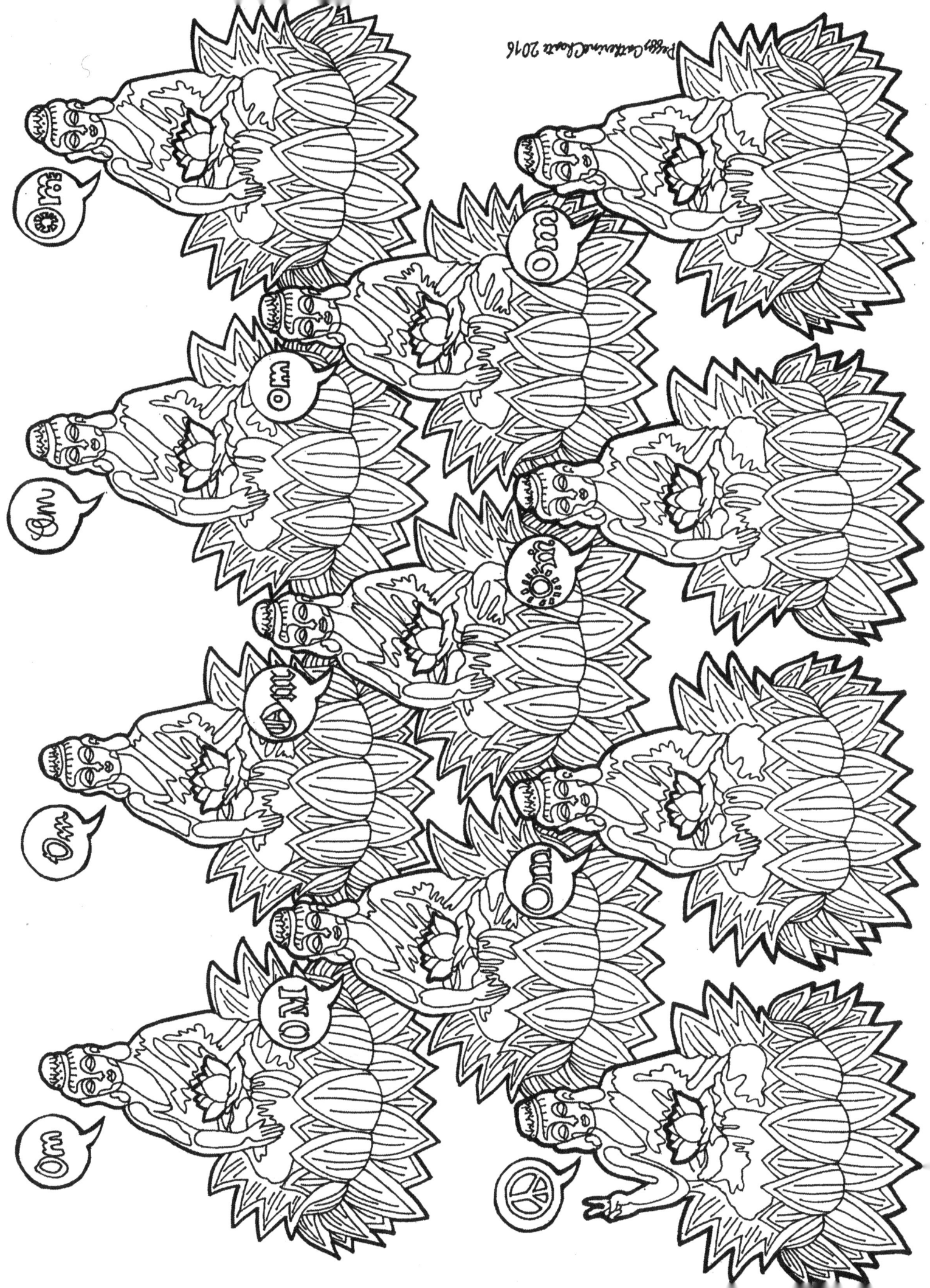

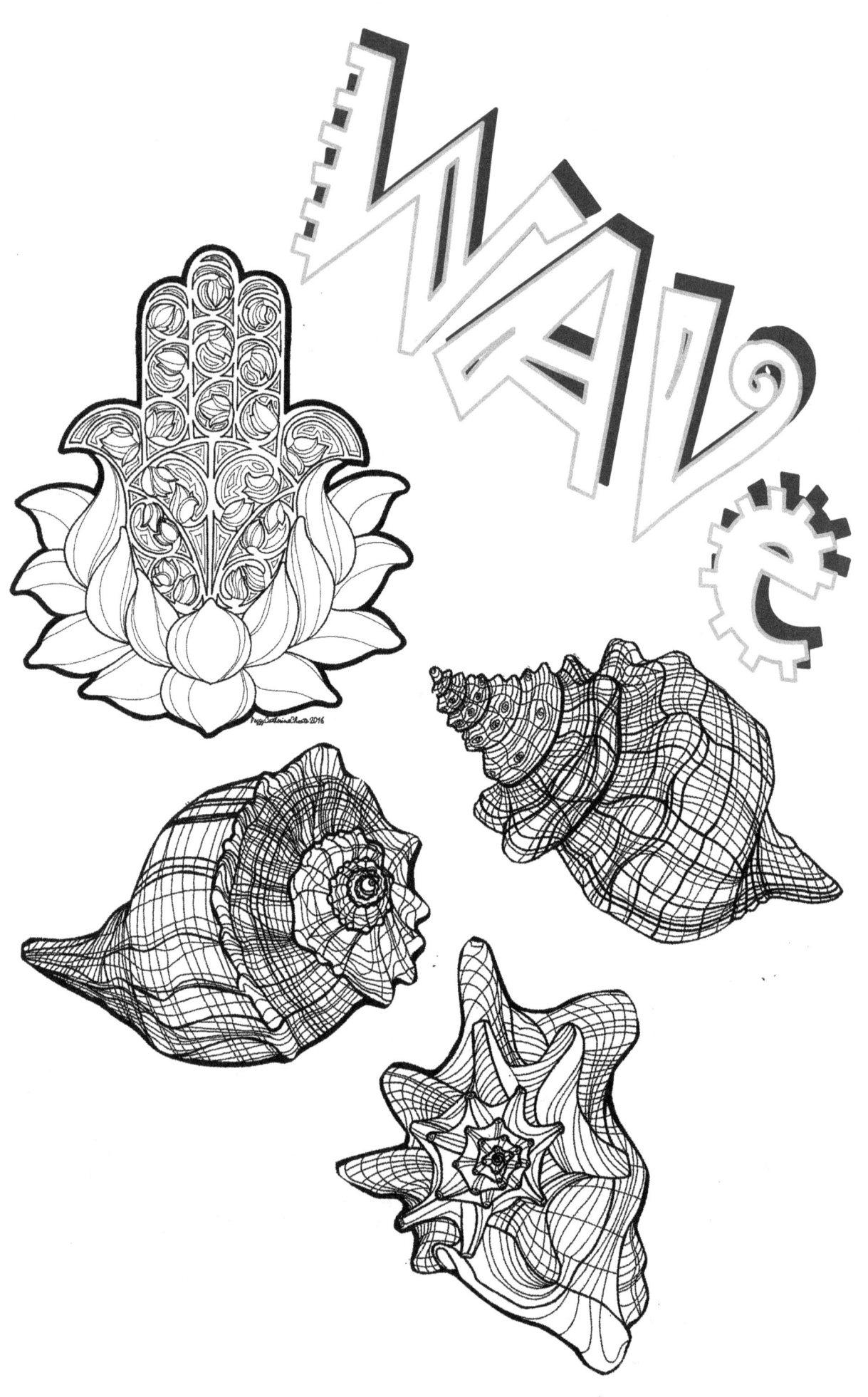

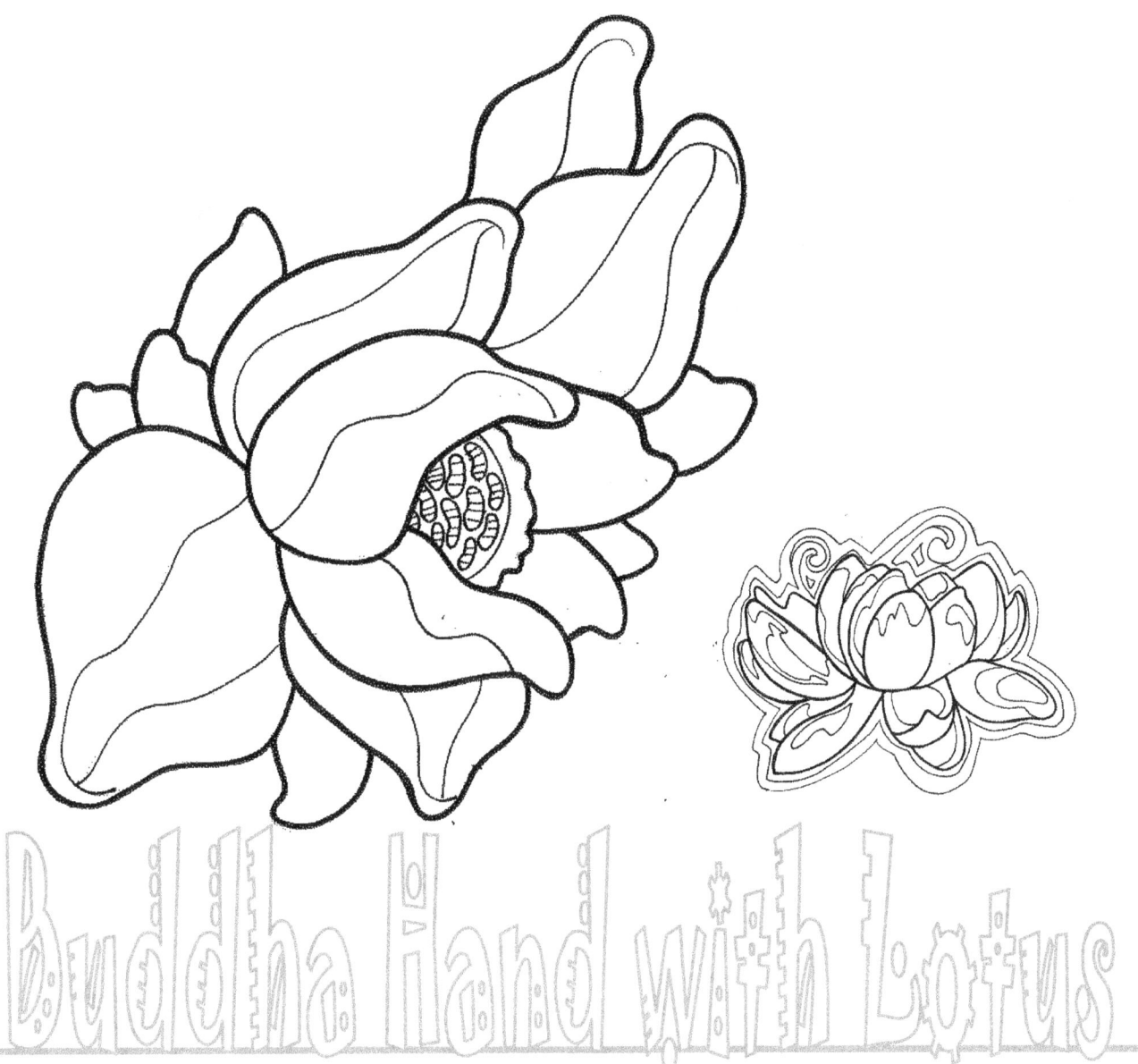

Buddha Hand with Lotus

I am ending with this symbol of a Buddha Hand. Its significance: This gesture was shown by Buddha immediately after attaining Enlightenment. It symbolizes Strength and Security, Reassurance, Fearlessness, Blessings and Protection. This is what I Wish for You.

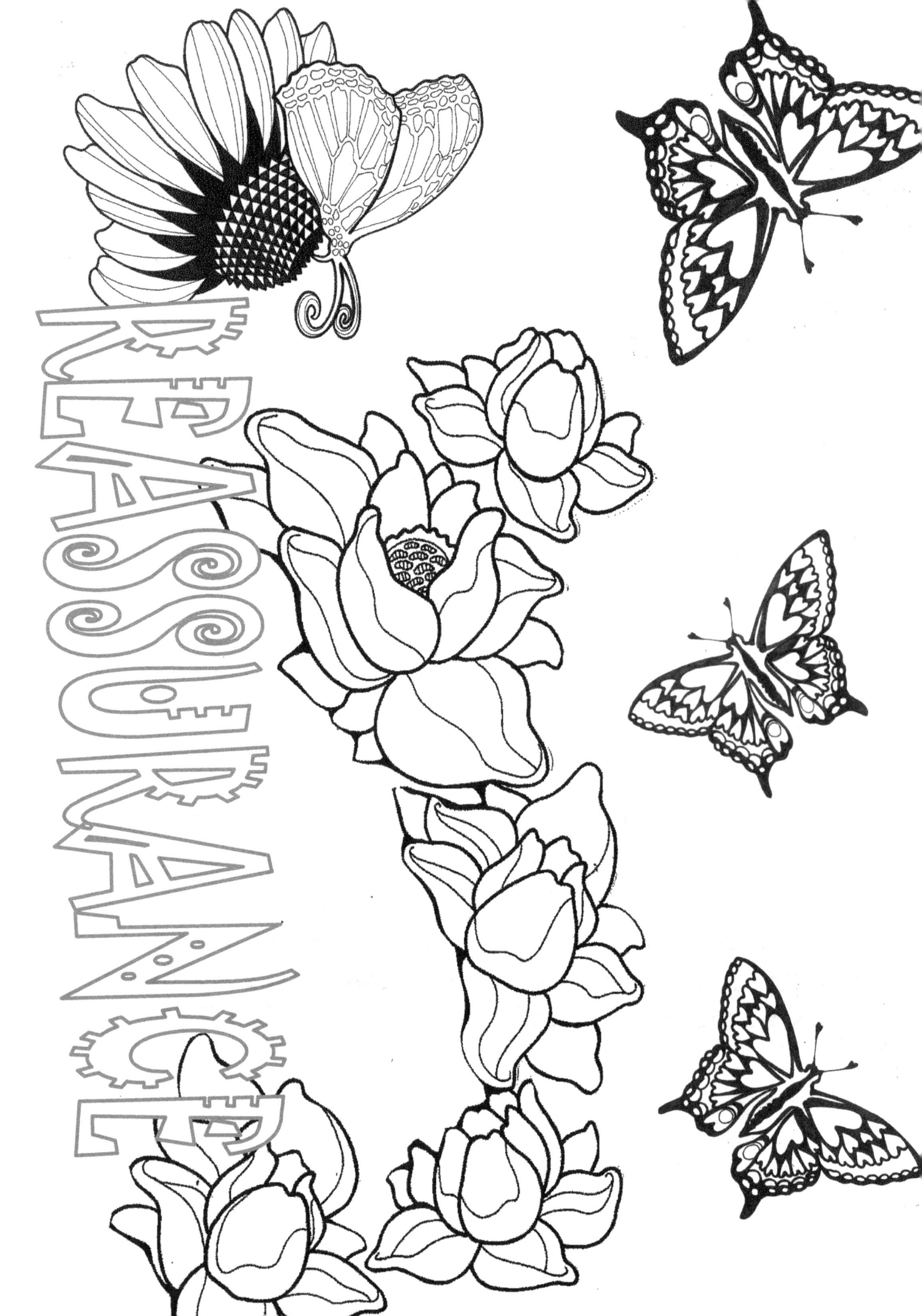

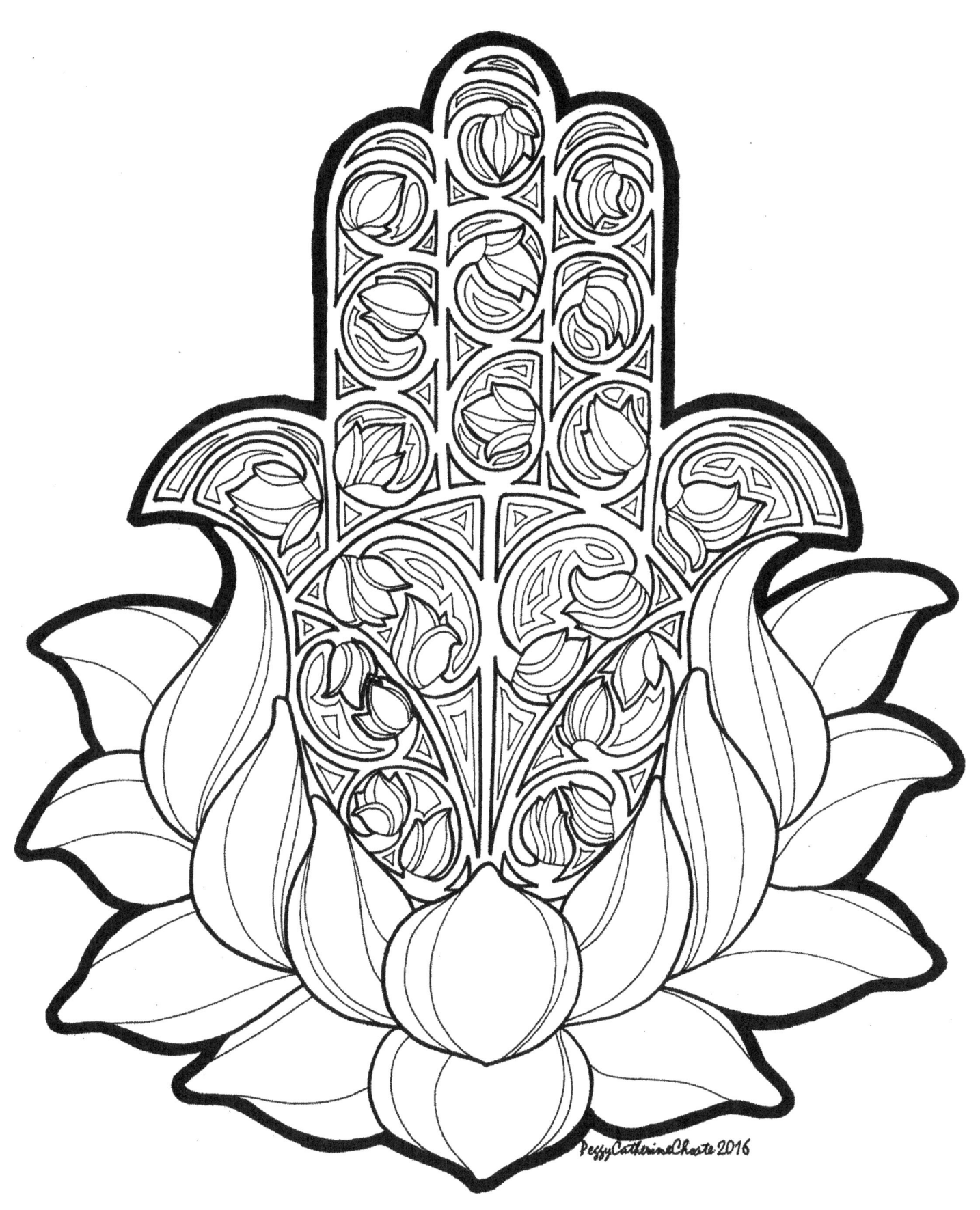

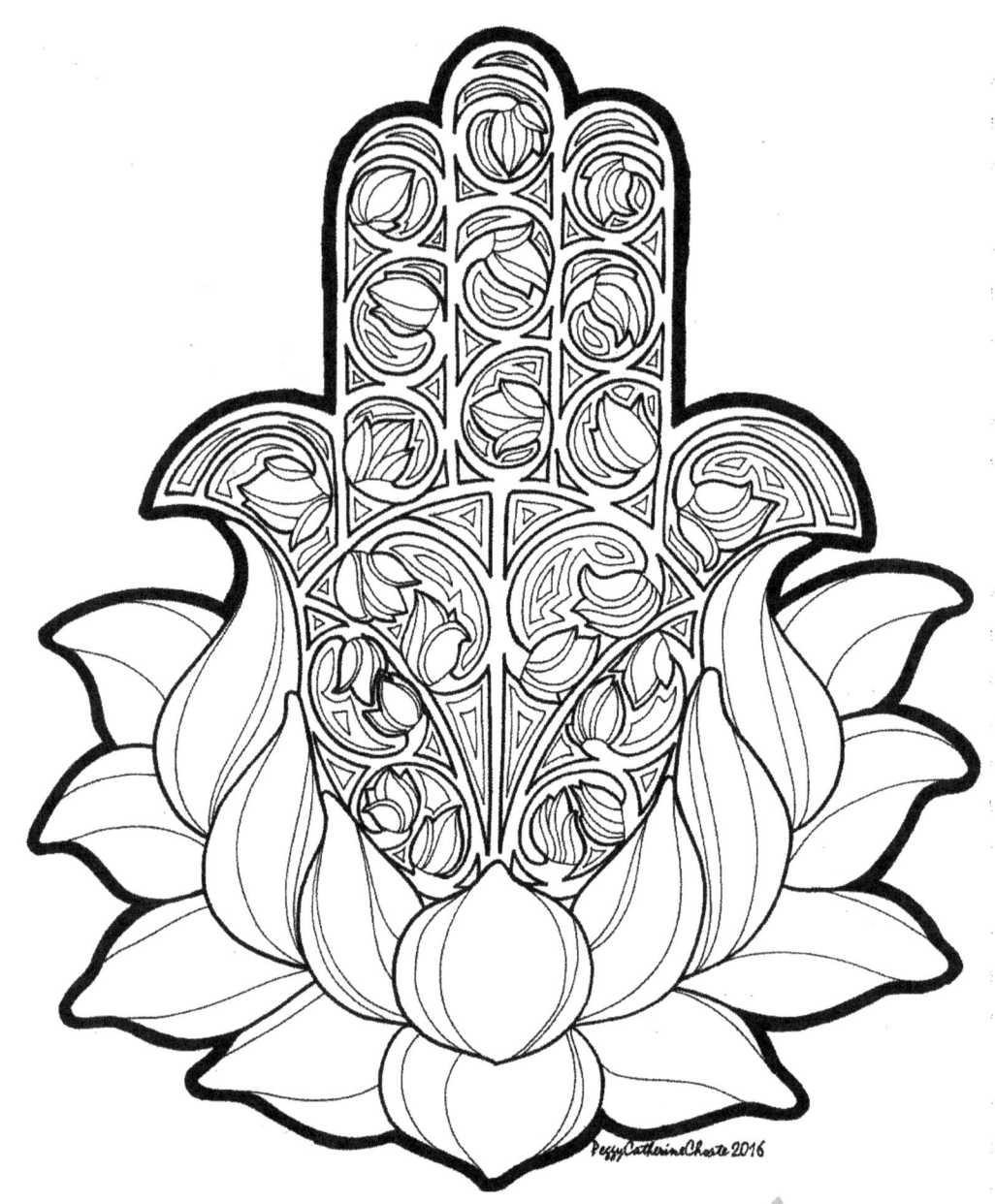

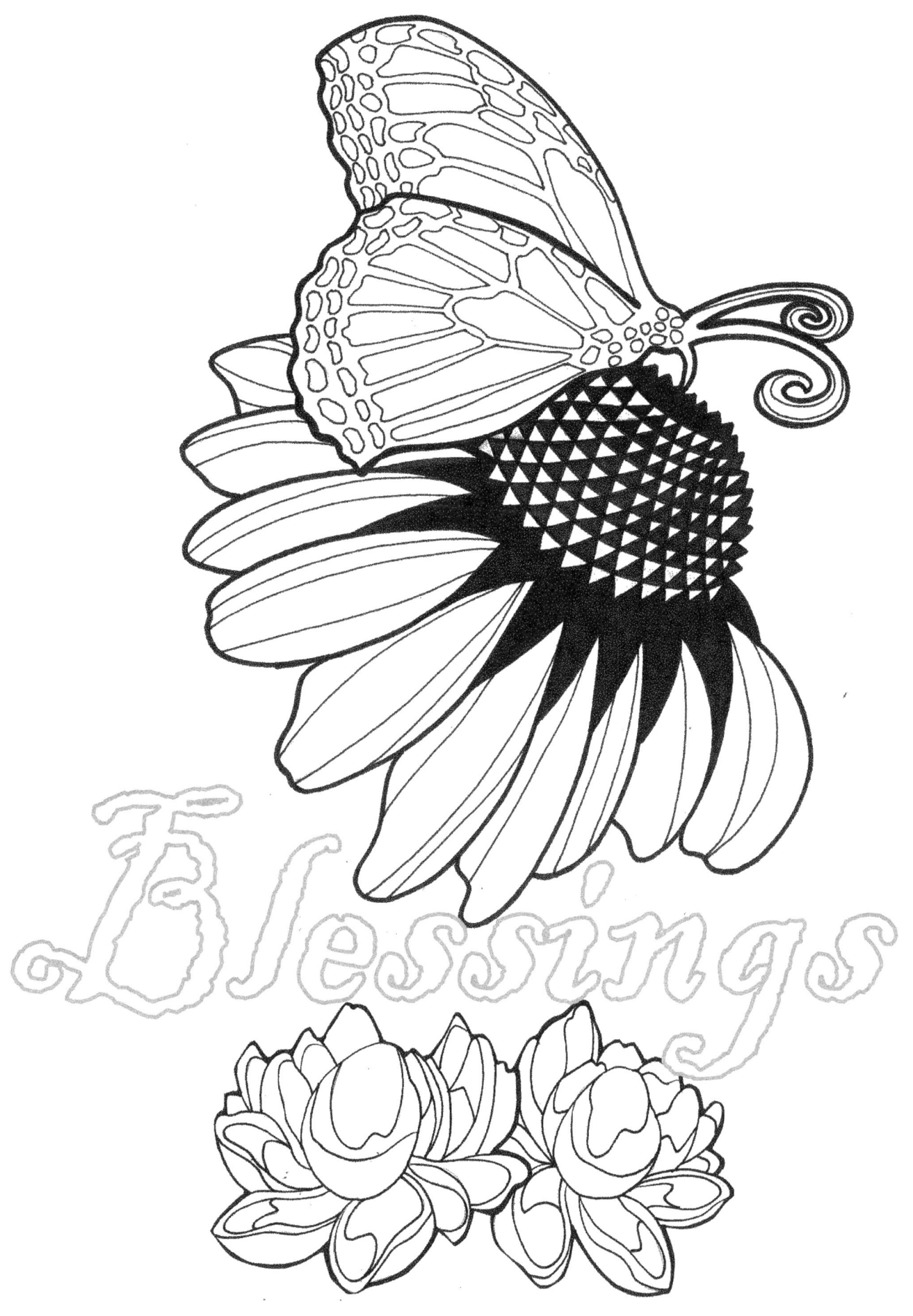

AUSPICIOUS

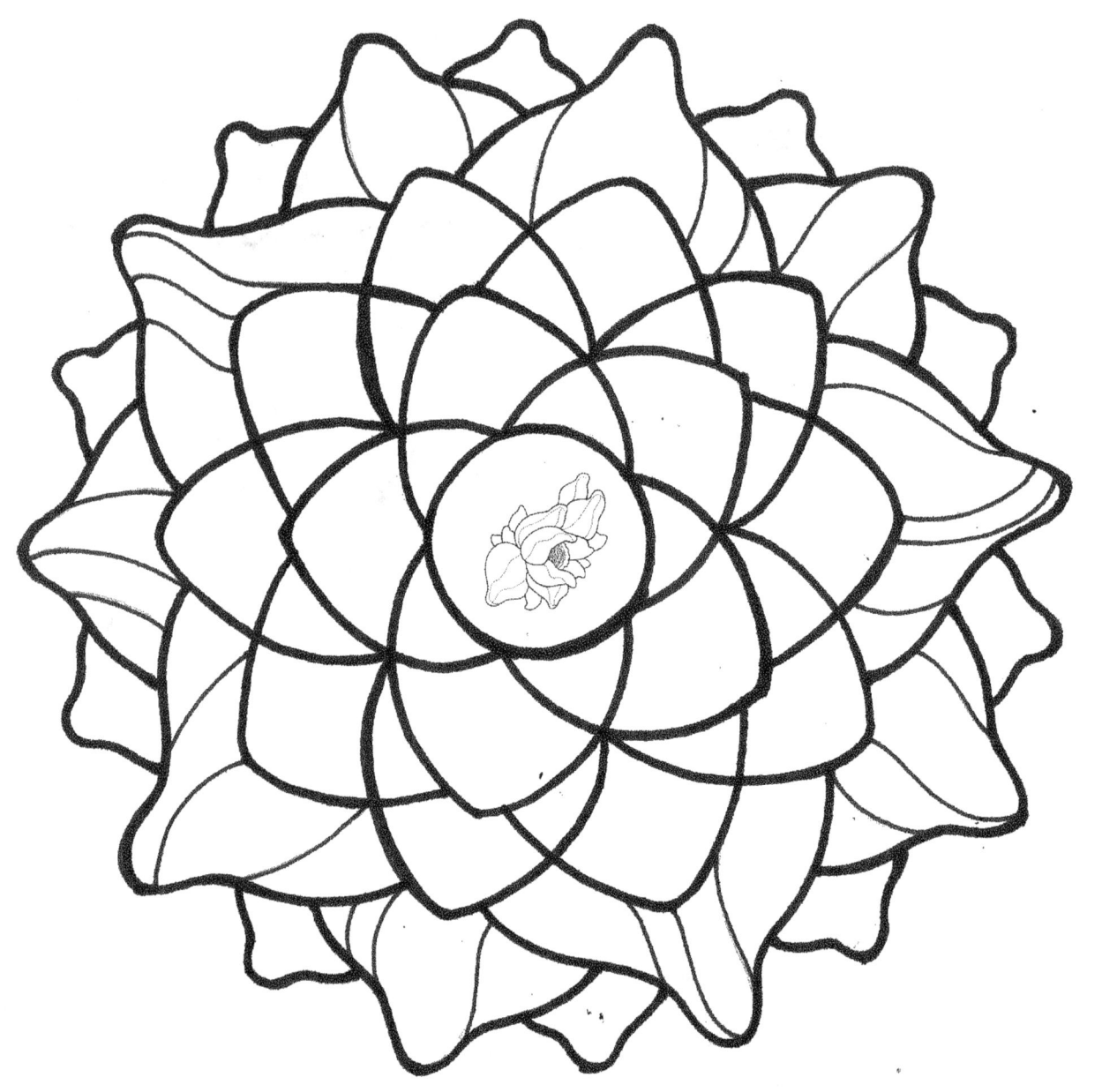

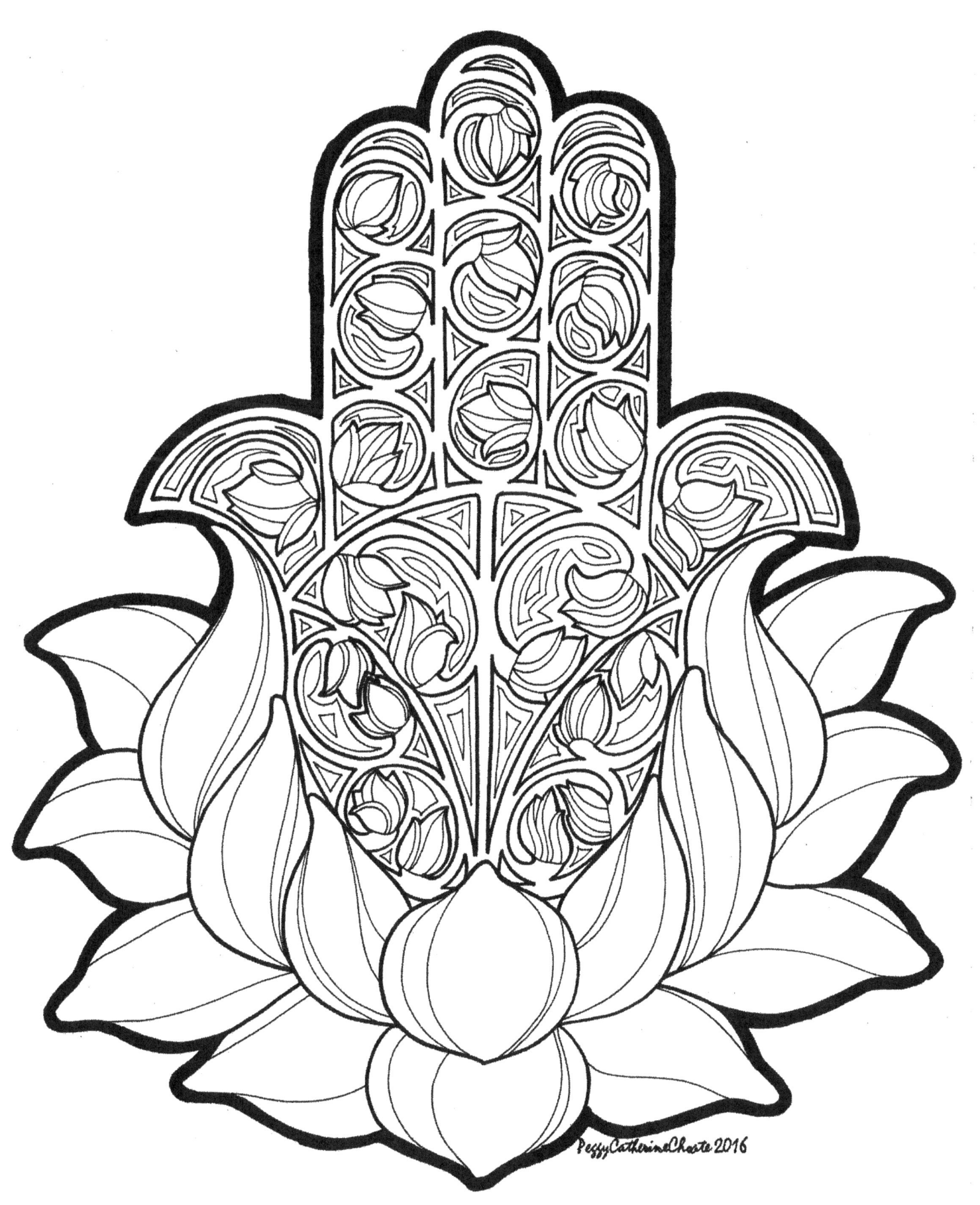

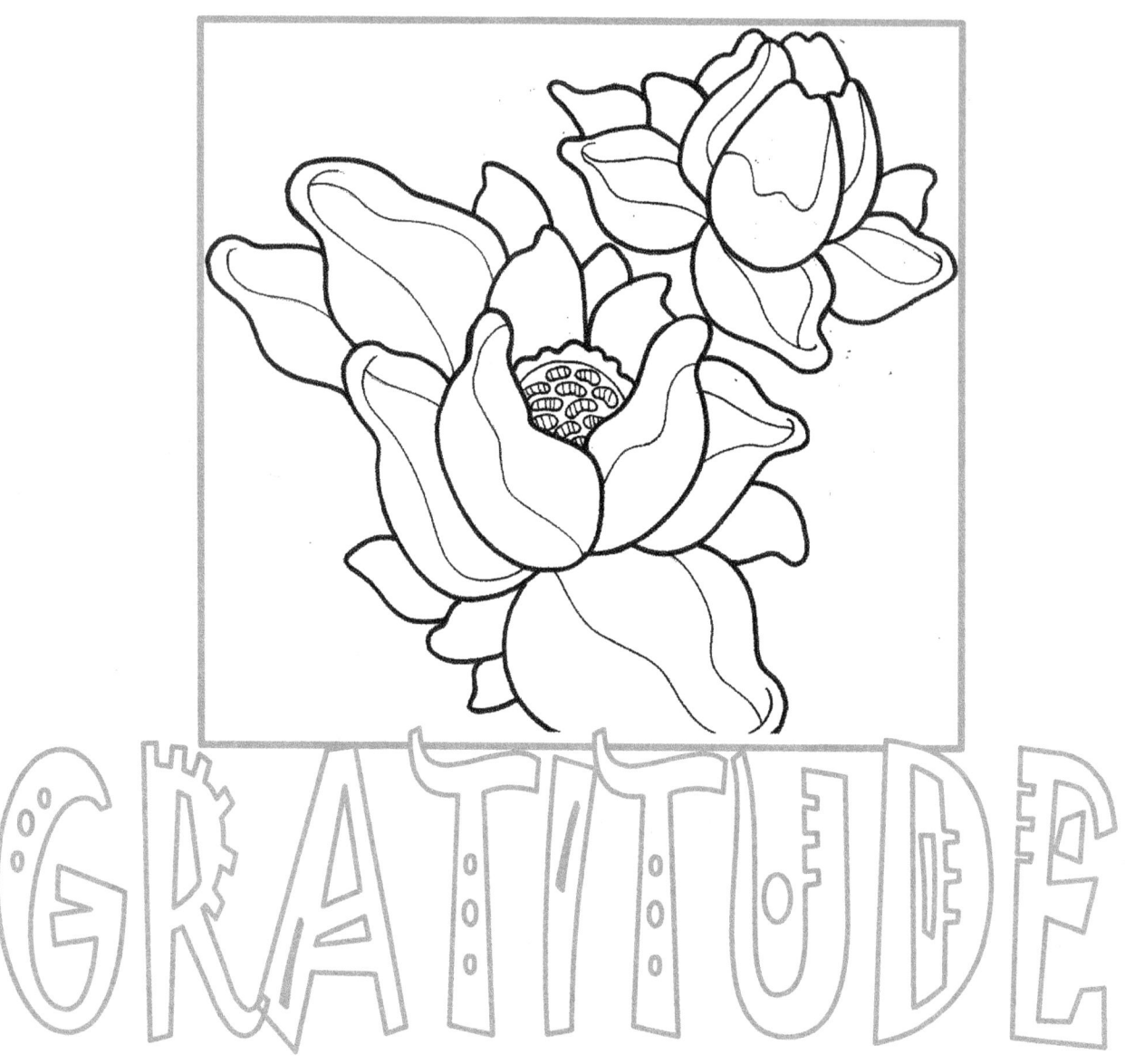

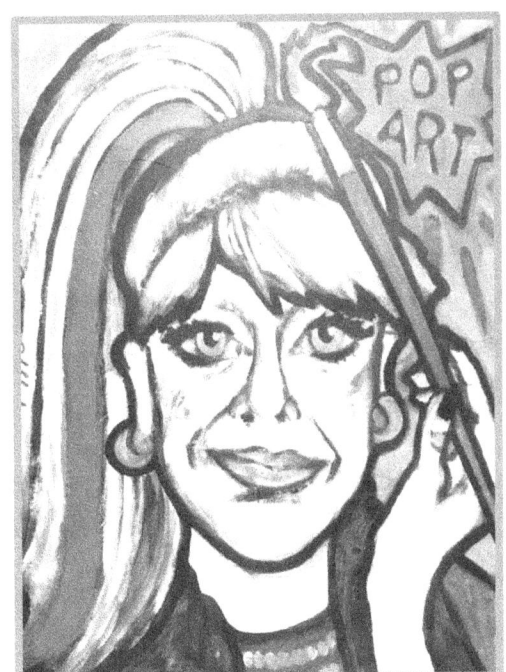

Thank You for Sharing this Trip with Me.

www.ingramcontent.com/pod-product-compliance
Lightning Source LLC
Chambersburg PA
CBHW060008210526
45170CB00017B/1994